PARIS 1900

edited by

Diane P. Fischer

with essays by

Linda J. Docherty

Robert W. Rydell

Gabriel P. Weisberg

Gail Stavitsky

Rutgers University Press

New Brunswick, New Jersey, and London

The Montclair Art Museum

PARIS

The "American School" at the Universal Exposition

1900

Published on the occasion of the exhibition, Paris 1900: The "American School" at the Universal Exposition, *organized by The Montclair Art Museum, Montclair, New Jersey.*

This exhibition and accompanying publication have been made possible through the generous support of The Florence Gould Foundation, the Henry Luce Foundation, Inc., the National Endowment for the Arts, a federal agency, and the Baird Family Fund.

Major support for the exhibition's presentation at the Musée Carnavalet in Paris has been provided by Lucent Technologies.

Funding for all Museum programs is made possible, in part, by the New Jersey State Council on the Arts/Department of State and PNC Bank.

ITINERARY

The Montclair Art Museum, New Jersey
September 18, 1999–January 16, 2000

Pennsylvania Academy of the Fine Arts, Philadelphia
February 11–April 16, 2000

Columbus Museum of Art, Ohio
May 18–August 13, 2000

Elvehjem Museum of Art, University of Wisconsin-Madison
September 16 - December 3, 2000

Musée Carnavalet, Paris
February 2–May 15, 2001

LIBRARY OF CONGRESS CATALOGING-IN-PUBLICATION DATA

Fischer, Diane Pietrucha.

Paris 1900 : the "American school" at the Universal Exposition / Diane P. Fischer ; with essays by Linda J. Docherty . . . [et al.].

p. cm.

Catalog of an exhibition held at the Montclair Art Museum and four other museums.

Includes bibliographical references and index.

ISBN 0-8135-2640 (closth : alk. paper). — ISBN 0-8135-2641-8 (pbk. : alk. paper)

1. Art, American—Exhibitions. 2. Art, Modermn—19th century—United States—Exhibitions. 3. Exposition universelle internationale de 1900 (Paris, France). I. Docherty, Linda Jones. II. Montclair Art Museum. III. Title.

N6510.F59 1999

709'.73'07444361—dc21 98-45276

CIP

British Cataloging-in-Publication data for this book is available from the British Library

BOOK DESIGN BY JENNY DOSSIN

Manufactured in China

This book is dedicated to

Adrian A. Shelby,

President, MAM Board of Trustees.

Her enthusiasm, commitment,

generosity, and profound love

for France, the United States,

and The Montclair Art Museum

serve as inspiration to us all.

CONTENTS

List of Illustrations *ix*

Works in the Exhibition Not Illustrated *xiii*

ELLEN S. HARRIS Foreword *xv*

DIANE P. FISCHER Preface and Acknowledgments *xvii*

Lenders to the Exhibition *xxi*

DIANE P. FISCHER Constructing the "American School" of 1900 I

LINDA J. DOCHERTY Why Not a National Art? Affirmative Responses in the 1890s 95

ROBERT W. RYDELL Gateway to the "American Century": The American
 Representation at the Paris Universal Exposition of 1900 119

GABRIEL P. WEISBERG The French Reception of American Art at the
 Universal Exposition of 1900 145

GAIL STAVITSKY The Legacy of the "American School": 1901–1938 181

Appendix A: List of Selected Participants, U.S. Commission to
the Paris Exposition of 1900 193

DIANE P. FISCHER Appendix B: The Annotated Catalogue of American Paintings,
AND VALERIE WALKER Paris Exposition of 1900 194

Notes 206

Selected Bibliography 220

Photograph Credits 222

Index 225

LIST OF ILLUSTRATIONS

1. *Hachette et cie
 Paris Exposition, 1900
 xiv

2. *Night View of the Eiffel Tower,
 Paris 1900*
 xviii

3. Edwin Lord Weeks
 *The Last Voyage; A Souvenir of the
 Ganges,* ca. 1884
 xxiv

4. Jean-Léon Gérôme
 Le Prisonnier (The Prisoner), 1861
 3

5. Charles Yardley Turner
 Saturday Evening at the Century, 1894
 4

6. *Underwood and Underwood
 *The Grand Palace of Fine Arts,
 Exposition of 1900, Paris, France*
 8

7. Floor Plan of the Grand Palais (left),
 Paris Exposition of 1900
 9

8. William Bouguereau
 *La Vierge aux anges (The Virgin
 with Angels),* 1900
 10

9. Henri Martin
 Sérénité (Serenity), 1899
 10

10. Entrance to the United States
 Industrial Arts Exhibit, Paris
 Exposition, 1900
 12

11. United States National Pavilion, Paris
 Exposition, 1900
 12

12. Robert Reid
 America Unveiling Her Natural Strength
 12

13. Cyrus E. Dallin
 The Medicine Man
 13

14. *Hermon Atkins MacNeil
 The Sun Vow, 1895–1899
 13

15. International Sculpture Decennial,
 Grand Palais, Paris Exposition,
 1900
 14

16. Corridor with the U.S. Exhibition of
 Prints, Drawings, Miniatures, and
 Small Sculpture, Grand Palais,
 Paris Exposition, 1900
 15

17. Corridor Leading to the U.S.
 Paintings Galleries, Grand Palais,
 Paris Exposition, 1900
 15

18. Plan of the U.S. Galleries,
 Grand Palais, Paris Exposition, 1900
 16

19. Gallery A, U.S. Paintings Exhibition,
 Grand Palais, Paris Exposition, 1900
 17

20. Gallery B, U.S. Paintings Exhibition,
 Grand Palais, Paris Exposition, 1900
 17

21. Gallery C, U.S. Paintings Exhibition,
 Grand Palais, Paris Exposition, 1900
 18

22. Gallery D, U.S. Paintings Exhibition,
 Grand Palais, Paris Exposition, 1900
 18

23. Gallery E, U.S. Paintings Exhibition,
 Grand Palais, Paris Exposition, 1900
 19

24. *Bessie O. Potter Vonnoh
 Young Mother, 1899
 20

25. *Alexander Proctor
 Panther, 1893–1898
 21

26. *James McNeill Whistler
 Brown and Gold, ca. 1895–1900
 22

27. *James McNeill Whistler
 *Mother of Pearl and Silver:
 The Andalusian,* ca. 1894
 23

28. *James McNeill Whistler
 *The Little White Girl; Symphony in
 White No. II,* 1864
 24

29. *John Singer Sargent
 *Portrait of Miss Carey Thomas,
 President of Bryn Mawr College
 (1894–1922),* 1899
 25

30. John Singer Sargent
 *Mrs. Carl Meyer, later Lady Meyer, and
 her two Children,* 1896
 25

31. *Edwin Lord Weeks
 Indian Barbers—Saharanpore,
 ca. 1895
 27

32. *Frederick Arthur Bridgman
 *Pharaoh and His Army Engulfed by the
 Red Sea,* 1900
 28

33. Henry O. Tanner
 Daniel in the Lions' Den, 1896
 29

34. Robert Loftin Newman
 Christ Stilling the Tempest, n.d.
 30

35. *Maxfield Parrish
 The Sandman, 1902
 31

36. *Charles Courtney Curran
 The Peris, 1898
 32
37. *George Willoughby Maynard
 In Strange Seas, 1889
 33
38. *Edwin Austin Abbey
 The Play Scene in "Hamlet" (Act III, Scene ii), 1897
 34
39. *Francis Davis Millet
 Unconverted, ca. 1880
 35
40. *Robert Blum
 A Flower Market in Tokyo, ca. 1892
 36
41. *Robert Blum
 The Ameya, 1890–1892
 37
42. *John La Farge
 Siva with Siakumu Making Kava in Tofae's House, ca. 1893
 38
43. Daniel Ridgway Knight
 July Morning, 1895
 39
44. *Charles Woodbury
 The Green Mill, 1896
 40
45. *George Hitchcock
 Vaincu (Vanquished), n.d.
 40
46. *Julius Garibaldi Melchers
 The Sisters, ca. 1895
 41
47. *Marcia Oakes Woodbury
 Mother and Daughter: The Whole of Life, 1894
 42
48. *Walter MacEwen
 Dimanche en Hollande (Sunday in Holland), ca. 1898
 43
49. *Julius Stewart
 Nymphes de Nysa (Nymphs of Nysa), n.d.
 44
50. *Joseph R. DeCamp
 Woman Drying Her Hair, ca. 1899
 45
51. *Alfred Maurer
 At the Window, 1899–1900
 46

52. Fred Dana Marsh
 The Lady in Scarlet, ca. 1900
 47
53. *William Merritt Chase
 Portrait of Mrs. C (Lady with a White Shawl), 1893
 48
54. *Cecilia Beaux
 Mother and Daughter, 1898
 49
55. Edmund C. Tarbell
 Across the Room, ca. 1899
 50
56. *Theodore Robinson
 Girl at Piano, ca. 1887
 51
57. *Abbott Handerson Thayer
 Young Woman, ca. 1898
 52
58. Abbott Handerson Thayer
 Virgin Enthroned, 1891
 53
59. *George de Forest Brush
 Mother and Child, 1895
 54
60. *George Hitchcock
 Magnificat, 1894
 55
61. Irving Wiles
 The Artist's Mother and Father, 1889
 56
62. *Charles Sprague Pearce
 The Shawl, ca. 1900
 57
63. Mary Fairchild MacMonnies
 Roses et Lys (Roses and Lilies), 1897
 58
64. Frank Weston Benson
 The Sisters, 1899
 58
65. *Rosina Emmet Sherwood
 Head of a Child, n.d.
 59
66. *J. G. Brown
 Heels over Head, ca. 1894
 60
67. *Eastman Johnson
 Prisoner of State, 1874
 60
68. Gari Melchers
 The Fencing Master, ca. 1900
 61

69. *John White Alexander
 Portrait of Rodin, 1899
 62
70. *Thomas Eakins
 The Cello Player, 1896
 63
71. Thomas Eakins
 Salutat, 1898
 65
72. *Thomas Eakins
 Between Rounds, 1899
 64
73. Winslow Homer
 The Lookout- "All's Well," 1896
 65
74. *Julian Alden Weir
 Midday Rest in New England, 1897
 66
75. *Charles Schreyvogel
 My Bunkie, 1899
 67
76. *Willard L. Metcalf
 Midsummer Twilight, ca. 1890
 69
77. William Lamb Picknell
 On the Banks of the Loing, ca. 1895
 70
78. *Theodore Robinson
 Port Ben, Delaware and Hudson Canal, 1893
 71
79. *Theodore Clement Steele
 Bloom of the Grape, 1893
 72
80. *George Inness
 The Clouded Sun, 1891
 73
81. *George Inness
 Sunny Autumn Day, 1892
 75
82. *George Inness
 The Mill Pond, 1889
 76
83. *Homer Dodge Martin
 Westchester Hills, n.d.
 77
84. *Homer Dodge Martin
 Newport Neck, 1893
 78
85. *Alexander Wyant
 In the Adirondacks, ca. 1881
 79

86. *Leonard Ochtman
Winter Morning, 1898
80

87. John Francis Murphy
Under Gray Skies, 1893
80

88. *Henry Gallison
Grey Day, ca. 1898
81

89. *Ralph Albert Blakelock
Woods at Sunset, BY 1902
82

90. *Alexander Harrison
Le Crépuscule, (Twilight), 1899
83

91. *Winslow Homer
Maine Coast, 1895
84

92. *Winslow Homer
Nuit d'Eté (Summer Night), n.d.
85

93. *Winslow Homer
Summer Night—Dancing by Moonlight, n.d.
85

94. *Winslow Homer
Fox Hunt, 1893
86

95. *William Merritt Chase
Big Brass Bowl, ca. 1899
87

96. *Childe Hassam
Fifth Avenue in Winter, ca. 1892
89

97. *Henry Ward Ranger
Brooklyn Bridge, 1899
90

98. Francis Tattegrain
Les Bouches inutiles, siège du Château-Gaillard (Useless Mouths, Siege of Château-Gaillard), 1203, ca. 1896
93

99. Court of Honor, World's Columbian Exposition, Chicago, 1893
97

100. Fine Arts Building, World's Columbian Exposition, Chicago, 1893
98

101. Parthenon, Tennessee Centennial Exposition, Nashville, 1897
101

102. William Henry Howe
Monarch of the Farm, 1891
102

103. Edwin Howland Blashfield, two details of *The Evolution of Civilization*, 1895–1896
104

104. *The Evolution of Civilization* (detail)
105

105. *Dewey Triumphal Arch and Colonnade*
107

106. Daniel Chester French
Peace (detail of above)
108

107. Edmund Charles Tarbell
In the Orchard, 1891
111

108. Julian Alden Weir
The Factory Village, 1897
112

109. Winslow Homer
The Wreck, 1896
115

110. George Inness
A Gray Lowery Day, 1877
116

111. Underwood & Underwood
Interior of Machinery Hall, Motive Power Machines, Exposition of 1900, Paris, France
118

112. *Perspective de l'Exposition Universelle de 1900*
121

113. Interior View of Commissioner-General Peck's Private Office
125

114. Cuban Exposition in the Trocadéro Building, Paris Exposition, 1900
127

115. Porte Binet, Monumental Gateway to the Paris Exposition, 1900
129

116. Fountain of the Château d'Eau, Paris Exposition, 1900
130

117. A Moving Sidewalk Panorama, Paris Exposition, 1900
131

118. Champ de Mars, Taken from the Eiffel Tower, Paris Exposition, 1900
132

119. "La Loïe's" Flying Skirts, Loïe Fuller Pavilion, Paris Exposition, 1900
134

120. Keystone View Company, Alexander Phimister Proctor
Liberty on the Chariot of Progress
135

121. *Exposition Universelle, 1900
Le Pont Alexandre III
136

122. Sousa's Band Playing "Stars and Stripes Forever," Paris Exposition, 1900
137

123. Miscellaneous Alcove and Indian Exhibit, Champ de Mars, Paris Exposition, 1900
140

124. Negro Social and Industrial Exhibit, Palace of Social Economy, 1900
143

125. Tiffany & Company's Exhibit, Palace of Diverse Industries, Paris Exposition, 1900
147

126. Portrait of Henry Roujon
148

127. Portrait of Georges Leygues
149

128. Invitation to the Opéra from Leygues to Rodin
150

129. Auguste Rodin
Buste de Georges Leygues
151

130. Portrait of Léonce Bénédite
152

131. Sergeant Kendall
St. Ives, Pray for Me, ca. 1891
155

132. Maria Longworth Nichols Storer
Chalice, 1898
156

133. Maria Longworth Nichols Storer
Vase, ca.1900
157

134. *Artus Van Briggle, Rookwood Pottery
Vase, ca. 1899
158

135. *Artus Van Briggle, Rookwood
 Pottery
 Vase, ca. 1899
 159

136. *Edward George Diers and William
 Watts Taylor, Rookwood Pottery
 Vase, 1900
 160

137. *George Prentiss Kendrick, Grueby
 Faïence Company
 Vase, ca. 1889–1902
 161

138. *Kataro Shirayamadani, Rookwood
 Pottery
 Vase, 1898
 162

139. *William C. Codman, Gorham
 Manufacturing Company
 Pair of Vases, 1899
 166

140. *Attributed to Paulding Farnham
 Tiffany & Co.
 Centerpiece, 1900
 167

141. *Tiffany & Co. Brooch,* ca. 1900
 168

142. *Louis C. Tiffany, Tiffany Glass and
 Decorating Company
 Cypriote Vase, ca. 1900
 169

143. Tiffany Glass and Decorating
 Company
 Punch Bowl with Three Ladles, 1900
 170

144. Léonce Bénédite
 Reinstallation of the Musée du
 Luxembourg
 171

145. Alexander Harrison
 En Arcadie, 1900
 172

146. John Humphreys Johnston
 *Portrait de la mère de l'artiste (Portrait
 of the Artist's Mother),* 1895
 174

147. *Ben Foster
 *Bercé par le murmure d'un ruisseau
 (Lulled by a Murmuring Stream),*
 1899
 177

148. Paul W. Bartlett
 Statue of Lafayette
 178

*denotes object in exhibition

WORKS IN THE EXHIBITION NOT ILLUSTRATED

PAINTINGS

Thomas Eakins, Cello Player, 1896. Oil on canvas mounted on board, 17 1/2 x 14 inches. Collection of the Heckscher Museum of Art, Huntington, New York. Museum Purchase: Heckscher Trust Fund, Stebbins Family, Priscilla de Forest Williams, George Wilhelm and Acquisition Fund.

Harvey Ellis, Silhouettes, 1899. Watercolor, 12 1/2 x 17 inches. Courtesy the Strong Museum, Rochester, New York.

Charles Fromuth, Un décor de neige, bateaux désarmés (Snow Decoration, Dismantled Boats), 1897. Pastel on paper mounted on board, 24 1/8 x 18 1/2 inches, Musée des Beaux-Arts de Quimper.

Frederick Childe Hassam, Winter Afternoon in New York, 1900. Oil on canvas, 23 x 19 inches. Museum of the City of New York, Bequest of Mrs. Giles Whiting, 71.120.107.

George Inness, Gathering Clouds, Spring, Montclair, New Jersey, ca. 1890-1894. Oil on canvas, 24 1/4 x 36 1/4 inches. The Montclair Art Museum, New Jersey, Museum purchase; Acquisition Fund, 1998.4.

J. Francis Murphy, September Noon, 1890. Oil on canvas, 14 1/4 x 19 1/4 inches. The Montclair Art Museum, New Jersey. Gift of William T. Evans, 1915.35.

Edward Redfield, France, 1898-1899. Oil on canvas, 31 1/4 x 40 3/16 inches. Daniel J. Terra Collection, 1992.126.

John Singer Sargent, Catherine Vlasto, 1897. Oil on canvas, 58 1/2 x 33 5/8 inches. Hirshhorn Museum and Sculpture Garden, Smithsonian Institution, Washington, D.C. Gift of Joseph H. Hirshhorn, 1966.

Henry O. Tanner, Daniel in the Lions' Den, 1907-1918. Oil on paper mounted on canvas, 41 1/8 x 49 7/8 inches. Los Angeles County Museum of Art, Mr. and Mrs. William Preston Harrison Collection.

James McNeill Whistler, Red and Black: The Fan (Portrait of Mrs. Charles Whibley), ca. 1891-1894. Oil on canvas, 73 3/4 x 35 3/8 inches. Hunterian Museum and Art Gallery, University of Glasgow.

SCULPTURES

Paul Wayland Bartlett, Lafayette on Horseback, 1907. Bronze, 16 1/4 x 15 1/2 x 9 1/2 inches. In the collection of the Corcoran Gallery of Art, Gift of Mrs. Armistead Peter, III.

Frederick MacMonnies, Bacchante, 1895. Bronze with bronze pedestal, 77 1/2 x 11 7/8 x 12 inches. Courtesy the Virginia Museum of Fine Arts. Gift of Mr. G.A. Peple.

Augustus Saint-Gaudens, Amor Caritas, 1899. Bronze, 8 x 4 feet. Paris, Musée d'Orsay, R. F. 1403.

Augustus Saint-Gaudens, Amor Caritas, 1880, reworked 1898. Plaster, 8 x 4 feet. Courtesy of the U.S. Department of the Interior, National Park Service, Saint-Gaudens National Historic Site, Cornish, New Hampshire.

DECORATIVE ART

Grueby Faïence Company, Vase, ca. 1900. Buff stoneware with matt glaze, 21 3/4 inches. Collection of William P. Curry.

Grueby Faïence Company, Vase, ca. 1900. Buff stoneware with matt glaze, 12 1/4 inches. Collection of William P. Curry.

Paulding Farnham, Tiffany & Co., "Aztec" Collar, 1900. 22kt gold, fire opals, diamonds, rubies, peridots, various color tourmalines, various color zircons, 14 1/2 x 1 5/8 inches. Tiffany & Co. Archives.

DIDACTICS

Official Illustrated Catalogue, Fine Arts Exhibit. United States of America at the Paris Exposition of 1900. (Noyes, Platt & Co., Boston), 1900. Book, 4 1/4 x 7 inches. Dr. Ronald Berg, Monticello, New York.

The Chefs d'Oeuvre: Art and Architecture, vol. 3 (George Barrie and Sons, Philadelphia), 1900-1902. Book, 15 1/2 x 11 3/4 inches. Special Collections, The Newark Public Library, Newark, New Jersey.

Tiffany & Co., Photographs, Tiffany & Co. Exhibit. Paris Exposition, 1900, 1900. Hardcover scrapbook with sepia photographs, 11 1/2 x 10 3/8 inches. Tiffany & Co., Parsippany, New Jersey.

Various photographs and posters depicting the fairgrounds of the Universal Exposition of 1900.

Jane Voorhees Zimmerli Art Museum, Rutgers, The State University of New Jersey, New Brunswick, New Jersey.

Louis Veyron, Seguret & Thabut, France, Paris Exposition Banner, ca. 1900. Silk, 30 1/4 x 24 inches. Joseph M. Napoli.

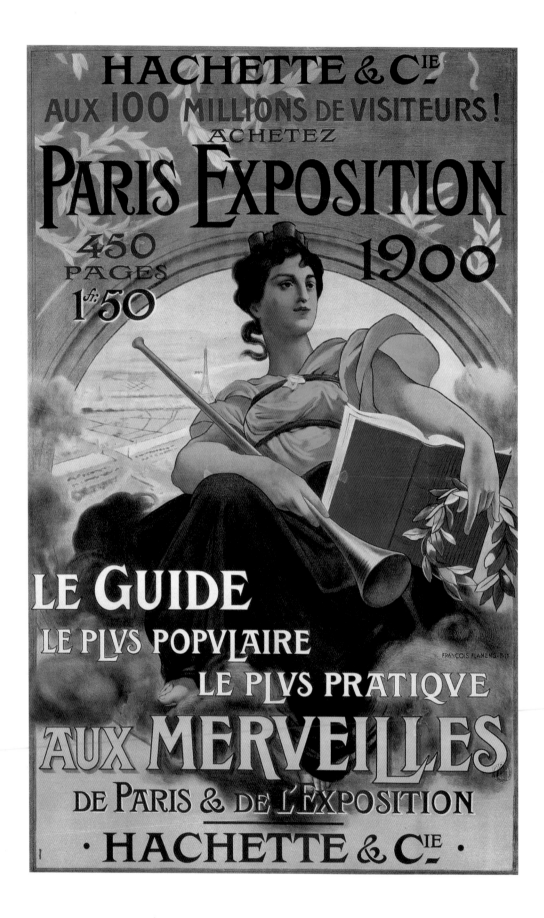

FOREWORD

There are fewer than six degrees of separation between The Montclair Art Museum (MAM) and the groundbreaking exhibition of American art at the Paris Universal Exposition of 1900. At the exposition, the celebrated American landscape painter, George Inness, was hailed as the "father" of the new national school. One of Inness's patrons, Montclair resident William T. Evans, was a major collector of American art and a cofounder of The Montclair Art Museum. MAM has been committed to American art since it opened in 1914, nearly twenty years before the establishment of the Whitney Museum of American Art in New York. Thanks to Evans's initiative, works by George Inness, a Montclair resident for the last nine years of his life, are among the crown jewels of MAM's collection. It is only fitting, then, that we celebrate this historic exhibition in our galleries.

Diane P. Fischer approached me after the museum's Julia Norton Babson Memorial Lecture in 1992 when Dr. William H. Gerdts spoke about George Inness and the early Montclair art colony. She introduced herself as a doctoral candidate in art history at the City University of New York with special interest and expertise in late-nineteenth-century painting. Two years later, she contributed an essay for *George Inness: Presence of the Unseen*, the exhibition Dr. Gail Stavitsky, our chief curator, had organized to mark the centennial of Inness's death. Soon after, Gail and Diane co-curated *The Montclair Art Colony: Past and*

Present, a groundbreaking and enormously popular show. When they approached me with an idea for a third collaboration, an exhibition that would reassemble American masterpieces from the Paris exposition of 1900, I knew we had a hit on our hands. The 1900 exposition had been the subject of Dr. Fischer's dissertation, and the show's centennial was just around the corner.

Dr. Stavitsky quickly enlisted the partnership of Rutgers University Press as copublisher of this book and invited the Pennsylvania Academy of the Fine Arts to become the exhibition's first tour venue. This was an entirely appropriate match: the academy had lent a number of works to the exposition in 1900, and they were now generously lending them again. As the exhibition's project director, Dr. Stavitsky has been instrumental in bringing this ambitious exhibition to fruition. Dr. Fischer's extraordinary scholarship and personal tenacity led not only to the beautiful and ambitious exhibit, book, and tour, but also to her being appointed associate curator at MAM, to the delight of us all.

We wholeheartedly thank the Henry Luce Foundation, the Florence Gould Foundation, and the National Endowment for the Arts, a federal agency, for their early enthusiasm and generous support for this project. André Simon and Sophie de Kinkelin were instrumental in making early arrangements with our Parisian collaborators.

We also thank the museums and private collectors who lent their spectacular works of art to this exhibition and its tour. In addition to the Pennsylvania Academy of the Fine Arts, these lenders include The Metropoli-

1. *Hachette et cie, *Paris Exposition, 1900*, poster, 53 1/4 x 34 inches. Musée Carnavalet. Copyright Photothèque des Musées de la Ville de Paris.

tan Museum of Art, the Musée d'Orsay, the National Gallery of Art, and the Tate Gallery, among many others. All lenders to the exhibition are listed on page *xxi*. Tiffany & Co. deserves special kudos for the loan of their award-winning decorative art objects that were first exhibited at the exposition as well as for their support of the Paris 1900 ball that launched public awareness of the project in 1998.

We are especially delighted to be sharing *Paris 1900* with four other museums: The Pennsylvania Academy of the Fine Arts; the Columbus Museum of Art; the Elvehjem Museum of Art, University of Wisconsin-Madison; and the Musée Carnavalet in Paris. Their staffs and trustees were helpful in arranging the myriad details of this complex undertaking.

Finally, we gratefully acknowledge our authors, Diane P. Fischer, Linda Docherty, Robert W. Rydell, Gail Stavitsky, and Gabriel P. Weisberg, and contributor Valerie Walker, as well as Marlie Wasserman and Leslie Mitchner at Rutgers University Press, our copublishers, for this splendid book. It tells a story well worth retelling and analyzing as we look back on the history of American art in the last century and look forward to the millennium. It is a proud history that serves as a foundation for, and informs, the collecting and exhibition activity of The Montclair Art Museum.

ELLEN S. HARRIS
Executive Director
The Montclair Art Museum

One hundred years ago, Americans believed that they deserved their own "school" of art, not simply because they produced quality work, but also because they assumed they were destined to inherit the mantle of western civilization. The United States contingent to the Exposition Universelle et Internationale de Paris of 1900 (which was open from April 15 through November 12) was administered through the Department of State, and it was no coincidence that the self-conscious promotion of American culture at the fair corresponded with the rise of the nation as a world power in the wake of the Spanish-American War of 1898. As the largest such event in terms of attendance, until the New York World's Fair of 1964, the exposition of 1900 was the perfect vehicle to advertise the arrival of the young "empire" to an international audience.

American art triumphed at the exposition of 1900. Critics on both sides of the Atlantic agreed that, based upon the preponderance of native themes in the paintings, an "école américaine" had indeed originated. The exhibition's explicitly national character countered the previous Parisian exposition of 1889, when American art had been dismissed as an "annex" of the French School. In his final report to the U. S. Congress, John B. Cauldwell, director of fine arts, predicted that the exposition of 1900 would "probably mark an epoch in the history of American art." However, because of modernist biases which soon rendered turn-of-the-century American art unfashionable, Cauldwell's declaration remained unexamined for almost a century. This book and the exhibition it accompanies reveal, for the first time on a large scale, the exposition's pervasive impact on American art.

Nineteenth-century exposition organizers were acutely aware of each fair's individual role as an historical marker, a mirror of prevailing conditions, and a harbinger of the future, just as we are today. *Paris 1900: The "American School" at the Universal Exposition* is the next in what has become a series of major exhibitions celebrating the centennials of these pivotal episodes as they relate to American art, following *Paris 1889: American Artists at the Universal Exposition* (1989; Pennsylvania Academy of the Fine Arts) and *American Art at the 1893 World's Fair* (1993; National Museum of American Art and National Portrait Gallery).

Paris 1900 is intended to evoke the singular aura of the American fine arts section of the exposition. As was the case in 1900, the emphasis in this exhibition is on oil paintings, but sculpture, decorative arts, and didactic materials are also included to provide the framework of the exposition as an extravaganza. Although a century has elapsed since 256 oils, watercolors, and pastels by more than 174 American artists were united at the Paris exposition, 98 of those works have been located for the current exhibition.

Some of the original paintings could not be included because they were deemed too fragile to travel, or were restricted to one or two venues. Others belong to institutions that either do not lend or had previous commitments. Despite these obstacles, we believe that a truly representative and beautiful exhibition conveying the essence of the initial installation has been assembled. Whenever possible, the actual object that was shown in 1900 is being exhibited again. Substitutions have been made sparingly and only to approximate the balance of

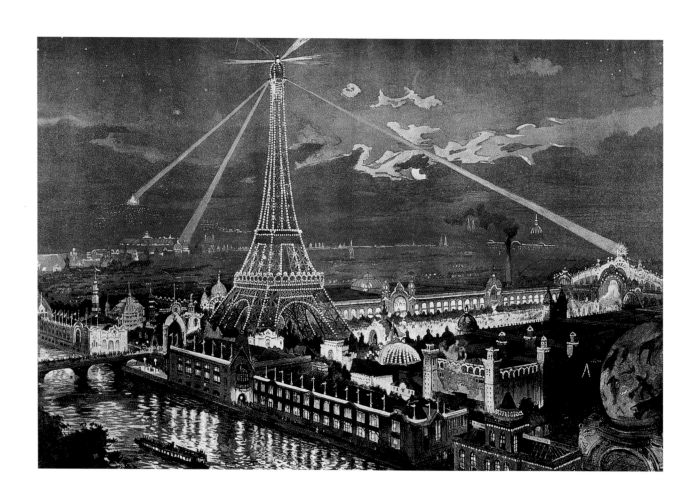

2. *Night View of the Eiffel Tower, Paris 1900.* Illustration in color from *The Book of Fairs: Materials about Worlds Fairs, 1834–1916,* in the Smithsonian Institution Libraries, American Library Association. Courtesy of Smithsonian Institution Libraries.

the original exhibition in terms of styles and types of work, as well as to insure that the artists who defined the "American School" of 1900 are duly represented.

This project was conceived a decade ago, when H. Barbara Weinberg, now The Alice Pratt Brown Curator of American Paintings and Sculpture at The Metropolitan Museum of Art, suggested that I pursue it for my doctoral dissertation. I remain indebted to Dr. Weinberg for her enduring guidance and utmost generosity. My dissertation committee, William H. Gerdts, Marlene Park, and Annette Blaugrund (who supported me both "at home" and "abroad") also deserve my warmest appreciation. Grants from the City University of New York and Seton Hall University made research trips to France and Washington, D.C. possible.

It was a pleasure to work with all of the authors, who masterfully examined uncharted scholarly terrain. Gabriel P. Weisberg and his wife, Yvonne, who have nourished me throughout the years, contributed enormously to many aspects of this exhibition. Linda Docherty offered valuable suggestions regarding my essay, and Robert W. Rydell provided me with fresh insights into this multifaceted exposition.

Among the authors, a very special note of thanks is reserved for Gail Stavitsky, Chief Curator at The Montclair Art Museum. It was Dr. Stavitsky who proposed that Montclair host *Paris 1900,* and who has wisely counseled me throughout this venture in her capacity as project director.

For believing in me and in *Paris 1900,* I am enormously grateful to Ellen S. Harris, director of The Montclair Art Museum, who enthusiastically facilitated all aspects of this show. Among the museum's trustees, Adrian A. Shelby, James E. Quinn, and Frank Martucci, were most helpful in sharing their valuable time and resources.

I could not have organized this exhibition without the able assistance of the museum's staff, most notably Randolph Black, registrar/collection manager, and Mara Sultan, associate registrar, who have graciously handled myriad details.

My appreciation is also extended to Tom Shannon,

exhibits designer/assistant facilities manager; Lugenia Foster, curatorial assistant; Anne-Marie Nolin, director of communications; Elyse Reissman, deputy director for institutional advancement; Kimberly Benou, grants manager; Leanne McGowan and Vivian James, development assistants; Susanna Sabolcsi, manager of library services; and Shunzyu Haigler, assistant to the director, all of whom played vital roles.

Valerie Walker zealously searched for paintings and related materials; her contributions to this book are substantial. Wendy Cross Cogdell is also to be commended for her tireless pursuit of research material, as are Marie Busco, Rose Merola, Jennifer Musawwir, Carla Ojha, and Melanie Greenspan. Thanks also go to Colleen Farkas for her help in preparing the manuscript.

Marlie Wasserman, the publisher of Rutgers University Press, and Leslie Mitchner, the editor-in-chief, were among the first to realize both the significance and appeal of *Paris 1900.* They have done an outstanding job in producing this attractive book, the only in-depth, multi-authored, and interdisciplinary study on the world's fair of 1900. Thanks are also extended to editors Brigitte Goldstein and Linda Perrin.

At the venues to which the exhibition will travel, the following individuals have significantly facilitated production: Jean-Marc Léri and Véronique de Jesus, Musée Carnavalet; Sylvia Yount and Cheryl Leibold, Pennsylvania Academy of the Fine Arts; Leslie Blacksberg, Elvehjem Museum of Art; and John Owens, Columbus Museum of Art.

In the diplomatic corps, Mary Carlin Yates, and Josette Steinbeck, of the United States Embassy in Paris, and Estelle Berruyer and Cecelia James-Nicoullaud, at the French Consulate in New York, were instrumental in negotiating foreign loans and bolstering Franco-American relations.

So many people have contributed to this exhibition that it is impossible to mention each person I would like to thank. Among the professionals at museums, libraries, and archives who have been especially helpful are: Arlene Pancza-Graham, Nancy Malloy and Judith E. Throm, Archives of American Art, Smithsonian Institution;

Judith Barter, The Art Institute of Chicago; Joanna D. Catron, Belmont, the Gari Melchers Estate and Memorial Gallery; Teresa Carbone and Kevin Stayton, The Brooklyn Museum of Art; Anita Ellis and Jennifer Howe, Cincinnati Art Museum; Charles L. Venable, Dallas Museum of Art; Mary Anne Goley, Board of Governors of the Federal Reserve System; Michael Quick, George Inness Catalogue Raisonné; Marsha V. Gallagher, Joslyn Art Museum; Ilene Susan Fort, Los Angeles County Museum of Art; Joan Barnes, Manoogian Collection; Kevin J. Avery, Susan G. Larkin, and Thayer Tolles, The Metropolitan Museum of Art; Carol Christ, Missouri Historical Society; Henri Loyrette, Geneviève Lacambre, Myriam Bru, and Monique Nonne, Musée d'Orsay; Liza Daum, Musée Historique de la Ville de Paris; Anne Dopffer, Musée National de la Coopération franco-américaine; Doreen Bolger and Thomas Michie, Museum of Art, Rhode Island School of Design; Erica E. Hirshler, Museum of Fine Arts, Boston; Nicolai Cikovsky, Jr., National Gallery of Art; Carolyn Carr and Brandon Brame Fortune, National Portrait Gallery; Elizabeth Broun, Lois Marie Fink, George Gurney, and Richard Murray, National Museum of American Art; Ulysses G. Dietz, The Newark Museum; Paula Baxter, New York Public Library; John Dryfhout and Henry Duffy, Saint-Gaudens National Historic Site; Susan Canterbury, Sterling and Francine Clark Art Institute; Nicholas

Serota and Robin Hamlyn, Tate Art Gallery; John Neff, Terra Museum of American Art; Annamarie Sandecki, Stephanie Carson, and Louisa Bann, Tiffany & Co.; and Stacey Hoshino, Whitney Museum of Art.

Scholarly assistance was unselfishly provided by Robert Rosenblum, who is organizing *1900: Art at the Crossroads* for the Guggenheim Museum, as well as by Virginia Butera, Susan Casteras, Adina Gordon, Patricia Mainardi, Susan Montgomery, Sarah J. Moore, Marsha Morton, Robert Olpin, Ronald Pisano, Tara Tappert, Roberta Tarbell, and James Yarnall.

In the gallery world, I extend my sincere gratitude to Warren Adelson, Adelson Gallery; Bruce Weber, Berry-Hill Galleries; David Rago, David Rago Auctions, Inc.; Lisa N. Peters, Spanierman Gallery; Vivian Bullaudy, Hollis Taggart Galleries; and Vance Jordan, Vance Jordan Fine Art, Inc.

Individuals who deserve to be acknowledged include Anthony E. Battelle, Ronald Berg, Christopher T. Emmet, John Larkin, Michael McGraw, Mary Chris Rospond, and Richard Sheinaus. My family, especially my parents, has been a considerable source of encouragement. Finally, I want to express that I absolutely cherish the abiding wisdom and devotion of my husband, James Fischer.

DIANE P. FISCHER

LENDERS TO THE EXHIBITION

Anonymous Lenders

The Art Institute of Chicago, Chicago, Illinois

Anthony E. Battelle, Brookline, Massachusetts

Belmont, The Gari Melchers Estate and Memorial
 Gallery, Mary Washington College,
 Fredericksburg, Virginia

Dr. Ronald Berg, Monticello, New York

Bryn Mawr College, Bryn Mawr, Pennsylvania

Carnegie Museum of Art, Pittsburgh, Pennsylvania

Cincinnati Art Museum, Cincinnati, Ohio

The Cleveland Museum of Art, Cleveland, Ohio

The Corcoran Gallery of Art, Washington, D.C.

William P. Curry

Dallas Museum of Art, Dallas, Texas

Elvehjem Museum of Art,
 University of Wisconsin-Madison,
 Madison, Wisconsin

Mr. and Mrs. Christopher T. Emmet

Fine Arts Museums of San Francisco, M.H. De Young
 Memorial Museum, Golden Gate Park,
 San Francisco, California

The First National Bank of Chicago, Chicago, Illinois

Gallerie 454

Heckscher Museum of Art, Huntington, New York

Hirshhorn Museum and Sculpture Garden,
 Smithsonian Institution, Washington, D.C.

Hunterian Museum and Art Gallery,
 University of Glasgow, Glasgow, Scotland

Indianapolis Museum of Art, Indianapolis, Indiana

Joslyn Art Museum, Omaha, Nebraska

Dr. John E. Larkin Jr.

Los Angeles County Museum of Art,
 Los Angeles, California

Manoogian Collection

The Metropolitan Museum of Art,
 New York, New York

MIT Museum, Cambridge, Massachusetts

The Montclair Art Museum, Montclair, New Jersey

Musée des Beaux-Arts de Quimper, Quimper, France

Musée Carnavalet, Paris, France

Musée d'Orsay, Paris, France

Museum of the City of New York, New York

Museum of Fine Arts, Boston, Massachusetts

Joseph M. Napoli

National Gallery of Art, Washington, D.C.

The Newark Public Library, Newark, New Jersey

J. Nicholson, Beverly Hills, California

Pennsylvania Academy of The Fine Arts,
 Philadelphia, Pennsylvania

Dr. and Mrs. Peter L. Perry

Philadelphia Museum of Art,
 Philadelphia, Pennsylvania

Saint-Gaudens National Historic Site,
 Cornish, New Hampshire

Sterling and Francine Clark Art Institute,
 Williamstown, Massachusetts

The Strong Museum, Rochester, New York

Tate Gallery, London, England

Terra Museum of American Art, Chicago, Illinois

Tiffany & Co, Inc., Parsippany, New Jersey

The Toledo Museum of Art, Toledo, Ohio

Virginia Museum of Fine Arts, Richmond, Virginia

Mr. Graham Williford

Yale University Art Gallery, New Haven, Connecticut

Jane Voorhees Zimmerli Art Museum, Rutgers,
 The State University of New Jersey,
 New Brunswick, New Jersey

PARIS 1900

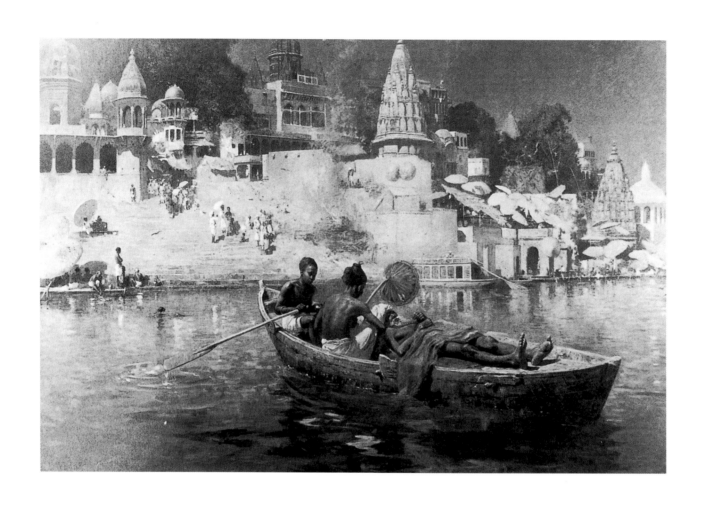

3. Edwin Lord Weeks, *The Last Voyage; A Souvenir of the Ganges*,
ca. 1884, oil on canvas, 83 x 121 1/4 inches. Private collection.

DIANE P. FISCHER

Constructing the "American School" of 1900

A self-conscious and politically motivated campaign was waged by the American Department of Fine Arts at the Paris Exposition of 1900 to confirm "a new position for the United States as an art-producing nation" free of "foreign trammels."[1] Declaring cultural independence directly challenged French Commissioner Alfred Picard's criticism after the Universal Exposition of 1889 (also held in Paris) that American art was "but a brilliant annex to the French Section."[2]

Establishing a national school at the 1900 exposition was an ambitious undertaking because American art had indeed looked French in 1889.[3] With its superb art schools, relatively low cost of living, and status as the capital of the art world, Paris had become the primary destination for American art students during the final quarter of the nineteenth century. Thus, most of the American artists who participated in the earlier exposition had attended Parisian art academies and ateliers and emulated their conservative French masters both stylistically and thematically, as in the case of Weeks and his teacher Jean-Léon Gérôme (figs. 3, 4).[4]

Through their participation in the annual Salon and other exhibitions, a number of Americans had been able to acquire international reputations which would have been impossible to secure at home.[5] In order to attract critical acclaim and reliable patronage, these artists adopted French academic methods (yielding an almost photographic exactitude) and subjects (primarily the historical, mythological, nude, and religious) which displaced their own native tendencies. Conservative French critics—considered the most discerning connoisseurs in the world—valued academic technique and American artists were eager to cater to their tastes.

With French academicism as the standard by which art was judged, the United States won more medals than any other visiting nation in 1889, thus achieving a new international status for American art. At the same time, however, and as they had at all of the Parisian expositions, held in 1855, 1867, 1878, and 1889, French critics continued to demand subjects revealing "national character." For only after American art had established an individual identity could it be considered a legitimate "school"—a rare and coveted designation in the nineteenth century.[6]

The quest for a national art that emerged after the 1889 exposition was fostered by the World's Columbian Exposition of 1893, for which many artists had repatriated.[7] The Chicago fair, at which American critics proclaimed the greatness of their own national art, marked the turning point away from French academic influence. However, to prove that the accomplishments in Chicago were not a fluke, and to gain international credence, American art would have to prevail at the next Parisian exposition already being planned for 1900.

Context

The efflorescence of domestic culture in the 1890s coincided with the ascent of the United States, both economically and militarily, as a world power. In particular, with the territories acquired from the Spanish-American War of 1898, the United States had effectively become an empire like "old world" Spain, France, or Great Britain, but with seemingly boundless potential because of its relative "youth."

Rooted in Enlightenment thought, and motivated by the more recent writings of Herbert Spencer, evolutionary theories proliferated in 1890s America.[8] Having predetermined character traits and life spans, nations, or "empires," were considered to be organic, evolving through the stages of Savage, Arcadian, Consummate, and Decadent, to the state of Desolation, as earlier envisioned in Thomas Cole's *Course of Empire* series (1836; The New-York Historical Society).

This course of empire presumably moved westward, from ancient Greece throughout Europe, and was progressing toward the "superior" Anglo-Saxon United States on the cusp of the twentieth century. In 1894, the art critic John C. Van Dyke evaluated American art in those terms, resolving that the center of art had already proceeded from Athens to Paris, from which it was "ebbing away" toward the United States.[9] In a lecture at the American Fine Arts Building in May 1899, Brooks Adams—author of the celebrated *Civilization and Decay* (1896) which promoted such theories—explained that art was a major indicator of "national vitality," and urged artists to "execute memorials which shall commemorate our empire."[10]

It was in this overconfident spirit of the American Renaissance (bracketed by the Philadelphia Centennial Exposition of 1876 and San Francisco's Panama-Pacific Exposition of 1915), that the U.S. contingent—administered through President William McKinley's expansionist State Department—emphasized the fine and industrial arts at a foreign exposition for the first time. As an editorial in the *New York Times* advised, "Really, it is by the showing that we make in the . . . fine arts that we shall be chiefly judged. . . . In truth, we have little interest in the exhibition as a "shop show."[11] Although the "American School" was predestined to exist, the organizers left nothing to chance. They cast the fine arts in a dual role at the exposition. Art not only projected the official image of the United States to an international audience; it also functioned as the administration's final frontier in achieving an empire.

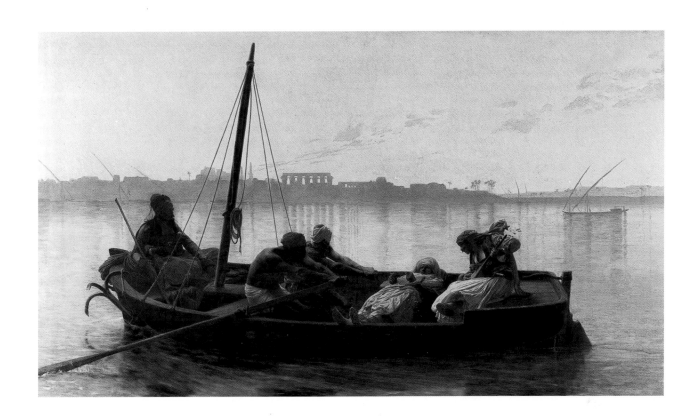

4. Jean-Léon Gérôme, *Le Prisonnier (The Prisoner)*, 1861, oil on panel, 18 7/8 x 30 3/4 inches. Musée des Beaux-Arts, Nantes.

5. Charles Yardley Turner, *Saturday Evening at the Century*, 1894,
oil on canvas, 25 7/8 x 35 7/8 inches. The Century Association,
New York. John Cauldwell (with moustache) is standing on
the left.

The Fine Arts

Eager to seek retribution for the predominance of the expatriates in 1889, a group of New York painters urged the National Academy of Design to "take action as soon as possible" in appointing a director of fine arts, and arranged a meeting at the Century Club for early December 1897.[12] That following February, the academy hosted an election also involving the Society of American Artists, National Sculpture Society, American Water-color Society, and the Society of Mural Painters—all based in New York—to recommend a candidate to U.S. Commissioner Ferdinand Peck, and ultimately to President McKinley.[13]

John Britton Cauldwell (1855-1932) (fig. 5) won the artists' endorsement, unanimously, on a single ballot. The artists selected Cauldwell for his unique combination of executive skills, fluency in French, love of art, and ties to the McKinley administration. Applauding the decision, which he regarded as refreshingly apolitical, the eminent critic Charles H. Caffin described Cauldwell as "a gentleman of means and with no ambitions in the direction of public life."[14]

The Brooklyn-born Cauldwell's fortune had been amassed through his family's china importing business.[15] After attending lycée in Paris, Cauldwell earned an engineering degree at Columbia University, served in the French Foreign Legion, and studied painting. He belonged to a number of associations frequented by artists, including the Century, University, Union League, and Metropolitan clubs in New York.

In order to present his best case for a national art, Cauldwell appointed the former assistant chief of the art department at the Columbian Exposition, Charles Kurtz of St. Louis, as assistant director,[16] and other like-minded art professionals, including a National Advisory Board (see appendix A). Cauldwell also focused on oil paintings. Emphasizing painting adhered to the hierarchy of mediums instituted at the salons, and because the support of French critics was crucial, the fight for an American school could be won only with paintings.

Toward that end, Cauldwell strove for a stunning exhibition revealing national character. To assure that discernibly American people and sites would predominate, it was stipulated that at least 70 percent of the paintings—executed by a generation of artists devoted to realist precepts—were to have been created at home.[17] Furthermore, while the stateside artists were limited to three paintings each, as they had been in 1889, artists living abroad (who were allowed as many as six in 1889) were initially restricted to two.[18] The goal was to prevent the large Franco-American "Salon machines" from overwhelming the display.

THE SELECTION PROCESS

During the spring of 1899, Cauldwell and Kurtz met with artists in major cities throughout the country in pursuit of paintings.[19] In May, Kurtz sailed to Europe intending to procure work directly from artists living there. However, his proposed tour of London, Paris, Munich, and Rome was interrupted in the summer by the need for an emergency kidney operation.[20] In October, Kurtz was replaced by the New York landscape artist Henry B. Snell. Snell assumed Kurtz's assignment, not by going abroad, but by visiting artists' studios in New York, thus further limiting expatriate participation.

As was standard for such large exhibitions, a jury charged with selecting submitted work was established. Indeed, Cauldwell's control of this jury would be the key to producing an all-American display. As had been the case in 1889, two national juries were established, one in New York and the other in Paris.[21] This time the expatriates did not dominate as they had in 1889. The twenty-one members of the New York jury for paintings (see Appendix A), including Winslow Homer, John La Farge, and William Merritt Chase, were all reputable artists residing primarily in the United States. Caffin approved of the jury's composition, finding "practically every tendency" of turn-of-the-century American painting represented.[22]

The selection jury in Paris convened in January 1900,

two months after the New York delegation, and included Britain-based John Singer Sargent, Francis Davis Millet, and Edwin Austin Abbey, along with John White Alexander, William T. Dannat, Alexander Harrison, Gari Melchers, and Julius Stewart from France.[23] All five Franco-Americans were active in the Parisian art world, which would prove to be beneficial in dealing with the French authorities.

In addition to submissions, some paintings were solicited by a subcommittee of the jury from American museums—the Pennsylvania Academy of the Fine Arts, the Carnegie Institute, and the Cincinnati Art Museum. Already designated as virtual masterpieces, these works had all been executed by resident artists, and most had explicitly indigenous themes.[24] Individuals such as J. Montgomery Sears, Potter Palmer, Mrs. Alfred Corning Clark, George Hearn, Andrew Carnegie, and William T. Havemeyer, were also invited to participate by lending work from their private collections.

After the list of paintings accepted by the New York jury was released in February 1900, the press was quick to react, focusing most of its attention on who was missing.[25] Dwight Tryon, Edwin Blashfield, and Frank Duveneck, for example, were not on the roster, but as selection jurors they were involved with the exposition in some capacity. Others, however, such as John Twachtman and Thomas Wilmer Dewing, did not participate in the exposition at all. Dewing, who had also skipped the 1889 exposition, avoided exhibiting his refined work to the masses.[26] From the Paris jury's list, most conspicuously absent was Mary Cassatt, who may simply not have been interested in exhibiting, as had been the case in 1889.

A number of well-known artists, including Tryon and Twachtman, refused to submit work to the exposition because they were insulted by the meager gallery space the French gave the United States—initially 550 feet of line, considerably less than they had received in 1889.[27] Despite the absence of some major artists, however, the critic Roger Riordan was pleased, declaring, "It is easy to imagine a more satisfactory collection, but it would be found difficult to make a better one."[28]

DEMOGRAPHICS

In order to compensate for the restricted space, Cauldwell resolved to mount "a small but dignified exhibit," representing all phases of American art produced since 1889.[29] While the exhibition itself was arguably inclusive, the composition of the participants was actually quite exclusive. In his quest to secure a new status for American art, Cauldwell understandably sought artists who had proven track records in winning awards. It is thus not surprising that most of the exhibitors were established: the majority were white male artists in their forties, living in the Northeast, primarily in New York.

Nonetheless, there were some exceptions. Some artists—notably the popular triad of landscape painters, George Inness, Alexander Wyant, and Homer Dodge Martin—were included, even though they were ineligible for medals because they were deceased. Alfred Maurer, Maxfield Parrish, and William Glackens (who exhibited two drawings) represented younger artists with untested reputations who would later become famous. And the United States had the highest percentage of works by women in the entire international art exhibition, reflecting the nation's greater acceptance of feminism, relative to Europe.[30]

The ethnic composition of American exhibitors was less diverse, however, with even the naturalized citizens originating from Northern Europe. The only American artist of African descent in the exhibition was Henry O. Tanner, who lived in Paris. And, although fourteen Cuban artists in the Fine Arts Decennial exhibited in the U.S. section in the Trocadéro, they were not included in the Department's catalogue because the United States denied having "colonies."[31]

It was relatively easy for the U.S. delegation to dismiss the "outsider" Cubans. However, grappling with the status of recognized Americans overseas was more perplexing. Because so many artists had lived abroad for so long and had become assimilated into the European art community, their identity as Americans was no longer taken for granted on either side of the Atlantic.

Great Britain, for example, filed a formal petition against the United States for including Sargent, Abbey,

Millet, and Mark Fisher—all painters who would have enhanced the British exhibition—in the American section even though they resided in England. In response, the American commission secured a signed statement from each artist indicating his desire to exhibit as a U.S. citizen.[32] Ultimately, the French authorities ruled against the British, decreeing that artists should exhibit according to nationality, not residence.[33] The fact that the artists' nationalities were questioned at all weakened their status as Americans, which the administration could not have welcomed. National labels may have seemed insignificant to cosmopolitan artists, but to those wishing to broadcast the grandeur of American art in 1900, it was essential to embrace as many celebrities as possible, even if that meant sacrificing some national character. The definitive measure of success, after all, was winning exposition medals and favorable reviews.

Determining exactly who lived abroad in 1900 is virtually impossible. At the turn of the century, American artists were peripatetic. Some artists are listed with a foreign address in the French catalogue, but have a resident address in the American edition. In the final report, a smattering of artists appear with one address at "home" and another abroad. And, although they lived overseas, Mary MacMonnies, Millet, and Sargent submitted work through the New York jury. Nonetheless, it appears that only about a quarter of the 221 Americans who exhibited paintings and drawings (Class 7) at the exposition lived in Europe at the time, even though many American artists still resided overseas. As a result, the still flourishing expatriate contingent was underrepresented.

EXPATRIATE VERSUS REPATRIATE

Exuberant about dominating the selection jury, supporters of the resident Americans could not refrain from gloating. As an editorial for the Chicago-based *Brush and Pencil* announced, "The foreign-American contingent abroad found this time that it did not control the walls, as was too truly the state of affairs in 1889."[34]

Naturally, the expatriates, who were accustomed to leading American art, were offended by such comments

as well as by their deflated status. As early as May 1899, Cauldwell expressed his awareness of the growing hostility toward him in a letter to Kurtz, who was in Paris at the time:

> I am quite of the opinion that they [Dannat and the other members of the Society of American Painters in Paris] are making some supreme effort to control the space or obtain [a] separate pavilion, and therefore urge you, confidentially, to keep a sharp look out and unfathom any secret plans that they may have. As you know I am disposed to treat them more than fairly, but we must not for a moment allow them to run this department to the disparagement of the men on this side.[35]

For the expatriates to even consider a "separate pavilion" indicated the depth of the fissure.

Indeed, a full-blown feud between the two groups of Americans was chronicled in the *New York Herald,* the leading American newspaper published in Paris. Along with many anonymous critics, Gari Melchers, a highly regarded expatriate and member of the Paris jury, concluded that Cauldwell had "made a great mistake in making a distinction" between American artists residing in France and the United States.[36]

While extreme opinions predominated, some conciliatory remarks were expressed by both sides. As the seasoned expatriate John White Alexander explained:

> I was in America last winter and I found that among the painters there the feeling was bitter as to the way they had been treated in the Exposition of 1889. I was not here in France at that time, nor was I exhibiting, and so I was not so interested. . . . Even if Mr. Cauldwell did discriminate this year in favor of painters on the other side of the Atlantic, I think he would only be "evening things up" a bit and giving them an opportunity they hadn't before.[37]

By this time, Alexander had grown weary of the strong Euro-centric tenor of late nineteenth-century American art.

bitterly treated in Paris

Likewise, a prominent member of the stateside community, John Beatty, the Director of Fine Arts at the Carnegie Institute, sent a cablegram to the *Herald*, warning:

> It would be unfortunate if an accident of this kind should in any measure create a feeling that an American is less of an American because conditions over which he has little control force him to reside and work abroad.[38]

The "accident" Beatty referred to was France's meager allocation of gallery space to the United States. Competing for restricted space aggravated the hostility already existing between the expatriates and resident Americans. Because of their close association with the French, the expatriates were blamed for the discourteous treatment the resident Americans believed their country was receiving. Indeed, the most nativistic commentators were beginning to regard the "Paris Americans" as more French than American, which Beatty rightly perceived as being divisive. Ultimately, however, regardless of where they lived, Americans banded together to make a superb national display.

SPACE ASSIGNMENTS

For the exposition of 1900, two buildings were erected for the fine arts. The Petit Palais housed the French retrospective exhibition of fine arts and crafts created through 1800, while the Grand Palais contained the *Centennial Exhibition of French Art, 1800-1899* as well as the *Decennial International Exhibition of Fine Arts, 1890-1900*—the largest art exhibition ever assembled (figs. 6, 7). Within the Grand Palais, France reserved over half of the space for its own art. The rest of the building was shared by thirty visiting nations plus an international section.

This discrepancy was so pronounced that a reviewer for *L'Aurore* criticized his compatriots for their overtly inhospitable treatment of foreign guests at the exposition, claiming:

> Our artists have a singular form of comprehending and practicing hospitality. They have thought, doubtless, that, in excluding others, they would be able to demonstrate irrefutably that they existed and that they alone were endowed with genius. Alas! They have demonstrated irrefutably only the boorishness of their great minds.[39]

The Grand Palace of Fine Arts, Exposition of 1900, Paris, France.
Copyright 1900 by Underwood & Underwood.

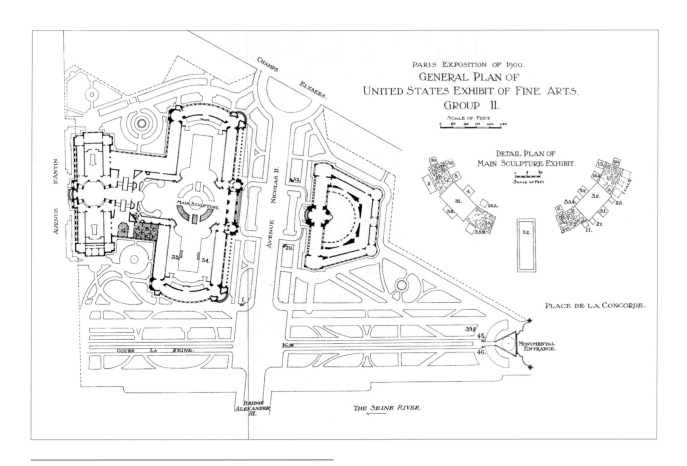

7. Floor Plan of the Grand Palais (left), Paris Exposition of
1900, with the United States Fine Arts sections shaded, and the
Petit Palais (right). From *Report of the Commissioner-General for
the International Universal Exposition, Paris, 1900*, Washington,
D.C.: Government Printing Office, 1901.

6. *Underwood and Underwood, *The Grand Palace of Fine Arts,
Exposition of 1900, Paris, France.* Private collection.

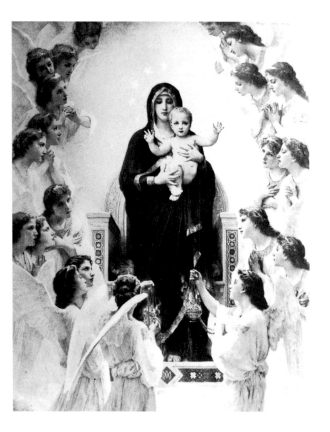

8. William Bouguereau, *La Vierge aux anges (The Virgin with Angels)*, 1900, oil on canvas, 114 x 74 inches. Ville de Paris, Musée du Petit Palais.

9. Henri Martin, *Sérénité (Serenity)*, 1899, oil on canvas, 11 feet 6 inches x 19 feet. Musée d'Orsay, Paris.

Although transparent, these tactics taken by the French, which had not been necessary in 1889, insured their domination. The French decennial featured almost two thousand paintings and drawings, mostly by staunch conservatives such as William Bouguereau (fig. 8) and Jean-Joseph Benjamin-Constant, with Henri Martin (fig. 9) and Paul Besnard among the most progressive.

Given the strong ties they had with the Parisian art establishment, and because French artists had been generously treated at the Chicago fair seven years earlier, Americans refused to accept their inadequate space assignment. Relentless negotiations for additional space ensued, instigated by Cauldwell, filtered through Assistant Commissioner Benjamin Woodward, and received by the French Director-General of Works Louis-Marie-Gabriel Delaunay-Belleville.

In addition to tapping the usual diplomatic channels, Cauldwell even enlisted the support of the expatriate artists. A petition signed by French Legion of Honor "Officiers" Sargent and Dannat and twelve "Chevaliers," protested that, due to lack of space, it would be "absolutely impossible" to install a "representative" exhibition, and threatened a boycott.[40] The artists continued:

> We feel this is a very serious matter for us and considering the very hospitable manner in which the French Artists have been treated by the various American Expositions and the great market America is and has been for French Art, we believe that if the matter was laid before the French Authorities by you [Woodward], they could hardly refuse to make an additional allotment even though only enough to add one more room to the U.S. Section.

Despite the eminence of its authors, this petition alone was unsuccessful. It was André Saglio of the French decennial committee, and an author for *The Chefs d'Oeuvre: Art and Architecture* (about the exposition, but published in Philadelphia, 1900-1902), who granted his American friends a small increase.[41]

CATEGORIZING ART

Another point of contention the Americans had with the exposition authorities was the way art was defined. Commissioner-General Picard arranged all of the products of the world into eighteen groups, in which the fine arts came second. The French classification further broke Group II into classes, based on a Salon system designed to accommodate academic art, which, of course, favored the French:

Group II: The Fine Arts:
Class 7: Paintings, Cartoons, Drawings (The
 United States further subdivided this class
 into: A, B, C (paintings in oil, watercolor, and
 pastel); D (drawings) and E (miniatures)[42]
Class 8: Engraving and Lithography
Class 9: Sculpture and Engraving on Medals
 and Gems
Class 10: Architecture

For Americans who worked in a variety of mediums, this system seemed obsolete. Even before Cauldwell's art department was formed, John La Farge, who had been largely responsible for originating the decorative arts movement in America two decades earlier, protested that there was no place reserved for American stained glass or murals in the fine arts.[43] Actually, stained glass, murals, and other decorative arts, in which the Americans excelled, were represented, but were exiled to the Palace of Diverse Industries (fig. 10).[44]

As a result, the resourceful Americans exhibited their "art" wherever they could. In fact, the critic Riordan dubbed Charles Coolidge's neoclassical national pavilion—which featured sculpture, murals, paintings, and furniture—the "chief artistic exhibit" of the United States (fig. 11).[45] The symbolism of this pavilion, with its Roman imperial dome, *Victory* quadriga by A. Phimister Proctor, and murals—notably Robert Reid's *America Unveiling her Natural Strength*—clearly advertised imperialistic intentions (figs. 12, 120).[46] Inside the pavilion

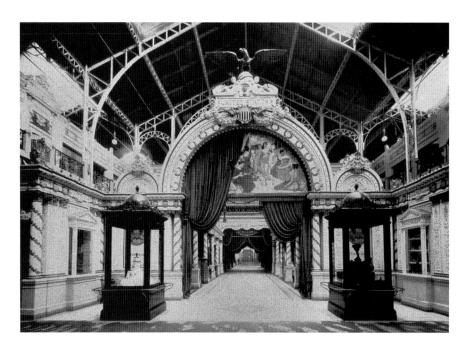

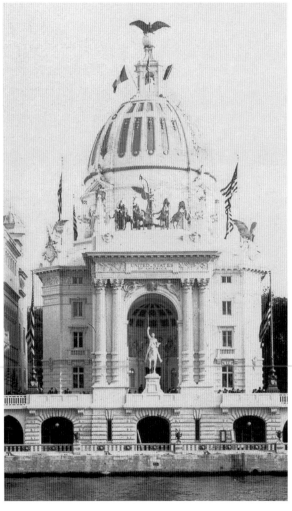

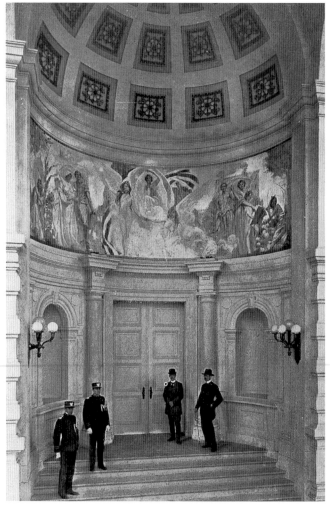

were surplus paintings from Class 7, as well as paintings, sculpture, and decorative art not associated with the official exhibition. In addition, monumental American sculptures from the fine arts group, many with native themes, by Cyrus Dallin (fig. 13), Hermon Atkins Mac-Neil (fig. 14), Frederick MacMonnies, A. Phimister Proctor, and others, were well-positioned throughout the fairgrounds.

Within the art palace, the Americans again managed to be noticed. A plaster cast of Augustus Saint-Gaudens's monumental *General Sherman* (fig. 15), was dominant in the international sculpture decennial. In total, there were seventy American sculptures by thirty-one artists in Group II.[47]

The sculptures and reliefs that were not on the fairgrounds or on the ground floor were placed in the hallway and in the painting galleries (fig. 16) upstairs. Most

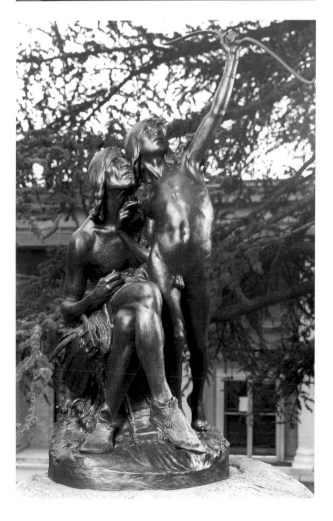

FACING PAGE, COUNTERCLOCKWISE FROM TOP:

10. Entrance to the United States Industrial Arts Exhibit, Paris Exposition, 1900, Palace of Diverse Industries, with Augustus Koopman's mural *Industrial Arts*. Archives Nationales, Paris.

11. United States National Pavilion, Paris Exposition, 1900. Library of Congress.

12. Robert Reid, *America Unveiling Her Natural Strength,* mural, Portico, U.S. National Pavilion, Paris Exposition, 1900. *Figaro Illustré,* vol. 2 (1900): 117.

THIS PAGE

13. Cyrus E. Dallin, *The Medicine Man.* On the fairgrounds of the Paris Exposition, 1900. *Paris Exposition Reproduced from the Official Photographs Taken Under the Supervision of the French Government for Permanent Preservation in the National Archives.* The R. S. Peale Co., 1900.

14. *Hermon Atkins MacNeil, *The Sun Vow,* 1895–1899, bronze, 69 x 32 x 38 inches. The Montclair Art Museum. Gift of William T. Evans, 1913.2. Photographed in front of The Montclair Art Museum. Another version of this sculpture was exhibited at the Paris Exposition, 1900.

works on paper were also placed in the corridor. At the entryway to the all-important paintings galleries stood a plaster of Saint-Gaudens's heroic *Shaw Memorial,* with his angelic *Amor Caritas* nearby (fig. 17). Like *General Sherman,* the *Shaw Memorial* is a Civil War theme. Colonel Robert Gould Shaw had led the first black infantry—the Massachusetts 54th—into a losing battle, in which Shaw and most of his troops perished. Symbolically, this relief celebrates both the reunion of a divided country and America's triumph over slavery. In this way, *Shaw* also commemorates the victory of the North, and thus of technology and progress. And, although Saint-Gaudens executed the relief with beaux-arts finesse, the subject itself was undeniably American.

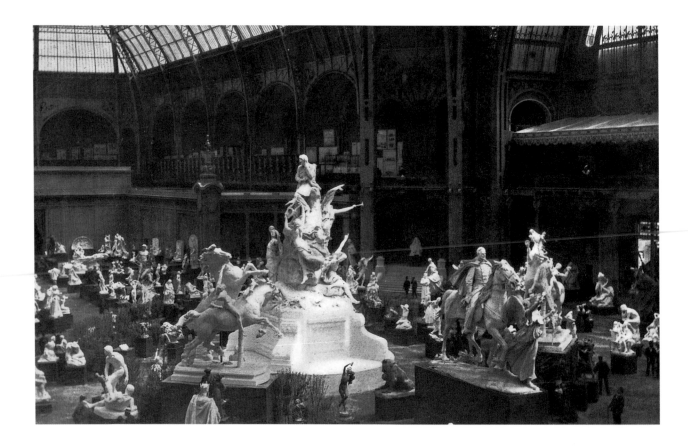

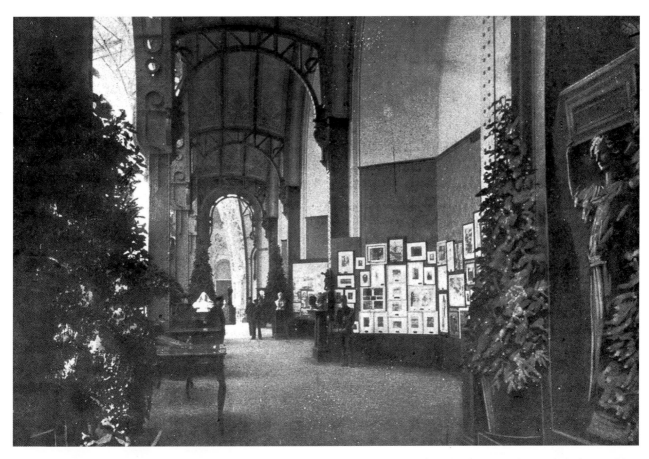

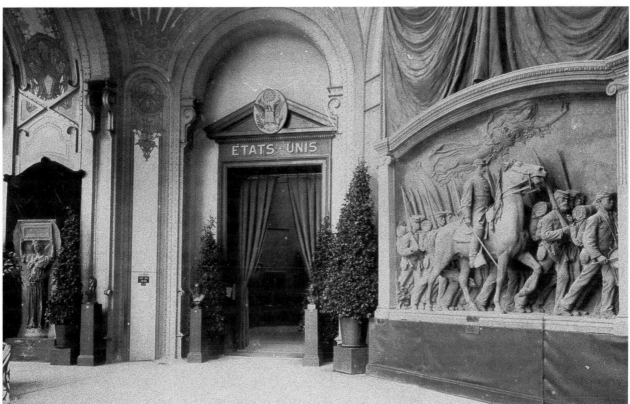

Paintings Installation

Despite the excellent quality and patriotic tenor of the sculpture exhibition, it was the paintings display that received the greatest attention, from organizers and critics alike. Although small, the six main galleries were situated in an ideal location on the second floor, between Great Britain and Japan, with an additional room on the ground floor (figs. 18-23).

Cauldwell carefully designed one of the most exquisite national installations in the Grand Palais. In the center of each gallery, a small bronze sculpture adorned the top of a circular divan (figs. 24, 25). The wall fabric, in "a quiet gray-green, between sage and olive," was selected only after the checklist was finalized, in order to coordinate with the paintings. Cauldwell was delighted with the

18 (*this page, below*). Plan of the U.S. Galleries, Grand Palais, Paris Exposition, 1900. From *Report of the Commissioner-General for the International Universal Exposition, Paris, 1900*, Washington, D.C.: Government Printing Office, 1901.

19 (*opposite page, top*). Gallery A, U.S. Paintings Exhibition, Grand Palais, Paris Exposition, 1900. Archives Nationales, Paris.

20 (*opposite page, bottom*). Gallery B, U.S. Paintings Exhibition, Grand Palais, Paris Exposition, 1900. Archives Nationales, Paris.

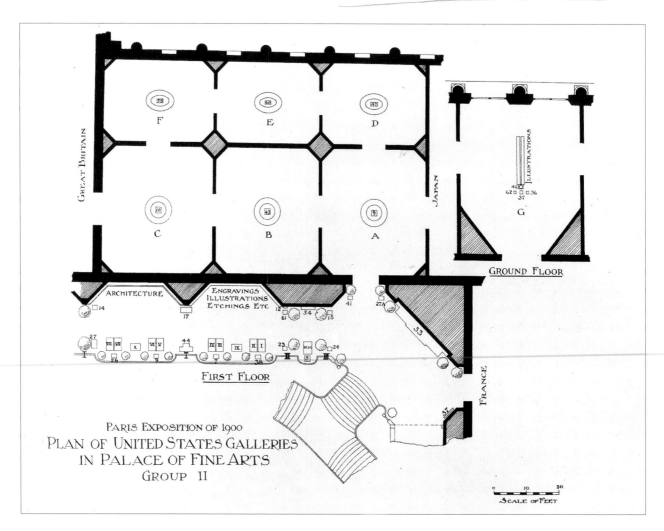

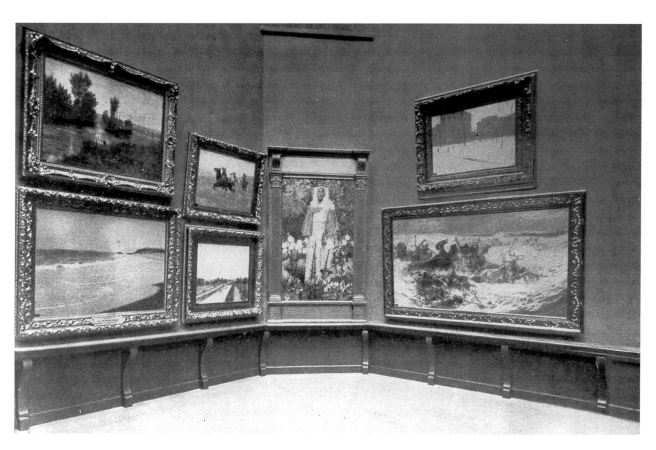

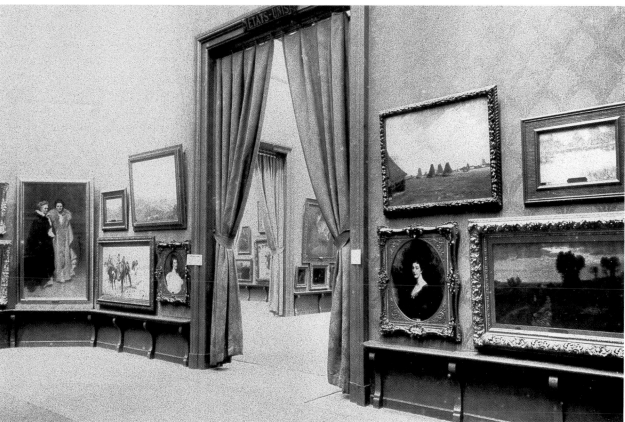

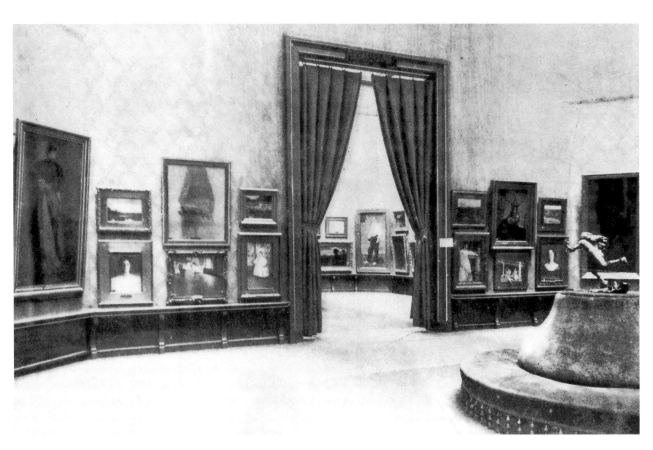

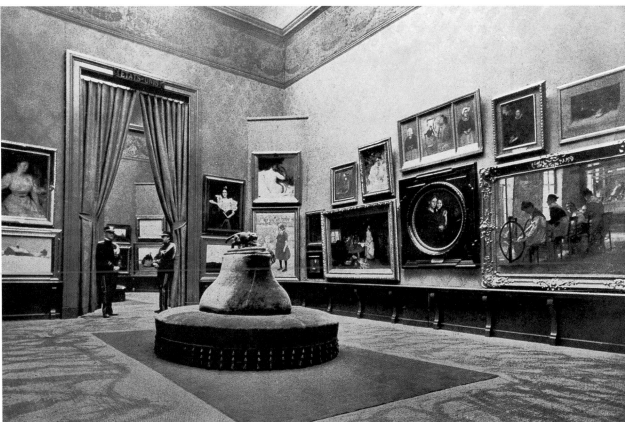

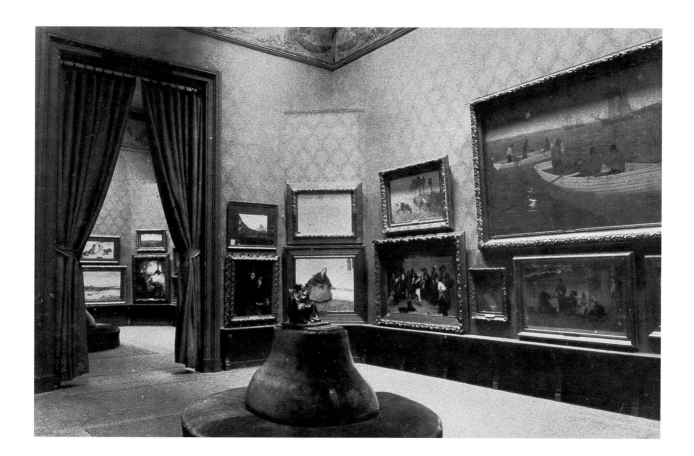

grayish salmon tone carpet and cocoa matting, "harmonizing perfectly with the walls."[48] By 1900, such refined installations were popular in New York,[49] and so seemed perfectly American. While this aesthetic approach to gallery design had originated with James McNeill Whistler in the 1870s, the overall atmosphere of this installation evoked the spirit of the deceased artist George Inness, who had been renowned for rendering native scenery in muted tones.[50]

Also harmonious was the composition of the installation jury which, unlike the selection jury, was equitable, including three artists each from home and abroad (see appendix A). In contrast to the 1889 exposition, paintings by expatriate and native artists were integrated in the galleries to create the illusion of solidarity in American art. Although conflicts were reported to have taken place between the two hanging committees, the installation projected unity.[51] This was possible because, even though the resident Americans exhibited more paintings than the expatriates, their canvases tended to be

21 (*opposite page, top*). Gallery C, U.S. Paintings Exhibition, Grand Palais, Paris Exposition, 1900. From *Report of the Commissioner-General for the International Universal Exposition, Paris, 1900,* Washington, D.C.: Government Printing Office, 1901.

22 (*opposite page, bottom*). Gallery D, U.S. Paintings Exhibition, Grand Palais, Paris Exposition, 1900. *Paris Exposition Reproduced from the Official Photographs Taken Under the Supervision of the French Government for Permanent Preservation in the National Archives.* The R. S. Peale Co., 1900.

23 (*this page, top*). Gallery E, U.S. Paintings Exhibition, Grand Palais, Paris Exposition, 1900. Archives Nationales, Paris.

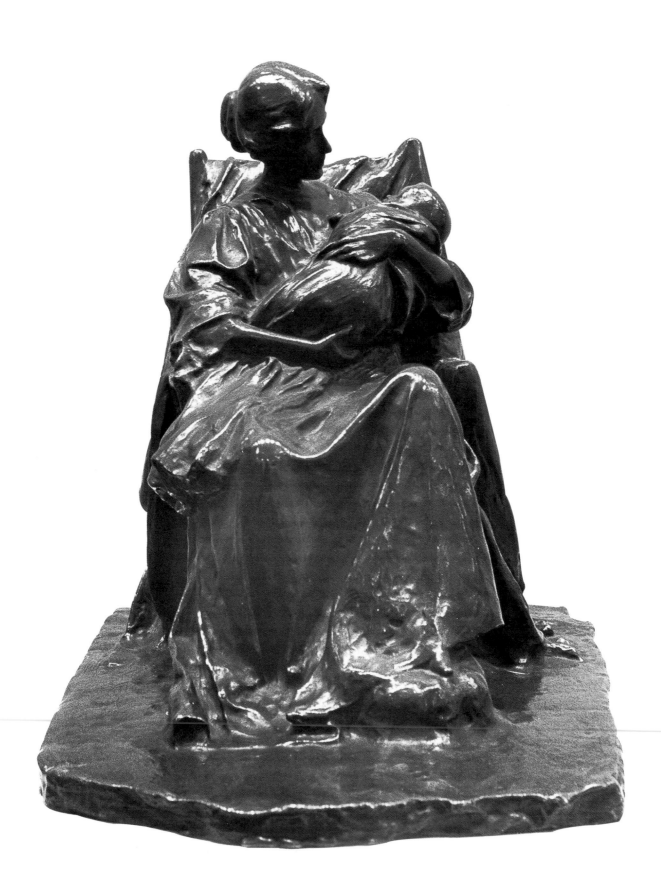

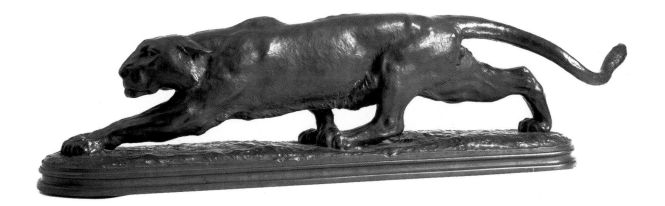

24 (*facing page*). *Bessie O. Potter Vonnoh, *Young Mother*, 1899, bronze, 14 3/4 x 15 x 12 inches. The Montclair Art Museum. Gift of Mrs. Gerard B. Townsend, 1931.14. A version of the sculpture was exhibited at the exposition of 1900.

25 (*this page*). *Alexander Proctor, *Panther*, 1893–1898, bronze, 9 1/2 x 38 1/4 x 6 1/2 inches. The Corcoran Gallery of Art, Washington, D. C. Bequest of Mrs. Mabel Stevens Smithers, 52.12. A version of this sculpture was exhibited at the exposition of 1900.

smaller. Thus, despite the expatriates' protest, the exhibition looked balanced. Furthermore, prime locations were reserved for artists from both sides of the Atlantic: Inness, Homer, Chase, Martin, Wyant, George de Forest Brush, and Abbott Thayer from "home," and Whistler, Sargent, Abbey, Harrison, Millet, Weeks, and Daniel Ridgway Knight from abroad.

Cauldwell's subtle installation in the predominantly red Grand Palais proclaimed that the United States was sophisticated, with citizens capable of creating and appreciating aesthetic nuances. Within the display, additional political messages were transmitted via the content and style of the paintings, as well as through the reputations of the artists themselves.

The "American School" of Painting in the Grand Palais

WHISTLER AND SARGENT

While they were not even mentioned in the narrative of the Department of Fine Arts's *Official Illustrated Catalogue* (1900) due to their expatriate status, the renowned Whistler and Sargent were nonetheless chief figures in confirming an artistic identity for the United

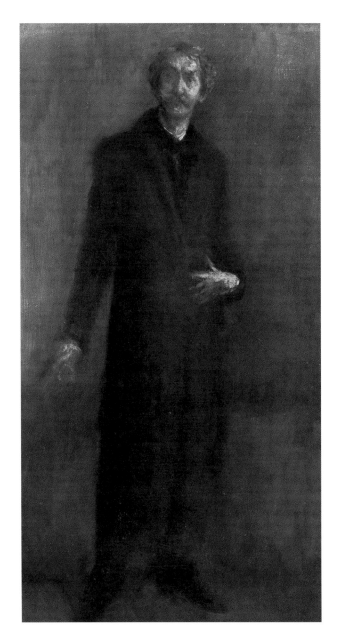

26. *James McNeill Whistler, *Brown and Gold,* ca. 1895–1900, oil on canvas, 37 3/4 x 20 1/4 inches. Hunterian Museum and Art Gallery, University of Glasgow, Birnie Philip Bequest.

States. At the time, Whistler was considered by some American and French critics to be the "greatest selective genius among living painters."[52] Despite the fact that he had never returned to his homeland since he left for Paris in 1855, Whistler had always considered himself an American. In her review of the exposition, Elizabeth Pennell—who, along with her husband Joseph, would soon become Whistler's biographer—observed:

> Mr. Whistler, of course, is to be considered apart. It makes no difference where he works, where he travels, where he lives, he still remains himself and his art his own, unaffected by the fashions and movements of the day. He is no more French because he happens to have his headquarters in Paris than Velasquez [sic.] was Italian after his visit to Italy, or Rubens Spanish after his journey to Spain. Whatever may be the future of art in America, the country can already claim one of the world's masters.[53]

Thus, having Whistler associated with the United States in 1900—as opposed to in 1889 when he exhibited with the British (because the Americans would not give him full control over what he exhibited)—seemingly validated the U.S. claim to greatness.

By exhibiting his recognizable self-portrait *Brown and Gold* (fig. 26), based on Velázquez's *Pablo de Valladolid* (ca. 1632) in the Prado, Whistler himself became a part of the national school's iconography—the American artist as old master. Critics searching for national character conveniently overlooked the European references in this painting, as well as in *Mother of Pearl and Silver: The Andalusian* (fig. 27), and focused on Whistler's dignity, grace, and elegance instead.[54]

A third Whistler, *The Little White Girl: Symphony in White, No. II* (fig. 28), was added at the last minute, underscoring its importance to the exhibition. As an archetype of refinement,[55] this image could easily have been interpreted by fairgoers as visualizing the nation's worthiness of inheriting western civilization. Although it had been completed in 1864—considerably earlier than the May 1889 deadline—Whistler was awarded a

grand prize. As an established master in his mid-sixties, Whistler was, ironically, honored by the French academic system which had earlier rejected a variant of this canvas, *The White Girl: Symphony in White No. I* (1862; National Gallery of Art), from the 1863 Salon.

As the other American painter to receive a grand prize, Sargent was one of the expatriates whose nationality had been contested by the British. In some ways, Sargent was even more marginally American than the elder Whistler. He was born in Florence and didn't visit the United States until he was twenty. It was only in the 1890s that he spent considerable time in America while painting murals for the new public library in Boston.

Despite his European upbringing, Sargent's forthright *Portrait of Miss M. Carey Thomas, President of Bryn Mawr College (1894-1922)* (fig. 29) nonetheless demonstrates his keen understanding of "American character." Dressed in academic robes with velvet Ph.D. stripes, Thomas embodied the "most highly organized type of 'new woman'" of the new world, both highly educated and independent.[56] Nonetheless, Sargent's rococo-inspired portrait of Mrs. Carl Meyer and her children (fig. 30) and his portrait of the London art dealer Asher B. Wertheimer (1898; Tate Gallery), are essentially European. The fact that the sitters in both portraits are Jewish could be a hidden editorial in paint supporting Captain Alfred Dreyfus, an Alsatian Jew who had been falsely accused of treason by a corrupt French military.[57] The Dreyfus Affair and controversy, which lingered during the exposition, was viewed by the press worldwide as signaling the demise of French civilization.

Sargent, who is said to have valued and respected his Jewish clients, placed them in guises traditionally reserved for the nobility, which would have piqued the anti-Dreyfusards. Sensitized by the scandal, exposition visitors probably would have recognized the sitters as Jewish, as had critics on previous occasions.[58] Perhaps Sargent exhibited these portraits as an act of revenge on the French government for the fiasco surrounding the scandalously décolletéed *Madame X (Virginie Avengo Gautreau)* (1884; The Metropolitan Museum of Art) at

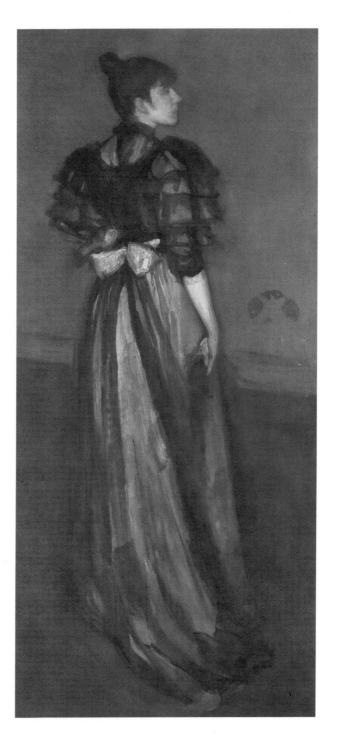

27. *James McNeill Whistler, *Mother of Pearl and Silver: The Andalusian,* ca. 1894, oil on canvas, 75 3/8 x 35 3/8 inches. National Gallery of Art, Washington. Harris Whittemore Collection.

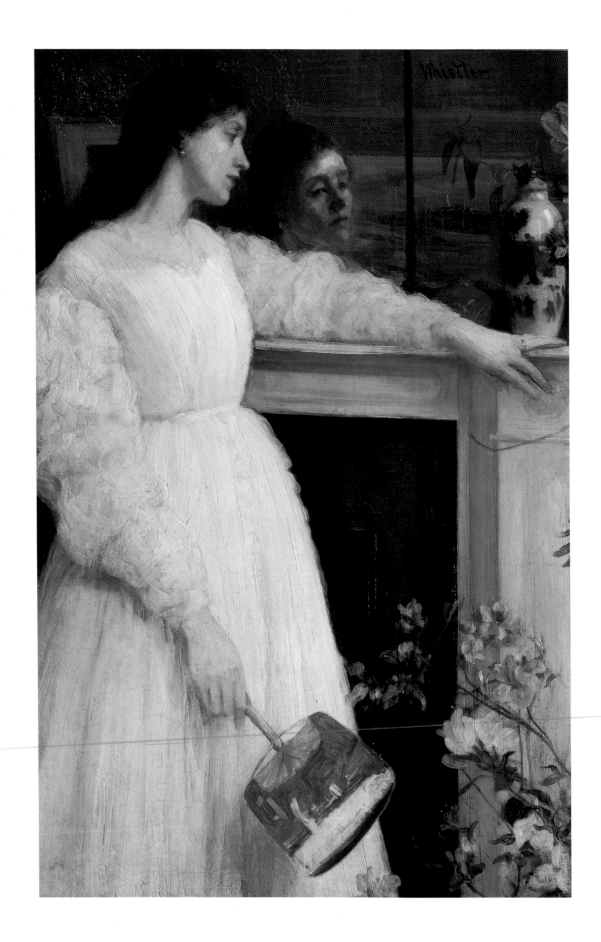

the Salon of 1884—for by 1900 Sargent, like Whistler, was too famous to be dismissed.[59]

Concerning Whistler's and Sargent's prominence at the exposition, the influential critic Royal Cortissoz explained that although their paintings may not be American, "at least they have nothing to identify them with any other school. They are original works of genius, their authors are Americans, they belong to us, and there's an end to it."[60] Distinguishing these cosmopolitan personalities as Americans—despite their expatriate status—elevated the national art. Additionally, Whistler and Sargent were pace-setters whose anti-academic styles were easily discernible from the typically conservative expatriates, whom Cortissoz castigated for producing work "which does not even begin properly to represent us."

29 (*above*). *John Singer Sargent, *Portrait of Miss Carey Thomas, President of Bryn Mawr College (1894–1922)*, 1899, oil on canvas, 58 x 38 inches. Bryn Mawr College, Bryn Mawr, Pennsylvania.

30 (*right*). John Singer Sargent, *Mrs. Carl Meyer, later Lady Meyer, and her two Children*, 1896, oil on canvas, 79 x 53 inches. Private collection/Bridgeman Art Library, London/New York.

THE HUMAN FIGURE

Unlike Whistler and Sargent, most expatriates produced work more attuned to the French academic pattern. In 1905, Samuel Isham outlined the subjects favored by Salon painters as the "religious, mythological, historical and nude," but they also included genre and figure paintings, primarily with exotic models (oriental and peasant).[61] All of these themes centered on the human figure, the cornerstone of French academic education. It was only after they had studied in Paris during the final quarter of the nineteenth century that Americans, who had previously been better known for landscapes, felt comfortable rendering the human anatomy to any great extent.

When they lived abroad, it was easy for Americans to utilize subjects which prevailed in academic circles. That was not the case at home, however. As devotees of realism, repatriated artists were compelled to adapt conventional European themes and treatment to accessible models and places. Thomas Eakins, for example, forsook European subjects in favor of Philadelphia scenes in the early 1870s, and Brush, a fellow student of Gérôme, specialized in painting Native Americans when he returned from France a decade later. For this reason, their work naturally looked more American than the works that were being produced abroad. Moreover, by 1900, even though many works were still tightly rendered, strict academic technique was considered too foreign to represent American art. In the process of creating a truly national art, artists relaxed the standards they had worked so hard to obtain in Parisian schools. This not only asserted their independence but also aligned them with modernism.

Thus, even though half of the oils, watercolors, and pastels in the U.S. decennial emphasized the human figure favored in French academicism, most of these narratives, genre scenes, figure paintings, and portraits depicted expressly American subjects. Indeed, the most obvious change since the 1889 exposition was the relative paucity of foreign narratives and genre scenes.[62]

THE "ALIEN ELEMENT" IN AMERICAN ART

There were some exceptions, however, most noticeably in the work of Edwin Lord Weeks and Frederick Arthur Bridgman. Although they were now in the minority among their compatriots, Weeks and Bridgman perpetuated their French master Gérôme's penchant for exotic topics rendered with archaeological exactitude.[63] For example, in Weeks's *Indian Barbers-Saharanpore* (fig. 31), technical details, such as tattered garments and the documentary quality of the street scene, reveal Gérôme's influence. Weeks, who had been granted a gold medal in 1889, received no award at all in 1900 for his work, which left Cortissoz "absolutely cold."[64]

In the same article, Cortissoz criticized Bridgman, who received silver medals at both expositions, for his "crude" and "chaotic" work. It makes sense that Cortissoz, who clearly favored American themes, would reject work that is indistinguishable from French Salon art, such as Bridgman's epic biblical narrative, *Pharaoh and His Army Engulfed by the Red Sea* (fig. 32). When Bridgman began his Exodus series in 1891, it fulfilled his desire to create both Middle Eastern and religious subjects. However, this account of the Jewish exodus assumed new meaning at the exposition of 1900, with Pharaoh's army symbolizing the deflated French military after Dreyfus was pardoned in the fall of 1899.[65] The selection jury may very well have chosen this canvas for political reasons, for Americans were among Dreyfus's most vocal supporters.[66] It is ironic, therefore, that on the walls of the Grand Palais during the summer of 1900, a painting with such an obvious French pedigree would seemingly undermine French authority.

In addition to the works of Sargent and Bridgman, other American paintings in the decennial also seem to symbolize the Dreyfus scandal, making their inclusion appear to be anything but coincidental. For example, Henry O. Tanner's Salon painting, *Daniel in the Lions' Den* (fig. 33), depicting an unjustly persecuted Hebrew prophet, also probably alludes to the racially motivated incarceration of Dreyfus, and would have been doubly meaningful to the

31. *Edwin Lord Weeks, *Indian Barbers—Saharanpore*, ca. 1895,
oil on canvas, 56 1/4 x 75 inches. Joslyn Art Museum, Omaha,
Nebraska. Friends of Art Collection.

32. *Frederick Arthur Bridgman, *Pharaoh and His Army Engulfed by the Red Sea*, 1900, oil on canvas, 45 1/4 x 83 inches. Dr. and Mrs. Peter L. Perry.

African-American artist.[67] Still, the presumably anti-French sentiment the painting assumed within the context of the exposition was not enough to appease the nativistic critic Ellis T. Clarke, who would have preferred the expatriate Tanner to deal directly with the "struggles of his race," and thus contribute to the creation of a national art.[68]

Clarke was probably bothered by the religious content of Tanner's painting because, in keeping with Protestantism's aversion to devotional images, biblical subjects were unpopular in America. This attitude changed somewhat in the 1890s, with the anti-realist influence of symbolism which reflected both the Catholic revival and the fin-de-siècle taste for escapism.[69] In terms of its emphasis on spirituality and introspection, Tanner's *Daniel* belongs more with European symbolism than academicism.

As was the case with religious paintings (fig. 34), other antirealist themes from folklore (fig. 35) and mythology (fig. 36) also betrayed foreign influence, even if they had been created in the United States. Fittingly, none of these categories was well represented in an exhibition orchestrated to exude national character. In

George Willoughby Maynard's *In Strange Seas* (fig. 37), mermaids lure men into unsafe seas where they will abandon them to die.[70] Because of their bewitching conduct, mermaids were also appropriate subjects for symbolist paintings.[71] However, because these sirens originated in ancient legends like the *Odyssey*, they are basically considered Old World subjects. Indeed, mythological paintings had only become common in American painting after increased exposure to French art in the 1870s. Although Maynard lived in New York at the time of the exposition, he had executed this painting in Paris during one of his many intervals abroad.

Most, but not all, of the foreign scenes in the decennial were contributed by artists living in France. Although artists residing in Great Britain, such as Edwin Austin Abbey and John Francis Millet, had also left their homeland for professional opportunities abroad, they were often spared the criticism directed at their compatriots in France. Unlike the Franco-Americans, they generally did not aim to produce Salon art. Their acceptance can also be explained in terms of the Anglomania that swept the United States during the final quarter of the nineteenth century, for their themes—English history or culture which developed prior to the American Revolution— would have been viewed nostalgically by New World critics, since many Americans had British ancestors. Regarding Abbey's *The Play Scene in "Hamlet"* (fig. 38), for example, William Walton rationalized that Shakespeare "is the common property of England and America."[72]

The same justification could be applied to Millet's Elizabethan genre scenes, such as *Unconverted* (fig. 39), in which two bawdy maids tempt an unyielding curate. Around the time of the exposition, Millet abandoned British themes such as this in favor of American ones.[73] As supervisor of decorations in the U.S. pavilion, Millet insisted upon colonial furnishings, which coincided with and perhaps even fortified this transition.[74]

A few noteworthy genre compositions involving foreigners were also displayed by stateside artists, further indicating that there was no definitive formula for distinguishing their work from that of their expatriated peers. Many turn-of-the-century American artists had

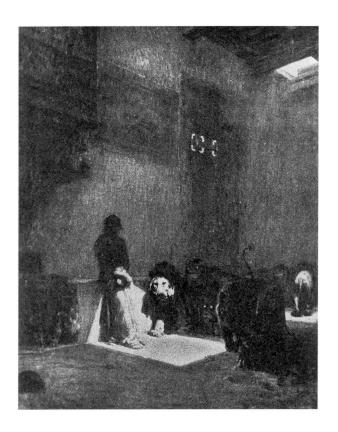

33. Henry O. Tanner, *Daniel in the Lions' Den*, 1896, oil on canvas. Unlocated. *Brush and Pencil*, vol. 6 (June 1900): 98.

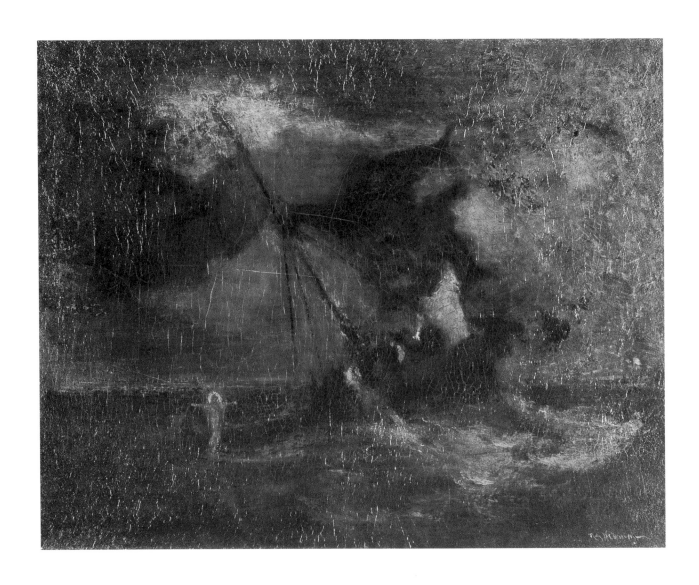

34. Robert Loftin Newman, *Christ Stilling the Tempest,* n.d., oil
on canvas, 14 x 18 inches. Virginia Museum of Fine Arts, Rich-
mond, Virginia. The Katherine Rhoads Memorial Fund.

35. *Maxfield Parrish, *The Sandman,* 1902, oil on board, 22 x 28 inches. Collection of J. Nicholson, Beverly Hills, California. This is a later version of the painting Parrish exhibited at the Paris Exposition, 1900.

36. *Charles Courtney Curran, *The Peris*, 1898, oil on canvas, 18 x
32 inches. Dr. Ronald Berg, Monticello, New York.

cosmopolitan orientations to both art and life, which made rendering foreign subjects seem natural. Two such artists were Robert Blum and John La Farge, who exhibited works inspired by the "exotic" people of the Pacific islands.

As an advocate of the "American Americans," Ellis Clarke was able to disregard Blum's faithfulness to academic procedures in the picturesque Japanese street scenes *A Flower Market in Tokyo* (fig. 40) and *The Ameya* (fig. 41), although he could not refrain from urging the artist to depict "home types."[75] In John La Farge's *Siva with Siakumu Making Kava in Tofae's House* (fig. 42), the sense of light and the fresh approach to watercolor correspond with the anti-academicism and naturalism of the French Barbizon school and oriental art, which La Farge had precociously admired since the 1850s. Barbizon painting, which had never been endorsed by the French state, seemed less French than academicism to

37. *George Willoughby Maynard, *In Strange Seas*, 1889, oil on canvas, 36 1/8 x 50 5/16 inches. The Metropolitan Museum of Art, New York. Gift of William F. Havemeyer, 1901.

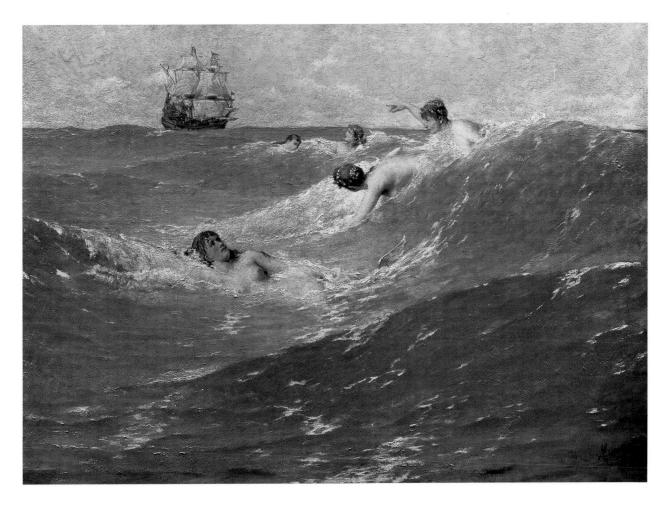

38. *Edwin Austin Abbey, *The Play Scene in "Hamlet"* (Act III, Scene ii), 1897, oil on canvas, 61 1/4 x 96 1/2 inches. Yale Art Gallery. Edwin Austin Abbey Memorial Collection.

Americans at the time. Because he was so highly respected, La Farge's meager representation of two watercolors in the decennial was lamented by Cortissoz, despite the foreign content of his work.[76]

In La Farge's Samoan genre scene, half-naked, brown-skinned women prepare an intoxicating ceremonial drink for their more "civilized" American visitors.[77] Even more than the previously mentioned portrayals of Asian barbers, candy makers, and flower vendors, these "primitive" Samoans represented a way of life that seemed antiquated and alien to middle and upper class American artists and patrons, although the paintings were thematically contemporary and technically fell within the dictates of realism.[78] Because they were intended for this sophisticated audience, these paintings of simple individuals implied that the United States, in contrast, is highly evolved within the course of empire.

A similar paternalism among Americans appears regarding European peasants. As an artistic genre, peasant paintings had been popularized by the Frenchman

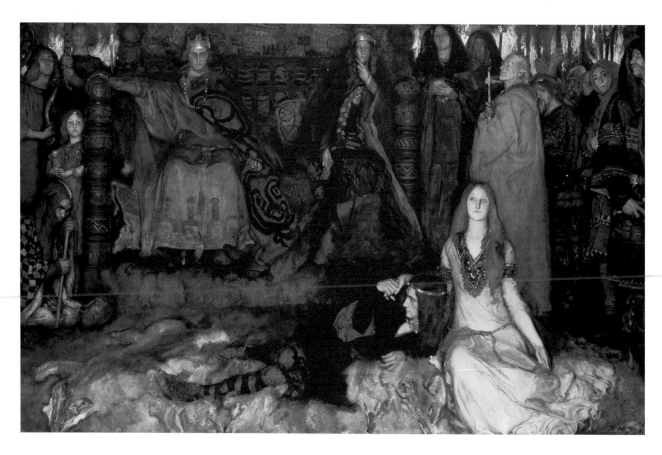

Jean-François Millet, and later became fashionable among Americans, who had no peasant class of their own. Millet, whose work was enthusiastically collected in the United States, had an enormous influence on American artists. Most Americans who rendered peasants worked either in France (fig. 43) or Holland (figs. 44, 45, and 46), often in colonies that had been fashioned after Millet's Barbizon model.[79]

Americans were attracted to peasant themes in part because they symbolized values believed to be on the brink of extinction. Peasants invoked the same antimodern qualities of the American colonial revival and the arts and crafts movement—such as quality handiwork versus shoddy machine-made objects. At the exposition, Marcia Oakes Woodbury (fig. 47), Walter Gay, and Emma Lampert Cooper exhibited paintings of peasants as industrious craftspeople, again recalling the lifestyles of their American forebears. Thus, even though the paintings were executed in Europe, drawing upon well-established French prototypes, they were imbued with American values.

39. *Francis Davis Millet, *Unconverted,* ca. 1880, oil on canvas, 30 1/2 x 50 1/5 inches. Private collection.

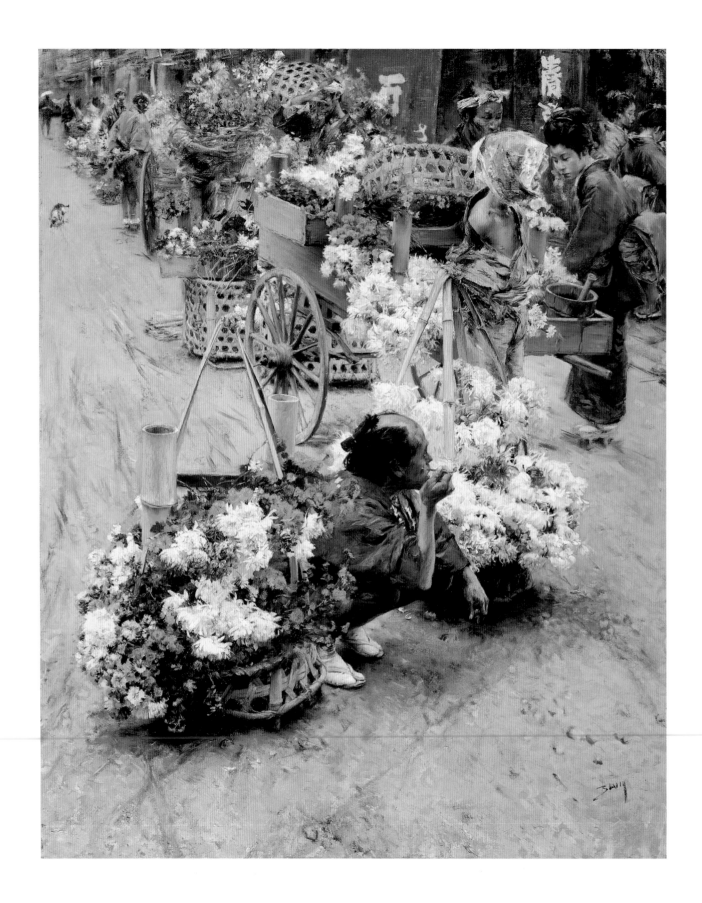

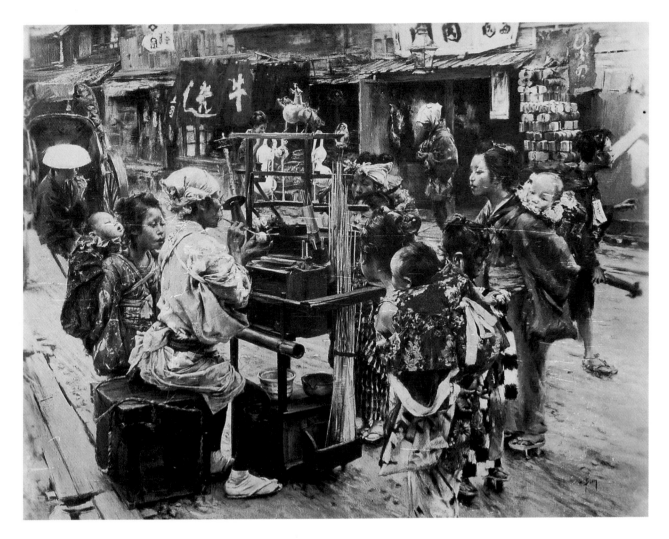

41 (*above*). *Robert Blum, *The Ameya*, 1890–1892, oil on canvas, 25 1/16 x 31 1/16 inches. The Metropolitan Museum of Art, New York. Gift of the Estate of Alfred Corning Clark, 1904.

40 (*facing page*). *Robert Blum, *A Flower Market in Tokyo*, ca. 1892, oil on canvas, 31 1/8 x 25 1/4 inches. Manoogian Collection.

Peasants were also typified as devout. However, because Protestant themes corresponded with the religious heritage of the United States, and in light of rampant anti-Catholic sentiments at the time, it is not surprising that Dutch Protestant peasants outnumbered Catholic ones (who were mostly French) in the American exhibition. Walter MacEwen's life-sized *Dimanche en Hollande* (fig. 48), for example, depicts three generations of women in Sunday dress, with the youngest holding the family Bible, symbolic of the piety she will impart to future generations of Protestants.[80] Nonetheless, with fewer than a dozen examples in the decennial, peasant paintings, even Protestant ones, did not represent the new American school. Indeed, in his review of the exhibition, Ellis T. Clarke railed against "alien subjects," which included the peasant.[81]

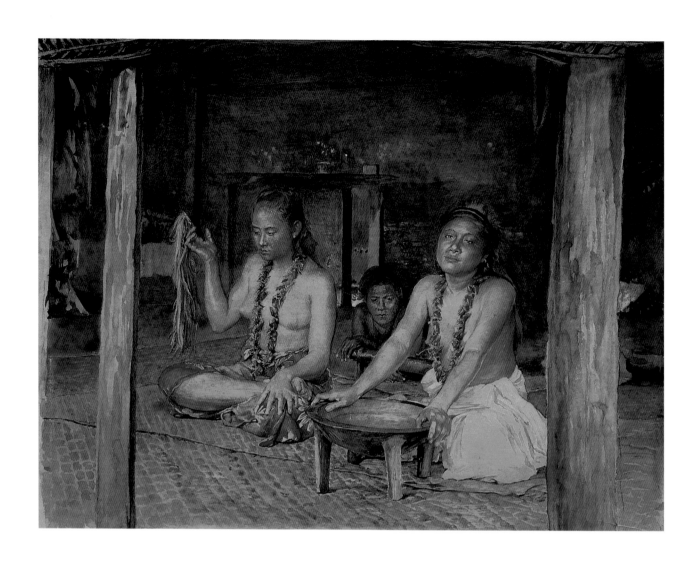

42. *John La Farge, *Siva with Siakumu Making Kava in Tofae's House,* ca. 1893, watercolor on vellum, 16 1/2 x 21 inches. Sterling and Francine Clark Art Institute, Williamstown, Massachusetts. Gift of L. Bancel La Farge, 1966.3.

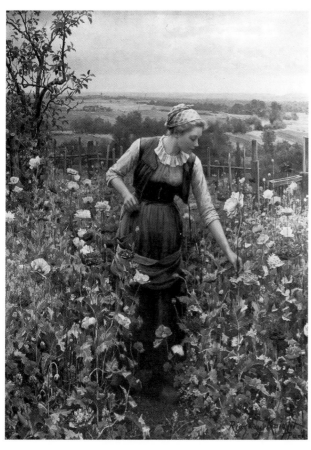

43. Daniel Ridgway Knight, *July Morning*, 1895, oil on canvas, 96 3/4 x 73 inches. Manoogian Collection.

However, of all the manifestations of the human figure in art, it was the nude that was most associated with the rise of French instruction, which centered on rendering live models. Nudes provided a high-minded link with the Western cultural tradition, especially the classical and Renaissance periods which the Americans admired. Still, paintings of nudes in the American section were scarce.

In one of the few paintings of nudes in the exhibition, Julius Stewart's *Nymphes de Nysa* (fig. 49), the presumably French models pose frontally, which would not have been considered offensive in France. However, to the American Cortissoz, this canvas illustrated "technical ability spent in the tasteless commemoration of merely ugly models."[82] As Isham observed a few years after the exposition regarding nudes, "such subjects were not in accord with the national habits."[83] Recounting his visit to the fair, Henry Adams similarly observed in his essay "The Dynamo and the Virgin," that, in contrast to

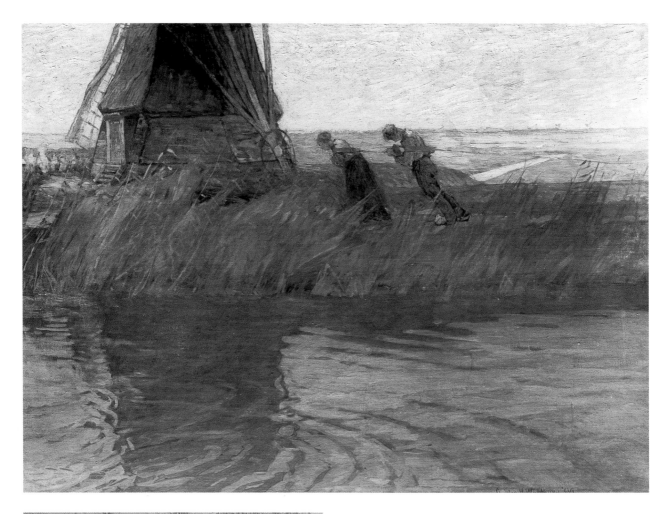

44. *Charles Woodbury, *The Green Mill,* 1896, oil on canvas, 31 x 42 inches. MIT Museum. Gift of Mrs. David O. Woodbury.

45 . *George Hitchcock, *Vaincu (Vanquished),* n.d., oil on canvas, 39 3/8 x 37 3/8 inches. Musée d'Orsay, Paris, R.F. 1977–194.

46 (*facing page*). * Gari Melchers, *The Sisters,* ca. 1895, oil on canvas, 59 1/4 x 39 5/8 inches. National Gallery of Art, Washington. Gift of Curt H. Reisinger.

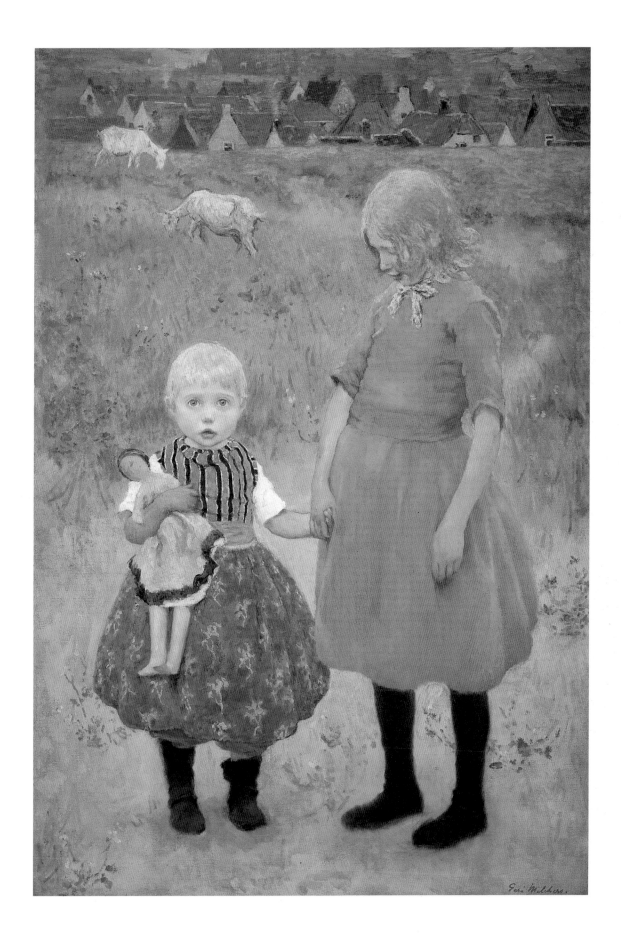

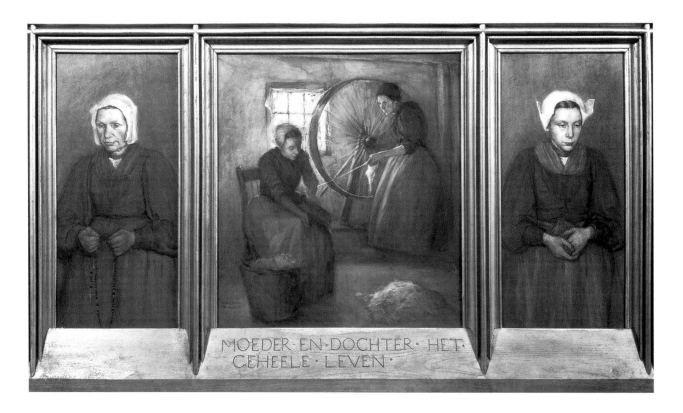

MOEDER·EN·DOCHTER·HET· GEHEELE·LEVEN·

47. *Marcia Oakes Woodbury, *Mother and Daughter: The Whole of Life,* 1894, triptych, watercolor on paper, 26 1/2 x 12 inches in left and right sections, 26 1/2 x 24 1/2 inches in center section. Museum of Fine Arts, Boston. Gift of Charles H. Woodbury.

Europeans, Americans were unable to fully appreciate the power of female sexuality, because they believed that sex was sinful.[84] Accordingly, the Bostonian Joseph DeCamp posed the model for *Woman Drying Her Hair* (fig. 50) modestly, from the back.

In this stroll through the American galleries at the exposition, it is apparent that French academic conventions were not extinguished, but were being perpetuated in paintings done abroad, including foreign narratives, genre paintings, mythological paintings, paintings of the exotic "other," and nudes. Nonetheless, even in the most foreign-looking of these themes, a distinctly American viewpoint can often be deciphered. However, it was in those paintings executed in the United States that explicitly American types emerged from the European tradition. Nowhere is this more apparent than in portraits and figure paintings depicting American womanhood.

48. (*facing page*) *Walter MacEwen, *Dimanche en Hollande (Sunday in Holland),* ca. 1898, oil on canvas, 74 3/4 x 47 1/4 inches. Musée d'Orsay, Paris.

49. (*facing page*) *Julius Stewart, Nymphes de Nysa (Nymphs of Nysa),* n.d., oil on canvas, 56 1/4 x 43 7/8 inches. Musée d'Orsay, Paris.

50. (*above*) *Joseph R. DeCamp, Woman Drying Her Hair,* n.d., oil on canvas, 36 x 36 inches. Cincinnati Art Museum. Mary Dexter Fund, 1899.67.

51. *Alfred Maurer, *At the Window,* 1899–1900, oil on canvas, 24 1/8 x 19 3/4 inches. Hirshhorn Museum and Sculpture Garden, Smithsonian Institution. Gift of Joseph H. Hirshhorn, 1966.

Women and Children

Since the 1870s, figure paintings of women had dominated American art. Again, this reflects increased exposure to French art in which female subjects prevailed, as exemplified by the young expatriate Alfred Maurer's *At the Window* (fig. 51). The social climate of the time also supported the shift from landscape and genre paintings to figure paintings of women, who were regarded as being more culturally astute than men, and so were perceived as civilizing agents.[85] As has already been suggested regarding paintings of nudes, American artists tended to render women at home with more propriety than those abroad. In fact, it was precisely the supposed purity of the American women in the decennial—in contrast with the *femmes fatales* in the European sections—that distinguished the United States as a genteel "empire," innocent enough to inherit western civilization.

A year before he repatriated to the United States, Fred Dana Marsh portrayed his wife as a *femme du monde,* wearing an off-the-shoulder gown in the latest Parisian fashion (fig. 52). However, in paintings created stateside such daring attire is rare. William Merritt Chase's very modestly dressed woman in *Portrait of Mrs. C (Lady with a White Shawl)* (fig. 53), for example, epitomizes the wholesome ideal of American womanhood at the time. According to the artist, the model for the painting was the original "Gibson Girl," with her "clear-cut face with a splendid profile—a steadfast expression of sweetness, loveliness, womanliness, and above all else, dignity and simplicity. . . ."[86] Martha Banta has asserted that the Gibson Girl (named after the illustrations of Charles Dana Gibson), in her role as the "nation's primary means for identifying its values to the world," needed to look like a white Anglo-Saxon princess.[87]

Cecilia Beaux's *Mother and Daughter* (fig. 54) likewise exemplifies such puritanical values. This full-length double portrait documents Mrs. Clement Griscom and her daughter Frances, elegantly wrapped in their evening cloaks. In her debut as a marriageable American woman, this daughter of a Philadelphia shipper and financier displayed regular Northern European features and

52. Fred Dana Marsh, *The Lady in Scarlet,* ca. 1900, oil on canvas, 77 x 51 1/4 inches. The Newark Museum. Gift of Mrs. Fred Dana Marsh, 1963.

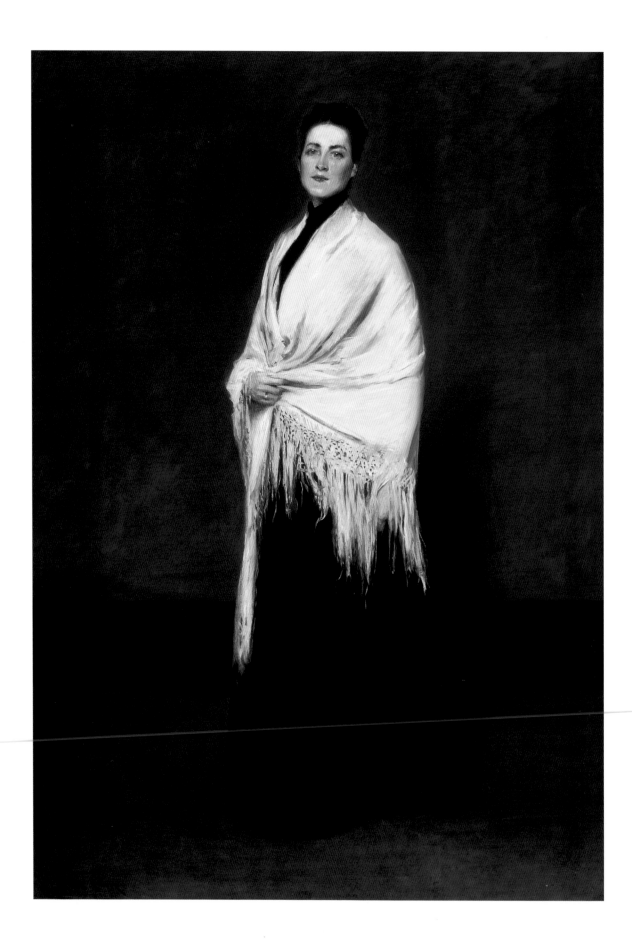

53 (*facing page*). *William Merritt Chase, *Portrait of Mrs. C (Lady with a White Shawl),* 1893, oil on canvas, 75 x 52 inches. Courtesy of the Pennsylvania Academy of the Fine Arts, Philadelphia. Joseph E. Temple Fund, 1895.1.

54 (*right*). *Cecilia Beaux, *Mother and Daughter,* 1898, oil on canvas, 83 x 44 inches. Courtesy of the Pennsylvania Academy of the Fine Arts, Philadelphia. Gift of Frances C. Griscom, 1950.15.

proper attire insuring that she was the best "breeding stock."[88]

In figure paintings such as Edmund C. Tarbell's *Across the Room* (fig. 55), women often lounged about in expensive dresses, just as ornamental as the art objects surrounding them. Women at leisure were reflections of their husbands' material success, whether they were idle, as in *Across the Room,* or participating in a genteel activity, as in Theodore Robinson's *Girl at Piano* (fig. 56). As with peasant paintings, artists who wanted to please their patrons (who were primarily male) idealized their subjects.

However, nowhere in the exhibition was American womanhood more exalted than in the paintings of Abbott Thayer (figs. 57 and 58). Thayer's *Virgin Enthroned* was such a powerful icon of American femininity at the exposition that Cortissoz rhapsodized, "a nation that could produce a work like this, the foreigner must say, is a nation to reckon with."[89] Critics praised this canvas, with models recognizable as the artist's children, for portraying real American womanhood.

Yet the models have a double identity. For, in addition to communicating the chastity of the artist's elder daughter, *Virgin Enthroned* also invoked the supernatural. As Elizabeth Pennell explained in the *Nation*:

> the dignity of the composition, suggested by the
> early Italian and Flemish Madonnas, and the inde-
> pendence with which Mr. Thayer, adapting it to his
> modern method, has steered clear of . . . sensation-
> alism. . . . Love of beauty has been his inspiration,
> and so well has he succeeded that the little child,
> wholly modern and American, kneeling to the right

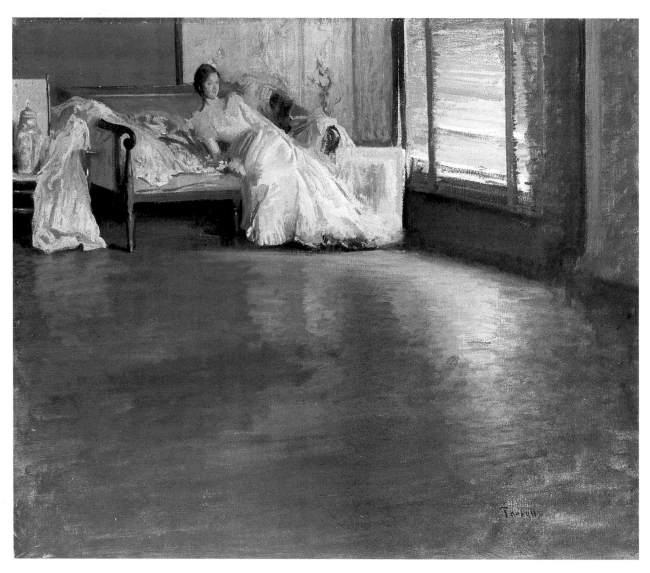

55. Edmund C. Tarbell, *Across the Room,* ca. 1899, oil on canvas, 25 x 30 1/8 inches. The Metropolitan Museum of Art, New York. Bequest of Miss Adelaide Milton de Groot (1876–1967).

of the Virgin, against the vague blue background, is as lovely as the angels of Bellini. It would have been strange had a gold medal been refused.[90]

Pennell's reference to European Madonnas is significant, for it was precisely the historical and spiritual elements that gave an entire category of turn-of-the-century paintings of American Virgins their potency. As products of the American Renaissance, these images are heir to the western pictorial tradition, especially the Italian Renaissance—the period which the sometimes conceited Americans believed they equalled. For example, in *Mother and Child* (fig. 59), Brush appropriated the tondo format of the Renaissance, suggesting a legitimate artistic lineage.

56. (*facing page*) *Theodore Robinson, *Girl at Piano,* ca. 1887, oil on canvas, 21 3/4 x 18 1/16 inches. Courtesy of the Pennsylvania Academy of the Fine Arts, Philadelphia. Henry D. Gilpin Fund, 1898.7.

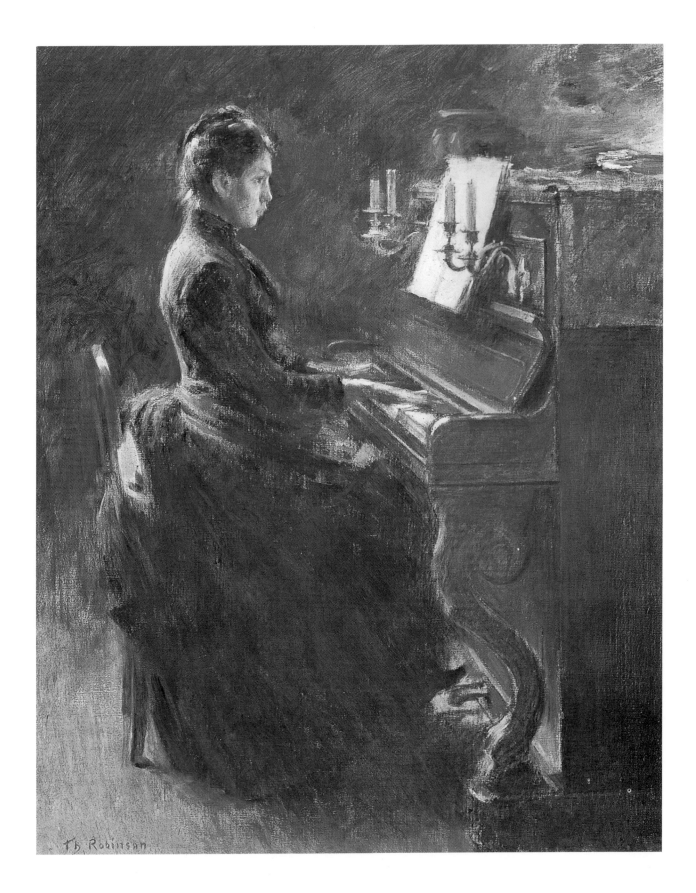

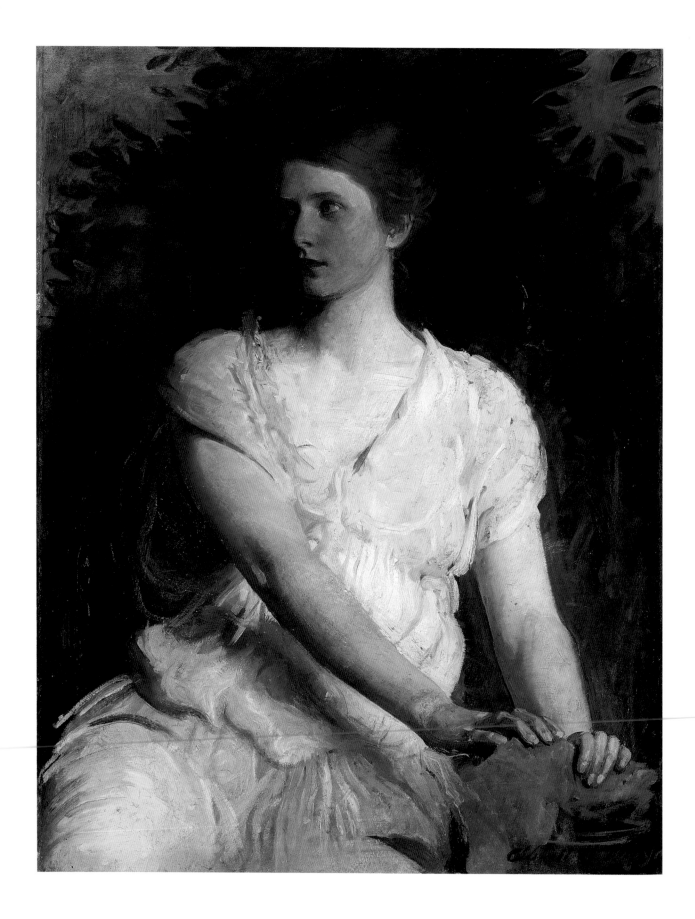

57 (*facing page*). *Abbott Handerson Thayer, *Young Woman,* ca. 1898, oil on canvas, 39 5/8 x 31 5/8 inches. The Metropolitan Museum of Art, New York. Gift of George A. Hearn, 1906.

58 (*right*). Abbott Handerson Thayer, *Virgin Enthroned,* 1891, oil on canvas, 72 5/8 x 52 1/2 inches. National Museum of American Art, Smithsonian Institution. Gift of John Gellatly, 1929.6.131.

Initially, it may seem inconsistent that the paradigm of American womanhood be presented in the guise of the Virgin Mary when the United States was asserting cultural autonomy. However, the Virgin became an appealing pictorial theme at the turn of the century only after she had been divested of her holy attributes, then secularized (and therefore Protestantized), modernized, and Americanized. Virgin paintings, without specific biblical references, were the most compelling religious paintings in American art at the time.

Paintings of the Virgin done by the expatriates, however, remain faithful to Catholic tradition. Hitchcock's *Magnificat* (fig. 60), for example, depicts a real Dutch peasant in Low Country attire. However, the halo negates the otherwise naturalistic scene, as does the formulaic placement of Mary in her *hortus conclusus* surrounded by lilies. Hitchcock's painting, which was neither secularized nor Americanized, was dubbed "a meaningless affair" by Cortissoz.[91] Thus this work has more in common with William Bouguereau's *La Vierge aux anges* (fig. 8) in the French decennial than with Thayer's *Virgin Enthroned.*

Paintings by Thayer and Brush, moreover, venerated American women as the vessel of the white Anglo-Saxon Protestant race to which most of the artists and their patrons belonged. These images suggested that, like the Catholic Madonna, the sitter was morally superior to all other women. But, while the Virgin was unique in Catholicism, any upstanding white Anglo-Saxon woman (even a married one such as Brush's wife, who was his model) could aspire to the position in the United States—a very democratic notion.

These paintings also fulfilled the desire for a goddess figure in American culture as articulated by Henry

59 (*above*). *George de Forest Brush, *Mother and Child*, ca. 1897, oil on canvas, 39 1/4 inches in diameter. Courtesy of the Pennsylvania Academy of the Fine Arts, Philadelphia. Joseph E. Temple Fund, 1895.1.

60 (*facing page*). *George Hitchcock, *Magnificat*, 1894, oil on canvas, 65 x 40 inches. Belmont, The Gari Melchers Estate and Memorial Gallery, Mary Washington College, Fredericksburg, Virginia.

Adams.[92] Protestant Mariolatry was not uncommon during the heyday of symbolism, as evidenced by the numerous paintings of the subject and the rise in Anglo-Catholicism.[93] In fact, at least pictorially, the American Virgins created a force with which to challenge the Catholic Madonna. This was especially useful during an era of mass immigration from predominantly Catholic eastern and southern Europe which threatened Anglo-Saxon preeminence in America. In fact, these immigrants quickly lost their romantic appeal as they struggled to support themselves with factory work and menial labor.[94] They would have to shed their foreign accents and appearance before they would be considered fully American.[95]

As demonstrated in the Virgin paintings and elsewhere, turn-of-the-century Americans were very interested in their heritage. The preponderance of "family pictures" in the decennial, which sharply contrasts with the 1889 exhibition, is a further indicator of this preoccupation. In addition to Thayer, Brush, and Marsh, the stateside painters Irving Wiles (fig. 61) and James Carroll Beckwith, along with the expatriates Charles Sprague Pearce (fig. 62), Mary MacMonnies (fig. 63), John Humphreys Johnston (fig. 146), and Julian Story, immortalized relatives in paintings they sent to the exhibition. The turn toward intimate portraiture underscores the artists' desire to look homeward for inspiration, even among Americans living abroad.

Like their mothers, American children were also rendered in an ideal light, as in Frank Benson's *The Sisters* (fig. 64).[96] Painted in a breezy impressionistic style, this canvas depicts healthy all-American girls, destined to become virtuous women and mothers. Along with Rosina Emmet Sherwood's *Head of a Child* (fig. 65), which also radiates innocence, *The Sisters* divines a bright future for the nation.

Thus, paintings of stateside women and children in the decennial took the European figural tradition and infused it with American values centered on morality and the family. When these paintings of American women and children were featured at the Paris exposition, they assumed a more powerful and politically charged meaning from when they had been exhibited in New York,

61 (*above*). Irving Wiles, *The Artist's Mother and Father*, 1889, oil on canvas, 48 x 36 1/2 inches. The Corcoran Gallery of Art, Washington. Museum Purchase, William A. Clark Fund, 39.1.

62 (*facing page*). *Charles Sprague Pearce, *The Shawl*, ca. 1900, oil on canvas, 81 x 42 inches. Elvehjem Museum of Art, University of Wisconsin-Madison. Members of the Elvehjem Museum of Art Fund and Art Collections Fund purchase, 1985.2.

63 *(top).* Mary Fairchild MacMonnies, *Roses et Lys (Roses and Lilies),* 1897, oil on canvas, 52 1/2 x 69 3/8 inches. Musée des Beaux-Arts de Rouen.

64 *(bottom).* Frank Weston Benson, *The Sisters,* 1899, oil on canvas, 40 x 40 inches. Daniel J. Terra Collection, 7.1996.

65. *Rosina Emmet Sherwood, *Head of a Child,* n.d., watercolor
with graphite and gouache on paper/board, 12 x 10 1/4 inches.
Mr. and Mrs. Christopher T. Emmet.

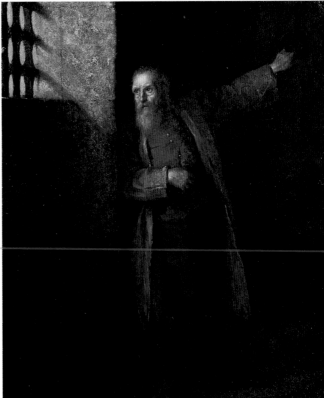

66 (*above*). *J. G. Brown, *Heels over Head,* ca. 1894, oil on canvas, 40 x 60 inches. Private collection.

67 (*right*). *Eastman Johnson, *Prisoner of State,* 1874, oil on board, 26 1/2 x 22 1/8 inches. Private collection.

Boston, or Philadelphia, because they professed the moral superiority of the United States to an international audience.

MEN

Compared with images of women, masculine themes were not as prevalent during the final quarter of the nineteenth century as they had been earlier. By 1900, however, paintings of men began to gain increased significance as a counter to the French-influenced femininity associated with the Gilded Age. They also communicated American supremacy by symbolizing vitality and virility. John George Brown's *Heels Over Head* (fig. 66), recalling hardy genre paintings of the Jacksonian era of active boys and men, was deemed "distinctively national" by Clarke.[97] This depiction of recent immigrants assimilating into the melting pot expresses the vigor of the nation.

Brown, whose career had peaked in the 1870s, was joined in the decennial by another veteran, Eastman Johnson, who had been one of Thomas Couture's first American pupils. For the exhibition, Johnson resurrected an 1874 painting, *Prisoner of State* (fig. 67). This representation of a defiant political prisoner, looking beyond the bars of his cell toward the sunlight, may well have been yet another demonstration of American outrage against the imprisonment of Dreyfus.

Paintings of men by stateside artists such as Johnson were generally better received than those by expatriates, whose portraits of Europeans often showed effete stereotypes. For example, the expatriate Gari Melchers, who had won a grand prize in 1889, received nothing but condemnation in 1900 for the "rude realism" in his portraits of foreign males, such as *The Fencing Master* (fig. 68).[98] Alexander's portrait of France's most famous sculptor, Auguste Rodin (fig. 69), was more favorably received, probably due to the artist's Whistlerian tendencies and alliance with Cauldwell. Cortissoz, for example, considered Alexander to be "Parisianized, but not too much."[99]

Nonetheless, Alexander was no paragon of Americanness. Rather, it was Thomas Eakins, whose reputa-

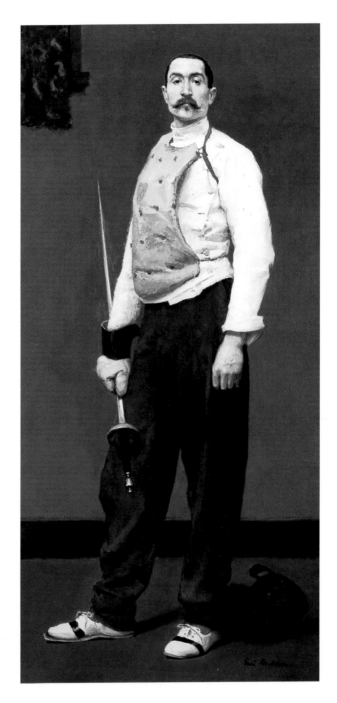

68. Gari Melchers, *The Fencing Master*, ca. 1900, oil on canvas, 81 x 40 inches. The Detroit Institute of Arts. Gift of Edward Chandler Walker.

69 (*right*). *John White Alexander, *Portrait of Rodin*, 1899, oil on canvas, 66 x 48 inches. The First National Bank of Chicago.

70 (*facing page*). *Thomas Eakins, *The Cello Player*, 1896, oil on canvas, 64 1/4 x 48 1/8 inches. Courtesy of the Pennsylvania Academy of the Fine Arts, Philadelphia. Joseph E. Temple Fund, 1897.3.

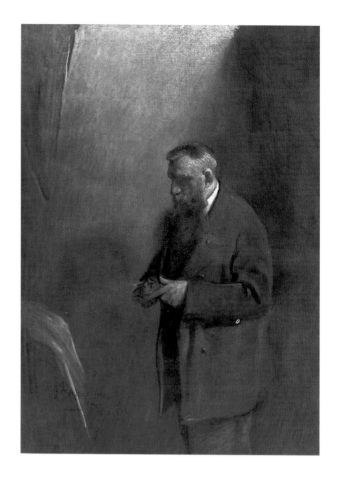

tion had suffered since he exhibited his disturbingly realist *The Gross Clinic* (1875; Jefferson Medical College of Philadelphia) at the 1876 Centennial exposition, whose stock as a patriot was beginning to rise in 1900.[100] Elizabeth Pennell praised Eakins's *The Cello Player* (fig. 70) as a "straightforward, vigorous and uncompromising rendering of a strong type as you could find."[101]

Pennell also applauded Eakins's more dynamic *Salutat* (fig. 71) for being "as astonishing in its vigor and truth as his portrait."[102] Eakins, who had studied with both Gérôme and Léon Bonnat, paid relentless attention to both detail and the anatomy of the figure.[103] However reminiscent *Salutat* may be of Gérôme's *Ave Caesar* of 1859, critics eager to establish an American art in 1900 were among the first of many who saw only Eakins's American subjects and not his French influence. In his *History of American Art*, published two years later, Sadakichi Hartmann praised Eakins's efforts in presenting masculine subjects, claiming, "Our American

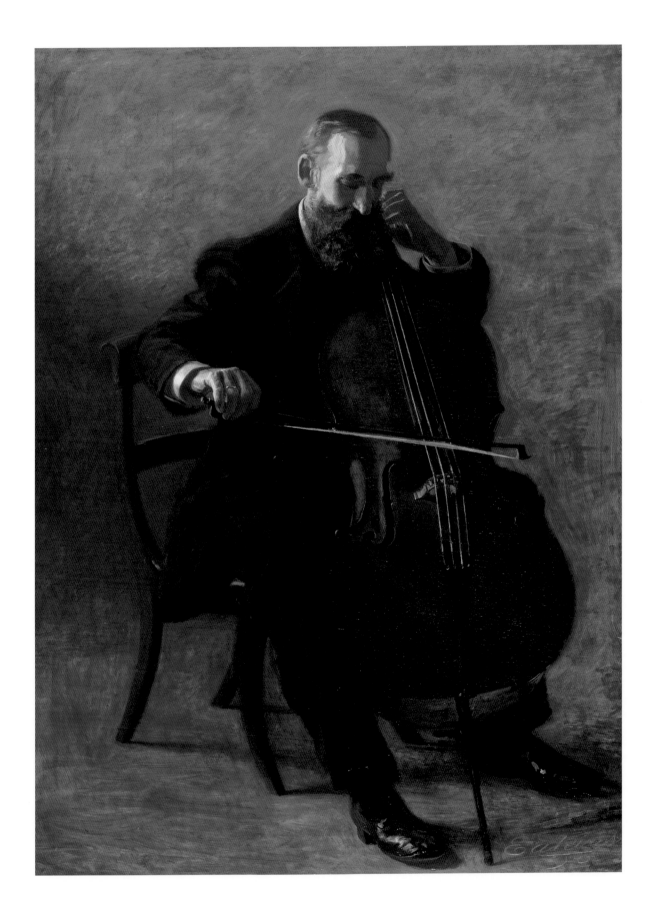

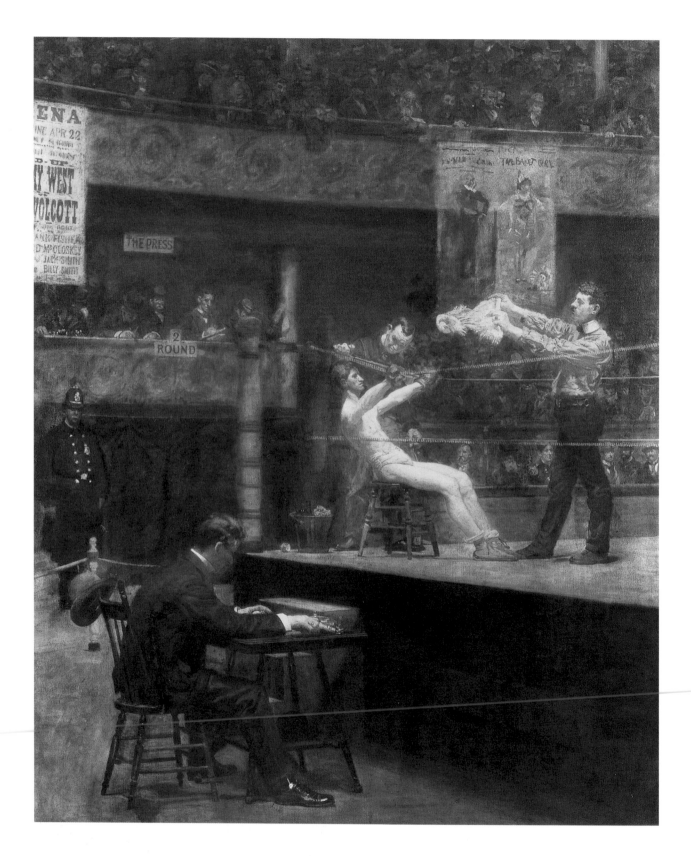

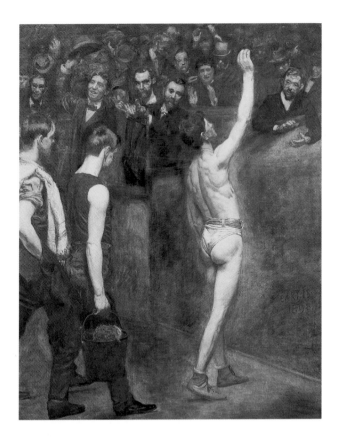

art is so effeminate at present that it would do no harm to have it inoculated with just some . . . brutality. . . ."104

Another painting that would have underscored the notion of the physical male as embodying Americanness at the exposition was Eakins's *Between Rounds* (fig. 72). This painting had been accepted by the stateside jury, but was presumably never installed, because it appears in neither the U.S. catalogue nor in the final report on the exposition.

In addition to athletes, men who worked outdoors and who relied on their physical strength were also portrayed. Such males, who were not confined to interior spaces in paintings, as women often were, symbolically had the whole world available for them to control, and thus became metaphors for the expansionist United States. Sailors, as in Winslow Homer's *The Lookout-"All's Well"* (fig. 73) and farmers, as in Julian Alden Weir's *Midday Rest in New England* (fig. 74), were typical of this breed. But it was best personified by the cowboy.

Charles Schreyvogel's *My Bunkie* (fig. 75), an action-packed western drama fantasizing a bygone era, trans-

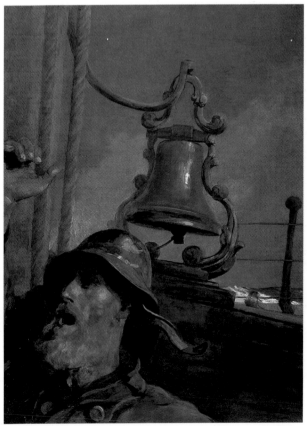

74. *Julian Alden Weir, *Midday Rest in New England*, 1897, oil on
canvas, 39 5/8 x 50 3/8 inches. Courtesy of the Pennsylvania
Academy of the Fine Arts, Philadelphia. Gift of Isaac H. Cloth-
ier, Edward H. Coates, Dr. Francis W. Lewis, Robert C. Ogden,
and Joseph G. Rosengarten, 1898.9.

lates imported themes, found in Bridgman's *Pharaoh and His Army Engulfed by the Red Sea,* for example, into an American idiom. This painting of cavalrymen at battle with Native Americans (who do not merit inclusion in the painting) focuses on one soldier assisting a bunk mate who has lost his mount.[105] *My Bunkie* could easily pass for a caricature of Theodore Roosevelt's "Rough Riders" who had charged up San Juan Hill just two years earlier. Roosevelt, who was the vice president in 1900, had become the incarnation of American manliness and imperialism.

Western topics such as this were especially timely in 1900, because the American frontier had been officially closed only a decade earlier and the indigenous population had all but been eliminated. These events radically altered the geographic and racial composition of the

75. *Charles Schreyvogel, *My Bunkie,* 1899, oil on canvas, 25 1/4 x 34 inches. The Metropolitan Museum of Art, New York. Gift of the Friends of the Artist, by subscription, 1912.

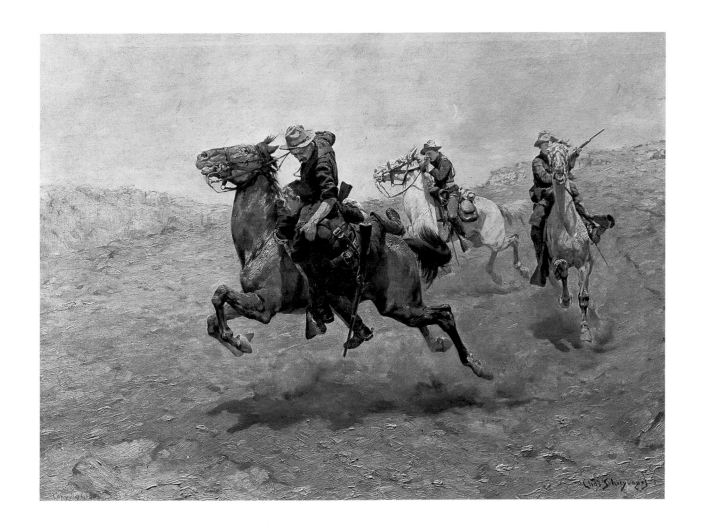

nation, as well as the way Americans viewed themselves in terms of evolutionary theories. In a momentous speech at the Chicago exposition in 1893, "The Significance of the Frontier in American History," the historian Frederick Jackson Turner professed that America's national character was shaped not by Europe, but by the western frontier.[106]

Victory for Schreyvogel's cavalrymen over a group of invisible Native Americans was guaranteed, in terms of both pictorial narrative and reality, to make this battle scene palatable for a polite audience. Compared with the French decennial, few confrontational subjects appeared in the American galleries. No major works representing blacks or immigrants, who belonged outside the white Anglo-Saxon Protestant majority, were included in the exhibition. Aside from the sculpture already mentioned and a few illustrations, the only references to events in American history in the decennial were two ship portraits (appropriately naval victories against Europe in 1812 and 1898) by Carlton Chapman. Essentially, the intention was to advertise the United States as a utopia.

As has been illustrated, the human figure at the Paris Exposition of 1900 assumed a variety of pictorial types. While paintings executed abroad essentially maintained European characteristics, those created at home idealized stereotypically American traits in women, children, and men. Although some of the best prizes in the American decennial were to be awarded to portrait and figure painters, Cauldwell nonetheless discerned "a weakness in our figure paintings," which ultimately did not epitomize the new national art.[107]

Landscapes, Seascapes, and Cityscapes

Rather, the American School would be primarily linked with landscapes and other paintings depicting places, which comprised two fifths of the oils, watercolors, and pastels in the decennial. Unlike any other subject in painting during the turn of the century,

identifiable native scenes mirrored the United States and thus functioned literally as portraits of America.

A reviewer from the *Boston Transcript*—who dated the birth of national portraiture and figure painting to the 1893 exposition, but singularly American landscapes to the Paris exposition of 1889—reasoned:

> While there is no questioning the merit of our portrait school, as represented at Paris, Americanism may not be predicated on it with the same unhesitating, uncompromising assurance as of our landscape school. . . . The average American landscape astray in a French exhibit could hardly escape detection; the average American portrait, on the other hand, similarly displaced, might readily be mistaken for the product of a Frenchman's brush.[108]

The critic attributed this to the "impossibility of giving to a portrait 'local color' which is so easy to do in landscape."

Foreign Scenery

In light of these observations, it is logical that only a handful of foreign landscapes appeared in the U.S. galleries. The most popular of these sites was the French countryside, where Americans had habitually ventured in search of picturesque locations, first as art students during their summer breaks, and later as professionals. An excellent example of this is Willard Metcalf's impressionistic view of French rooftops in *Midsummer Twilight* (fig. 76), which the artist had painted a year before he returned home from France in 1889 and began specializing in New England scenery.

The insignificance of foreign landscapes to the success of the exhibition was demonstrated when William Lamb Picknell's *On the Banks of the Loing* was banished to the national pavilion, away from both the primary exhibition and the international audience (fig. 77). Picknell, who had lived in Moret-sur-Loing near Fontainebleau until shortly before his death in 1897, had enjoyed

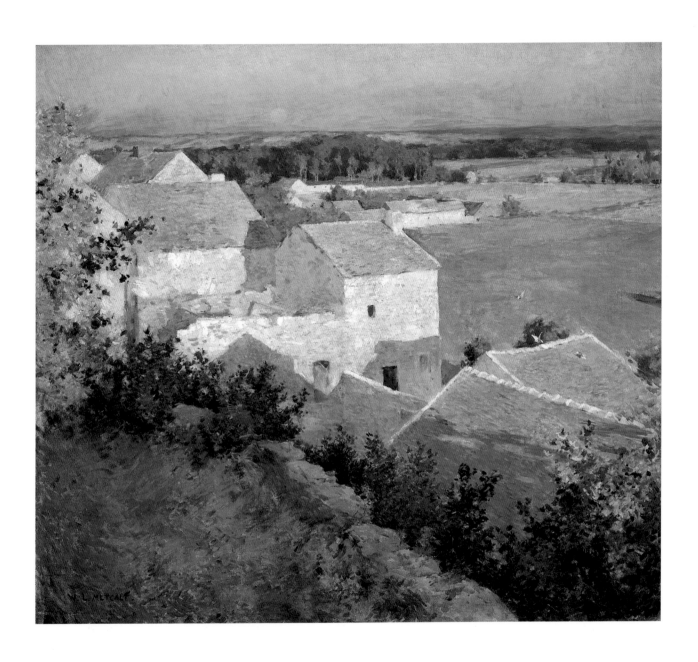

76. *Willard L. Metcalf, *Midsummer Twilight*, ca. 1890, oil on canvas, 32 1/4 x 35 5/8 inches. National Gallery of Art, Washington. Gift of Admiral Neill Phillips in memory of Grace Hendrick Phillips.

77. (*below*) William Lamb Picknell, *On the Banks of The Loing*, ca. 1895, installed in the U.S. National Pavilion, Paris Exposition, 1900. From Archives Nationales, Paris.

success as a Salon painter. However, by 1900, this deceased expatriate's academic painting of foreign land was easily expendable from the American installation.

Regarding "alien" scenery, Clarke reasoned that an American artist "may paint brilliant canvases that please for an hour, but in interpreting foreign scenes he must needs look through alien eyes, and his pictures will likely be characterized by lack of sympathy and truth."[109] Clarke's conviction that an artist must paint familiar subjects in order to be "honest" echoes often repeated Ruskinian and realist precepts, but with an added sense of nativism.

NATIVE SOIL

In contrast to the foreign landscapes, American scenes such as Theodore Robinson's *Port Ben, Delaware and Hudson Canal* (fig. 78), which represents a specific

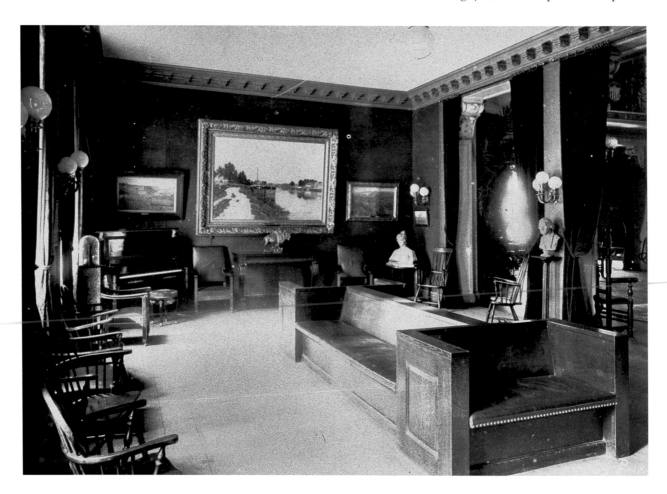

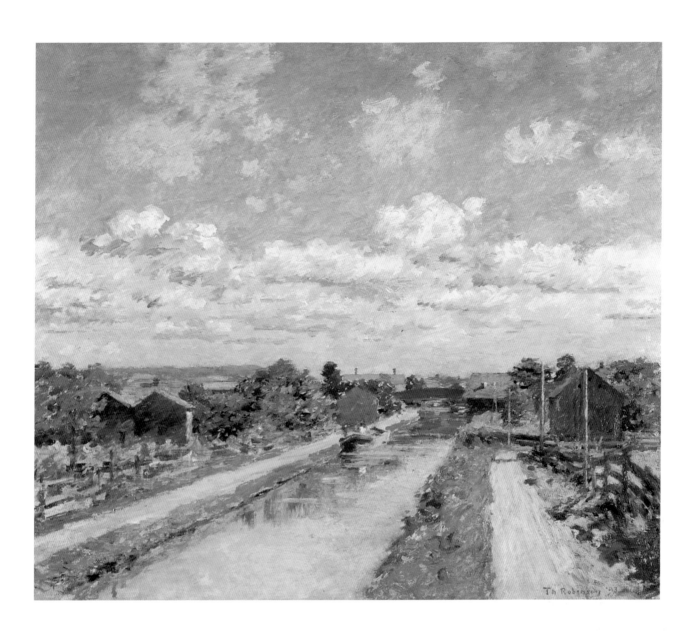

78. *Theodore Robinson, *Port Ben, Delaware and Hudson Canal*, 1893, oil on canvas, 28 1/4 x 32 1/4 inches. Courtesy of the Pennsylvania Academy of the Fine Arts, Philadelphia. Gift of the Society of American Artists as a memorial to Theodore Robinson, 1900.5.

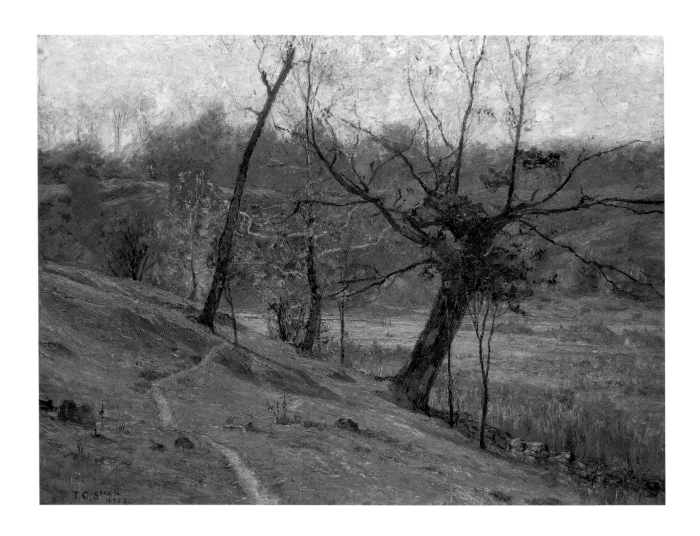

79. *Theodore Clement Steele, *Bloom of the Grape,* 1893, oil
on canvas, 30 1/4 x 40 inches. Bequest of Delavan Smith,
Indianapolis Museum of Art.

location in the Catskill Mountains, functioned as patriotic symbols. When it opened in 1828, this canal celebrated American technology, yet by 1900 it would have been viewed nostalgically for it already represented an obsolete mode of transportation. Because Robinson had been searching for American subject matter when he repatriated in 1892, the nationalistic content was intentional, and could have been inspired by his friend Claude Monet, whose allegiance to the French landscape in the 1890s was pronounced.[110]

Theodore Steele's *Bloom of the Grape* (fig. 79), an autumnal scene along Indiana's Muscatatuck River, likewise venerates native land.[111] In 1900, Steele was the lone representative of the Hoosier School of impressionism, which had been so admired in Chicago only seven years earlier. Along with some figure paintings, these landscapes were among the relatively few examples of impressionism at the exhibition. This was surprising because Americans had domesticated impressionism by

80. *George Inness, *The Clouded Sun*, 1891, oil on canvas, 30 1/8 x 45 1/4 inches. Carnegie Museum of Art, Pittsburgh. Museum purchase, 99.9.

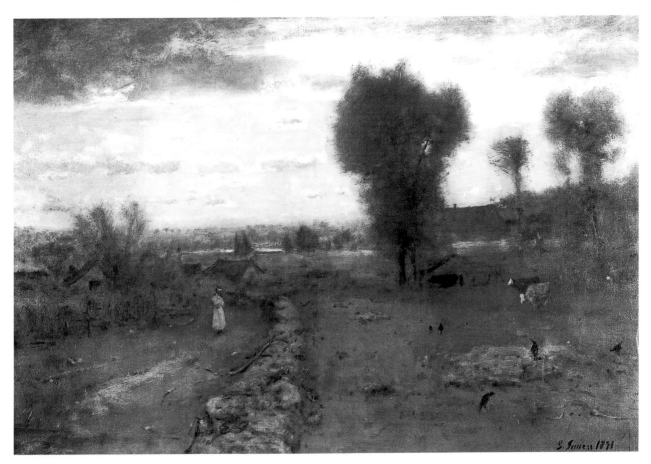

the 1890s, both thematically and stylistically—primarily by ignoring the French avant-garde's obliteration of form—and it continued to be popular until the first world war.[112]

Instead, the preferred tendency for landscapes in 1900 was tonalism, which was considered to be an American invention.[113] While not immune to impressionist and realist influences, many of the landscapes in the exhibition were primarily tonalist; they were muted in color and refined but not belabored in terms of execution, and furthered the tendencies of the Barbizon School and Whistler.

The exemplar of tonalism was George Inness. Although he was a contemporary of the earlier Hudson River School generation, Inness had never truly adopted wide angles or minute details when they were fashionable. Rather, inspired by the old masters and the Barbizon painters, Inness seemed incurably European to mid-century American critics. Inness's reputation began to improve around the time he participated in the Paris exposition of 1878. By 1889, the exposition committee exhibited an Inness, despite the artist's protest, which revealed his rising importance to national culture.[114]

Paradoxically, when the exposition of 1900 opened, the now deceased Inness was, as one critic elucidated, "canonized as the patron saint of our American landscape art."[115] For Cauldwell, "the three powerful paintings [at the exposition] by this master's hand were potent factors in creating a real appreciation of our art which is now entertained by critics of other nations."[116] With its overall gray-green palette, Inness's *The Clouded Sun* (fig. 80) was the perfect model for Cauldwell's gallery design.

Inness's late works from the 1890s belong to his tonalist style and are nationalistic in a number of ways. Although exact sites cannot always be identified, the essence of the American countryside is captured in Inness's poetic paintings. In *The Clouded Sun*, for example, the field with trees, farm structures, stone wall, and cattle, would have provided a spiritually renewing and nostalgic site reminiscent of the northeastern United States.

Patriotism was also conveyed in terms of the mood a landscape elicited. Elizabeth Pennell regarded *Sunny Autumn Day* (fig. 81), for example, as being more optimistic than its French counterparts.[117] The connection between the sunshine and hope for the future is apparent. However, on a deeper level, Inness's self-proclaimed "civilized" landscapes, in which nature and culture are carefully balanced, straddle the "savage" panoramas of the Hudson River School and future Ashcan realist depictions of the "decadent" city.[118] These paintings, such as *The Mill Pond* (fig. 82), which contain mere hints of industry (the tiny mill in the background), seem to illustrate the United States in its "youthful" phase of Empire on the brink of consummation. The implication is that the United States, no longer a wilderness frontier, is sufficiently evolved to have its own culture. Furthermore, Inness's very modern flattened forms transform the three-dimensional reality of the American soil into a two-dimensional realm, evoking the afterlife of Swedenborgianism, the Protestant sect to which the artist belonged.[119]

In Hudson River School paintings, the Creator's presence had been implied by what was in essence a "God's-eye view," affirming that the United States was blessed with a manifest destiny to conquer the continent.[120] However, in Inness's late paintings, which coincided with the closing of the frontier, God's beneficence upon the nation was replaced by an infiltrating celestial light.

For Inness and his colleagues, ignoring details also meant abandoning French academic realism as practiced by Picknell. Because these scenes are indistinct, the viewer's imagination fills in the details. When displayed in the federal government's official display at the Paris exposition, Inness's primarily religious intentions assumed political meaning: just as any virtuous Anglo-Saxon woman could potentially become an American Virgin, any "wholesome" American countryside could be idealized as heavenly—the New Jerusalem of Swedenborgianism.

Grouped with Inness by the U.S. Department of Fine Arts at the exposition as the founders of a national art were Martin and Wyant, also recently deceased. Although Martin's *Westchester Hills* and *Newport Neck*

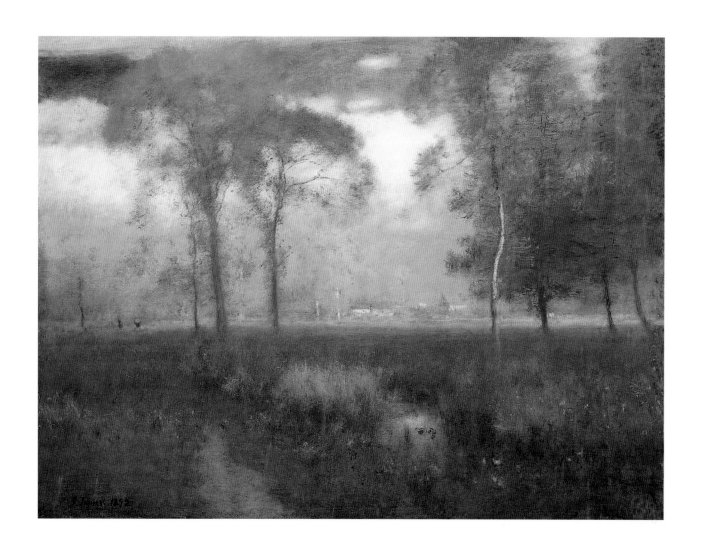

81. *George Inness, *Sunny Autumn Day,* 1892, oil on canvas, 32 x
42 inches. The Cleveland Museum of Art, 1998. Anonymous
Gift, 1956.578.

82 (*facing page*). *George Inness, *The Mill Pond*, 1889, oil on canvas, 37 3/4 x 29 3/4 inches. The Art Institute of Chicago. Edward B. Butler Collection, 1911.30.

83 (*this page*). *Homer Dodge Martin, *Westchester Hills*, n.d., oil on canvas, 33 1/2 x 60 1/4 inches. Collection of Dr. John E. Larkin Jr.

84 (*this page*). *Homer Dodge Martin, *Newport Neck,* 1893, oil on
canvas, 28 11/16 x 45 inches. Fine Arts Museums of San Fran-
cisco, M. H. de Young Memorial Museum. Memorial Gift from
Dr. T. Edward and Tullah Hanley, Bradford, Pennsylvania,
69.30.133.

85 (*facing page*). *Alexander Wyant, *In the Adirondacks,* ca. 1881,
oil on canvas, 43 x 33 inches. Collection of Anthony E. Battelle,
Brookline, Massachusetts.

86. *Leonard Ochtman, *Winter Morning*, 1898, oil on canvas, 30 x 40 inches. Courtesy of Gallerie 454.

87. John Francis Murphy, *Under Gray Skies*, 1893, pastel on paper, 14 x 18 1/2 inches. Indianapolis Museum of Art. Gift of Mrs. E. H. Adriance.

(figs. 83 and 84) have an overall unity, the attention to details, site-specificity, and relatively wide-angled view reveal the artist's connection with the preceding generation. With its more intimate perspective and variegated surface texture, Wyant's *In the Adirondacks* (fig. 85) is more personalized and thus more in tune with modernism.

In 1896, Inness, Wyant, and Martin had been included along with younger artists in the exhibition *American Landscape Painters* at the Lotos Club in New York. Organized by the club's chairman, the collector William T. Evans, this show sowed the seeds for the formation of the tonalist-oriented Society of American Landscape Painters, which held its first exhibition in 1899.[121] In their Parisian debut, the intimate landscapes exhibited by Leonard Ochtman, John Francis Murphy (figs. 86 and 87), and others in this group provided a refreshing antidote to baronial Salon paintings.

Tonalists outside of the Society of American Landscape Painters—such as Henry Gallison (fig. 88), Ben Foster (fig. 147), Charles Warren Eaton, Birge Harrison, and Charles Adams Platt—likewise received critical acclaim as well as exposition medals. Their unassuming canvases, which had been so popular a century ago, are the most difficult to locate today, due to their often inexplicit titles and subjects. Among the most recognized of these tonalists is Ralph Blakelock, who won his only award ever in 1900 for a work simply entitled *Landscape.* Typically, Blakelock's canvases of the 1880s and 1890s were laden with dark tones and layers of paint and glaze (fig. 89), characteristic of the Barbizon School.[122] Unlike the majority of artists at the time, the spontaneous and emotional Blakelock was essentially self-taught. Thus, his unconstrained painting seemed freer, and therefore more American, than the more disciplined brushwork of

academically trained artists. Along with Eakins, Homer, and Ryder, Blakelock—a specialist in native landscapes and Native American themes—would later be erroneously heralded as being untouched by French art.

When comparing Blakelock's work with that of expatriates such as Picknell, for example, it becomes clear that American landscapes in 1900, like figure painting, relied on a variety of strategies. Often, the style in which the painting was executed reflected where the work was created—with academic realism and impressionism preferred in France, and American impressionism and tonalism prevalent in domestic scenes. By the turn of the century, regional approaches to the American

88. *Henry Gallison, *Grey Day,* ca. 1898, oil on canvas, 35 x 45 inches. Private collection.

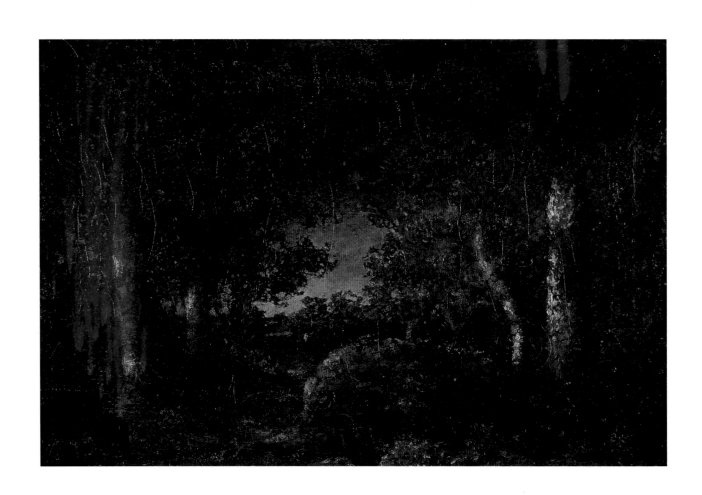

89. *Ralph Albert Blakelock, *Woods at Sunset*, n.d., oil on canvas, 16 x 24 inches. The Montclair Art Museum. Gift of William T. Evans. The painting Blakelock actually exhibited at the Paris Exposition, 1900, has not been confirmed.

landscape were developing throughout the nation—for example, in Old Lyme, Connecticut, and in New Hope, Pennsylvania.[123] In colonies such as these, artists generally shared both thematic and stylistic tactics, thus giving the local land a consistent artistic "look." However, while paintings of the American land expressed nationalism like no other subject, they were closely rivaled by other works portraying places—seascapes and cityscapes.

Seascapes

In comparison to landscapes, seascapes generally provide fewer visual clues that identify specific locations, making nationalism less of an issue in many cases. None of the four paintings that Alexander Harrison exhibited in 1900, including the nocturnal seascape *Le Crépuscule* (fig. 90)—most likely depicting the coast of Brittany—are identifiably French. Because of this, and because of his non-academic approach, the critic Royal Cortissoz did not consider Harrison "hopelessly French."[124]

However, seascapes created by stateside artists—presumably rendering U.S. waters—were considered patriotic for representing "the new naval power of the west," whether they were site-specific or not.[125] One reviewer

90. *Alexander Harrison, *Le Crépuscule, (Twilight),* 1899, oil on canvas, 27 3/4 x 57 inches. Courtesy of Mr. Graham Williford and Federal Reserve Board, Fine Arts Program.

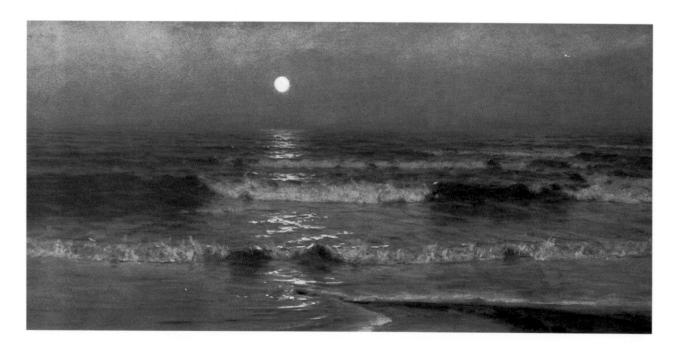

91 (*this page, below*). *Winslow Homer, *Maine Coast*, 1895, oil on canvas, 30 1/4 x 44 1/4 inches. The Metropolitan Museum of Art, New York. Gift of George A. Hearn, in memory of Arthur Hoppock Hearn, 1911.

92 (*facing page, top*). *Winslow Homer, *Nuit d'Eté (Summer Night)*, n.d., oil on canvas, 18 x 24 inches. Musée d'Orsay, Paris.

93 (*facing page, bottom*). *Winslow Homer, *Summer Night— Dancing by Moonlight*, n.d., oil on canvas, 18 x 24 inches. Collection of Dr. John E. Larkin Jr. This is a study for figure 92.

pointed to the specificity of the rocks and rushing breakers in Winslow Homer's *Maine Coast* (fig. 91) for displaying a "most virile"—and thus impliedly American—"technique."[126] Likewise, the illustrator Francis Hopkinson Smith rhapsodized that *Maine Coast*

> . . . could have kept an American bareheaded for hours if he had enough red corpuscles running through his veins to set his heart tingling when his eye lighted on some master-effort of his country- man. If there was another landscape in the Exposi- tion expressing more power, truth, beauty and poetry. . . I could not find it.[127]

Presumably, patriotism for Smith was expressed through the combination of power and truth (through the paint- ing's straightforward realism) and beauty and poetry (by its reductive palette, composition, and mood, which relate to tonalism). Thus, the work of this sixty-four-year-old

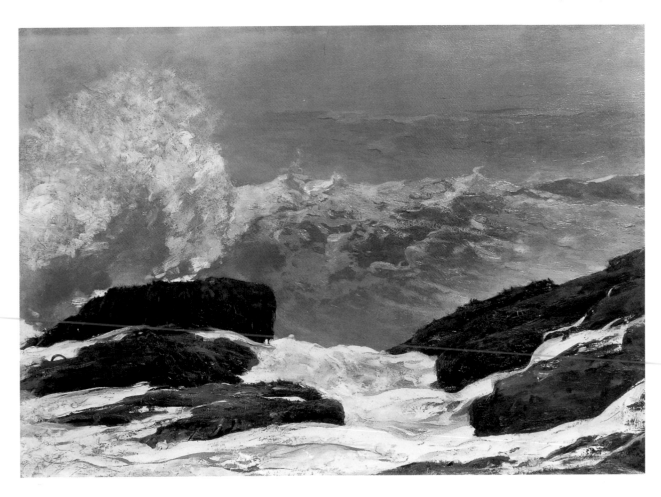

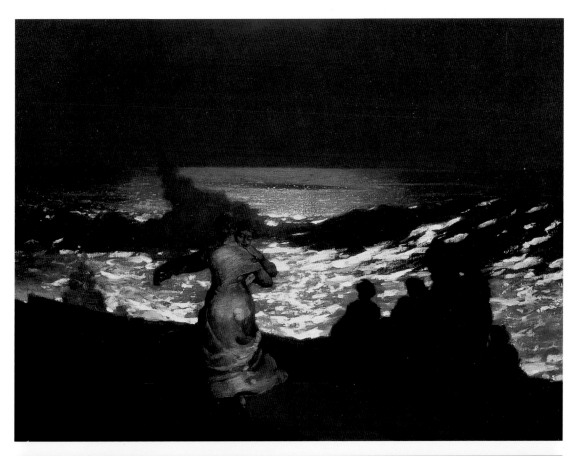

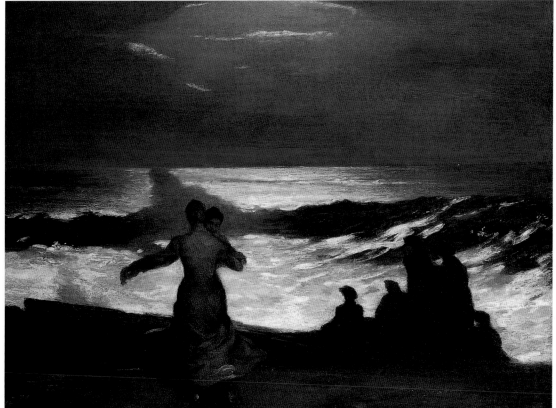

94. *Winslow Homer, *Fox Hunt*, 1893, oil on canvas, 38 x 68 1/2
inches. Courtesy of the Pennyslvania Academy of the Fine Arts,
Philadelphia. Joseph E. Temple Fund, 1894.4.

artist, who had not studied formally abroad, seemed especially effective as a remedy for the residues of foreign training and expatriation.

Yet not even Homer was immune to foreign influences. Although the inspiration for *Nuit d'Eté* (figs. 92 and 93) was the shore near the artist's home in Prout's Neck, Maine, its mysterious moonlit glow and ominous figures in the middle distance link it with an international millennial tendency toward introspection, typified by Edvard Munch's *Dance of Life* (1899-1900, Nasjonalgalleriet, Oslo).[128] Obviously, *Nuit d'Eté* is not a pure marine painting: in this canvas featuring the sea, the land, and figures, artistic genres merge.

Other hybrid or less represented genres at the exposition deserve mention. Homer's *Fox Hunt* (fig. 94), for example, is basically an animal painting within a snow-covered American landscape. In contrast with the 1889 exposition, in which *animalier* themes of the academicians and Barbizon farm subjects proliferated, *Fox Hunt* stands out as a rare depiction of animals in 1900. Another type of painting, still life, was also not well represented in the exhibition. Conspicuous among only a

95. *William Merritt Chase, *Big Brass Bowl*, ca. 1899, oil on canvas, 35 x 40 inches. Indianapolis Museum of Art. Anonymous gift.

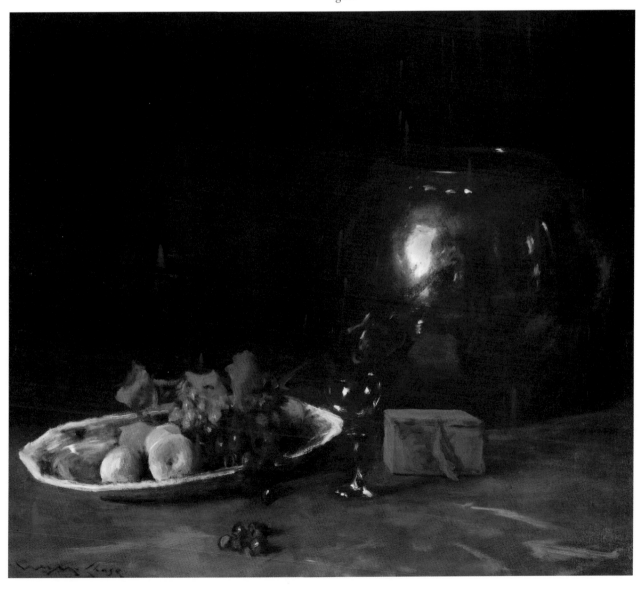

handful of still lifes, which were mainly contributed by lesser-known female artists, was Chase's *Big Brass Bowl* (fig. 95).

Cityscapes

Another relatively uncommon artistic genre in the American decennial was the cityscape. However, more than humble animal paintings or still lifes, the cityscape communicated nationalism on a grand scale. Cityscapes had been part of the topographic landscape tradition in the eighteenth century, then became popular with French realists at mid-century and with the impressionists in the 1870s. Whistler also executed urban themes in the late 1850s, while Chase, Hassam, and other American impressionists adopted the city as a motif in the 1880s.

Nevertheless, the cityscapes shown in 1900 transmitted a new message: the United States's passage from an agrarian to an industrial nation—the "consummation" of Empire—on the brink of a new century. These urban sites looked especially novel in the middle of Paris. Nothing in the French decennial, the fairgrounds, or even in Paris itself rivaled the dynamism of the American metropolis.

Hassam's *Fifth Avenue in Winter* (fig. 96) is animated with street cars and pedestrians in the bustling New World business center. Nonetheless, as exemplified in this canvas, artists frequently aestheticized the city with atmospheric effects. Like Alfred Stieglitz's circle of pictorial photographers, American painters in 1900 could not yet bear to reflect the imperfections of the city; they had to soften the focus. The ideal American city was also often sanitized with a covering of white snow, connoting the purity of the nation. Indeed, Pennell found snow scenes such as Hassam's equal to Inness's landscapes in terms of communicating individuality and thus Americanness.[129]

A few paintings in the exhibition (including Charles Austin Needham's unlocated *Park Snows*) depicted skyscrapers—American inventions—symbolic of the national genius.[130] However, in the decennial, Yankee ingenuity was most explicit in Henry Ward Ranger's *Brooklyn Bridge* (fig. 97). When it was completed in 1883, the East River bridge—connecting Manhattan and Brooklyn—was the longest suspension bridge in the world, and it transformed New York into a megalopolis. Like the bridge, with its steel cables and Gothic towers, Ranger's tonalist painting is a symbol of modernity in an antimodern style. Well into the twentieth century, the bridge continued to function as an icon as well as an inspiration for artists. As the painter Joseph Stella later explained, "it impressed me as the shrine containing all the efforts of the new civilization of AMERICA."[131]

Ranger's painting anticipated Hartmann's essay, "A Plea for the Picturesqueness of New York,"[132] published in the fall of 1900, recommending the city as a viable subject for art. Although still veiled in a tonalist mist, urban subjects such as Ranger's *Brooklyn Bridge* paved the way for the unflinching realist themes of the so-called Ashcan School less than a decade later.

As illustrated by works ranging from Weeks's *Pharaoh* to Ranger's *Brooklyn Bridge,* American paintings in the decennial of 1900 cannot easily be codified, as the artists embraced a wide variety of themes and styles. While at times the work of artists at home and abroad is indistinguishable, largely due to their shared knowledge of French technique, a definite shift had occurred since the 1889 exposition away from conventional European subjects toward expressly American ones.

Moreover, many of the paintings selected for the exposition imaged "America" in an idealized, sometimes politicized manner. This composite portrait of the United States was assembled by an elite segment of society—artists, administrators, critics, and collectors—devoted to establishing an explicitly national art. By suppressing the still influential expatriates, this outspoken group convinced fairgoers that American art was more nationalistic than it actually was.

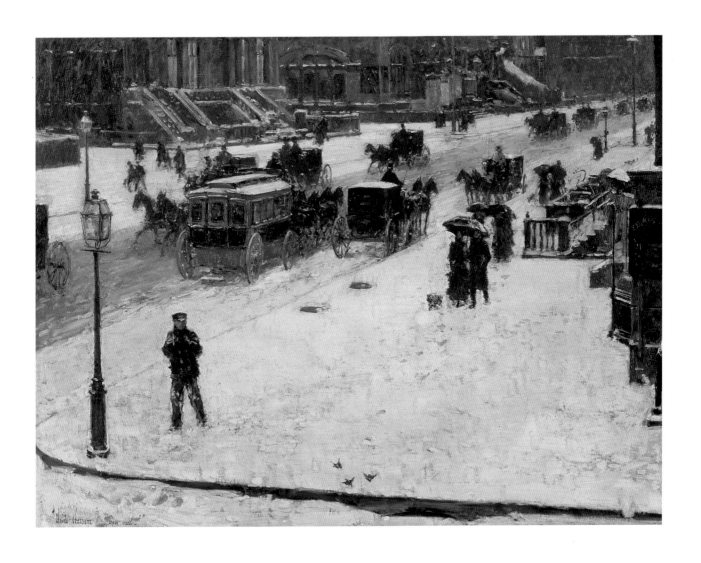

96. *Childe Hassam, *Fifth Avenue in Winter,* ca. 1892, oil on canvas, 21 5/8 x 28 inches. Carnegie Museum of Art, Pittsburgh. Museum purchase, 00.2.

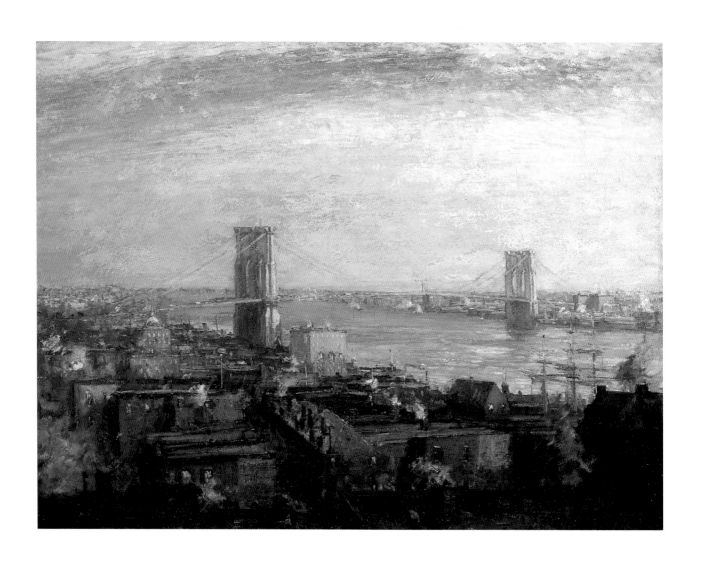

97. *Henry Ward Ranger, *Brooklyn Bridge,* 1899, oil on canvas, 28 1/2 x 56 inches. The Art Institute of Chicago. Gift of Charles L. Hutchinson, 1925.720.

Evaluating Success

The exhibition's success was immediately measured by the criticism and awards the artists received. Especially encouraging was the unprecedented approval of French art officials and critics, which Gabriel P. Weisberg analyzes elsewhere in this book. However, in a more subtle way, the third faction of the French establishment, the academicians, also helped to endorse the fledgling *Ecole américaine.*

With 114 medals in all of Class 7, Americans—as they had in 1889—again outclassed everyone except the French, who received 522.[133] It is not surprising that the French hosts, who comprised over half of the international class jury, retained most of the prizes for themselves. However, this jury, which was presided over by Gérôme, included many former teachers of the Americans, who regularly helped their students win prizes.[134] Indeed, only a handful of the medalists, notably Homer, Abbey, and Alexander, had not studied formally in Paris.

As in 1889, the United States earned two grand prizes for painting, this time for the work of the cosmopolitan luminaries Whistler and Sargent. Five "American Americans," Homer, Beaux, Brush, Chase, and Thayer, but only two expatriates, Abbey and Alexander, received gold medals. Most of the silver and bronze medals were also won by artists living in the United States. Unlike the higher levels of awards, the honorable mentions were selected by Millet (one of only two class jurors assigned the United States), who also favored native artists.[135] In total, the resident painters garnered more than two-thirds of the awards. In contrast, many expatriates—such as Melchers, Knight, Weeks, Stewart, and Dannat—who regularly won prizes received nothing. Thus, the French academicians who dominated the jury paradoxically supported an American art movement intent on supplanting them.

Shifting Relations with France

French approval of American art coincided with American disillusionment with French culture. With its financial and political woes, and particularly with the Dreyfus Affair, France no longer seemed capable of cultural infallibility. Furthermore, because impressionism and post-impressionism were omitted from the conservative French decennial, the picture of Gallic art was so skewed that Pennell observed, "There are no signs of new movements, no daring departures, no gay proclamations of rebellion," concluding that the 1890s was actually a decade of "much needed rest" for the French.[136]

Even worse, many paintings in the French decennial seemed to validate that country's alleged degeneration, with themes including "the sordid, the pathological, the pestilential, and even the infernal."[137] The American critic Roger Riordan was particularly disturbed by the cannibalistic motif in Francis Tattegrain's monumental *Les Bouches inutiles, siège du Château-Gaillard, 1203* (fig. 98).[138] Repulsive subjects such as this were nowhere to be found in American art, even in the work of the expatriates. It was Walton, however, who summed up the new antiacademic sentiment most succinctly:

> From Paris, the source of artistic light twenty-five years ago, the sceptre seems to be surely departing,—the most fervent of the élèves of the Ecole des Beaux-Arts of that period, now return to shake their heads mournfully over the thinness of the Salons and the decadence of Carolus[-Duran] and [Léon] Bonnat.[139]

Walton's remarks concur with evolutionary theories professing United States ascension and European decline.

Even studying in Paris was newly discouraged. In his final report to Congress on the exposition, Cauldwell explained, "To-day we have many well-equipped institutions in which the student can develop an artistic temperament. . . ."[140] Caffin likewise insisted, "If the student still needs to finish his course in Paris, which at

least is questionable, let him hasten home again as soon as he has perfected his craftsmanship. For the influence of Paris today is devitalizing, except to the strongest individuals."[141]

Despite these prevailing attitudes, the artists who were based in Paris played a crucial role in forming a national school. As members of the international art community, they had not only prepared the world to embrace American art, but they also had the clout to request additional space and win the nation's two grand prizes for painting. Without them a worldly wise "American School" could not exist; exhibiting only native landscapes and figures would have smacked of a provincialism inconsistent with the imperial image the administrators desired. Interestingly, many American artists remained abroad until World War I, notwithstanding the harsh criticism they received at the exposition.[142]

Defining the "American School" of 1900

In light of these crucial contributions by artists residing in Europe, the perimeters of the "American School" had to be flexible. Although Inness had epitomized national art for the McKinley administration, via Cauldwell, there really was no one single master or mandatory style among the Americans, meaning that there was no "School" in the traditional sense. Rather, those who defined the new art drew precisely upon its diversity. Americans, it seemed, absorbed the best elements from the greatest civilizations (in order to transcend them), which was understandable since they had traveled widely for inspiration. Just as the nation was composed of immigrants from many foreign lands, so American art thrived precisely because it was a veritable melting pot, able to accommodate not only the native Inness and Homer but also the urbane Whistler and Sargent. Whoever and whatever was usable in the construction of an "American School" was invoked.

Within this jumble of personalities, subjects, and styles, critics eager to establish cultural independence from Europe identified certain traits as typically American. Caffin, himself a naturalized American from Britain, defined the "national characteristics" as "sincerity, wholesomeness and pursuit of perfection; tending towards an art which is elevated in feeling, reticent, and earnest. . . ."[143] Cortissoz discerned "freshness and sincerity," and "sanity as well as vigor."[144] The Frenchman Georges Lafenestre concurred, claiming "the common character . . . is energy, sanity and intensity of impression, by very simple and clean expression," and added, that "the dilettantism of the old world, myth, religion, and fantasy, do not have a large place in the new world."[145]

Indeed, subject matter became the most essential component of the new national school of 1900—found in paintings of America's pure women, innocent children, strong men, and terrain full of potential. Landscapes, associated with American art since the 1820s, were regarded the most patriotic. As Elizabeth Pennell, who was based in England, stated, "But when all is said, it is not in the portraits that the originality of the American artist is revealed. What strikes me most is the fact that an entirely new school of American landscape has sprung up in America."[146] To a generation of artists who generally did not receive formal instruction out of doors, landscapes would have seemed less academic, and thus less European, than figure painting. Even though critics generally avoided stylistic labels, technique also helped to determine a painting's Americanness. A "wholesome" look was not achieved with slick academic dexterity, which Caffin labeled a "drug in the market."[147] Rather, loosened brushwork—as revealing of an individual personality as handwriting—was preferred. Obviously, academicism was the least nationalistic tendency.

Impressionism, which was popular in America at the time, was also considered too foreign to represent the national school. For although that style had abandoned academic rigidity and had been Americanized, it still had Gallic roots in the works of Claude Monet and Pierre Auguste Renoir of the late 1860s. Furthermore, the French Republic had finally sanctioned impressionism as its own at the exposition: although omitted from

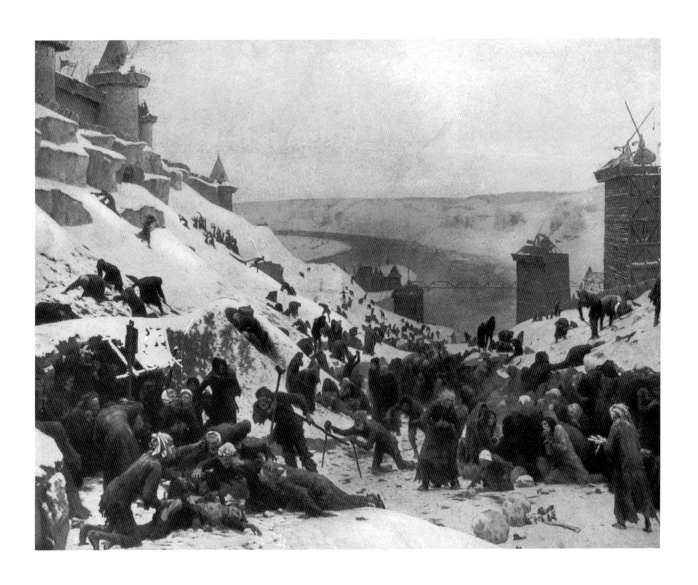

98. Francis Tattegrain, *Les Bouches inutiles, siège du Château-Gaillard (Useless Mouths, Siege of Château-Gaillard), 1203*, ca. 1896, oil on canvas, 16 feet 2 inches x 25 feet 2 inches. Musée des Beaux-Arts, Nantes. *Paris Exposition Reproduced from the Official Photographs Taken Under the Supervision of the French Government for Permanent Preservation in the National Archives.* The R. S. Peale Co., 1900.

their restrictive decennial, it was featured in the more liberal centennial display.

With its origins in mid-century France, realism was also not endorsed by Cauldwell as the primary style of the American School. It was also too brusque to project the desired "civilized" image of the United States in 1900. However, realism had been domesticated in the work of Homer and Eakins and was praised by reviewers for its sincerity. Cauldwell singled out Homer as one of the "strongest and most distinctively national painters, as well as the most individual" living artist following the deceased Inness and Martin.[148] As a purportedly "styleless style" (devoid of stereotypically European excesses), it was realism that was to become the standard of Americanness in the twentieth century.

Clearly, the favorite tendency among American officials and critics alike at the exposition was the native-born tonalism. This approach was embraced by "over-civilized" urbanites such as Cauldwell for its escapist qualities.[149] Additionally, many of its patrons, again, like the New Yorker Cauldwell, were McKinley Republicans. Befitting this administration, tonalism was both international (like Whistler), and national (like Inness). It was also perfectly refined. As one critic, who correlated McKinley's military victory with the battle for culture, announced, we are "not fighting the Philippinos but the Philistines."[150] Tonalism was thus the appropriate style to represent the United States at the exposition.

Despite such strong opinions, style still deferred to subject matter, and at times was even deemed expend-able. As Pennell saw it, domestic artists "do not strive after technical eccentricity, they make no attempt at classicism, at what is called impressionism, or any other ism, except Americanism."[151] This imperious statement presumes that American art had not only shed its reputation as an "annex" of the French—by no longer depending on its styles—but had also achieved a sufficient status of its own.

Although the cultural construction called the "American School" triumphed in 1900, it was almost as ephemeral as the exposition itself. Within a decade, the nineteenth-century themes and styles which defined it seemed old-fashioned. As a result, the exposition has long been overlooked as an event in the annals of art history.

Regardless, the Paris Exposition of 1900 did constitute a milestone for American art. By advancing both cultural nationalism and anti-academicism, it functioned as a bridge to the next century, anticipating both urban realism and modernism.[152] Thanks to the efforts of their predecessors in competing with Europe, Americans after the turn of the century were secure enough to participate in the international avant-garde. Ultimately, however, the exposition helped sow the seeds for New York to displace Paris as the center of the art world, fulfilling predictions made around 1900. Indeed, when European artists, seeking political freedom during World War II, themselves expatriated to the United States, they encountered a climate that was more than ready to embrace them and their art.

LINDA J. DOCHERTY

Why Not a National Art?: Affirmative Responses in the 1890s

Between the World's Columbian Exposition of 1893 and the Paris Exposition of 1900, American art elicited a new level of national enthusiasm and pride. Having demonstrated their ability to compete successfully with Europeans in the cultural arena, artists enjoyed increased opportunities for creation, exhibition, and sales, and participated actively in the promotion and interpretation of their work. Art labeled "American" in this period ran the gamut from allegory to genre, academicism to impressionism, idealism to realism. This multiplicity of expression seemed to exemplify the complex character of the United States. Among artists, critics, and patrons, a collective interest in advancing American art led to inclusivity in cultural self-definition. National art, as a concept, encompassed both the universal and the local.

This unity in diversity was exemplified by the Chicago fair, where classical forms provided a cohesive frame for individual achievement. In the Court of Honor, monumental buildings painted white with a common cornice line contained a dizzying number of agricultural and industrial displays (fig. 99). The

exterior harmony of the architecture belied the competitive spirit that underlay world's fairs in general and American capitalism in particular.[1] As an adjunct to the ensemble, Charles B. Atwood's Fine Arts Building featured paintings and sculptures that varied widely in subject, style, and scale (fig. 100).

American painters made a brilliant showing at Chicago, dispelling the judgment made at the Philadelphia Centennial Exhibition that they were technically deficient.[2] While George Inness and Winslow Homer won praise for their distinctively American points of view, John Singer Sargent, Abbott Thayer, and Edmund C. Tarbell demonstrated that younger artists had assimilated lessons learned in foreign studios. American painters could now draw the figure, handle the brush, and compose a picture on a par with any academician. A comparatively small number of impressionist works in the French section made the Americans appear not only accomplished, but more progressive. Commenting on the variety in the exhibit, critic John C. Van Dyke wrote, "It is these added individualities that produce nationality in art when there is homogeneity in fundamental thought and aim."[3] He anticipated that American life would be a source of collective inspiration in the coming years.

The nationalism generated by the Columbian Exposition signaled the demise of the old genteel tradition. In the years that followed, economic depression attended by images of striking workers, impoverished farmers, and suffering immigrants undermined the ideal vision of harmony and unity it had promulgated. As America divided along its fault lines, it underwent what John Higham describes as a cultural "reorientation."[4] Opposition to the mechanized structures of corporate capitalism sprang up in a variety of quarters.[5] Higham cites specifically "a boom in sports and recreation; a revitalized interest in untamed nature; a quickening of popular music; an unsettling of the condition of women."[6] Intellectual innovators of the period—William James, Frederick Jackson Turner, and Frank Lloyd Wright—refused to be constrained by traditional formulas.

A rising tide of activism and optimism produced a new breed of political leader, who responded to national disunity with a nationalist agenda. The epitome of this type was Theodore Roosevelt, reformer, soldier, and exemplar of "the strenuous life." As a cultural critic, Roosevelt mounted an attack on both base materialism and cloistered intellectualism; as a public servant, he exhorted Americans to meet their challenges head on. "It is only through strife, through hard and dangerous endeavor, that we shall ultimately win the goal of true national greatness," he declared in a speech outlining his credo.[7] Roosevelt scorned the jeremiads of genteel writers who sought to cast American culture in a European mold.

In an 1894 essay, Roosevelt defined "Americanism" as "a question of spirit, convictions, and purpose, not of creed or birthplace."[8] Rejecting invidious comparison to Europe, he claimed that originality, in any form, trumped imitation every time.

> It is precisely along the lines where we have worked most independently that we have accomplished the greatest results; and it is in those professions where there has been no servility to, but merely a wise profiting by, foreign experience, that we have produced our greatest men. . . . On the other hand, it is in those professions where our people have striven hardest to mould themselves in conventional European forms that they have succeeded least.

Speaking specifically of painters, Roosevelt decried the "over-civilized, over-sensitive, over-refined" expatriate who "does not really become a European . . . [but] only ceases being an American, and becomes nothing."[9] True Americans, in his view, were not timid and critical, but courageous and creative.

As proof of what Americans could achieve when they turned their practical genius to artistic ends, the Columbian Exposition was a goad to action. Shortly after the closing ceremonies, Sadakichi Hartmann outlined a proposal for developing American art in the inaugural issue of *The Art Critic*.[10] Hartmann's plan consisted of an organizational network designed to foster

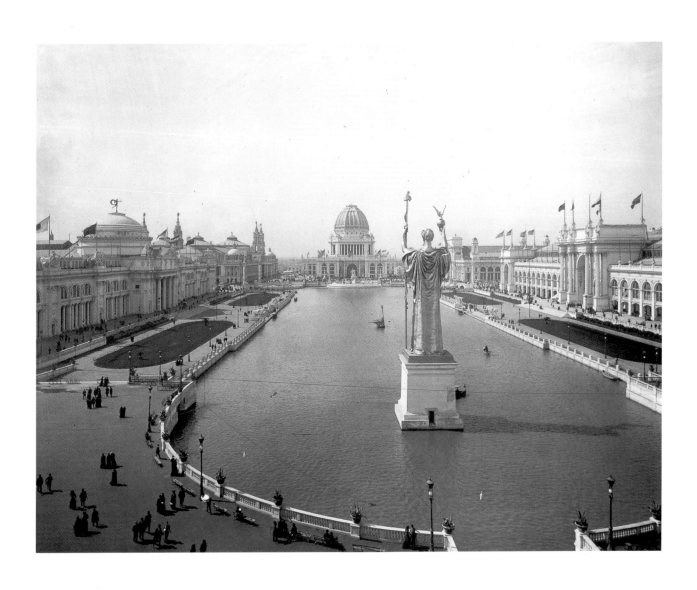

99. *Court of Honor, World's Columbian Exposition, Chicago, 1893.*
View to west past Daniel Chester French's *Republic.* Chicago
Public Library, Special Collections & Preservation Division.

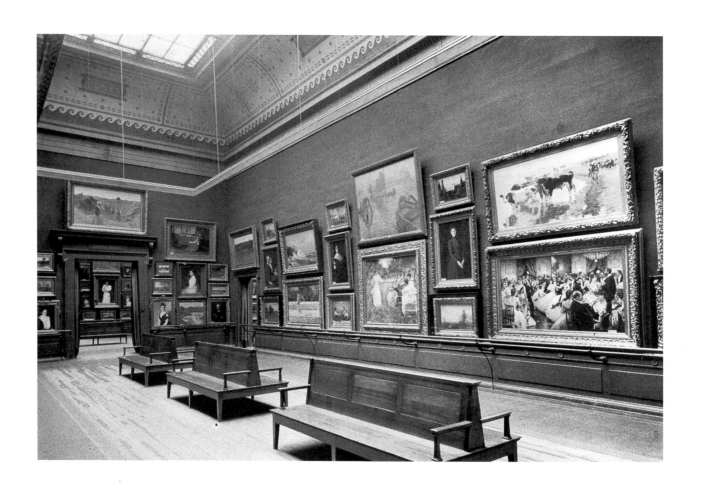

100. *Fine Arts Building, World's Columbian Exposition, Chicago, 1893.* Gallery 3, north and east walls. Chicago Public Library, Special Collections & Preservation Division.

creation and appreciation on native ground. An Art Guild would improve opportunities for social intercourse among artists, advocate for commissions, and maintain a fund for needy members and their families. It would bring art to the people through public education, free exhibitions, and newspaper publicity. A trio of "great art institutions" would provide Americans the means for advancement that Europeans had long enjoyed. An Academy of Fine Arts would offer students free instruction; a National Art Gallery would exhibit works by living artists and award monetary prizes; a Museum of Fine Arts would house a permanent collection of originals and reproductions through which to study the masterpieces of all times.

Hartmann's program for developing a national art was informed by foreign models, but its purpose was to consolidate and elevate New World civilization.

> Let us belong if we will to different creeds, enter-
> tain different political and moral views, different
> ideals for our mental, emotional and physical
> nature, but let us be united in the one effort to ren-
> der our national life richer, purer, and more power-
> ful, by giving to it a National Art.[11]

Like Van Dyke and Roosevelt, Hartmann urged American artists to recognize and celebrate the distinctive beauty of local life. To those in search of literary inspiration, he recommended Whitman (the realist), Hawthorne (the romantic), and Poe (the idealist). The critic simultaneously called upon the public, and particularly the federal government, to support artistic enterprise.

> As long as patriotism is considered an unnecessary
> expenditure of force in times of peace, as long as
> members of Congress can announce in public
> speech that the United States treasury cannot spare
> one cent for the solving of artistic problems, so long
> will foreigners instead of native artists supply our
> artistic demands and the Americans will fall short
> of being a really great nation.[12]

Insisting that the nation could and should satisfy its own artistic needs, Hartmann maintained that self-definition was a determinant of greatness.

While they concurred that American art must break free of European domination, cultural nationalists of the 1890s were broadly pluralistic. Their definition of "nation" was conceived in terms both psychological (by experience) and institutional (by law).[13] Historian Wilbur Zelinsky has shown that American nationalism in the 1890s comprised symbolic memory and nascent statism.[14] The former produced world's fairs, historic preservation, and national parks; the latter a more powerful federal government and a foray into imperialism. The wide variety of artistic expressions acclaimed as national in this period reveals how the construction of America fluctuated in response to an overarching need for cultural legitimation. As the highest achievement of a civilization, art constituted an object of desire for a protean nation that sought to affirm its maturity and distinction.

World's Fairs

The impulse to assign national meaning broadly to artistic achievement informed regional world's fairs organized between 1893 and 1900. While each of these projects featured a U.S. government exhibit, they were financed largely by private investors in their respective states. Like the World's Columbian, these international expositions reified a national ideal of unity in diversity. By promoting communication and understanding among regions, they enlarged the concept of the union.

The Atlanta Cotton States and International Exposition of 1895 and the Tennessee Centennial and International Exposition of 1897 brought the New South to national attention. The former celebrated economic and social progress and potential; the latter gave pride of place to history and art. Following the example of the Columbian Exposition, Nashville's White City featured classical architecture, electric lighting, gondolas, and waterways.[15] Reproductions (varying in scale and accuracy) of famous monuments provided symbolic contexts

for exhibits: the Pyramid of Cheops (City of Memphis, Tennessee), Parthenon (Fine Arts), Erechtheum (State of Tennessee), Andrew Jackson's Hermitage (Women's Building), and Richard Morris Hunt's Administration Building (State of Illinois). The predominance of Greek architecture had both universal and local meaning. In paying homage to classical antiquity, fair designers revived forms traditionally favored in Tennessee.

A replica of the Parthenon, at the center of the ensemble, proclaimed Nashville the Athens of the South (fig. 101). Within the cella, a committee of artists headed by Edwin Blashfield installed one thousand "well-selected pictures" representing many foreign masters and virtually every American of note. Visitors to the Parthenon in its reconstructed state experienced not a partial ruin, but "the full beauty and majesty of its entirety." Rather than attempt to rival the visionary architecture of Chicago, the "plucky Tennesseeans" had brought the most noble of buildings back to life.[16]

Compared to the Columbian Exposition, the Tennessee Centennial was small in scale and provincial in content, yet its display of competence and pride constituted a nationally applicable exemplar. Boston painter F. Hopkinson Smith wrote,

> This is not a National Exposition—it is almost exclusively a State Fair, illustrating what Tennessee has done, can do, and will do. But it has been done so well that its influence must be national, lifting it infinitely above what has been heretofore known as a State Fair.[17]

The Nashville fair also demonstrated the reconciliation that had occurred since the Civil War. In the Tennessee history exhibit, Confederate Veterans, Grand Army of the Republic, Colonial Dames, and Daughters of the Revolution stood united in collective memory. Over the fairgrounds, an American flag flew from a pole made of southern pine and northern steel.

While the Tennessee Centennial symbolized the end of sectional hostilities, the Trans-Mississippi Exposition of 1898 expanded the national consciousness to include the western states.[18] Following an economic debacle wrought by attempts to turn grazing land into farmland, Omaha organizers sought to reassert the region's contribution to American progress and kindle its aesthetic sensibilities. The Trans-Mississippi Exposition also borrowed from Chicago; it achieved distinction by adding color to the exterior decoration and connecting the principal buildings with courtyards and colonnades. An Arch of States crowned by twenty-three coats of arms of western states signified regional unity and purpose. On the side of the arch, arms of the oldest states made the iconography national.

The artistic aspect of the Trans-Mississippi Exposition surprised and delighted many visitors. The Art Building, designed by the St. Louis firm of Eames and Young, consisted of twin pavilions joined by a colonnaded open court. No provincial display, the painting and sculpture exhibit aimed to improve taste and augment knowledge gained previously through magazine reproductions. *Century*'s correspondent explained,

> The purpose . . . is not to exhibit the crude beginnings of Western art to Western people, but rather to utilize the exposition period for the purpose of giving the Western visitor an opportunity to see pictures fairly representative of the best European and American painting.[19]

In a survey of the selections, Bureau of Fine Arts Superintendent A. H. Griffith emphasized the educational function.[20]

The second work illustrated in Griffith's article, *Monarch of the Farm* by William Henry Howe (fig. 102), constituted a convenient blend of technical accomplishment and iconographic interest. He introduced the painter as "one of the very few American artists whose pictures are admitted to the Salon without going before the jury."[21] Howe's privileged status in the European art world no doubt gratified western viewers who would have been attracted personally to his subject matter. Monumental in size and proud in demeanor, the Norman bull was an aesthetic incarnation of the raw material of the cattle industry.[22]

The Tennessee Centennial and Trans-Mississippi

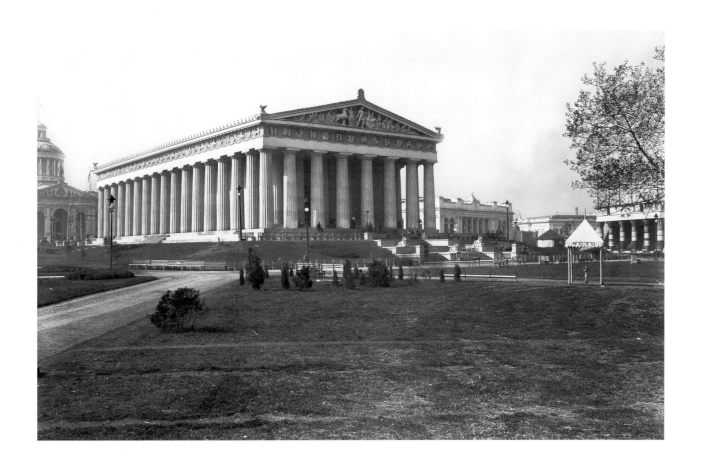

101. Parthenon, Tennessee Centennial Exposition, Nashville, 1897. Smithsonian Institution Archives.

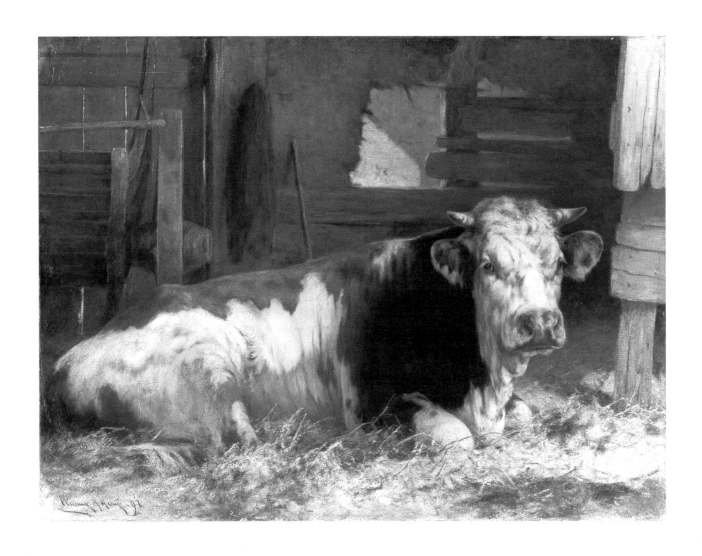

102. William Henry Howe, *Monarch of the Farm*, 1891, oil on canvas, 36 1/2 x 49 1/4 inches. National Museum of American Art, Smithsonian Institution. Gift of Mrs. William Henry Howe.

Expositions enhanced America's concept of itself more than its prestige abroad. Significantly smaller in scale and attendance than the World's Columbian, they highlighted local histories and achievements.[23] Both southern and western states proudly demonstrated their ability to contribute to the nation's material advancement through agriculture, industry, and trade. Both simultaneously promoted cultural development through painting and sculpture exhibits and architectural design. Art was the container, literally and metaphorically, for commerce at the regional expositions of the 1890s. While marginalizing African Americans, Native Americans, and women, they embraced ideals of national harmony and unity.[24]

The American Renaissance

International expositions were temporary productions, but they inspired permanent forms of public art. The premier national project of the 1890s was the Library of Congress, begun in 1888 and dedicated in 1897. This monumental collaboration of American architects, sculptors, and painters constituted an exception to the U.S. government's propensity to decline responsibility for artistic patronage. Costing $6,300,000, the new library included a public reading room, art gallery, exhibition halls, and shelf space for 1,900,000 volumes.[25] In scale, form, and content it embodied American Renaissance ambitions and ideals.[26]

Based on a design by Smithmeyer and Pelz, the building recalled both classical and contemporary architecture. Critic Montgomery Schuyler compared the Italianate façade to Charles Garnier's Paris Opéra, and the domed reading room to the British Library. For Schuyler, however, the distinguishing characteristic of the project was its monumentality.

> The exterior architecture makes its effect, the effect
> of a Roman largeness, power, and durability, and of
> an orderly and coherent design which is also
> Roman, of a national building. In the interior, in

spite of a lavishness of decoration, sculptural and pictorial without any precedent in our national architecture, the source of the impressiveness is equally architectural.[27]

Solid rather than scenic, the Library of Congress evoked the grandeur of imperial Rome.

Edwin Blashfield's colossal mural for the dome of the main reading room portrayed America as cultural heir to all the ages. One hundred forty-four feet in circumference and twelve feet high, *The Evolution of Civilization* consists of twelve winged allegorical figures representative of different countries, epochs, and religions (figs. 103 and 104). The figures sit on monumental thrones with the attributes of their accomplishments, which are inscribed on a painted banderole that runs around the base. Beginning with Egypt (written records), the program includes Judea (religion), Greece (philosophy), Rome (administration), Islam (physics), the Middle Ages (modern languages), Italy (fine arts), Germany (printing), Spain (discovery), England (literature), and France (emancipation). Civilization culminates in America (science), a male figure with the head of Abraham Lincoln who leans pensively over a dynamo at his feet (fig. 104).

While Blashfield's mural associated America with science, the Library of Congress also manifested the nation's artistic power. A team of forty painters and sculptors collaborated on the interior decoration, under the direction of architect Edward Pearce Casey.[28] As the building took shape, critic Royal Cortissoz anticipated it would become "our national monument of art."[29] In praise of the muralists specifically, *Scribner's Magazine* declared,

> They may make of the Library of Congress a
> National Museum where will be preserved for all
> time the best art of which America is capable to-day,
> and they will insure that the progress of the move-
> ment for monumental painting shall be irresistible.[30]

Unlike its forerunner, the Boston Public Library, the Library of Congress featured the work of painters

103. Details of Edwin Howland Blashfield, *The Evolution of Civilization*, 1895–1896. Library of Congress Reading Room, interior of dome. Library of Congress.

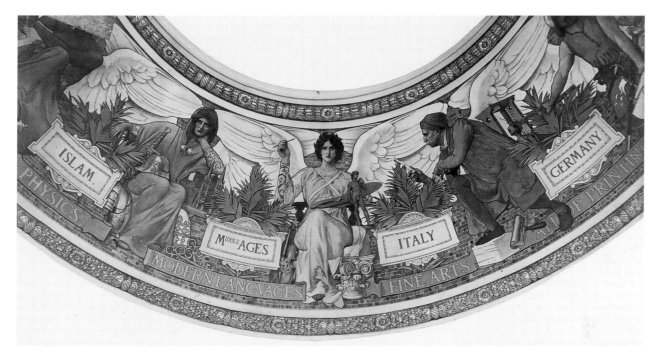

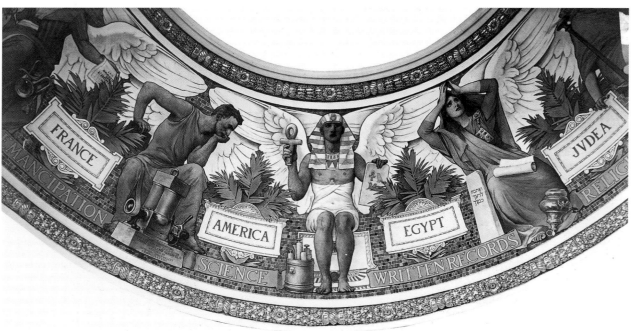

104. Details of Edwin Howland Blashfield, *The Evolution of Civilization*, 1895–1896. Library of Congress Reading Room, interior of dome. Library of Congress.

trained in France, but resident in the United States.[31] *Scribner's* contended further,

> We are convinced, that great decoration can only be painted by Americans, if not living in America, at least in touch with the country, and combining all the technique of their craft with instinctive knowledge of the requirements of the case, and with that subtle harmony with the surroundings that cannot be over-estimated.[32]

According to this reasoning, national sympathies gave Americans an advantage over the most celebrated foreign decorators.

For some art writers of this period, architectural ensembles like the Library of Congress possessed the greatest potential for national expression and influence. Muralist Will H. Low disparaged "the unrelated, detachable work of art" as a phenomenon of the modern age. While easel painting was elitist and rarefied, decorative painting was democratic and relevant. Low wrote,

> The decorator . . . works for the world; his production, no longer conceived for the stifling atmosphere of the studio or gallery, breathes the open air; and art, instead of being as it is too often a thing apart, becomes a portion of our daily life.[33]

To achieve national distinction, Low believed, mural painters must speak to the experience and interests of the American people. He did not rule out classical forms, but opposed reliance on vitiated formulas.

> We painters must leave the commonplace and the trite; we must learn to distinguish in the complex and cosmopolitan civilization, where we find ourselves, the essential qualities which are at once pictorial and national.[34]

By forging a relationship with the public, artists could free themselves from the tastes of individual collectors and gain support from political and business leaders.

A nationalistic alliance of art and enterprise was vividly embodied in the triumphal arch and colonnade built to celebrate Admiral George Dewey's victory in the Philippines (fig. 105). Erected temporarily in New York's Madison Square in 1899, this monumental project extended for two blocks along Fifth Avenue, from Twenty-third to Twenty-fifth Street. The arch itself measured one hundred feet in height, eighty feet in width, and thirty-five feet in depth, including sculpture. Modeled on the Arch of Titus, which commemorates the Roman emperor's destruction of the Jewish temple in Jerusalem, it proclaimed America's new identity as an imperial power.

Conceived and executed in the short span of two months, the Dewey Arch was a tribute to American daring and administration. Although critics detected weaknesses of composition and modeling in the sculptural groups, they praised the overall effect of harmony.[35] Under the auspices of new professional organizations, New York artists had voluntarily assumed responsibility for the monument's design.[36] Architect Charles R. Lamb collaborated with the National Sculpture Society on the arch and colonnade; the National Society of Mural Painters created polychromatic decorations for the houses on the parade route as a counterpoint to classical white.

The iconographic program comprised real and ideal figures honoring the nation's naval history and its recent triumph over Spain. A *Victory at Sea* quadriga crowned the arch; portraits of naval heroes lined the attic; and allegorical groupings adorned the piers.[37] Admiral Dewey appeared twice on the lower level. Charles B. Niehaus's *Triumphant Return*, on the south face, showed him as a victorious sailor being welcomed by his parents. Daniel Chester French's *Peace*, on the north face, featured a medallion portrait of Dewey displayed by a mother as a model for her child (fig. 106). French's group also included a blacksmith and a farmer and his wife, who holds a baby and a lily. American militarism figured in this allegory of peace as the companion of agriculture and industry.

While military victory was the overriding theme of

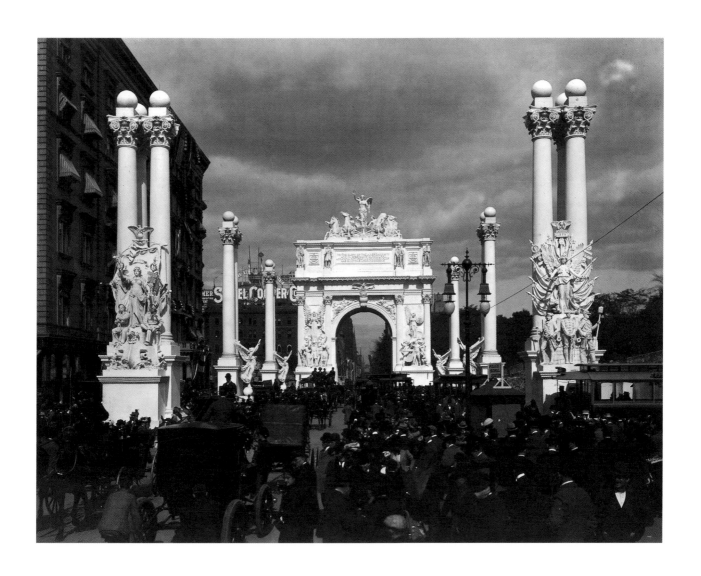

105. *Dewey Triumphal Arch and Colonnade,* Madison Square,
New York, 1899. Library of Congress.

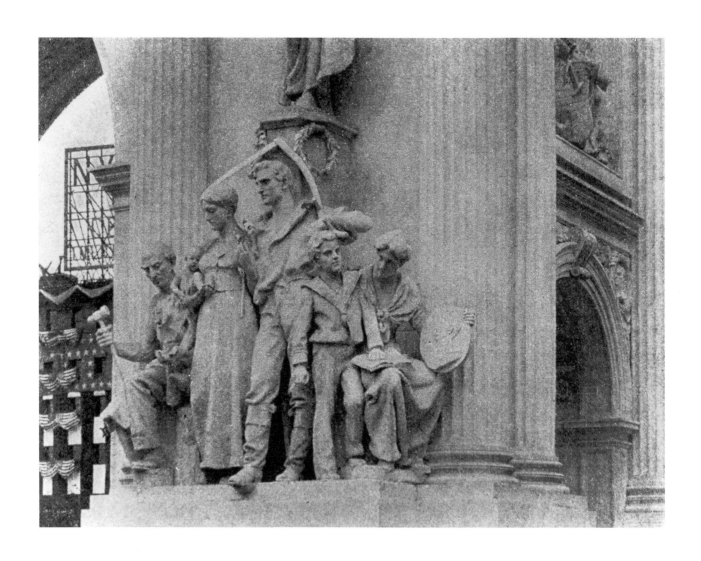

106. Daniel Chester French, *Peace*, detail of *Dewey Triumphal Arch and Colonnade.*

the Dewey Day celebration, political conflict over the Philippines had not subsided in the fall of 1899. The end of the Spanish-American War had exacerbated the rift between expansionists, such as Theodore Roosevelt and Henry Cabot Lodge, and anti-imperialists ranging from Andrew Carnegie to Charles W. Eliot to Samuel Gompers.[38] At issue was the sovereignty of the island country: would it become an independent state or a colony of the United States? Tied to this question was the definition of America: would the nation abide by its philosophical principles or yield to material ambitions?

It was not in politics, but in art that the nationalism of the 1890s produced consensus. Public monuments like the Library of Congress and the Dewey Arch showed how beauty could be achieved when architects, sculptors, and painters worked together for a common end. These collaborative enterprises covered social conflicts and material values with an aesthetic veneer of harmony and unity. Idealistic and imperialistic, they characterized America as a leader in scientific progress and inheritor of artistic tradition.

American Impressionism

Other American artists in this period pursued a nationalistic agenda by more modern means. Eschewing the classical form and allegorical content of the American Renaissance, they drew inspiration from the local scene. The distinctive accomplishments of these painters bolstered John Van Dyke's assertion,

> The chief value of a nation's art, aside from its
> being good art, lies in its nationality, its peculiar
> point of view, its representation of a time, a clime,
> and a people. We shall never have any great art in
> America unless it is done in our own way and is
> distinctly American.[39]

Van Dyke deemed it patriotic to paint American themes from an American perspective.

While they believed that characteristic expression depended on sympathy with local life, writers before the Columbian Exposition tended to bemoan the New World's lack of "artistic atmosphere."[40] Occupied with getting and spending, ordinary citizens had neither opportunity nor desire to cultivate an aesthetic sense. The U.S. government exacerbated this situation by maintaining a punitive tariff on foreign works of art.[41] Throughout the late nineteenth century, American artists flocked to Europe for training and inspiration, sometimes never to return.[42]

After 1893, however, critics began to hold artists as well as government and society responsible for creating an environment favorable to art growth. Sadakichi Hartmann declared, "The everlasting complaint is: There is no atmosphere in America! Pshaw! The true artist creates his own atmosphere wherever he goes."[43] *Scribner's Magazine*, too, would brook no more excuses.

> We cannot expect busy and mercurial Americans to
> adopt the light-hearted and leisurely manners of
> the Old World in order to provide an atmosphere
> for the artists. . . . the matter mainly rests with the
> artists themselves. The atmosphere will come when
> they begin to make it . . . by striking root in the
> American soil, by living in sound artistic sympathy
> with things around them.[44]

The Art Collector rebutted the contention that "art cannot thrive in a trading democracy" by citing the achievements of Florence, Athens, medieval Paris, and Holland. In response to the rhetorical question "Why not a national art?" it claimed the first shoots of an American school were sprouting on native soil.[45]

Hartmann detected the "very faint . . . but palpable" beginnings of a national art specifically in the work of Boston painters. In praise of Edmund C. Tarbell, he cited the artist's truthfulness to nature and sympathy for characteristic scenes.

> His very desire to see things as they really are without emotional or intellectual embellishment, his
> very indifference or incapacity for painting any-

thing except common-places with which he is thoroughly familiar, makes the selection of his subject strictly American.[46]

In Hartmann's eyes, Tarbell's images of modern life showcased recognizably American girls. He described *In the Orchard* (fig. 107), a sunlit scene of bourgeois leisure, as having "a Howellesque flavor."[47]

Tarbell also attracted the attention of Hamlin Garland, for whom the display of American impressionism at the Columbian Exposition had heralded the end of the old pictorial order. The midwestern writer found the new painting distinguished by its naturalism, colorism, and individualism.

> [The impressionist] deals with the present . . . He does not feel that America is without subjects to paint because she has no castles and or donjon-keeps. He loves nature, not history. His attitude toward nature is a personal one.[48]

For Garland, impressionism represented a perception, as opposed to a delineation, of modern life. Its vitality resided not in subject or technique per se, but in the artist's individual vision.

Garland saw "local color" in both art and literature as an expression of national character. Rooted in love for one's native surroundings, this "statement of life as indigenous as the plant-growth," could not be achieved by a mere "tourist."[49] Artists of local color were expressive and alive, not imitative and scholarly. They democratized the definition of beauty and found significance in familiar things. Garland praised local color as "the native element, the differentiating element. It corresponds to the endless and vital charm of individual peculiarity."[50] A product of natural and spontaneous feeling, it achieved distinction through perpetual originality.

Garland's view of impressionism as simultaneously individual and national was manifest in the organization known as The Ten. In 1898, this group of painters, which included Frank W. Benson, Joseph DeCamp, Thomas W. Dewing, Childe Hassam, Willard Metcalf, Robert Reid, Edward Simmons, Edmund C. Tarbell, John H. Twachtman, and Julian Alden Weir, withdrew from the Society of American Artists in response to what they perceived as a lowering of standards.[51] The Ten were not radicals, but established artists who wanted to exhibit under more favorable, and less overtly commercial, conditions. The majority shared academic training and impressionist interest in color, light, and atmosphere.

The Ten appealed to the nationalism of the 1890s by appropriating foreign techniques for native themes. Stylistically, they combined graphic design with broken brushwork and prismatic color; iconographically, they favored traditional aspects of the American scene. Julian Alden Weir's *The Factory Village* (fig. 108), for example, represents a pastoral idyll of rural manufacturing. Behind a foreground of broadly brushed summer foliage, the more firmly outlined mill town appears to coexist peacefully with nature.[52] The *International Studio* praised this picture for its "frank, searching vision which far transcends the befogged scrutiny of the faddist."[53] Rather than imposing French effects on the New England landscape, Weir had achieved a penetrating and personal interpretation.

The exhibitions of The Ten, held annually from 1898 to 1917, featured local subjects seen from individual points of view. Each member displayed his works together in a separate section of the gallery. *The Critic* characterized the group by saying, "They do not propose to merge their individual artistic aspirations in any corporate aim, however exalted. They remain, and are to remain, ten distinct persons."[54] The individualism of The Ten was not, however, strident or competitive; their group shows also revealed the influence of aestheticism. Pictures were hung sparingly, against a harmonious wall color, with an eye for complementary relationships. The result was a remarkable effect of unity.

Artistic more than patriotic purposes underlay the formation of The Ten, but their interest in American themes lent itself to nationalistic interpretation. Their paintings combined sound technique, characteristic of the Society of American Artists, with freshness and vitality of perception. American impressionists exemplified Van Dyke's concept of a distinctive school of art

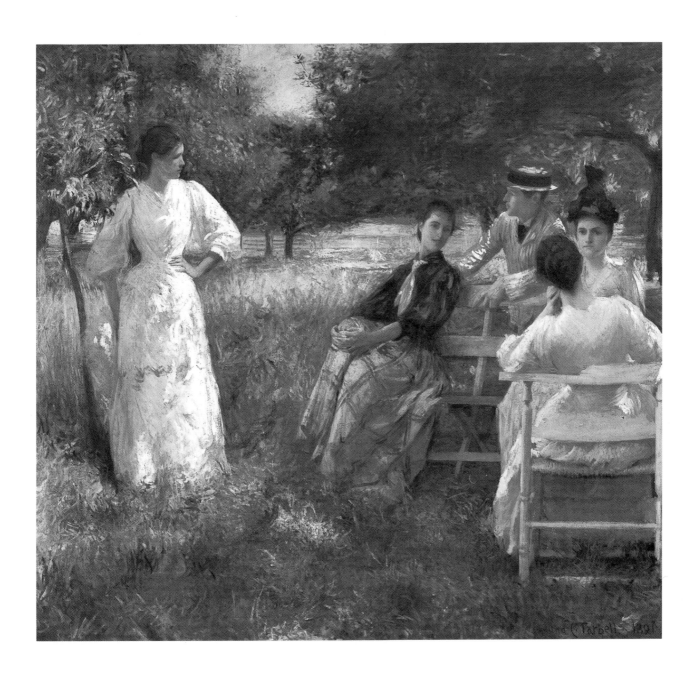

107. Edmund Charles Tarbell, *In the Orchard*, 1891, oil on canvas,
60 3/4 x 65 1/2 inches. Daniel J. Terra Collection, 1.1992.

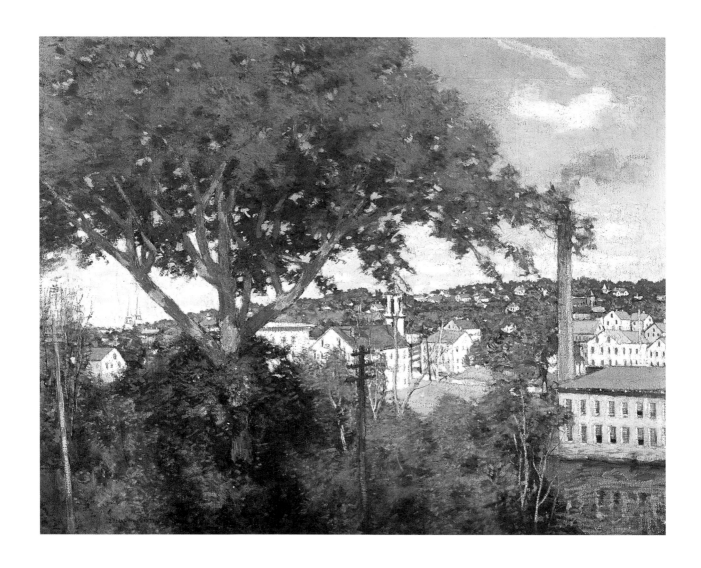

108. Julian Alden Weir, *The Factory Village*, 1897, oil on canvas, 29 x 38 inches. Jointly owned by the Metropolitan Museum of Art and Cora Weir Burlington, 1979.487.

founded on "added individualities" and attachment to local life. The financial success the group enjoyed for twenty years bespoke the growing power of American artists to create their own art atmosphere.

Museums, Galleries, and Collectors

While support for American artists increased in the 1890s, the general public remained comparatively ignorant of, or indifferent to, their progress. After the Centennial Exhibition, American collectors had evinced a decided preference for European work, which had, in turn, influenced museums and galleries. Isolated efforts were made to encourage home production, and by the end of the century a canonical group of native masters had emerged. George Inness, Alexander Helwig Wyant, Homer Dodge Martin, and Winslow Homer rivaled foreign accomplishments with a distinctive brand of poetry.[55]

First singled out by critics and collectors, these older painters, along with the younger impressionists, received institutional recognition in the 1890s as museums began to build American collections. A primary instrument of this process was an annual exhibition of contemporary paintings, coupled with prizes that were used for purchases. Hope for monetary reward and public recognition inspired artists to participate in these shows and to send their finest work. Across the country, academies and associations, as well as museums, stimulated national art growth in this way.[56]

Most prestigious among the museum annuals was the international exhibition held each fall at Pittsburgh's Carnegie Institute. The only regularly scheduled event of this kind, it attracted submissions from both sides of the Atlantic with prizes and medals and $40,000 in purchase funds. At the inaugural exhibition in 1896, a $5,000 first prize and $3,000 second prize were given for the best oil paintings produced that year by American artists, native or expatriate, and exhibited for the first time in Pittsburgh. The winning pictures, *The Wreck* by

Winslow Homer (fig. 109) and *The Shipbuilder* by Gari Melchers, were installed permanently in the museum "to represent the progress of American Art." Three additional prizes and medals of honor were awarded to painters regardless of nationality "whose works were adjudged of the highest artistic value among those exhibited."[57] The Americans whose paintings were purchased for the Chronological Collection also received medals.[58]

Although some artists complained about the international character of the Carnegie annuals, critics maintained that comparison with Europeans and expatriates would improve the quality of home production. The *International Studio* advised,

> Let them [stateside artists] set to work during the coming summer to paint pictures that will so far outstrip these foreigners that the committee of awards, who, by the way, do not represent the management, but are selected by the exhibitors themselves, will unanimously bestow the prizes upon native talent, and the public with one accord, will applaud their decision.[59]

Noting how Homer's "virile work" had outshone foreign entries, the writer insisted that the Carnegie awards were based on merit, and should not be based on charity. Yet despite the homegrown painter's triumph, American artists had reason to be chary of European competition. In 1895, twenty landscapes by the recently deceased George Inness sold at auction for $31,000; the following year, twenty-four French Barbizon pictures brought $150,000.[60]

In the undervalued market of the 1890s, national art received a significant boost from American entrepreneurism. Having long courted sales primarily through art organizations, gentleman's clubs, and private studios, American painters began to attract the attention of art dealers.[61] The pioneering figure in this history was William Macbeth, who, in 1892, opened the first New York gallery to deal exclusively in American art.[62] In 1896, he began publishing *Art Notes,* an occasional mag-

azine that provided information on the market and circumstances or events affecting native painting.

An eminently hardworking and trustworthy businessman, Macbeth sought to democratize art in the United States. He provided a venue for painters whose work had been rejected or neglected elsewhere and reached out to a middle-class clientele. Landscapes by the established trio of Inness, Wyant, and Martin were the mainstay of Macbeth's gallery in the early years, along with works by New England artists William Morris Hunt, George Fuller, and Winslow Homer. He also sold pictures by American impressionists and supported symbolists such as Albert Pinkham Ryder and Arthur B. Davies. Today Macbeth is best remembered for mounting the controversial 1908 exhibition of The Eight, yet his decision to commit his business solely to American art was a more daring professional act.[63]

Macbeth's success as a dealer was facilitated by the period's foremost collector of American art, Thomas B. Clarke.[64] Between 1872 and 1899, this prosperous dry goods merchant purchased hundreds of contemporary American paintings and contributed time, money, and acumen to art-related organizations and events. Clarke generously sent selected works to public institutions, private clubs, and international expositions. Loan exhibitions of his collection were held at the American Art Galleries in New York in 1883 (to endow a prize at the National Academy of Design) and at the Pennsylvania Academy of the Fine Arts in 1891.[65]

Clarke also served as agent for George Inness and sold pictures by him and other artists through consignment to Macbeth. Clarke's avid patronage of individual artists and his willingness to make his purchases publicly available created an American canon. The World's Columbian Exposition featured fifty-one works from his collection, including fifteen by Inness and six by Homer. Fellow entrepreneur and philanthropist Andrew Carnegie commented,

> I did not know any one connected with the entire
> exhibition who can more truly be considered a public benefactor than this artistic gentleman, who has

evidently for many years had faith in the genius of his countrymen, and has quietly purchased the best examples of their works.[66]

Clarke's favorite painters won critical acclaim at Chicago for uniquely American expression. John Van Dyke wrote,

> With less technical skill than some of our younger
> men, Winslow Homer stands by himself, a painter of
> strength whose works command attention everywhere, largely because they are American without
> preface or apology. They breathe of the soil and the
> sea, tell of their place of origin, give the American
> point of view. Just so with the landscapes of Mr.
> Inness. They are peculiarly our own in every respect,
> and would be recognized as such in any country.[67]

The individual, forceful, and sometimes unpolished technique of Homer and Inness captured the character of American subjects. Clarke's steadfast support of these artists had brought to maturity an original idiom which the nation could claim as its own.

The appreciation for America's artistic achievement, which Clarke helped to foster, culminated in February 1899 with the sale of his collection. This four-day event reaped a total of $234,495, an average of $630 per painting. The highest price paid was $10,150 for Inness's *A Gray, Lowery Day* (fig. 110), a previously little-known picture painted in 1877. Homer's *The Life Line* sold for $4,700, inspiring the painter to write to his patron, "I never for a moment have forgotten you in connection with what success I have had in art. I am under the greatest obligations to you."[68] The press hailed Clarke as a pioneer and a patriot, whose collection had encouraged artists, stimulated buyers, and enlightened the public.[69]

The burgeoning demand for American art among museums, galleries, and collectors in the 1890s validated the nation's cultural ambitions. Individuals who followed Clarke's lead patronized his beloved native realists and, to a greater extent, classicists, impressionists, and tonalists.[70] Clarke's heir apparent, William T. Evans, also bought

109. Winslow Homer, *The Wreck*, 1896, oil on canvas, 30 3/8 x 48 5/16 inches. Carnegie Museum of Art, Pittsburgh. Museum purchase, 96.1.

110. George Inness, *A Gray Lowery Day*, 1877, oil on canvas,
17 7/8 x 25 9/16 inches. Davis Museum and Cultural Center,
Wellesley College, Massachusetts. Gift of Mr. and Mrs. James
B. Munn (Ruth C. Hanford, Class of 1909) in the name of the
Class of 1909, 1977.35.

pictures from artists' studios, lent works to exhibitions, participated in New York club life, and sold paintings at auction in 1900 and 1913. Evans went one important step further, however, by endowing institutions with American art, most notably The Montclair Art Museum near his New Jersey home and the Smithsonian Institution in Washington, D.C.[71] Through such gifts the fruits of cultural nationalism became a national possession.

Conclusion

In the 1890s, cultural nationalists in America viewed culture in two ways. The first, elite interpretation derived from an ideal of civilization as an elevating force. Art's purpose, from this perspective, was to inspire viewers by inculcating humanistic values and communicating eternal truths. The second, popular conception embodied a distinctive world-view rooted in the real conditions of modern life. Art in this sense was expressive rather than instructive; it provided spiritual uplift by representing feeling for the familiar.[72]

The chauvinism and imperialism of the years following the World's Columbian Exposition created a climate in which both cultures flourished simultaneously. While teams of architects, sculptors, and muralists translated large ideas of history and character into a universal language, easel painters represented intimate encounters with aspects of local life and land. An expanding network of publications, organizations, museums, dealers, and collectors brought the achievements of American artists to the attention of the public. Together they constructed a multifaceted, though by no means fully inclusive, definition of national art.

One may fault America in the 1890s for political imperialism and socioeconomic inequity, yet the cultural pluralism remains remarkable. Works ranging in form and content from the universal to the local won recognition in this decade as manifestations of the national. Whether nationalistic enthusiasm had produced a legitimate school of art remained a burning question. Americans would find the answer not on home ground, but in Paris, at the Universal Exposition of 1900.

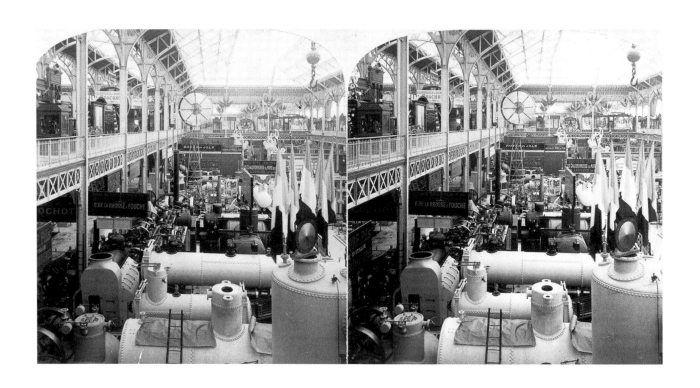

111. Underwood & Underwood, *Interior of Machinery Hall,
Motive Power Machines, Exposition of 1900, Paris, France.* Library
of Congress.

ROBERT W. RYDELL

Gateway to the "American Century": The American Representation at the Paris Universal Exposition of 1900

"Until the Great Exposition of 1900 closed its doors in November,
Adams haunted it, aching to absorb knowledge, and helpless to find it."

HENRY ADAMS, *The Education of Henry Adams*[1]

With these words, the American historian Henry Adams opened "The Dynamo and the Virgin," the most famous chapter of his autobiography. Captivated by the exposition's displays of automobiles and dynamos, radium and X rays, cinematography and chromophotography, Adams reflected on the distance the world had traveled since the Middle Ages. On the Paris exposition grounds Adams "entered a supersensual world, in which he could measure nothing except by chance collisions of movements. . . ." (figs. 2, 111) Awe-struck by "physics stark mad in metaphysics," he proceeded to reflect on the symbols of power on view at the fair and concluded: "All the steam in the world could not, like the Virgin, build Chartres."[2]

Whether Adams was right about steam and Chartres, or about dynamos and virgins for that matter, he certainly captured the lure that the Paris Universal Exposition held for anyone interested in the

meaning of modernity. And Adams was not alone. Some fifty million people visited this fair, making it the most highly attended event of its kind since the world's fair movement had begun with London's 1851 Crystal Palace Exhibition.[3] To be sure, not all of these visitors "felt the forty-foot dynamos as a moral force" and most, while fatigued, probably derived more pleasure than anguish from the stunning array of exhibits divided among the Trocadéro, the banks of the Seine, and the Bois de Vincenne (fig. 112). But Adams's account, while exceptional, should not be discounted. He did, after all, recognize the Paris Universal Exposition for what it was—a force to be reckoned with.[4]

So did the United States government which spent more than any other foreign government on its national exhibits. To what purpose? Why, in the aftermath of the 1893 depression, America's worst economic crisis prior to the Great Depression, did the U.S. government, together with American business, agricultural, and cultural interests, spend millions of dollars organizing, shipping, and establishing displays at a fair in Paris? Answers to these questions are rooted in the bitter social struggles that characterized the period between the end of the Civil War and the beginning of the new century when America's own world's fair movement took form.

The Era of American National Reconstruction

After the Civil War, the (lower case u) united States became the (upper case u) United States. Exactly when this happened is a subject that deserves more study.[5] One thing is certain. The reconstruction of the United States was not automatic or natural. How could it have been? The fact that six hundred thousand Americans died in the Civil War guaranteed that divisive memories would linger. True, political reunification between North and South was accomplished in 1877 when the Republican Party won control of the U.S. presidency, in the bitterly disputed 1876 election, by agreeing to the withdrawal of federal troops from the South. But the restoration of political unity among white Americans came at the expense of recently liberated African American slaves and unleashed the full force of the United States government on Native Americans in the aftermath of Custer's death a year earlier. The so-called Compromise of 1877 certainly paved the way for the advance of industrial capitalism, but could not negate the effects of the Panic of 1873, the first in a series of industrial depressions that would plague the American economy well into the twentieth century. In 1877, railroad workers went out on strike and were met with brutal force from the new alliance between industrial capitalists and America's political leaders. Economic instability and industrial violence remained the keynotes of American life throughout the rest of the century, leading Americans to wonder if the war between North and South had only served as a prelude to a more ominous war—a war between social classes.

These concerns led America's political leaders and economic elites to redouble their efforts to win popular support for their nationalizing agenda. One medium they chose to build this support was the world's fair. Their decision to invest in world's fairs made perfect sense. In the aftermath of the 1851 Crystal Palace Exhibition, world's fairs spread to the European continent and became primary weapons in the cultural arsenals of emerging nation-states, such as France, that were threatened with internal division (planning for the 1900 fair took place in immediate context of the Dreyfus Affair) and radical political challenges from socialists, communists, and anarchists.[6]

Given the class divisions and industrial violence that plagued the United States during the years immediately following the Civil War, it was hardly surprising that American political authorities turned to English and European models to aid their own national reconstruction efforts. In 1876, with the United States still in the throes of the industrial depression that had hit three years earlier, Philadelphia civic leaders secured financial backing from the U.S. Congress for the world's fair in that city to celebrate the centenary of American inde-

1 Porte Monumentale.	5 Pavillon de la ville de Paris.	9 Vieux Paris.	13 Tour Eiffel.	17 Château d'Eau et Electricité.	21 Hôtel des Invalides.
2 Petit Palais.	6 Pavillon de l'Horticulture.	10 Trocadero et Colonies.	14 Palais des Eaux et Fôrets.	18 Agriculture salle des fêtes.	22 Exposition de l'Esplanade.
3 Grand Palais.	7 Pont des Invalides.	11 Pont d'Jena.	15 Tour du Monde.	19 Village suisse.	23 Gare des Invalides.
4 Pont Alexandre III.	8 Palais du Congrès.	12 Palais de la Navigation.	16 Palais du Champs de Mars.	20 Grande Roue.	24 Rue des Nations (sections étrangères.)

EXPOSITION
universelle
1900.

112.*Perspective de l'Exposition Universelle de 1900 (color illustra-
tion of the fairgrounds; panoramic view with key). Musée Car-
navalet, Cabinet des Estampes (Atelier Photo 32 bis). Copyright
Photothèque des Musées de la Ville de Paris.

pendence. Smaller fairs followed: the Centennial Exhibition in Louisville (1883–1887) and New Orleans (1884–1885). Then, with memories still alive of the 1886 Haymarket Square bombing in Chicago, the U.S. government determined to hold an international exposition in Chicago to commemorate the 400th anniversary of Columbus's arrival in the New World and to advance the cause of American nationalism.[7]

The timing of the Chicago fair could not have been better, despite the fact that it opened in 1893, a year later than planned. In 1893, with millions of people thronging to see Chicago's neo-classical exhibition palaces arranged into a White City, as well as its multiple amusements organized along the Midway Plaisance, the bottom fell out of the American economy. Bracketed by the violent 1892 Homestead Strike and the 1894 Pullman Strike, the World's Columbian Exposition would be remembered as a bastion of civilization and culture set against the forces of anarchy and barbarism. It would also be remembered as a powerful engine of nationalism. This fair, after all, served as the primary vehicle for introducing the Pledge of Allegiance into America's schools.[8]

The nationalizing effects of the Chicago fair did not go unnoticed. Steel magnate Andrew Carnegie, for one, liked what he saw. From his commanding position high atop America's socioeconomic pyramid, Carnegie responded to the widening fault lines of class conflict and lingering feelings of sectionalism by praising the fair for promoting feelings of "intense Americanism." He took immense satisfaction from the behavior of the crowds at the fair:

> The impression made by the people *en masse* was highly complimentary to the American. I never heard a foreigner give his impression who failed to extol the remarkable behavior of the crowd, its good manners, temperance, kindliness, and the total absence of rude selfish pushing for advantage which is usual in corresponding gatherings abroad. The self-governing capacity of the people shone forth resplendently.[9]

Long before cultural theorist Michel Foucault advanced his theories about the power of cultural institutions to regulate behavior and long before sociologist Tony Bennett described the role of Victorian-era universal expositions in "winning the hearts and minds" of the masses, Carnegie voiced similar sentiments and lent his prestige to advancing the cause of America's "exhibitionary complex."[10] As Carnegie put it, "the seventeen years that passed between the Philadelphia exhibition and that at Chicago was a period quite long enough." "At least once every twenty years," he declared, there should be "a national reunion" similar to the World's Columbian Exposition held in every section of the country.[11]

Carnegie would get his wish—in spades. The 1893 fair launched a full-blown world's fair movement in the United States. Following Chicago's triumph, major international fairs were held in San Francisco (1894); Atlanta (1895); Nashville (1897); Omaha (1898); Buffalo (1901); St. Louis (1904); Portland (1905); Jamestown (1907); Seattle (1909); San Francisco (1915–1916); and San Diego (1915–1916). In an age rife with world's fair mania, no other nation held as many fairs in so short a period of time. Clearly, these fairs were not fads or follies. They were part of the immensely serious business of reconstructing the American nation-state after the Civil War and perpetuating the American union in the face of a rising tide of industrial violence and class conflict.[12]

Organizers of the United States's representation at the 1900 Paris fair would draw encouragement and inspiration from America's exhibitionary tradition, but they would do so in an international context that differed from that of the earlier Paris expositions of 1878 and 1889. In 1898, America's relationship with the rest of the world changed. In that year, the United States, after its victory in the Spanish-American War, gained control over Cuba and the Philippines; within a year it would control other islands in the Pacific, including Hawaii, that were perceived as stepping stones to Asian markets.

Fresh from their conquest of Native Americans on the upper Plains, imperialists at home now had an opportunity to show the "civilized" world that they would measure up as imperialists abroad. More than that, they would unveil exhibits in Paris that displayed a new brand of imperialism, an American neo-imperial enterprise that would, at least in theory, be based less on

military conquest than on the expansion of private capital.[13] The Americanization of imperialism, however, was never the primary goal of America's exhibit planners; their goal was more ambitious: to use the Paris exhibit as a staging ground for what an English observer would describe as "the Americanisation of the world."[14]

Planning the U.S. Representation in Paris

In 1897, President William McKinley appointed newspaper publisher Moses P. Handy as the U.S. special commissioner to the Paris fair. That appointment forged links between the 1893 Chicago World's Columbian Exposition and American representations at the 1900 Universal Exposition that would only grow stronger as the opening of the Paris fair approached. Raised in Missouri, Handy abandoned his loyalty to the southern cause of secession while advancing the commitment of many former Confederate leaders to expand American economic influence in Latin America. After the war, Handy entered the newspaper business and, because of his success, was asked to serve as the director of publicity for the 1893 Chicago fair. In that capacity, he churned out press releases and advertising copy that helped lay the foundation for the emergence of the modern-day public relations profession. His experience with the Chicago fair, his aggressive pursuit of trade relations with Latin America, and his public relations savvy contributed to his selection to take charge of the Paris operations for the U.S. government.[15]

Shortly after accepting his appointment, Handy received a congratulatory telegram from the U.S. minister to Argentina, William I. Buchanan. Buchanan, who had served as director of the Agricultural Department at the 1893 fair and would shortly become president of the 1901 Buffalo world's fair, spelled out in no uncertain terms his views on the importance of the Paris exposition:

> I believe we should not waste our ammunition there on sentimentalities—Prison Reform, Bible Soci-

eties, Educational Systems, Municipal Government, Fine Art, etc., etc.—these, or some of them, might ornament the table, as it were. From my point of view . . . , what we should do there would be to try to force a breach in the trade wall of every country for new lines of our goods—to work with but one object in view—that of endeavoring to keep our skilled labor employed.

Written while memories were still fresh of both the 1893 fair and 1893 economic crash, Buchanan's letter sent a clear message: "We cannot afford to and must not fail in our exhibit. It must be commanding in concrete effectiveness and convincing in its relation to those who will go there to study and buy."[16]

Handy did not need to be persuaded. But he did need to convince French exposition authorities to allocate sufficient space for the American pavilion and exhibits. What made this task difficult was that the U.S. Congress, faced with lingering aftershocks from the 1893 depression and requests for funds for fairs in Atlanta, Nashville, and Omaha, had delayed appropriating money for an American exhibit in Paris. In the meantime, French authorities had allocated prime pavilion sites and exhibition space to other nations. Handy traveled to Paris in late 1897 and succeeded in persuading the French to expand the overall space for American exhibits to 147,403 square feet, but this was still less than the amount of space allocated to Germany and Great Britain. More troubling to American officials was the realization that the space provided on the Quai des Nations for the U.S. national pavilion relegated the United States to second-class status at what was fast becoming the most important European exposition since the last French fair in 1889.[17]

A bad situation suddenly worsened in January 1898. Shortly after his return to the United States, Handy died of diabetes and heart failure. With just over two years remaining before the opening of the fair, and with national attention focused on a possible war with Spain over Cuba, there was every reason to believe that the American showing in Paris would be an unmitigated disaster. But 1898 proved to be a year of miracles for

exposition enthusiasts. First, America won its "splendid little war" with Spain, gaining, as a result, control over Spanish colonies in two oceans. Second, President McKinley appointed Ferdinand W. Peck to succeed Handy as the U.S. commissioner to the fair (fig.113). By the close of the year, what had been shaping up to be a lackluster industrial and agricultural exhibit in Paris acquired a newfound sense of purpose: to demonstrate to the world and to Americans back home that the newly reconstructed American nation-state had come of age as an imperial power.

There is no overstating the significance of Peck's contributions to the U.S. showing in Paris. Like Handy, Peck was an ardent nationalist and expansionist. To heal Civil War memories, Peck had led a movement to erect a monument in Chicago to Confederate soldiers. Moreover, Peck was a seasoned exposition hand, having served as chair of the finance committee at the 1893 World's Columbian Exposition. Equally to the point, he had the right connections, both through family ties (one historian describes him as "the youthful son of Chicago wealth"[18]) and through his background in law and cultural enterprises. Described as a man of "great energy," Peck wasted no time applying his talents for organization to the task at hand. On Peck's advice, President McKinley designated Benjamin D. Woodward, a professor of romance languages at Columbia University, as assistant commissioner general. Peck then prevailed on the President to appoint an impressive cadre of proven world's fair experts to manage the Paris exhibit. These included Frederick J. V. Skiff, head of Chicago's Field Museum and arguably America's foremost expert on organizing world's fair exhibits; Paul Blackmar, a prominent real estate developer and former head of the department of collections at the 1893 fair; Charles Dodge, who had extensive experience with agricultural exhibits at previous fairs; Howard T. Rogers, who had charge of the New York State educational exhibits at the 1893 exposition; and Alexander Capehart, who had chaired the jury of mechanical arts at the Chicago exposition.[19]

Appointments of other exhibit managers reflected Peck's devotion to memories of Chicago's World's Columbian Exposition, especially its neo-classically designed White City that embodied, at least in the minds of the men and women who designed it, the best of culture and civilization. For instance, to advise Charles A. Coolidge, the chief architect of the U.S. pavilion at the Paris fair, Peck appointed George B. Post, one of the primary architects of the World's Columbian Exposition, thus linking America's national pavilion at the Paris exhibition with the beaux-arts style the Chicago fair had inspired (figs. 11, 99). Then, to make the visual connection with the Chicago exposition explicit, Peck appointed John Getz, who had served as juror for New York State exhibits at the 1893 fair, to administer decorative arts. Peck's choice to direct the exhibit of American fine arts in Paris was the New Yorker John B. Cauldwell, an independently wealthy art enthusiast, who played no direct role in the 1893 fair, but was appointed after receiving approval from Chicago's art patrons. As Peck and his lieutenants envisioned it, American art and architecture would once again be deployed at the Paris fair to define the United States as a nation that belonged among the first ranks of the world's civilized powers.[20]

Peck wasted no time setting up headquarters in Chicago and branch offices in New York City, Washington, D.C., and Paris. Then, in early December 1898, he attended a Chicago banquet that had been arranged to welcome him home from his recent trip to Paris where, with the help of the American Chamber of Commerce and of the U.S. Embassy, he had persuaded French authorities to increase the amount of exhibition space for the United States by reducing the sites of the Turkish and Austrian buildings. No ordinary banquet, this was an ideologically charged love feast that celebrated the marriage of American nationalism and overseas imperialism.

As the glasses clinked, Peck told the assembled guests what they expected to hear: "This is a period of national expansion. The booming of the guns of Admiral Dewey has reverberated around the earth and awakened all Christendom to the fact that the great American Republic now reaches across the globe and that the

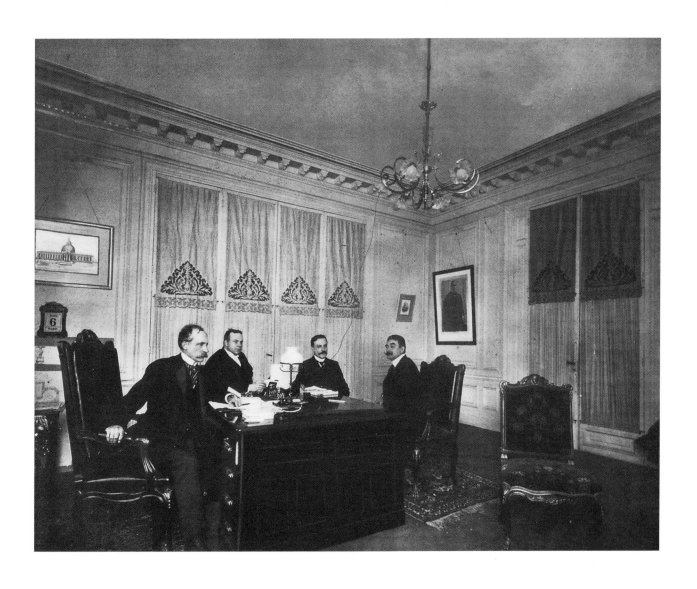

113. Interior View of Commissioner-General Peck's Private
Office, Avenue Rapp, Paris. From left to right: Ferdinand Peck,
Benjamin D. Woodward, Georges Morin-Goustiaux, and
Alexander S. Capehart. *Paris Exposition Reproduced from the Offi-
cial Photographs Taken Under the Supervision of the French Gov-
ernment for Permanent Preservation in the National Archives.* The
R. S. Peale Co., 1900.

nation of the new century is rising on this side of the Atlantic." There would be no favoritism shown to any part of the country, Peck assured the guests: "no Chicago, no New York, no Boston, no San Francisco, no sectionalism, but always and only our great nation in all its length and breadth, wherever our starry banner may float."[21]

Politicians and businessmen from different regions of the country then stood to praise Peck's achievements and celebrate the promise of the Paris Exposition for promoting America's overseas economic interests. New York representative Gorton W. Allen urged potential exhibitors to think in terms of penetrating foreign markets through "the widest display of such goods as we can largely make in excess of our own wants." "Many say that trade follows the flag," he added. "I say that where the manufacturers of the United States go with their goods, when suited to the wants of the people for whom they are made and when offered at prices at which they can be afforded, and 'protected by our flag,' the flag of conscience and liberty, no people can compete with us on anything like even terms." Representing the American Southwest, Missouri Congressman E. O. Stanard, echoed these thoughts and predicted that in the near future the United States would "control very largely the Asiatic commerce, whereby we will be enabled to dispose advantageously of a large proportion of our surplus productions." A representative of the National Association of Manufacturers succinctly summarized this line of reasoning: "The United States is no longer the world's market; the whole world is now our salesroom."[22]

But not all Americans were comfortable with these prospects. Indeed, by late 1898, questions were being asked about the implications of overseas imperialism for American political values. Anticipating the growth of the anti-imperialist crusade that would be led by politicians like William Jennings Bryan and popular writers like Mark Twain, the next banquet speaker, Charles A. Collier, seized the offensive. A democrat and the former president of the 1895 Atlanta exposition and mayor of Atlanta, Collier minced few words about his support of American imperialism. "The so-called dangers of territorial expansion hold no terror for us in the South. We

were jingoes in the spring; we are expansionists to-day. We belong to the party which inaugurated the experiment of conquest and expansion; we believe in the glory and greatness of the American Union and are ready to expend our blood and treasure for its promotion and aggrandizement."[23]

Other banquet guests struck a less belligerent tone and took a different tack toward the same destination—the globalization of American markets. Chicago businessman Alexander H. Revell, for instance, explained how the drive to erect a statue in Paris commemorating Lafayette's contributions to the American War for Independence had helped Peck's efforts "to secure additional space for the manufacturers of the United States." By the time Paul W. Bartlett's Lafayette monument was actually dedicated on July 4, 1900, Lafayette's name, and French support for American independence, would be invoked many times to justify America's actions in "liberating" Cubans and Filipinos from oppressive Spanish rule. What was left unsaid, of course, was that after American independence, France had withdrawn its troops from the United States.[24]

Another Chicago businessman, Elbridge G. Keith, explained the importance of American economic expansion in these terms: "Whether we favor expansion of territory or not we are all agreed that our trade should expand to every quarter of the globe If we enlarge our commerce with mankind we shall also be able to maintain higher wages for the American laborer, adequate profits for the capital employed, and benefiting them not only by our commerce, but by those higher influences which should go with our commerce—that righteousness which exalts a nation."[25] National righteousness wedded to the drive to expand American commerce overseas—this line of imperial thinking would take visible form in the exhibits the U.S. government would sponsor from Cuba and Hawaii, two of America's recent imperial trophies.

But what would not be seen in the American representation would be equally important. With the outbreak, in 1899, of the Philippine insurrection against American military occupation of the islands, the U.S.

114. Cuban Exposition in the Trocadéro Building, Paris Exposition, 1900. Burton Holmes, *The Burton Holmes Lectures,* vol. 2. New York: McClure, Phillips & Co., 1901. Reproduced, with permission, from the collections of the Sanoian Special Collections Library, Henry Madden Library, California State University, Fresno.

government decided against sending an exhibit from the Philippines to the Paris fair. And the Cuban and Hawaiian exhibits glossed over the degree to which American neo-imperial practices relied on the tried and true threat of military intervention to secure U.S. commercial ends. The official government report of the U.S. exhibit would insist on the fiction that the United States had no colonies. However, the location of the Cuban exhibits on the Trocadéro, site of European colonial exhibits, confirmed what many people in America's insular possessions already knew—that the difference between neo-imperialism and imperialism was minimal.[26] (fig. 114)

New Frontiers

In late 1899, a U.S. ship arrived in France carrying the bulk of the American displays. The *U.S.S. Prairie* bore a name that was full of meaning. Ten years earlier, the U.S. Census had proclaimed the end of the frontier period in American life; three years later, at the 1893 Chicago fair, historian Frederick Jackson Turner had read his famous paper on the significance of the frontier in American life in which he had cautioned: "He would be a rash prophet who should assert that the expansive character of American life has now entirely ceased."[27] The *Prairie* and its Paris-bound stores bore out Turner's prediction.

When they arrived in Paris, the nearly seven thousand exhibits, already categorized according to the exposition's classification scheme, were dispersed to pavilions and annexes spread around the exposition's various sites. Unlike many world's fairs with a central site, the Paris Universal Exposition, like many European universities both then and now, occupied diverse areas throughout the city. The arrangement was complicated, but not beyond human understanding, as the U.S. Assistant Commissioner General, B. D. Woodward, tried to explain:

> From the domain of Pure Art on the Champs Élysées one is led, on the Esplanade des Invalides, to the home of Art applied to Industries; thence to the Champ de Mars, where the raw products of the earth are viewed side by side with achievements wrought by human intelligence and ingenuity; and, finally, to the Trocadéro, where, amid exotic surroundings, the remote races of the earth strive to enter into competition with the elements of advanced civilization.

The core ideas of the exposition, in other words, were saturated with ideas of racial hierarchy and the deep-seated conviction that "civilization" had triumphed over "savagery."[28]

These broad racialized zones of the exposition were linked by exhibition avenues that ran along both sides of the Seine (figs. 115, 116, 117). On the Left Bank, foreign pavilions joined the Champ de Mars (fig. 118) (site of the tower that Gustave Eiffel had erected for the 1889 exposition) and the Esplanade des Invalides. On the Right Bank, a mélange of commercialized entertainments and official exposition structures stretched between the Trocadéro and the Champs Elysées. Even with these exhibition areas, French exposition officials had concluded long before the fair opened that additional space would be required to accommodate the quantity of domestic and foreign exhibits. Consequently, exposition planners established an exposition annex in the Bois de Vincennes, six miles across the city to the east, and the future site of the 1931 Paris Colonial Exposition.

Even this expansion of the exposition grounds left American officials wanting more. A year and a half before the fair opened, the French director-general had tried to put a stop to U.S. demands by reminding Peck: "You know the old saying, 'The prettiest girl in the world can only give what she has.'" But American officials refused to take the hint. By the time the fair opened, they had persuaded French authorities to accommodate the desires of several American corporations, including the McCormick Harvester and Southern Railway companies, to build their own pavilions, and to provide additional annexes to major exposition palaces to satisfy the demands of American business and agricultural interests.[29]

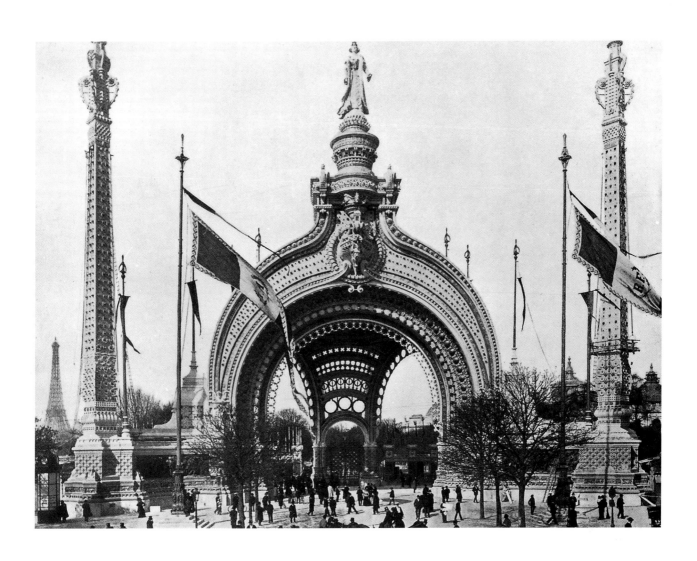

115. Porte Binet, Monumental Gateway to the Paris Exposition, 1900. *Paris Exposition Reproduced from the Official Photographs Taken Under the Supervision of the French Government for Permanent Preservation in the National Archives.* The R. S. Peale Co., 1900.

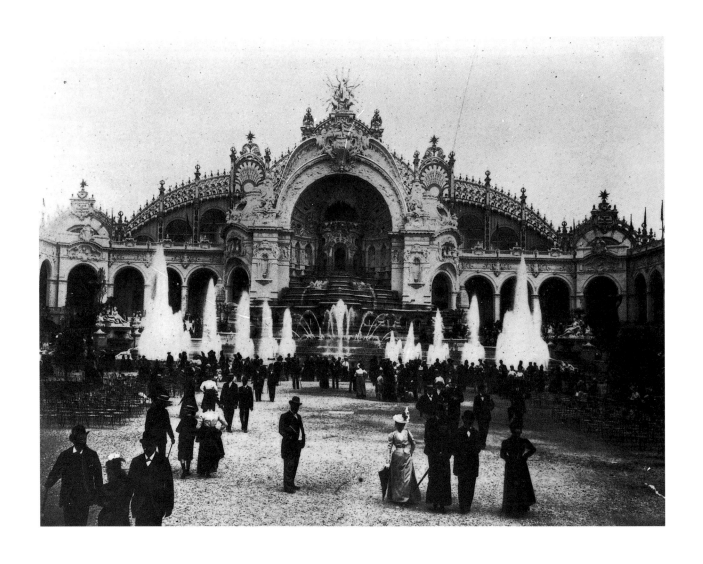

116. Fountain of the Château d'Eau, Paris Exposition, 1900. *Paris Exposition Reproduced from the Official Photographs Taken Under the Supervision of the French Government for Permanent Preservation in the National Archives.* The R. S. Peale Co., 1900.

117. A Moving Sidewalk Panorama, Paris Exposition, 1900. *Paris Exposition Reproduced from the Official Photographs Taken Under the Supervision of the French Government for Permanent Preservation in the National Archives.* The R. S. Peale Co., 1900.

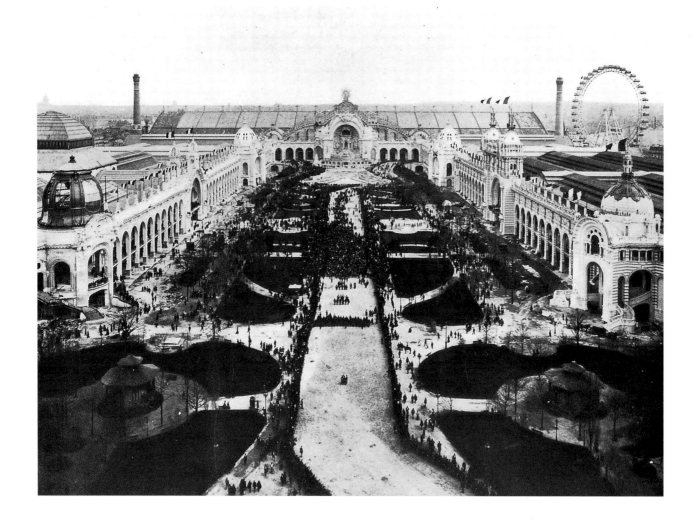

118. Champ de Mars, Taken from the Eiffel Tower, Paris Exposition, 1900. *Paris Exposition Reproduced from the Official Photographs Taken Under the Supervision of the French Government for Permanent Preservation in the National Archives.* The R. S. Peale Co., 1900.

Exactly why French authorities conceded so much to the American commission is not hard to explain. The Paris Universal Exposition, like all world's fairs, reflected the intrigues of international politics. Increasing the exhibit space of the United States to the levels enjoyed by Britain and Germany had the not-so-subtle effect of diminishing the stature of France's European rivals at the exposition. But the decision to inflate the American presence at the fair had an unintended consequence: it gave the United States a commanding port of entry to European and French markets.

In retrospect, it might seem as if the strength of the U.S. presence at the Paris fair was diluted because American exhibits were scattered around various exposition sites. But the breadth of the U.S. presence across the fair's exhibitionary expanses made it difficult to find a sector of the fair that did not have an American presence.

For instance, in the major exhibition palaces near the Eiffel Tower, dedicated to outfitting visitors with lasting lessons about the meaning of "civilization," the United States developed displays devoted to mining and metallurgy, education and liberal arts, civil engineering and transportation, chemical industries, and textiles. Exhibits included a replica of an American surgical theater, a miniaturized 10-foot-tall model of a modern American office building, and numerous models devoted to improving river transportation systems. In the area of natural resources, U.S. displays of mining processes and products occupied half of the ground floor exhibit space in the Palace of Mines. Of all the American exhibits in this zone of the fair, perhaps the most captivating was the "moving stairway," forerunner of the modern escalator, that was installed to convey visitors between the floors of the textile building. As one exposition official explained: "If in a hurry you can run upstairs; if you wish to come down your speed in descent must exceed that of the stairway's ascending motion."[30] Clearly, this was a device befitting a nation that thought of itself as moving only in an upward direction.

Across from the Champ de Mars, in the area of the exposition set aside for colonial exhibits, the U.S. government, despite its formal denials of having colonies,

requested and received space in the Trocadéro Palace for exhibits from Cuba and Hawaii. Because of an outbreak of plague in Hawaii, the Hawaiian displays were relatively small. But the Cuban exhibit, housed in a renaissance-style pavilion built within the Trocadéro Palace, more than made up for the limited Hawaiian showing. For these displays, the U.S. War Department allocated $25,000 and detailed its military liaison to the U.S. Commission to Cuba to help Gonzalo de Quesada, Cuba's future minister to Washington, D.C., assemble displays of natural resources from over 400 exhibitors that would "illustrate the opportunities that capital now has in the development of the island."[31]

As vital as they were to the American representation in Paris, the Cuban exhibits also posed a dilemma. As Peck explained the situation to Secretary of State John Hay, French exposition authorities had decided that, since Cuba was not technically a colony or an independent nation, exhibits from Cuba "would have to be received from Cuban exhibitors as American citizens" thus granting "recognition on the part of the Commission that Cubans are American citizens." Given the divisive debates in the U.S. Congress over the annexation of Cuba, the secretary of state was unwilling to open a back door to Cubans wanting to claim U.S. citizenship on a technicality. Consequently, Peck had to persuade French exposition authorities to make an exception to their rules of classification to allow the Cuban exhibits to appear in a niche by themselves. But having negotiated this concession, the question came up as to whether the United States flag could be flown over the Cuban exhibits. This, too, required delicate diplomacy and apparently was resolved with a decision to drape the Cuban pavilion in red, white, and blue bunting.[32]

The American presence at the fair was also in evidence along the Right Bank of the Seine, in the area allocated to the commercial amusements, where American dancer Loïe Fuller's private theater became one of the hits of the fair (fig. 119). Clad in layers of revealing gauze, Fuller became a one-woman living tableau and the personification of the exposition's art nouveau style as she danced in a green spotlight. Her modern dance

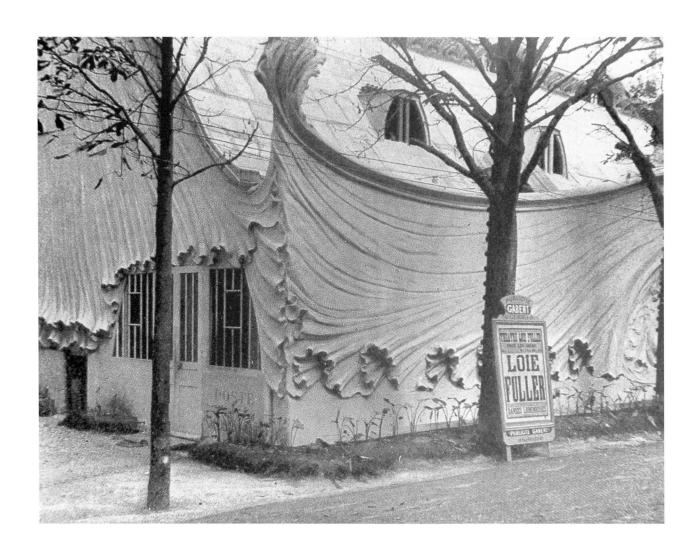

119. "La Loïe's" Flying Skirts, Loïe Fuller Pavilion, Paris Exposition, 1900. Burton Holmes, *The Burton Holmes Lectures,* vol. 2. New York: McClure, Phillips & Co., 1901. Reproduced, with permission, from the collections of the Sanoian Special Collections Library, Henry Madden Library, California State University, Fresno.

performances made the neo-classically designed U.S. National Pavilion, which stood across the river, seem out of step with modern times.[33]

Scrunched into the site between the Austrian and Turkish pavilions, the U.S. pavilion was built primarily to serve ceremonial functions and to provide meeting spaces for visiting dignitaries. Here, Woodward assured prospective visitors, "The American will be at home with his friends, his newspapers, his guides, his facilities for stenography and typewriting, his post-office and his telegraph station, his money exchange, his bureau of public comfort and even his ice-water. He may consult his 'ticker,' where from four to six each afternoon he can receive direct from the New York and Chicago Stock Markets the latest quotations of the busy forenoon hours at home."[34]

Intended to demonstrate the strength and stability of America's commercial present and future, the building's structural steadiness, ironically, was always in doubt. Indeed, one *New York World* reporter leaked engineering reports warning that the pavilion was so poorly designed that, if it were ever filled to capacity, "the whole structure would inevitably collapse toward the centre, and the great dome would fall on top of that

120. Keystone View Company, Alexander Phimister Proctor, *Liberty on the Chariot of Progress*. U.S. National Pavilion, Paris Exposition, 1900. Library of Congress.

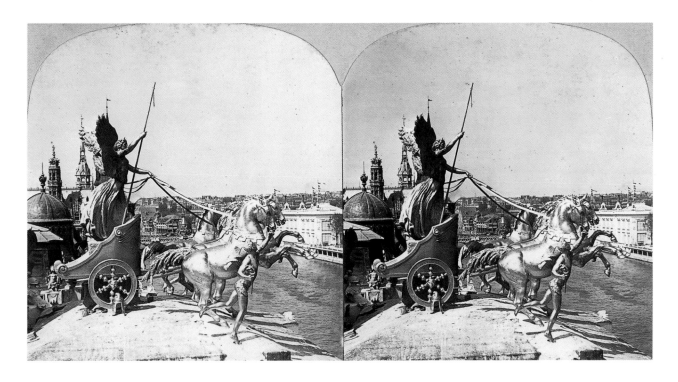

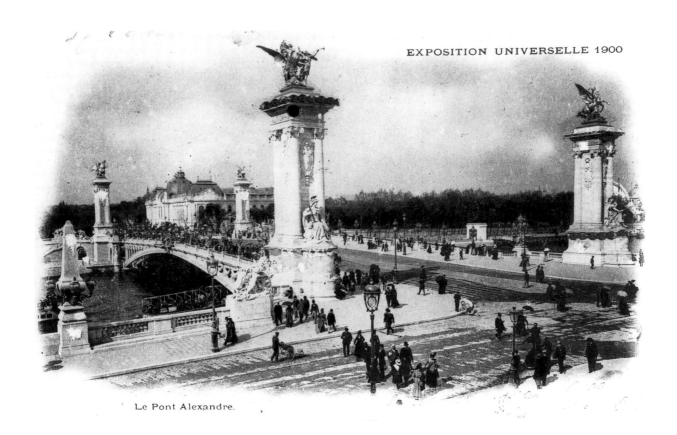

Le Pont Alexandre.

121. *Exposition Universelle, 1900, *Le Pont Alexandre III*, hand-colored postcard, 3 1/2 x 5 3/4 inches. Private collection.

heap." These reports struck nerves already frayed by a steady barrage of criticism about the building's structure and neo-classical design.[35]

Where American architects failed to project a distinctive national identity, the painters and sculptors succeeded. As Diane P. Fischer has argued, American art was carefully packaged to convey a sense that the United States had both the economic resources and talent to merit consideration for full membership in that elite club of "civilized" nations dominated by Europe's colonial powers, especially the French. As Fischer puts it, representations of fine art were selected "to demonstrate not only America's new cultural status, but also its economic, technological, imperial, and agrarian riches."[36] These messages were clear not only in the exterior and interior decorations of the U.S. National Pavilion (figs. 11, 12, 120) but also in the sections of the Grand Palais given to American painting and sculpture. As the other essays in this book note, far from simply occupying an independent, aesthetic realm at the fair, American art provided visual reinforcement for assertions of America's new role as a neo-imperial civilization.

One of the primary underpinnings of this new civilization was on view across the newly erected Alexander III Bridge (fig. 121) from the Grand Palais in the U.S. Publisher's Building. Inside this building, it was not so much culture as the commercialization of culture—what cultural critic Walter Benjamin would term "art in the age of mechanical reproduction"[37]—that was on view. The centerpiece of the exhibit was the enormous Goss Press that, each hour, printed and folded fifty thousand copies of the sixteen-page Paris edition of the *New York Times*. As one foreign commentator wrote: "These Americans introduced us to a machine far more formidable than their revolving cannon—the machine which produces and automatically disgorges a newspaper by a single operation. A man, or—in default of a man—a boy, plays upon a key-board for a few minutes, and lo! the type has been selected and set up, and the characters printed upon a revolving cylinder. It is as rapid and complete as the transformation of a pig into pork, in the great factories of Chicago."[38] While not exactly laudatory, this commentary captured an important truth about American "civilization" at the dawn of the new century, namely that mass production and mass culture were fast becoming its defining features.

Further examples of American mass culture were on

122. Sousa's Band Playing "Stars and Stripes Forever," Paris Exposition, 1900. Library of Congress.

view at the Vincennes Annex of the fair, where displays of automobiles, bicycles, railroads, elevators, revolvers, and machine tools were featured in the American sections of Machinery Hall, and where the McCormick Company erected its own separate exhibition hall. Inaugurated with ceremonies that featured John Philip Sousa's band (fig. 122)—which also played on the Fourth of July when Americans overran Paris—these exhibits lent visible support to the proposition offered by the American exhibit as a whole that "the Republic is rapidly developing a highly perfected as well as a soundly organized civilization, and particularly that it promises to solve, to the satisfaction of all, that problem which has so long annoyed Europe and the world and all ages, viz, the practical and satisfying combination of the artistic with the utilitarian, the aesthetic with the enduring, the beautiful and graceful with the progressive and strong."[39] This was a heady proposition—and one that not all Americans agreed with.

Contested Representations

Like the world's fairs in the United States, the Paris exposition posed enormous challenges for America's racial minorities and women. Since 1876, these groups had been demanding inclusion at fairs and control over their own representations. Their struggles with exposition authorities had always been contentious, but they had won some concessions. Leaders of various women's organizations had demanded and received space for a separate Woman's Building at the 1893 Chicago fair, which afforded white, middle- and upper-class women at least a forum for articulating numerous concerns ranging from suffrage to child welfare legislation.[40] Some Native Americans also had a measure of success at fairs. As badly as they may have fared at the hands of white showmen and anthropologists, world's fair shows had at least afforded them opportunities to negotiate contracts that paid more money than did the few jobs available to them on reservations.[41] African Americans also made inroads in gaining representational space at fairs. At the recently concluded 1895 Atlanta exposition, in return for giving their tacit support to segregation, Booker T. Washington and his allies in the industrial-education movement had negotiated space for a separate Negro Building where African Americans exhibited their contributions to American society since emancipation.[42] These partial victories gave each of these groups some confidence that they would be able to control their representations at the Paris exposition. However, except for the African Americans, their hopes were dashed.

Many women watched with dismay as Peck and McKinley selected the team of all-male U.S. world's fair managers. They also read with chagrin *The Ladies' Home Journal,* in which its editor, Edward Bok, made clear his opposition to demands for a separate Woman's Building at the Paris fair. Calling the Woman's Building at Chicago a "hen's house," he insisted that the very concept of a separate woman's pavilion was wrong. Most women, he wrote, "objected, and rightly so, to be classed apart, and have their handiwork shown as that of a set of freaks. If their work was good, they asked, why should it be separated from the main exhibits simply because it was the work of women?" Merit, he argued, not gender, should determine the exhibits at the Paris fair.[43]

Bok certainly did not speak for all women. Chicago socialite Bertha Honoré Palmer, former head of the Board of Lady Managers of the Chicago fair and wife of a wealthy Chicago businessman, expressed her concerns publicly over the absence of women on the commission, forcing Peck and Woodward to respond. The two commissioners took refuge in legalistic and paternalistic arguments. The U.S. Congress, they pointed out, had not, as it had in the case of the 1893 fair, mandated that women be appointed to any positions on the commission. Furthermore, Peck wrote, "I believe it would be embarrassing to the ladies [because] the appointees would likely be 'persona non grata' to the French officials" Paternalism, in this case, masked deeper concerns that were expressed by one anonymous American official who referred to the possible presence of women on the commission as a "fifth wheel" and declared that "we have no funds to spare in such a useless direction."[44]

As the issue of women's representation at the fair threatened to get out of control, President McKinley intervened and agreed to appoint Palmer to a post on the U.S. National Commission, an honorific body without substantive influence over the content of the American show. Peck tried to mollify her with the news that French exposition managers had granted a concession variously called the Women's Club or the Women's Pavilion. But even one of Peck's chief lieutenants, Frederick Skiff, was forced to admit that this exhibit was "a miserable fake," more of a comfort station than a serious exhibition hall. For the most part, with the notable exception of Loïe Fuller's pavilion and the International Women's Congresses, American women had no independent voice at the Universal Exposition.[45]

Given the U.S. Commission's treatment of white, affluent women, who, after all, had some access to political and economic power, it is hardly surprising that Native Americans were never allowed control over their representations at the Paris fair. But what is surprising, especially in light of the highly popular performances of Buffalo Bill's Wild West Show at the 1889 Paris fair, is that American Indians themselves were not put on display at the 1900 exposition. Did U.S. officials fear that a large-scale American Indian presence would steal the show by detracting from representations of American "civilization" on the exposition grounds? Or were U.S. officials trying to protect American Indians from the crass exploitation they had suffered at the hands of some American Indian showmen?

There is evidence to support both possibilities. At the recently concluded 1898 Omaha fair, the U.S. government had sponsored a massive ethnological exhibition of American Indians from the Great Plains. This "ethnological congress" had quickly turned into a wild west show complete with sham battles fought between American Indians and whites. From the vantage point of the Bureau of Indian Affairs, this exhibition had been so damaging to its efforts to "civilize" American Indians, that the Bureau placed a moratorium on sanctioning wild-west-style entertainments. As an alternative for the Paris fair, the Bureau decided to sponsor an Oneida

Indian's efforts to organize an Indian musical band that would be a "credit to his race." The musicians actually performed in several cities on the East Coast to raise funds for their Paris venture, but lost so much money that plans for sending the troupe to Paris had to be abandoned. The problem, according to the Commissioner of Indian Affairs, was that "the average amusement seeker prefers the grotesque and painful exhibitions of savagery to proofs of the Indians' civilized advancement."

The Bureau could have fallen back on a wild-west-style show and taken the low road towards the goal of demonstrating the triumph of "civilization" over "savagery." But, having been severely criticized by reformers for its Omaha exhibit, the Bureau determined to take, at least in its judgment, a higher road toward the same destination. Recalling the criticism leveled by reformers of wild-west-style Indian shows, the Commissioner of Indian Affairs decided to concentrate government efforts for the Paris fair on representing the "civilizing" work of American Indian schools. In the three cases devoted to American Indians, the government put on view the Indian students' uniforms, products from workshops, lacework, "class-room papers showing the intellectual progress and ability of Indian youth from the kindergarten to the normal and business classes," along with decorative blankets, a canoe, and "a fine, large crayon head of an Indian in full native regalia."[46] (fig. 123)

The American Indian exhibit may have been small and a crass example of tokenism, but it was viewed in France as an effective demonstration to the world that the United States had taken steps to "civilize" those it had not exterminated through its wars of imperial conquest at home. As the Commissioner of Indian Affairs boasted: "the exhibit received much attention and favorable comment" and "was especially timely because the whole matter of race education is now uppermost among the French, and they appreciated the combination of theoretical and practical training which was exemplified. The exhibit received a Grand Prix."[47]

This same combination of colonial theory and practice guided the thinking of the U.S. Commission about

123 (*this page*). Miscellaneous Alcove and Indian Exhibit, Champ de Mars, Paris Exposition, 1900. From *Report of the Commissioner-General for the International Universal Exposition, Paris, 1900,* Washington, D.C.: Government Printing Office, 1901.

representing African Americans at the fair (fig. 124). In an atmosphere where "colonial questions appear to be the order of the day," the U.S. Commission decided to shove the so-called Negro exhibit into a classification category devoted to "comparative social conditions of the races." Like Belgian colonial officials who wanted their Belgian Congo exhibit to show "the moral evolution accomplished by natives of Congo" under Belgian rule, American commissioners hoped to show how conditions in the United States had uplifted people of African descent and how the "race problem" had been solved through political compromise.[48]

To get these points across, Peck, at the urging of Booker T. Washington, selected Thomas J. Calloway, Washington's vice-principal at the Tuskegee Institute, to be the special agent in charge of the Negro exhibit. From Peck's perspective, Calloway was the perfect choice. Calloway worshiped Washington as "the most conspicuous and the wisest servant of his race" and was utterly devoted to Washington's ideal of industrial education as "the road to salvation."

Like Washington, moreover, Calloway rejected the argument that should "the Negro demonstrate his ability in abstruse thought and be able to contest for honors in the professions and the fields of mental activity purely, other forms of prejudice would quickly fall away." Too much time and energy had gone into "proving our equality by competing for places which have hitherto been forbidden us," Calloway insisted. Instead, blacks should be "bending our energies to hold the positions which slavery left to us . . ." In other words, African Americans should become better laborers, establish their economic independence, and thereby earn the respect of whites.

This had been Washington's message in his famous "Atlanta Compromise" speech that had inaugurated the 1895 Atlanta fair; it was the message that Calloway wanted to convey in the Negro exhibit at the Paris fair. Properly carried out, the exhibit would confirm the lessons that African Americans had supposedly learned in the aftermath of the Civil War, and would inspire Africans to follow suit. As one supportive editorial in an

African-American newspaper explained: "As most of Europe is now engaged in African colonization, it is very important that these countries find a hopeful view of racial adjustment, and no better way is known than through such an exhibit."[49]

Booker T. Washington's—and Calloway's—theory of racial adjustment was not, however, a theory shared by all of the black intellectuals invited by Calloway to participate in shaping the Negro exhibit. Two individuals in particular, Daniel P. Murray, a librarian at the Library of Congress, and W. E. B. Du Bois, a sociologist at Atlanta University, took exception to Calloway's emphasis on industrial education and organized displays devoted to African-American contributions to literature and to the socioeconomic status of blacks in the American South. Intended by its prime movers to promote an ideal of "racial adjustment" to the realities of apartheid, the exhibit actually hinted at an alternative future—one that held out the possibility of decolonization both at home and abroad.[50]

Just as the Paris exposition was closing, Du Bois's description of the Negro exhibit appeared in *The American Monthly Review of Reviews.* In carefully controlled language, he suggested that a visitor who took "his sociology from theoretical treatises would be rather disappointed" with the "science of society" displays housed in the Palace of Social Economy. The U.S. section, Du Bois related, was "small, and not, at first glance, particularly striking." But the African-American exhibits were "sociological in the larger sense of the term," presenting "in as systematic and compact a form as possible, the history and present condition of a large group of human beings."[51]

As Du Bois described it, the Negro exhibit was anything but a model colonial show. There were, to be sure, photographs and artifacts from the industrial schools, but these were supplemented with exhibits from Howard and Atlanta universities showing the accomplishments of professional schools, "especially in medicine, theology, and law." And Du Bois's own statistical survey of black life in Georgia did not present "a rose-colored picture." His statistics, in fact, confounded

stereotypes by depicting a black population divided between different occupations, some of whom controlled and paid taxes on nearly one million acres of land. No less important was a display case devoted to African-American soldiers who had received the Medal of Honor and another featuring 350 inventions patented by black Americans. If these exhibits were not enough to refute the assumption that all African Americans subscribed to Washington's accomodationist strategy, Du Bois also called attention to "the development of Negro thought" as evidenced by Daniel Murray's compilation of fourteen hundred books by black authors, two hundred of which were on view at the fair.[52]

What were the messages of the Negro exhibit? From Calloway's perspective, the exhibit "gave clear insight into the advancement made with regard to domestic and educational life as a result of the new-born aspirations of the race." For Du Bois, the message was rather different: "We have thus, it may be seen, an honest, straightforward exhibit of a small nation of people, picturing their life and development without apology or gloss, and above all, made by themselves." Through the efforts of Du Bois and Murray, in short, the Negro exhibit offered glimmerings of a process at work at world's fairs that anthropologist Burton Benedict has described as "the transformation of ethnic displays at world's fairs from manifestations of imperialism to manifestations of nationalism."[53]

That is certainly not how Paris exposition jurors understood the Negro exhibit. Rather, they were impressed by what they understood as first-rate examples of how the civilizing process could work to make better colonial subjects. They awarded the exhibit as a whole a grand prize and awarded individual African-American exhibitors nearly a dozen medals. Among the individuals receiving medals were Booker T. Washington, who received a silver medal for his work on education, and Du Bois, who received a gold medal for his exhibit on African Americans in Georgia. Ironically, just as the 1895 Atlanta Exposition had propelled Washington to a position of national prominence, so the Paris Exposition bestowed international recognition on Du Bois as an

equally authoritative spokesperson for people of African descent. Three years later, when Du Bois published his sharp criticism of Washington's accommodationist strategy in *The Souls of Black Folk,* the differences between them would be absolutely clear. But in important ways, these disagreements were already writ large in the exhibition cases of the Negro exhibit at the 1900 fair.

Conclusion

The American exhibits at the Paris Universal Exposition of 1900 are best understood as ideological constructions that were sometimes bitterly contested by people who felt they were misrepresented. There were notable omissions in the exhibits, especially in the area of women's representations. There were outright distortions, as in the exhibits depicting American Indians and America's new insular possessions; and there were signs of resistance, as in the case of the Negro exhibit.

What the American representation did reveal with some degree of accuracy was the development of an enormous government-backed undertaking to extend American economic and cultural influence around the globe. Two years into the new century, the English writer W. T. Stead coined the expression "the Americanisation of the world" to describe this process. It did not just happen spontaneously. This process was hastened by the American representation at the Paris Universal Exposition of 1900 and validated by the fact that nearly one-third of the American exhibits received prizes, medals, or honorable mention from exposition juries.[54] For the United States, the Paris fair represented a window of opportunity and a gateway to the "American Century."

GABRIEL P. WEISBERG

The French Reception of American Art at the Universal Exposition of 1900

French reaction to the exceptionally large American creative presence at the Universal Exposition was both framed and influenced by a series of economic, political, and artistic issues that dominated discussions between France and the United States throughout the 1890s. Among the most pressing concerns were the ways in which French products, including works of art, were to be treated overseas in exchange for favorable trade guarantees for American products and artworks sent to France.[1] According to a memorandum dated 19 August 1899, and prepared by the French consul general in New York, the sale of art in the United States had increased since "conditions d'accès" for French goods had been readily enlarged.[2]

Little known in France was the fact that the reciprocity treaty between the two countries had generated heated discussion in American political arenas. Indeed, extreme protectionists who wanted little contact with the outside world opposed any improvement of relations between the two countries.[3] A similar, although less agitated, discussion occurred in France; forces opposing change remained vigorous there as well.

Interest in strengthening ties between France and the United States dominated discussions between the two countries in the closing years of the nineteenth century. This heightened atmosphere made it possible for the United States to be taken seriously in many fields, among them the visual arts, an area in which American accomplishments often seemed overshadowed by those of the Europeans.

As interest in the wildly anticipated Universal Exposition mounted, a document was circulated among potential exhibitors in the United States in March 1900. It stated in part, "We assume that every American exhibitor at the Paris Exposition expects some benefit to accrue to his particular industry by enlarging the market for his product and therefore we ask that you carefully read the enclosed facts relating to the proposed French treaty. . . ."[4]

The document challenged potential exhibitors to take action and urged readers to lobby members of Congress to realize that the proposed treaty would benefit the majority of citizens. American presence in Paris had to be encouraged and increased. In order to benefit from the changing atmosphere between the two countries, the United States needed to be represented at the exposition by its most recent achievements.

Another equally important debate emerged at the same time. American manufacturers were keenly aware that their competitors around the world held the United States as a model of energy, creativity, and perspicacity. A document prepared by the Manufacturers Committee and presented to the United States Senate Committee on Foreign Relations on 19 February 1900 emphasized American supremacy: "The journals of the world, and especially the trade journals, are filled with proofs today of the supremacy of American methods and American machinery."[5] This was occurring to such an extent that visitors from "foreign countries" were trying to "learn the secret of our success." In response, they asserted that American tariffs could no longer be restrictive. Instead, they had to be more open and flexible, or American goods, including works of art, would not be favorably received in Europe.

With the tariff situation improving, the American presence in Paris was being closely watched, measured against current commercial concerns, and constrained whenever it became too dominant. It became important to show American paintings and industrial arts in the most advantageous and extensive way. Doing so would ensure America's supremacy. Manufacturers bartered for more exhibition space to display American goods throughout the world's fair. Their goal was to attract attention to the United States and its progressive style of modernism (fig. 125).

Even more significant than the economic benefit to opening France to American commerce was the interest expressed by leaders of the Third Republic, especially those involved with the visual arts, in learning more about American artistic progress since 1889. Like their colleagues in industry, they wanted to study American innovations in order to renew French creativity. Since the mid-1890s the directeur des beaux-arts had sponsored several official French missions to observe the visual arts in the United States.

For one "mission" to America, Henry Roujon, directeur des beaux-arts, selected two individuals deeply committed to improving French industrial arts: Siegfried Bing, a noted art dealer and entrepreneur, and Victor Champier, a highly respected art critic.[6] In the mid-1890s Bing and Champier visited industrialized cities where they met with business and creative groups such as Rookwood Pottery in Cincinnati, Ohio, and Tiffany & Company in New York. In their published reports they fostered a heightened awareness of the range of American originality in the applied arts. Bing and Champier also made it possible for American applied art to enter official French collections and to be sold at art galleries in Paris. Such efforts prepared the foundation for a more enlightened official response to American art at the Universal Exposition in 1900.

125. Tiffany & Company's Exhibit, Palace of Diverse Industries,
Paris Exposition, 1900. From *Report of the Commissioner-General
for the International Universal Exposition, Paris, 1900*, Washing-
ton D.C.: Government Printing Office, 1901.

The Third Republic
and the United States

As part of their responsibility to improve educational
conditions under the Third Republic, officials con-
nected with setting government policy for the visual arts
adopted an extremely open attitude toward the United
States. Initiatives were always similar, whether they
were led by Henry Roujon as directeur des beaux-arts,
Georges Leygues as minister of public education and
the beaux-arts, or Léonce Bénédite as the curator of the
Musée Nationale du Luxembourg, which was charged
with promoting appreciation of contemporary art. Their
ideas meshed in their understanding of the visual arts'
appropriate position within the larger mission of the
state. By working closely together and by developing
various artistic constituencies, these three men shaped a
cohesive policy toward public art by 1900.

In his own way, each of these men emphasized the
need for greater accessibility to, and interest in, America
and its art. They strengthened communication between
the two countries by sending French teachers to the
United States and by encouraging American students to
visit France.[7] Stronger relationships were encouraged at all
levels, including the improvement of language studies.

Roujon, Leygues, and Bénédite also held deeply
rooted republican beliefs that influenced their response
to the arts. They believed in France above all else, and
they were determined to improve French awareness of
the nation's rich cultural heritage. Central to this philos-
ophy was their passionate commitment to all the visual
arts and their desire to create an Athenian vision of a
republic of the arts. As political leaders, they saw the
fine and applied arts as being equal. One could not be
placed higher than the other in the pantheon of creativ-
ity. In this vein, they recognized that French applied arts
needed to be stimulated, improved, and open to new
forms, processes, and uses. Since many of these ideas
derived from American reformers, it made sense to
sponsor American promotion of the industrial arts. All
three men remained open to American applied arts,

126. Portrait of Henry Roujon. Private collection.

which they assumed would receive numerous medals at the Universal Exposition. These awards would lead to work being selected for public and private French collections. With the best American works on view in French museums, American ingenuity would be increasingly understood. At the same time the French competitive spirit would spark the drive to succeed in all the arts.

Henry Roujon (1853–1914; fig. 126), perhaps the least known of the three administrators, was an extremely active directeur des beaux-arts at the turn of the century.[8] An intellectual and passionate writer, he was recognized as an enlightened connoisseur who developed close ties throughout the artistic community.[9] Termed a "reformer" by contemporary critics, Roujon was seen as a significant member of the Athenian Republic.[10] He was totally committed to reducing friction among diverse creative groups, and to establishing functional, fraternal relationships. Under his leadership museums flourished and collections expanded to include works by foreign artists, especially Americans. Indeed, Roujon was so highly regarded by artists that he was elected to the Institut in 1900. His sponsorship of this open atmosphere was crucial to the success of the Third Republic's artistic mission at the end of the century. Through Roujon's liberal attitude, others found the sense of freedom necessary to encourage an independent voice.[11] With foreign art openly evaluated, a more cosmopolitan atmosphere pervaded many French exhibitions in the 1890s.

Another inspirational figure, Georges Leygues (1857–1933), served twice as minister of public education and beaux-arts (1893–1894 and 1898–1902) when Roujon was directeur des beaux-arts. Both a practical administrator and an intense patriot, Leygues (fig. 127) believed in serving his country by supporting the arts and following the fundamental goals of the Third Republic: to make education accessible and broadly available to everyone in the country. He was soon recognized as a major reformer both in the press and through government legislation that he actively championed. In speech after speech Leygues

127. Portrait of Georges Leygues. From *La France contemporaine,* vol. 4 (1903–1905).

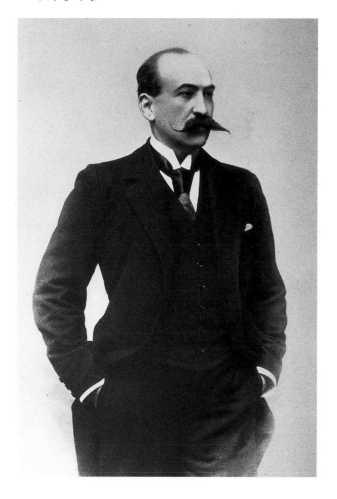

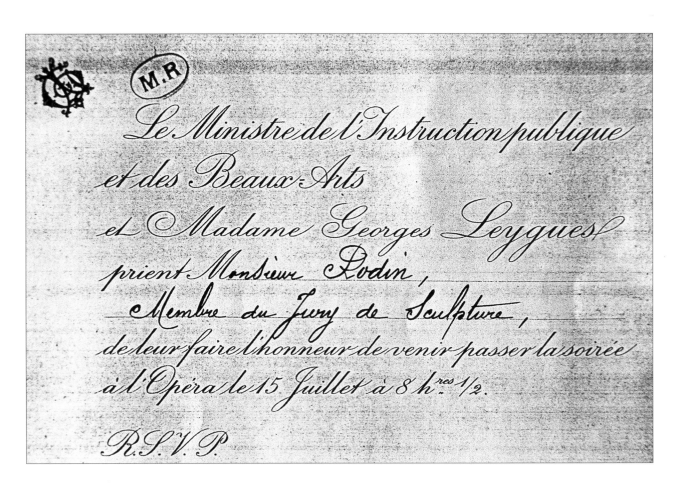

Le Ministre de l'Instruction publique et des Beaux-Arts et Madame Georges Leygues, prient Monsieur Rodin, Membre du Jury de Sculpture, de leur faire l'honneur de venir passer la soirée à l'Opéra le 15 Juillet à 8 h.res 1/2.

R.S.V.P.

128. Invitation to the Opéra from Leygues to Rodin. Musée Rodin Archives, Paris.

emphasized the need to educate French adults so they could compete effectively with citizens in other nations.[12]

Leygues's notion of accessibility extended to the artistic community as well. He scarcely missed an artistic event or snubbed any artist during his tenure as minister. During the late 1890s he traveled the country making countless speeches to elevate awareness of the visual arts. By 1900 he was known as a sympathetic, tolerant spokesman for government policies.[13] He also well understood the importance of the press, and repeatedly used newspapers to increase awareness of the arts. One of his major achievements was to reform education, which he accomplished in 1902. In his book *L'Ecole et la vie* (1903), Leygues summarized his belief that education must get students "ready for life" and only through accessible education could France prosper.[14] Competition from abroad made it absolutely imperative that the country move forward.

By the turn of the century Leygues enjoyed a strong

following among all levels of society. He played a pivotal role in shaping the cultural life of France, and he seemed to take government policies to heart. Already placed in a highly visible position—and easily recognized by his striking handlebar mustache—Leygues extended his interest in the arts by holding impressive social gatherings to which the day's leading figures, such as sculptor Auguste Rodin, were invited (fig. 128). He was also sculpted by Rodin who completed several variants of his portrait bust in terra cotta before he worked on the final marble (fig.129).

At the Universal Exposition, Leygues apparently became intrigued with American art. Two journals went so far as to report that Leygues had acquired American paintings of his own, presumably to hang in his home.[15] By taking such public initiatives, Leygues endeared himself to his fellow countrymen, which made him a popular figure throughout a lifetime of active public service.[16] Undoubtedly, through his involvement, American art received more support from the French government than would have been possible if a more conservative minister had been in power. Citizens of the Third Republic most surely realized that Leygues not only urged France to change in order to remain competitive, but that he also admired American achievements in their own right.

As curator of the Musée Nationale du Luxembourg, the third member of this group, Léonce Bénédite (1859–1925; fig. 130), had the most difficult mission. Charged with supporting contemporary art, he was responsible for enlarging the museum through acquisitions, even though he sorely lacked sufficient funds. In his desire to make the Luxembourg the most representative museum of its day, Bénédite planned to reorganize the collections and add significantly to holdings of paintings and decorative arts.[17] To educate French viewers about foreign arts, he encouraged the inclusion of works by all artists and schools, especially American. Along with Roujon, Bénédite encouraged public acceptance of the glasswork of Louis Comfort Tiffany. Tiffany pieces were added to the Luxembourg museum and to the collection at Sèvres,[18] the national repository

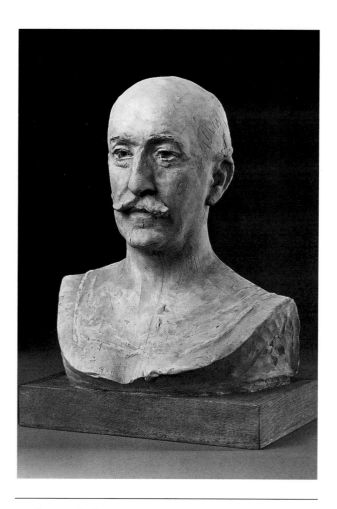

129. Auguste Rodin, *Buste de Georges Leygues,* terra cotta, 14 1/8 x 12 x 7 1/8 inches. Musée Rodin, Paris.

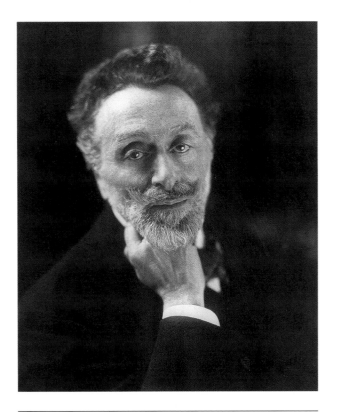

130. Portrait of Léonce Bénédite. Documentation, Musée d'Orsay, Paris.

for numerous decorative arts objects, located just outside the city limits of Paris.

Bénédite's solid ideas were positively accepted until 1903, when government support of his initiatives apparently faltered. Some resisted his desire to enlarge or renovate the Luxembourg or to build a new structure in which contemporary art could be shown to its best advantage. Others objected to his fiery personality or to his Jewish heritage (particularly at a difficult moment in France). Branded a radical who advocated the new, Bénédite was stymied in his desire to build a spacious modern art museum in time for the Universal Exposition, even though such a structure was needed to accommodate the growing collection. Similar to his colleagues Roujon and Leygues, Bénédite was fully aware of American talent, as indicated in his report on the international jury of 1904.[19]

Significantly, these three officials created an atmosphere extremely receptive to American art and interests. As effective spokesmen with tremendous prestige, they established a receptive tone toward American artwork. They also used American art to instruct French artists about foreign advancements in order to keep France's creative edge honed.

The American Arrival in 1900

It is significant to note that the United States's officials were determined to stress all areas of the visual arts at the Universal Exposition, even though they highlighted painting. Stung by the harsh criticism that American painting had come under French domination at the 1889 exposition, American administrators made every effort to showcase originality. They were determined to provide French critics with every opportunity to discover the true "nature" of American creativity. This idea became a type of slogan that several French writers incorporated into their reviews of American art.

Despite French restrictions on space, the U.S. government was determined to construct an extremely large and practical national pavilion that included American

paintings and some decorative art objects. Judging by photographs of the pavilion installation, a series of large canvases was put on view but excluded from the official catalogue of the exposition. The American catalogue clearly documents that American sculpture was exhibited in the pavilion (an area that attracted little attention in the Parisian daily press), but the paintings were so inadequately listed that it is now difficult to determine where all the art works were located.[20] Paintings were also hung in the pavilion at the last moment, which further complicates the question of what was ultimately presented at the exposition.

American applied arts were also shown at the exposition, often within the industrial arts areas and frequently without any relation to the American presentation of paintings. A few objects, such as a Grueby ceramic, were included in the United States pavilion, but for the most part works by Tiffany, Gorham, and the Rookwood and Grueby ceramic companies were exhibited in other areas. Even though the applied arts were valued by the awards juries, the works that received medals were often neglected by those art critics who concentrated on what was exhibited in each art building. For the most part, French newspaper reviews focused on paintings and remained silent about sculpture and the applied arts. We now turn to this aspect of the French reception of American art in 1900.

French Response to American Art: The Daily Press

French reaction to the American works on view at the Universal Exposition was complicated and varied. Some critics closely examined art from many countries, including the United States. In general, they spoke favorably of the better-known painters, such as John Singer Sargent and James McNeill Whistler, as well as of artists with little reputation, which suggests they were looking at American art with almost "new" eyes. Official publications of the exposition featured reports gener-

ated by Léonce Bénédite and other government officials which identified and analyzed the native qualities of American art. The increased appreciation of American art was also reflected in the awarding of official medals to painters and leaders in the applied arts, especially Tiffany, Rookwood, and Grueby, who garnered significant acclaim.[21]

Following the exposition the French government, and quite possibly Leygues, purchased American paintings. In addition, critics and writers for the French press attempted to provide a context for readers to understand the burgeoning interest in American art and in the United States in general. Discussions of what the United States had, or did not have, to offer the French helped to situate the visual arts within a much more complicated web of social and political relationships.

As the exposition opened, numerous articles examined the long-standing relationship between France and the United States to determine where additional ties could be established.[22] Other articles assessed the "American character" to explain why the United States could serve as a useful model for the French, especially in those areas that were practical in nature.[23] Clearly, the United States as a nation, and Americans as a people, were very much on the minds of the French.

Critics examining the fine and decorative arts at the Universal Exposition directed considerable attention to how the Grand Palais des Beaux-Arts had been organized and to the validity of the French representation.[24] Since the French installation was the most important one to the nation, it was naturally judged first by a French-dominated jury, and then compared to the displays of the visiting countries. Interest circled around the American exhibits and national pavilion, whose configuration was seen to express American values as it also provided hospitable surroundings for the hundreds of Americans who traveled to Paris to attend the exposition.[25]

Scores of articles in the daily press assisted exposition visitors in making informed comparisons between France and the United States. One thoughtful review, written by the major critic Gustave Geffroy, appeared in *Le Journal* on 16 July.[26] In discussing various aspects of

American painting, Geffroy found it remarkable that the United States had achieved such a homogenous effect at the Universal Exposition. He commented that the art was "truly American, that it reflected their character." Like other critics, Geffroy examined the work of Gari Melchers, John White Alexander, and others, and gave American creativity considerable value. He credited Whistler with exerting a profound impact on both the old and the new world, classifying his work as "great." In this way Geffroy shaped the debate around American painting and defined the range of issues for other critics.

Two days later another examination of American painting appeared in the daily press, this time in an assessment of foreign specimens on view at the Grand Palais.[27] Le Voltaire, a leading liberal newspaper, published an extensive review on 18 July and outlined the reasons why American painting deserved to be better known:

> The American school is definitively consecrated. Talented painters are now in the majority. In spite of borrowings, the American school remains original, and the totality of its artistic production provides a feeling of independence that is quite notable.[28]

The reviewer went on to draw parallels between certain American painters, such as Whistler, and the concept of painting the "soul," then a key measure of symbolist figure painters in France.

According to this critic, American painting was not mundane but rather possessed a noteworthy intellectual aspect. Like Geffroy, this critic placed Whistler and his "superb portraits" at the highest level, and he deemed Alexander's study of light to be significant. Other Americans, including Sargent, William Merritt Chase, Cecilia Beaux, Frank Benson, Robert Blum, George Hitchcock, Homer Lee, and Sergeant Kendall, were given words of high praise as being "true painters" who were able to achieve "colored harmonies." The critic also described a landscape by William Lamb Picknell that

hung in the U.S. pavilion, and indicated that he had looked at American paintings throughout the exposition grounds.[29] This same review appeared in Le Rapide on 20 July, which suggests that a strong group of supporters endorsed the writer's views and felt his opinions bore repeating.[30]

At almost the same time, the critic Léon Plée set out to annihilate the reputation of American art through his article in the newspaper La Liberté. On 20 July, Plée published a review that attacked every aspect of the American art installation. His writings became a virtual blueprint for the opposition. He found almost all the artists were lacking in originality, particularly the portraitists, who were "copying others when they were not copying themselves."[31] Only rarely did he find American painters able to disengage from any foreign influence, echoing criticism from the 1889 Universal Exposition. When he did identify an "original" master, Plée retreated to safe ground by advocating only the work of Chase and Whistler, who were labeled among the most "personal" of the American masters. Plée concluded that American painting had a long way to go since its artists were still wearing "langes" (that is, diapers, to suggest their infancy). This damning comment was diametrically opposed to views expressed in other newspapers at precisely the same time. With such different views appearing early in the exposition's run, it is obvious that the merits of American art remained controversial.

As if inspired by this controversy, other critics entered the fray in mid-August. E. Grosjean-Maupin, writing for Le Matin, had a more positive reaction, noting that American portraitists were "particulièrement remarquables," especially Whistler, Beaux, John Humphreys Johnston, and Henry Bisbing. He cited a painting by Kendall—probably acquired by Georges Leygues—as being "a painting truly religious in feeling and interpretation."[32] (fig. 131).

The reviewer for L'Aurore, B. Guinaudeau, took the opposite stance, claiming that American painters created works of art as if they were businessmen.[33] To him, the Americans were skillful and audacious, but their works had a practical and almost unimaginative effect.

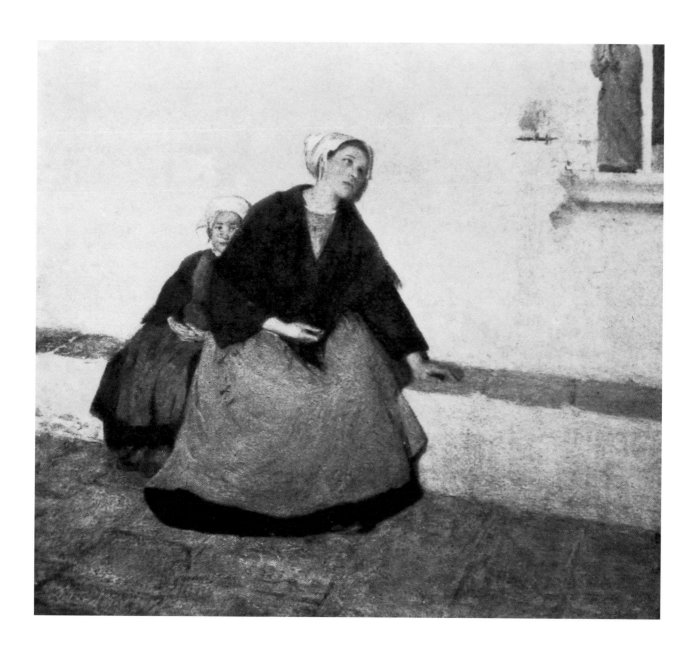

131. Sergeant Kendall, *St. Ives, Pray for Me*, ca. 1891. Unlocated.
Die Kunst für Alle, vol. 16 (1901).

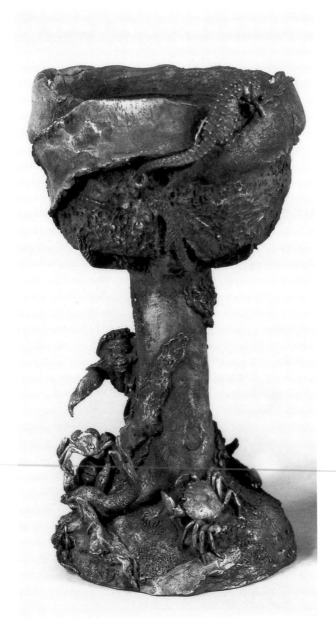

132 (*left*). Maria Longworth Nichols Storer, *Chalice*, 1898, bronze, 12 1/4 inches high. Cincinnati Art Museum. Gift of the artist, 1903.387. Gold medal at the Paris 1900 Exposition.

In introducing the parallel with business, this reviewer, like so many other French writers, asserted that American painters lacked a personal dimension. He believed their artistic growth had been stunted by their desire to see everything and to understand what was in fashion. He did admit that certain painters were able to combine these influences and occasionally achieve some quality of genius that "almost" allowed them to be considered original. Alexander and Sargent were singled out as true creators, even though he believed Sargent's work in 1900 to be "dead."[34]

While some of his comments were quite positive, Guinaudeau also maintained that a true American quality was not apparent in these works. He, too, believed that American works approximated the efforts of other foreign artists and "once more they don't appear more American than French or German." Since these artists don't paint "their country more than they would represent other countries," they were not thought to be truly American.[35] Guinaudeau did note, however, the cosmopolitan nature of their work, which allowed Americans to compete effectively with other nations. On the less-supportive side, he reiterated the belief that American art looked like other works from European countries, which undermined the progress that some critics had detected at the Universal Exposition.

In September, the prominent critic Louis de Four-caud offered his comments on the American installation. Writing for *Le Gaulois du Dimanche*, Fourcaud introduced an added dimension to the press debate by utilizing a two-page photo layout of the actual installation in the Grand Palais.[36] He carefully presented the two factions of the American effort: those artists who worked in France and those who lived in the United States. In recognizing that few could call this "a school profoundly united," he did admit that it was a force, a "school already boldly constituted and which becomes conscious of itself."[37] Throughout the article Fourcaud discussed aspects of the American spirit and the different types of people living in that "new" country. Like other writers, he emphasized Whistler and Sargent as crucial figures in the American art world, but he also

highlighted the work of Homer Lee, whose "quasi symbolique" painting of an apartment building most likely was acquired by Leygues. When he described independent figures, Fourcaud turned to Winslow Homer, whose creativity was that of "a vigorous performer with a solid personality who is insufficiently known in Europe." To Fourcaud, who was searching for native characteristics, Homer was "strongly and truly American."[38] Thus, whether Americans were considered truly original or merely products of cosmopolitan assimilation, their paintings were undoubtedly causing a stir.

Press coverage largely centered on American paintings, yet the applied arts, most of which were exhibited in the Palais de l'Industrie Diverse, were well known to the French.[39] There was little specific coverage of American industrial arts, which were discussed in terms of their materials and their practical applications according to their exposition categories, in Groups XII and XV. Innovations in American glass, for example, appeared in the subcategories of stained glass windows, glassware for the table, glass for mausoleums, and glass shades used with electrical lighting. American ingenuity was also noted in jewelry, silverware, ceramics, and small bronzes.[40] The imaginative bronzes of Maria Longworth Nichols Storer from Cincinnati, Ohio, garnered her recognition and a gold medal from the exposition (figs. 132, 133).[41]

Also emphasized were four leading companies: Gorham Manufacturing of New York, Tiffany and Company of New York, Rookwood Pottery of Cincinnati, and the Grueby Faïence Company of Boston. Parisian newspapers routinely published the names of recipients of jury awards, but they gave special attention to Rookwood Pottery when it received the grand prize in ceramics (figs. 134, 135, 136).[42] In addition, the Grueby Faïence Company, recognized for the diversity of its work (fig. 137), was awarded a gold medal.[43] Designers who worked for these companies could also receive individual recognition by exhibiting works on their own. In the ceramic category Albert R. Valentien of Rookwood Pottery and William H. Grueby of the Grueby Faïence Company were designated gold medal

133. Maria Longworth Nichols Storer, *Vase,* ca. 1900, bronze, 11 1/2 inches high. Cincinnati Art Museum. Gift of the artist, 1903.392.

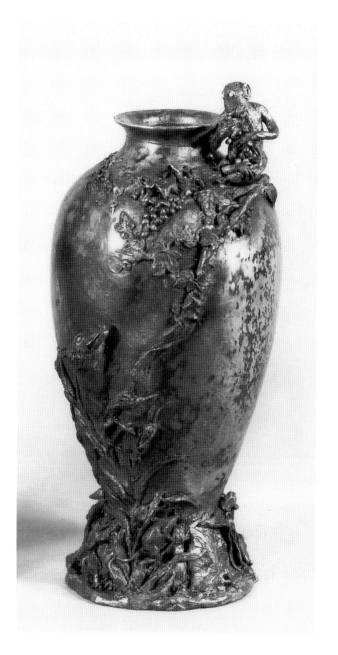

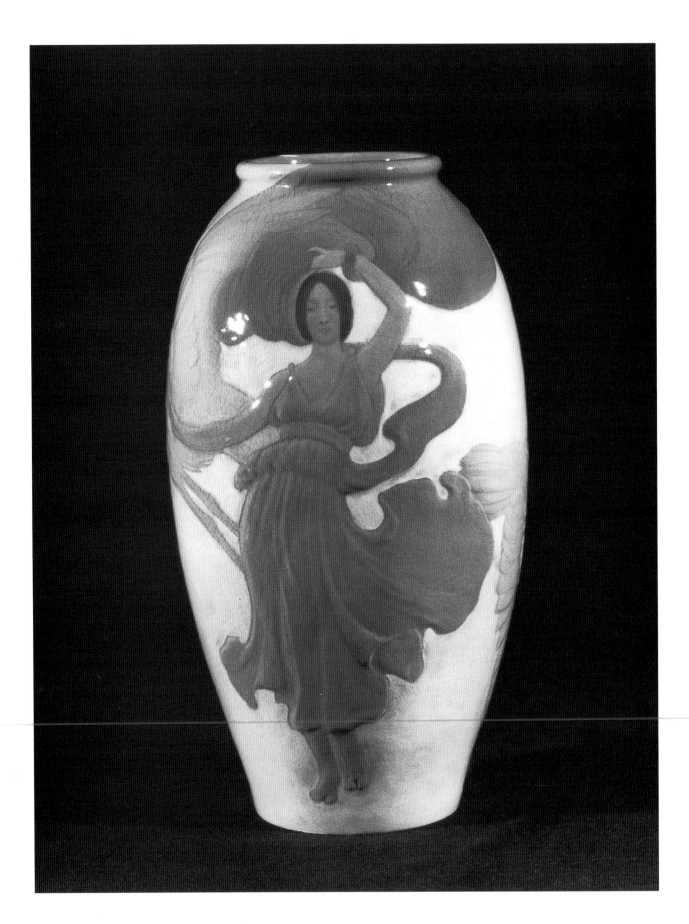

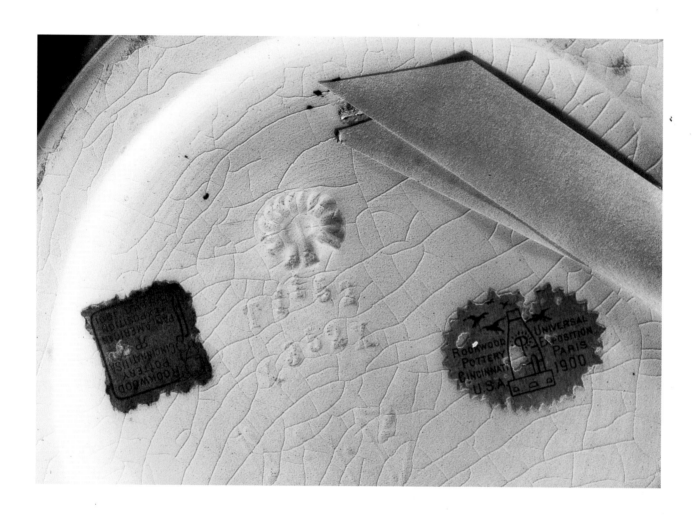

134 (*facing page*). *Artus Van Briggle, Rookwood Pottery (1880–1960), *Vase,* ca. 1899, ceramic, 13 3/4 x 7 1/2 inches. Shown at the Paris Exposition, 1900. Private Collection. Rookwood received a grand prize at the Paris 1900 Exposition.

135 (*this page*). *Artus Van Briggle, Rookwood Pottery (1880–1960), *Vase,* ca. 1899, ceramic, 13 3/4 x 7 1/2 inches. Sticker indicating that the vase was shown at the Paris Exposition, 1900. Private collection.

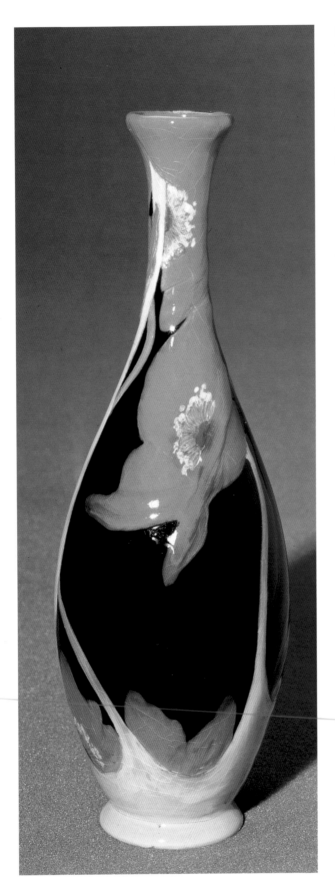

136 (*this page*). *Edward George Diers and William Watts Taylor, Rookwood Pottery (1880–1960), *Vase,* 1900, ceramic, 9 1/2 inches high. Cincinnati Art Museum. Gift of Walter E. Schott, Margaret C. Schott, Charles M. Williams, Lawrence H. Kyte, 1952.322. The black iris glaze line was very popular at the Exposition of 1900.

137 (*facing page*). *George Prentiss Kendrick, Grueby Faïence Company, *Vase,* ca. 1900–1902, glazed earthenware, 10 7/8 x 5 3/4 inches. Private collection. This is very similar to a vase exhibited in 1900. Grueby received a gold medal at the Paris 1900 Exposition.

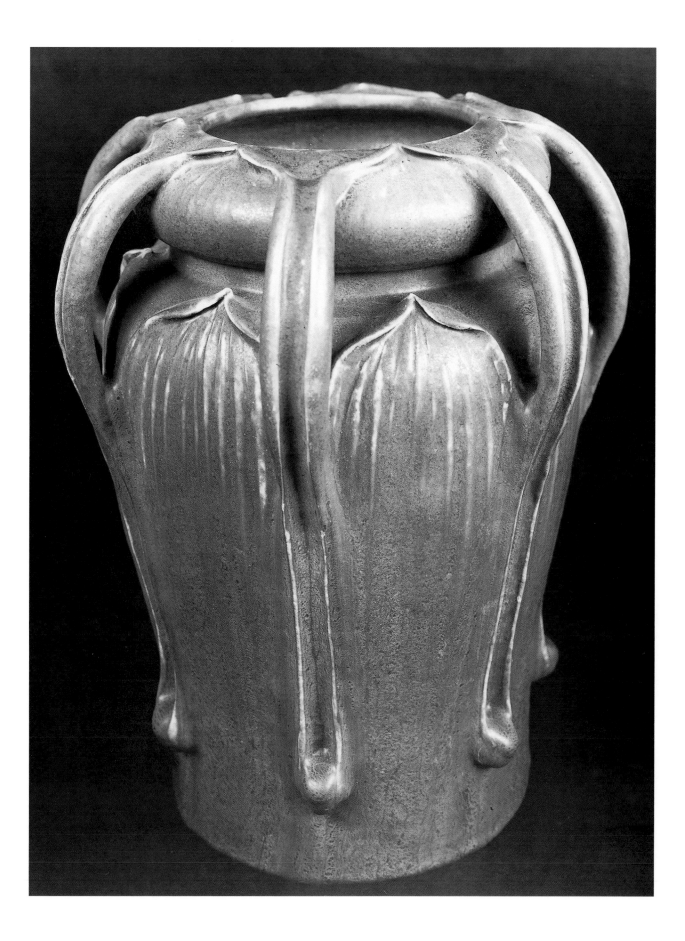

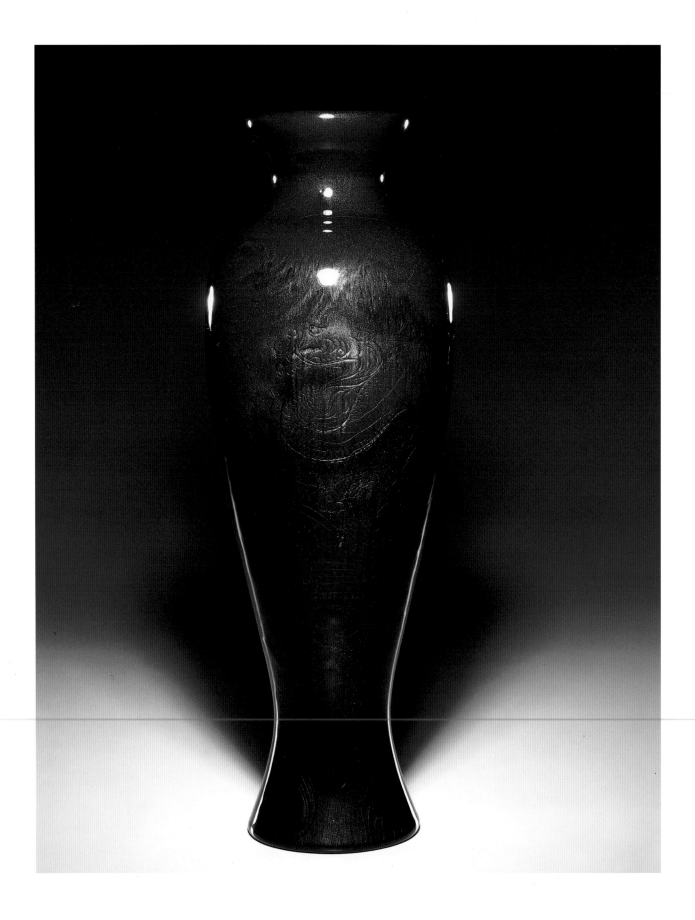

138 (*facing page*). *Kataro Shirayamadani, Rookwood Pottery, *Vase*, 1898, glazed earthenware, 14 1/2 inches high. Dallas Museum of Art. This vase is one of a pair; the other bears the exposition label.

winners.[44] Such exposure gave firms and designers additional contacts with dealers in Paris who sponsored their work, such as Siegfried Bing at his shop *L'Art Nouveau* which was located with relative ease to the fairgrounds. This was also the case with directors of applied arts museums, who acquired American pieces to instruct and inspire young craftsmen. In fact, the collections of the Museum für Kunst und Gewerbe in Hamburg, Germany, the Museum für Angewandte Kunst in Vienna, Austria, and the Kaiser Wilhelm Museum in Krenfeld, Germany, added numerous examples of American art pottery after the Universal Exposition. These pieces effectively demonstrated the high level of aesthetic creativity in American work.

Neither published catalogues nor lists of award recipients tell the entire story of the representation of American applied arts at the Universal Exposition. Organizers were inundated with requests for admission. Judging from partial documents preserved in the Archives Nationales, firms and individual designers wanted to show as many works as possible. Kataro Shirayamadani, a principal designer at Rookwood Pottery, for example, exhibited innovative pottery (fig. 138) and showed a series of drawings (possibly watercolors) for work in process or for ideas being developed and in need of support from potential buyers.[45] Many other Rookwood artisans followed his example of showing finished pieces with their preliminary drawings.[46] French designers carefully studied the Americans' work for their own experiments with form, color, and glazes.

Thus, even though American applied arts were not effectively covered in the French daily press, collectors and administrators in the arts certainly recognized the originality of certain pieces. American contributions to the applied arts throughout the fairgrounds were fully visible, and French reception to the significance of the United States was effectively enlarged as it had been with the paintings display. Even sculpture, which received little press coverage, found a rare mention. Some reviewers belatedly commented on the work of Augustus Saint-Gaudens or Daniel Chester French, although the notations were only cursory.

Critical Reception in France: Journals and Books

Before the Universal Exposition closed, several authors were asked to document their opinions about the fair in general and American achievements in particular. These comments, recorded for the benefit of future generations, provided additional evidence of how the American contribution was viewed.

Progressive critics, such as Camille Mauclair, a leading Symbolist writer and critic, offered their support. Mauclair began his examination of "La Décennale étrangère" with an article in *La Grande Revue de l'Exposition* in July. Like other critics, Mauclair studied Whistler's contribution, adding that his work could be favorably compared with the portraits and decorative interiors of French painter Albert Besnard, a reigning Salon favorite. Whistler's influence was in turn detected in portraits by the French artist Eugène Carrière and the Spaniard Antonio de la Gandara. Also singled out were American portraits by Alexander Harrison, John White Alexander, and Humphreys Johnston, whom Mauclair saw as the "the first direct student of Mr. Whistler."[47] Auguste Marguiller's article in the September issue of *Revue Encyclopédique* followed in a similar vein.[48]

In contrast to these articles the author of *L'Exposition du siècle, Paris: Le monde moderne*[49] savagely attacked American fine and applied arts. Following a slightly different tactic, the anonymous writer claimed that the American installation was deceptive. Writing as if he had actually visited the United States, the author criticized American artists for not representing their country and for not bearing witness to the daily life of the American people. To know the "human heart," he wrote, it was necessary to look at "the lowly," something these American artists apparently refused to do. The author then retreated slightly by stating that he believed all participating countries, including the United States, had sent the best works they could to the exposition.

His denunciation of American art continued in a diatribe against the sterile imagination and material richness evident in works by Tiffany and Company, which he found surprising given the vigor of the American representation at the 1889 exposition. According to this writer, Tiffany's reliance on rich materials far surpassed the importance of the object being created. American design and the industrial arts had become too materialistic, with objects created for the rich alone.[50] Considered with his attack on American painters, this critic obviously favored the disenfranchised, a stance that colored his examination of luxury art objects intended for the few, and further supports the case for French reception of American art according to political ideologies.

To counteract such negative criticism, exposition organizers published *Le Livre d'or de l'exposition de 1900*, in which the American section was addressed positively and without personal bias.[51] In 1901, the U.S. government issued its own official report of the American representation at the Universal Exposition.[52] Bearing in mind the criticism of 1889 and the press debates of 1900, John Cauldwell referred to a letter from Léonce Bénédite, in which the French director wrote, "I have no difficulty in observing in your brilliant exhibition a strong movement, unknown to us, less in contact with European centers, more local, and which no doubt marks the beginning of a really national school."[53]

Whether or not these remarks were completely truthful, Bénédite and his government colleagues were determined to maintain this position about American art. Cauldwell followed this same line of reasoning in his own commentary, writing that "it was generally acknowledged that our exhibit was, after that of France, the most interesting, the most impressive, and the best installed; constituting a manifestation of art that was a revelation to the foreign critics and connoisseurs."[54]

Propaganda aside, Cauldwell had to publish these statements in the exposition's official publication to justify his efforts. He undoubtedly knew that controversy still overshadowed American art in 1900. As other reports on the fair appeared, particularly in France, a more detailed assessment of American contributions emerged and was bolstered by the value of hindsight.

Among these texts was Léon Greder's in *Loisirs d'Art*.[55] While finding little that was truly American in the painting installation, Greder noted that several American artists had to be taken seriously in comparison with painters in Europe.[56] Whistler was no longer the effective painter he once had been, Greder added, but paintings by Sargent (to him, the best portraitist), Chase, Alexander, and Beaux deserved attention, as did works by Homer and Harrison. Greder admitted that some landscapes and seascapes had "a taste of the native land," which indicates that he too was searching for some native characteristics of American art. Although he found some artists were dependent upon European traditions, especially within the category of genre, Greder was in general supportive of American art. He believed artists could hold their own internationally and "rival their European colleagues."

In 1902 the French minister of commerce issued the official jury report on the industrial arts shown in 1900.[57] This publication examined the contribution of American industrial arts from the French position. Within the category of "goldsmith or silversmith craft," Henri Bouilhet, writing for his section, reported that the two champions were the same ones identified in 1878 and 1889: Gorham Manufacturing (fig. 139), and Tiffany and Company (figs. 140 and 141). Bouilhet believed that Tiffany had slipped somewhat since 1889, which allowed Gorham to receive a grand prize in 1900.[58] In other areas the report complimented the bronze pieces by Mrs. Storer from Cincinnati (figs. 132, 133), whose compositions were deemed extremely "original" and were executed with great care. Similarly, works by the Tiffany Glass and Decorating Company, especially its glasswork "strange tonalities," were thought to be quite seductive and successful, and thereby was justified in receiving a gold medal[59] (figs. 142 and 143). This assessment and that of the entire report reiterated the belief that among artists and manufacturers at least, American applied arts had been appreciated. Not every critic agreed with this estimation, since writers often bore a political bias.

In his later official report on the fine arts, Bénédite reiterated the position he had expressed in his earlier letter to Cauldwell. While he noted French influence in the United States, he also stressed the originality of American efforts, seen particularly in the work of Sargent and Whistler, and the ingenuity in portraits and landscapes.[60] He mentioned the Luxembourg Museum's recent purchases of paintings by Ben Foster and Sergeant Kendall. (The latter was a mistake on Bénédite's part, since Leygues, it was believed, had acquired the work by Kendall.) Clearly Bénédite's preaching was having an effect.

By 1906, when the conservative Alfred Picard, who had been the commissioner-general of the exhibition, published *Le Bilan d'un siècle,* he carefully iterated that even though America had not yet achieved its mature style—this might take centuries to accomplish, he believed—the country's enthusiasm, energy, and "original temperament" was slowly beginning to eliminate outside influences. Picard then identified several artists whose efforts had been validated by the 1900 exposition.[61] Picard had been the one to label American art an "annex" of the French in 1889, so these more positive remarks are especially indicative of the change in French attitudes during the 1890s.

Liberal critic Georges Lafenestre commented further upon the progress of American art in 1907, when he wrote about the value of the "foreign schools" seen in 1900. Lafenestre believed:

> American painters, which doesn't surprise us, already exhibit in their best works, several great qualities. . . A consummate truthfulness in their observation, a vigorous simplicity of perception, the subordination of the process to interpretation. . . . It is one of the foreign sections, where, for the past twenty years, progress has been the most rapid and the most decisive."[62]

Lafenestre closed his review by commenting that, as American art continued to free itself, it would become an active force on the world stage.

These late publications, produced after various juries had submitted their official reports, did not so much

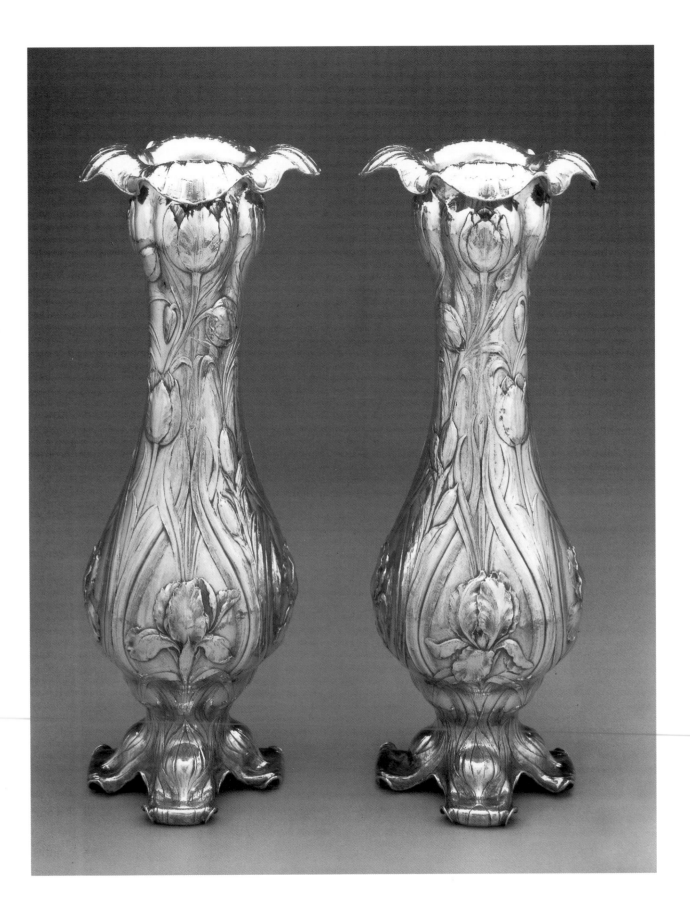

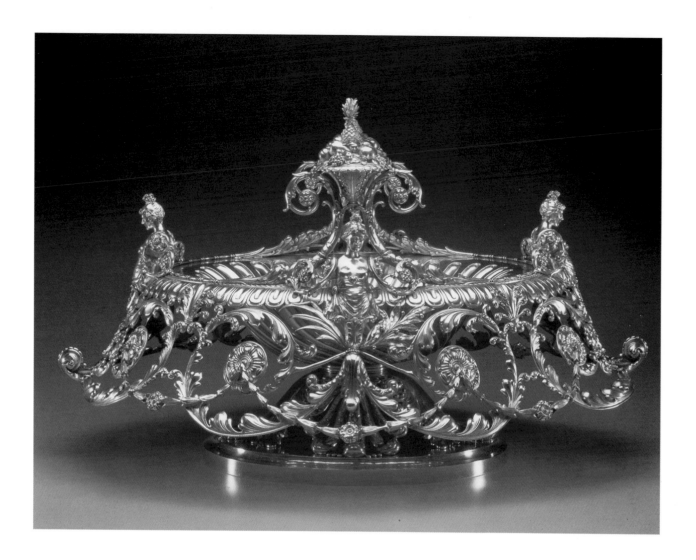

139 (*facing page*). *William C. Codman, Gorham Manufacturing Company, *Pair of Vases,* 1899, silver, 18 1/4 x 6 inches. Dallas Museum of Art. The Oberod Collection. Anonymous Gift. Gorham received a grand prize at the Paris 1900 Exposition.

140 (*this page*). *Attributed to Paulding Farnham, Tiffany & Co., *Centerpiece,* 1900, silver, 19 x 32 1/2 inches. Dallas Museum of Art, gift of Michael L. Rosenberg through the Discretionary Decorative Arts Endowment Fund. Tiffany & Co. received numerous awards at the Paris 1900 Exposition, including a grand prize.

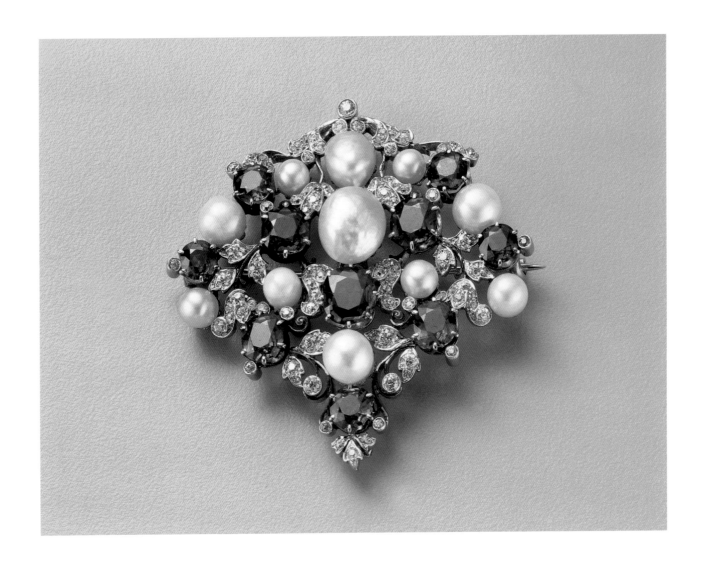

141 (*this page*). *Tiffany & Co. Brooch*, ca. 1900, 2 1/4 x 2 1/8
inches, Montana sapphires, natural fresh-water pearls from
Wisconsin and Tennessee, diamonds, platinum, and
enamel. Permanent Collection of Tiffany & Co.

142 (*facing page*). *Louis C. Tiffany, Cypriote Vase*, ca. 1900,
favrile glass, 9 7/16 inches. Tiffany Glass and Decorating
Company. Received numerous awards at the Paris 1900
Exposition, including gold and bronze medals for favrile
glass. Philadelphia Museum of Art. Purchase: The Temple
Fund.

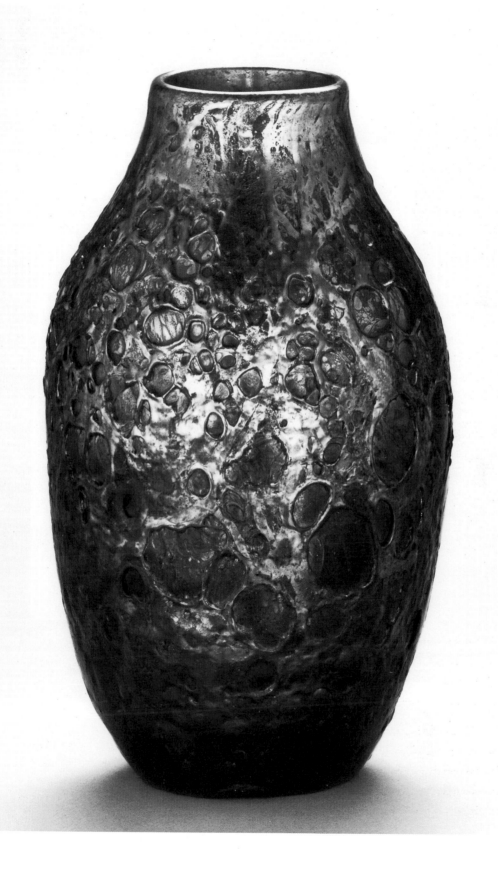

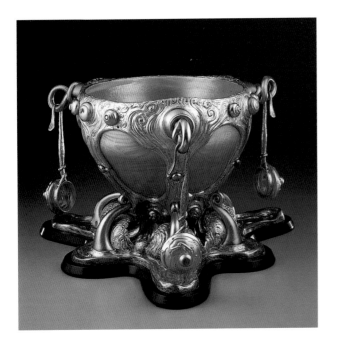

rewrite history as they provided a clearer insight, with the benefit of the passage of time, into what had actually happened. Despite opposition that was often based on political motivations, critics—sometimes outside the group within the administration of the Third Republic—independently confirmed that American art had made genuine progress. French critics and writers detected a shift in certain areas, especially the industrial arts. Quite perceptively, some of these observations were made during the 1900 exposition. In a bold move, a few individuals who were sensitive to change began to add American works to their French collections of art.

Collecting American Art: The State

Central to any discussion of how American art was perceived and collected by the French state is the role played by Léonce Bénédite. Extremely open to American painters, both living in France as well as in the United States, Bénédite acquired the most representative works for the collection of the Luxembourg museum. In restructuring the Luxembourg, the director integrated examples of the decorative arts, such as the Tiffany glass he had secured in 1894, with the paintings on view. He prepared drawings of his projected installation (fig. 144), and his positioning of vitrines containing glass and ceramics indicates that, in his mind, Tiffany's achievements were on par with ceramics by Alexandre Bigot and Adrien Dalpayrat, leaders in the French design reform movement.[63] By placing these vitrines in the center of the painting galleries, Bénédite stressed his belief in the equality of the arts being shown at the Paris Salons and at the major museums of modern art.[64]

Throughout his tenure at the Luxembourg, Bénédite corresponded with foreign artists, including many American painters.[65] From the mid-1890s on, with the support of Henry Roujon, Bénédite secured American paintings for his public collection. A work by Lionel Walden, who was represented at the 1900 exposition,

143. Tiffany Glass and Decorating Company, *Punch Bowl with Three Ladles*, 1900, favrile glass and gilded silver; bowl: 14 1/2 x 24 inches diam.; ladles:1/2 x 3 1/2 inches. Virginia Museum of Fine Arts, Richmond, Virginia. The Sydney and Frances Lewis Art Nouveau Fund.

was added in 1896.[66] By 1900, Bénédite acquired four more American paintings for the Luxembourg, with works by Walter MacEwen, John Humphreys Johnston, Ben Foster, and Winslow Homer. The purchase of Alexander Harrison's *En Arcadie* (fig. 145), which had been a success at the 1889 Universal Exposition (but was not exhibited in 1900), underscores Bénédite's historical perspective and the importance of acquiring important works from an earlier time.[67]

Among other works acquired in 1900 was *Portrait de la mère de l'artiste* (fig. 146) by the expatriate Humphreys Johnston, who was recognized as a follower of Whistler. Bénédite was obviously adhering to the insight of some critics or his own inclinations by acknowledging Whistler's influence on the American school.[68] MacEwen's *Dimanche en Hollande* (fig. 48), which had been shown at the most recent exposition, was acquired in October 1900 for 1,000 francs.[69] This work suggests the artist's roots in French and Dutch genre scenes (the kind of compositions that often were highly praised at the time).[70] The acquisition was aided by MacEwen's reputation as a well-honored painter who contributed extensively to the Paris Salons and who received a silver medal at the 1900 Universal Exposition.

A third painting purchased by the state was New Yorker Ben Foster's *Bercé par le murmure d'un ruisseau* (fig. 147), which was obtained in January 1901 for 500 francs.[71] Although Foster is little known today, his work offered new directions for landscape paintings at the turn of the century both in terms of tonalist style and New England setting. All of these canvases conform to the ways in which progressive critics and arts administrators of the era regarded American painting. They readily recognized achievements in genre painting but were more hesitant with innovations in portraiture and landscapes, preferring instead to accept the influence of Whistler or the poetic mood of European symbolist imagery, as seen in the work of Foster.

With the acquisition of Homer's *Nuit d'Eté* (fig. 92), American representation in the Luxembourg became even more adventuresome. While this enigmatic composition is difficult to situate in Homer's career, at the

144. Léonce Bénédite, Reinstallation of the Musée du Luxembourg, Archives du Louvre.

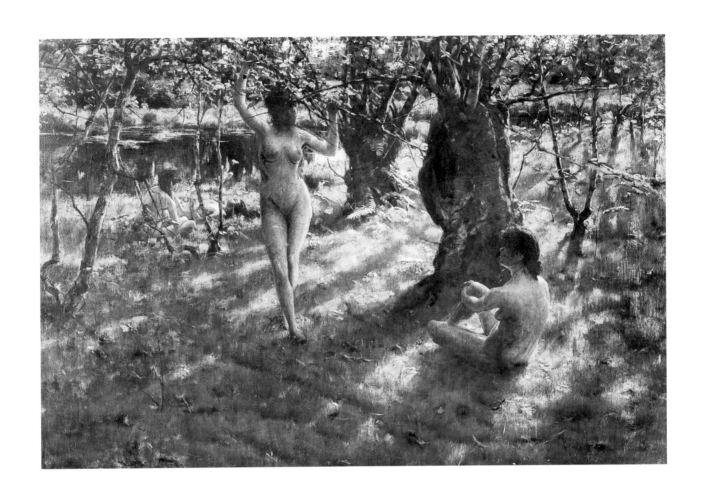

145. Alexander Harrison, *En Arcadie,* 1900, oil on canvas, 6 feet 5
inches x 9 feet 7 inches. Musée d'Orsay, Paris.

time it was probably seen as reflecting the independent character of American art and as linking the American school with the most advanced symbolist interests of the period. The purchase of this painting, aquired in January 1901 for 1,000 francs, as well as the one by Foster, was negotiated directly through John Cauldwell in New York.[72] Writing to Roujon, Cauldwell was enthusiastic about the acquisition of these works, which represented a high point in his assistance of American artists.[73] The selection of a painting by Homer confirmed the high esteem in which he was held—he received a gold medal at the 1900 exposition—and suggests the international appeal of his mysterious scene of a summer night near the sea.[74]

Bénédite's intense dedication to American art remained constant. In 1907, when the Carnegie Institute of Fine Arts in Pittsburgh expanded its facility, Bénédite was asked to deliver an inaugural address. This speech, which exists in preliminary form in the Archives du Louvre, provides evidence of Bénédite's perception of his mission, his efforts to further awareness of French art in the United States, and his role of promoting art through education, much as Andrew Carnegie was doing in Pittsburgh.[75] The trip across the Atlantic enabled Bénédite to determine how American art could be integrated into the Luxembourg collections and allowed him to study art firsthand by visiting New York, Boston, Chicago, Cincinnati, Baltimore, Philadelphia, and Washington, D.C.[76] Aside from paintings, Bénédite also purchased sculpture from Augustus Saint-Gaudens, who had received a grand prize at the exposition. This acquisition included his *Amor Caritas* and fourteen medallions.

As the last remaining member of the original trio of Third Republic administrators, Bénédite continued to support American art and to write about his interest in it as ties between France and the United States deepened both before and after World War I.[77] Bénédite saw the dreams of his confreres realized by organizing an impressive international retrospective of American art on view at the Luxembourg in the fall of 1919. Drawing upon the fifty-six works that were then in the Luxembourg collection, he added a sizable number of works sent from the United States. As he wrote in the catalogue text, American art possessed "l'esprit de fantaisie, de sentiment, de poésie et de mystère." He also recognized that the exhibition reinforced the role French art had in influencing American painting.[78] What Bénédite had earlier advocated—greater awareness of American art on the public level—had come to pass. In the private realm, however, the French were more tentative about American art.

Private Collecting: The Case of Georges Leygues

Although the acquisition of American art by private French collectors cannot be substantiated, Georges Leygues's alleged pursuit of this interest represents a significant development in that area. American newspapers avidly reported Leygues's purchase of American paintings from the Universal Exposition after John Cauldwell announced the acquisition at a news conference.[79] For Cauldwell, Leygues's acquisitions would have been the necessary confirmation, by an official of the French government no less, that American painting finally had been accepted. While none of the works Leygues reportedly purchased has been found—some of his descendants deny any collecting habits on his part at all—he still might have developed artistic tastes similar to those of Georges Clemenceau.[80] Family descendants in the United States, including one who lived with Leygues over the last fifteen years of his life, have asserted that Leygues had no art collection and little personal money with which to buy paintings.[81] Leygues was hardly poor, for in 1909, at a relatively young age, he received a fortune from his friend Alfred Chauchard.[82] Even though this money was not available to him at the time of the Universal Exposition of 1900, it is still possible that Leygues purchased American paintings by lesser-known artists at a low cost. All of this remains speculative, since none of the paintings thought to be in

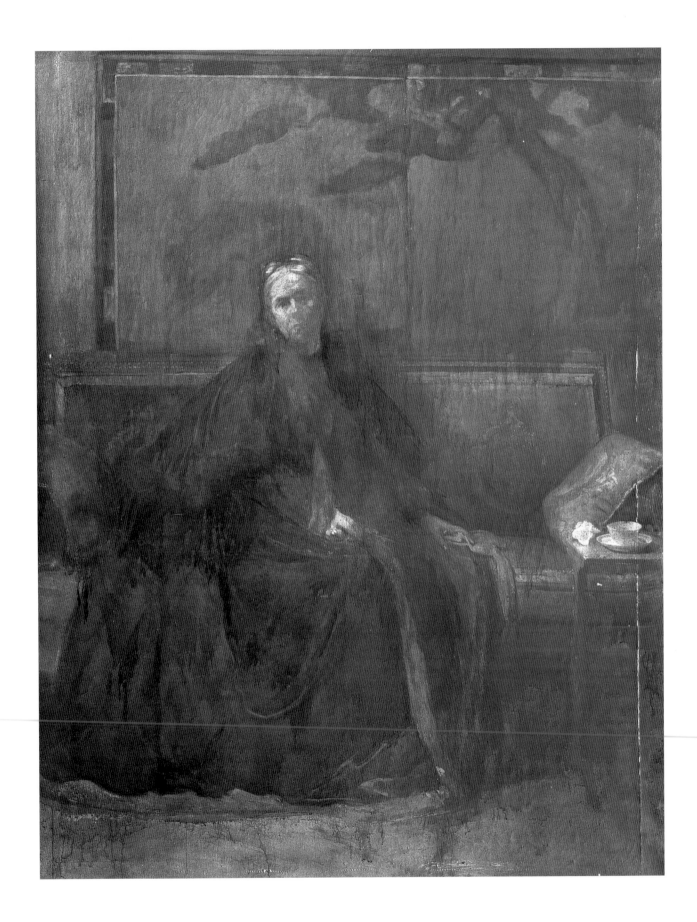

146 (*facing page*). John Humphreys Johnston, *Portrait de la mère de l'artiste (Portrait of the Artist's Mother)*, 1895, oil on canvas, 74 3/8 x 61 1/4 inches. Musée de la Coopération franco-américaine, Château de Blérancourt.

Leygues's possession has surfaced, despite repeated efforts to locate them.[83] Leygues supposedly purchased works by Charles C. Curran, Charles Warren Eaton, Homer Lee, and Sergeant Kendall. Of the four, Curran was the best known in 1900, when he served as a "sous-directeur" for the beaux-arts section of the exposition.[84] Curran showed two works at the exposition—*The Dew* and *The Peris*—(fig. 36) but the specific work attributed to Leygues's collection remains unknown (with *The Peris* ostensibly being lent to the exhibition by a private collector). Eaton, on the other hand, had a studio in New York City and exhibited three works in 1900, including a pastel and a watercolor. As a tonalist landscape painter, who lived in Bloomfield, New Jersey, Eaton represented an important aspect of American creativity. The third artist, Homer Lee, was of an older generation, and his work of 1900 was unusual in that it depicted a tall apartment house, the kind of skyscraper that endeared his work to the French who were mesmerized by American architecture. Kendall, the fourth artist, submitted two works to the exhibition, one of which, *St. Ives, Pray for Me* (fig. 131), was mentioned by critics and reproduced in official publications. Again, it is uncertain which work Leygues obtained, but he most likely acquired *St. Ives* because it was a press favorite. Since no documentation on these paintings has been located in the records of works secured by the state or by the Musée Nationale du Luxembourg, they were acquired by Leygues if they were purchased at all.[85]

The history of this phase of private art collections lies with the domain of the Leygues family. The only trace of a tie between Leygues and these American artists, beyond American newspaper articles, is a recent report from a family lawyer that a letter from Homer Lee to Leygues was found in material from 1900.[86] Since Leygues did know English and was open to American contacts—one daughter eventually married an American—he might have corresponded with artists in the United States, such as Lee, on his own. Since Leygues was also instrumental in helping to secure Bartlett's sculpture of *Lafayette* for the courtyard of the Louvre (fig. 148) there is another instance of his willingness to

obtain American imagery for France, if not for himself. The record of this relationship and of such French-American contacts remains largely unprobed. The possibility nevertheless endures that Leygues was building a small, private collection in conjunction with the one being formed at the Luxembourg. This development on a private level would represent a major step forward in the appreciation of American art in France.

Because Bénédite and Leygues were in constant communication on matters regarding art, Leygues's championing of American artists would have been timely.[87] His assistance and own interest in collecting bore real importance, since they preceded the larger interest in American art and commercialization that swept France after 1905.

The Taste for American Art After 1900

The fact that the French were acquiring American art greatly affected the American art community. For example, the American Art Association increased its presence in France after the exposition, and by 1905 a League of American Artists was instituted to provide a permanent marketplace for American painters.[88] The idea of establishing an ongoing American Salon also received considerable support from several influential French and American patrons.[89] The Universal Exposition of 1900 had obviously made American art extremely popular in France.

However, American art was not being collected or studied in France for purely commercial reasons. Certain administrators of the Third Republic genuinely believed that the United States, by inventing itself and defining its own culture, represented something new and timely. This greatly appealed to French concepts of progress and modernity, which dominated the era. In particular, American innovations in the industrial arts and architecture were strongly praised and utilized as teaching tools for France's emerging generation. The

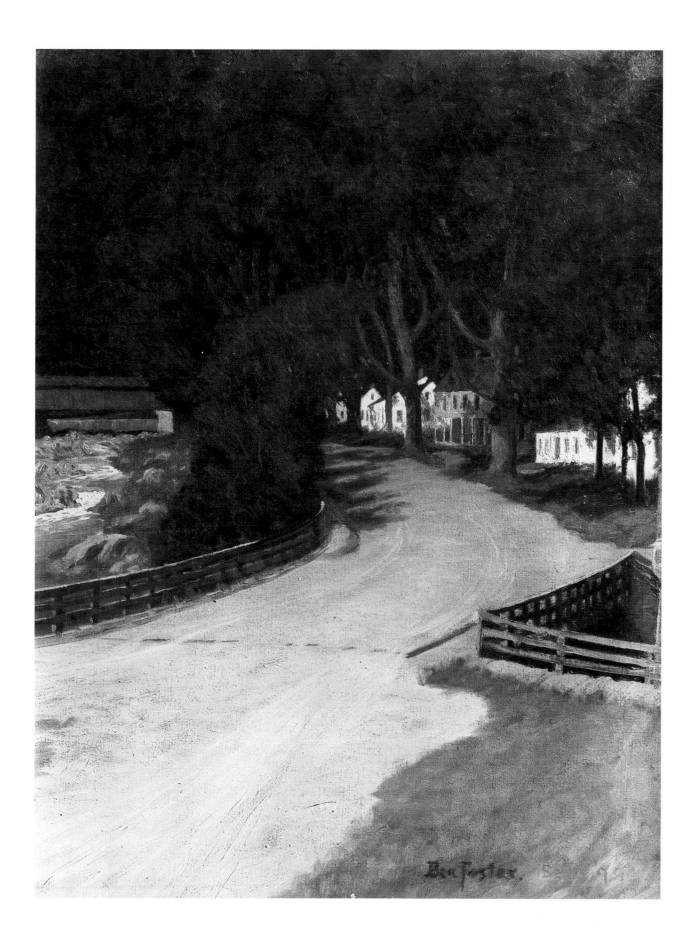

Ben Foster.

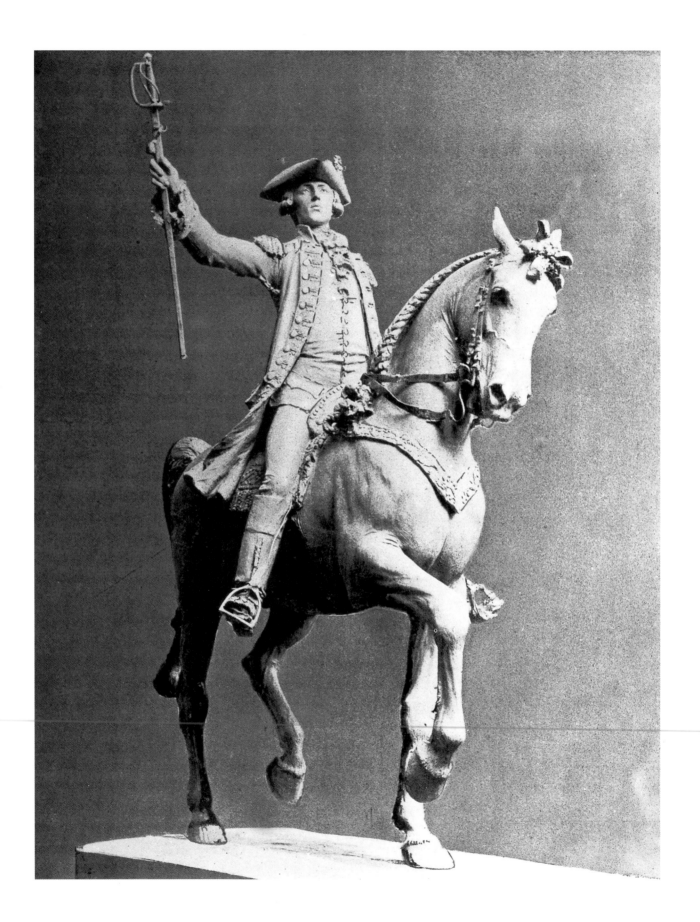

148 (*facing page*). Paul W. Bartlett, *Statue of Lafayette,* plaster sculpture temporarily in the Place du Carousel Paris, 1900. *Paris Exposition Reproduced from the Official Photographs Taken Under the Supervision of the French Government for Permanent Preservation in the National Archives.* The R. S. Peale Co., 1900.

United States was held up as a standard against which France should measure itself.

Only after the French moved beyond the Americans' reliance upon European traditions in painting and their ability to assimilate the most recent developments in the arts, did they admit that Americans had originality, especially in portraiture and landscapes. Public debate regarding American achievements in part reflects the Third Republic's open philosophy toward innovations in the arts. By presenting American art as an inspiration to French creators, leaders of the French art world, guided by Georges Leygues and his close friend Léonce Bénédite (as well as Roujon), forged a major shift in the artistic philosophy of France. They insisted that France become less insular and more open to outside stimuli which were shaping the modern spirit. The foundations for change, laid around 1900—with the United States serving as the core agent for modifications—are still being debated, as France once again tries to maintain its cultural supremacy in the current cycle of intense competition.

GAIL STAVITSKY

The Legacy of the "American School": 1901–1938

The Exposition of 1900 contained an American section which revealed a great deal of motive and character that could not be lightly dismissed as but a reflex of Europe Then one gradually became conscious of more sobriety, earnestness, and simplicity; in fact, of a more obvious conviction, in the American work than in that of the French section as a whole. The Americans did not seem to be painting in obedience to some vogue Their work . . . was unassuming and straight-forward, penetrated with realism and often tempered with poetic feeling These qualities of earnest force, of directly independent vision, and strong, straightforward treatment, so conspicuous in Homer's pictures, drew the foreign critics to a conclusion that this virile personality might be really representative of American art.

CHARLES CAFFIN, 1902[1]

The exposition of 1900 provided a rich legacy for the early twentieth century as its critics and participants defined much of the mythic, critical discourse concerning the nature of the "American School." This ongoing, obsessive struggle to construct a nationalist American art was manifested during subsequent expositions and in pioneering surveys of American art by critics and museum curators. For many of these cosmopolitan individuals, the

perimeters of the American School were flexible, accommodating an eclectic array of masters, from the urbane expatriates Whistler and Sargent to the home-grown talents of Inness, Eakins, and Homer. The Paris 1900 generation was recognized as having provided a viable foundation for a diverse American culture rooted in a complex apprehension of native character, experience, and environment.

Nationalism and Internationalism in American Art: 1901–1910

Even before the first major expositions of the new century, part of the American paintings display of 1900 was brought home for Americans to savor their international triumph. At the Pennsylvania Academy of the Fine Arts, seventy-five paintings were presented early in 1901 as a complement to the annual exhibition, commonly regarded as the largest and most representative display of current American art. The majority of works were native landscapes produced by stateside painters; expatriates were excluded, thus giving "the false impression that the Paris show was more 'native' than it actually was."[2] The exhibition was hailed as manifesting a truly national spirit, and various critics attempted definitions of this phenomenon.[3] Whereas the directness, vigor, and simplicity of Eakins's frank portraiture was contrasted to the flamboyant work of Sargent, another critic observed that American "painting has become, not a record of current life, but a solution of artistic problems exclusively decorative."[4] Nevertheless, the exhibition was commonly regarded as a sign of the great progress that American art had made, "not only with respect to work done by the artists, but with respect to the appreciation accorded by the art-loving public."[5]

Later in 1901 the Pan-American Exposition in Buffalo featured over 20 percent of the paintings from the Paris show. With entries limited to work by North and South Americans, the paintings of stateside artists dominated this large show, promoted as the most complete and representative exhibition of contemporary American art. Also included were paintings by "such eminent artists as George Inness, Homer Martin, and A. H. Wyant, among those who have passed away, but whose work lends glory to the contemporary American school."[6] Inness was represented by a group of seven canvases which confirmed his status, along with Martin and Wyant, as the pioneers of a new direction in American landscape painting—away from topographical accuracy and toward broad, painterly, subjective interpretations of nature.

The liberating influence of the Barbizon School and study abroad played critical roles in this cosmopolitan development, enabling American painters, in the opinion of prominent modernist critic Charles H. Caffin, to "establish . . . themselves in rivalry with the best painters of Europe."[7] As the art critic for the *New York Post*, Caffin was among the most visible and authoritative critics of his day when increasingly professional art criticism was becoming established in conjunction with the rise of mass newspaper and periodical presses.

As he looked around the American display at Buffalo, Caffin declared that eclecticism prevailed as a result of the native artists' constant travel and free exchange of ideas. Proclaiming the eminently artistic quality of the Americans' techniques, he noted a lack of imagination in the treatment of the human figure, except in portraiture. Praising the strength of the landscape and marine paintings, Caffin observed that "it is here that American art finds its most spontaneous and individual expression."[8]

Another leading voice of authority was Royal Cortissoz, renowned conservative art critic on the *New York Daily Tribune*, who praised the truly representative scope of the Buffalo show as ranging from orthodox members of the National Academy to "the most impressionistic or otherwise adventurous juniors."[9] Cheered by the variety, vitality, and artistic skill of the work on view, Cortissoz commented on "the peculiar sincerity and beauty of our landscapes" rooted in French romanticism which "unleashed our sense of national individuality."[10]

Finding Inness, Wyant, and Martin to be the most eminent and imaginative of American artists, Cortissoz decried the lack of individuality of many artists identified with Paris and its Salon. He listed the works of Alexander Harrison, John Alexander, and Gari Melchers as exceptions to this rule in terms of their freshness. He also observed that the narrative element in American art was less important for most painters than the strictly aesthetic quality of their work, citing F. D. Millet and the "homely Americanism" of the work of J. G. Brown as exceptions.[11] Cortissoz concluded that it is "to America that Europe must look for the two men [expatriates Whistler and Sargent] who have reached the highest level of art at this end of the century."[12]

The Pan-American Exposition was the source of inspiration for an informative survey of the aims of leading American painters. Authors John Rummell and E. M. Berlin anointed Whistler as the most loyal apostle of art for art's sake, La Farge as the celebrated American colorist, and Chase as the master technician. Inness painted the varied native landscape in a genuinely American spirit and exerted a strong influence on contemporary artists who had absorbed much of his virility and breadth of vision. Yet Winslow Homer was "the most American of all our painters [whose] work never betrays the influence of any school of art or the method of any other artist."[13] Nevertheless, expatriate Edwin Lord Weeks's choice of Oriental themes was also praised and accompanied by the observation that American artists were often denigrated for not confining themselves to American subjects. The authors commented that critics of this tendency, "in their zealous desire to hasten the day when we shall have a distinctly national art, forget that the artist paints what attracts him most, and if he is to express the best that is in him, he must be allowed to follow the bent of his own genius."[14]

In contrast to the Pan-American Exposition, the next major fair—a centennial celebration of the Louisiana Purchase—was international in scope. The St. Louis fair of 1904 featured many of the artists in the Paris exposition, including Americans living abroad. Furthermore, there was a historical section of American art created between 1803 and 1893 (before the Chicago Columbian Exposition). In the catalogue preface, the claim for a national school was made:

> The exhibit of paintings in the United States sections demonstrates again, a fact made plain at the Paris Exposition, and cordially acknowledged there, that we have a distinctive American art, so individual that it can be mistaken for no other. American art, like American literature, is eclectic; but when from the technique of the foreign school the artist comes home for his subject, his interpretation and his atmosphere, we have the American picture.[15]

According to J. W. Buel, who edited *Louisiana and the Fair*, the American artists' eclecticism, virility, and originality stemmed from a characteristic absence of prescribed formulas, nurtured by America's progressive environment of invention and new ideas. Among the highlights of the show were landscapes by Inness; according to Buel, "neither [his] training nor extensive travels [abroad] eradicated or even affected his inherited American tendencies."[16] Portraits by Whistler and Sargent were also regarded as among the most notable works, and were praised by Caffin as among the best works by these two great masters of American art while Homer, foremost among living American painters, was not as well represented.[17] Caffin regarded the exhibition as probably the most truly representative show up to that time with its inclusion of Americans residing abroad, coverage of a wide territorial range, and introduction of such younger painters as Robert Henri and William Glackens. Caffin contributed more thorough analyses of the distinctive qualities of American art in two landmark surveys of 1902 and 1907.

In *American Masters of Painting* (1902), Caffin promoted Inness, La Farge, and Whistler as great innovators whose achievements were firmly rooted in the native environs, despite their European connections. Although La Farge was of French descent "with romantic and adventurous associations," he was nevertheless influenced by "the vital practicalness of the American envi-

ronment."[18] Caffin also had high regard for Sargent's possession of the alertness and versatility of the American temperament, although, as a master of the actual, he was considered inferior to the spiritual genius Whistler. Homer was the quintessentially American artist whose art focuses on the tangibility of things with a unique vigor and directness.

Caffin ranked Homer Dodge Martin as the most poetic of all American landscape painters, reasserting the relative independence of some of America's landscape and marine painters from European influences as they engage the local character of various American terrains. Indeed he felt that the tonalist landcapes of Dwight Tryon and others best represented the "kind of contribution that the American temperament might be expected to make to the progress of painting" by combining "a largeness of outlook with alert sensibility to impressions; being, at once, big in character and minutely subtle."[19] Caffin reprised these themes in *The Story of American Painting* (1907), emphasizing the cosmopolitanism of landscape painting, stemming from Barbizon, as the most vital tradition in American art, which restored the claims of the spirit in an age of rampant materialism.

Regarding American landscape painting as a product and expression of native sentiment throughout the course of its history, Caffin believed that the progress of figure painting was more uncertain. Only relatively recently had such artists as Brush, Thayer, and Dewing expressed a distinctly American attitude towards maternity and maidenhood in their puritanical images of women.[20] Furthermore, Caffin asserted that "a great deal of American painting is characterised . . . by a desire to be amiable rather than convincing," as a reflection of the "taste of our time [which] runs to superficial sentimentality."[21] Exceptions to this rule were Eakins and Homer, the latter of whom Caffin regarded as America's greatest exponent of realism. Both possessed qualities of manhood and rationality that were considered rare in American art.

Caffin concluded that progress in American art was typified by Whistler and Thayer among figure painters,

as well as by Twachtman and Homer among landscapists who have "treated the actual appearance as a symbol of moods and apprehensions of the imagination and spirit."[22] Despite the cultural and geographical diversity of America, Caffin believed that the art of this country had made "a very separate impression" at the Paris Exposition of 1900 and employed the following words to analyze it: "capability, moderation, sanity, and perhaps a lack of individualism."[23]

Besides Caffin, several other critics made early, major contributions to defining the history of American art. In his 1902 survey, the modernist critic Sadakichi Hartmann typically identified Inness as America's greatest landscape painter who expressed the most feeling for the poetry of his country. Eastman Johnson was America's only great storyteller; few succeeded as well as he in rendering the picturesque aspects of American life. Hartmann believed, however, that it was rare to "find an American artist who is also American by nature," citing the cosmopolitan Whistler's profession "that art is universal."[24] He found it peculiar that nearly all the masterpieces painted in America by Americans show refinement rather than the strength characteristic of a young nation. The key exceptions to this effeminate, native sensibility were Homer and Eakins, who fulfilled "the Whitman ideal, just to state a thing virilely."[25] They were the fulfillment "of what all the men since 1828 had struggled for, the beginning of a native art . . . masters [who] have strong, frank, and decided ways of expressing something American."[26]

The most extensive history of American painting was that of the painter Samuel Isham, whose observations in 1905 are similar to those of his contemporaries. Asserting that foreign models influenced American landscape and figure painters alike, Isham found Homer to be the great independent exception. Attempting to define native aspects of our art, he described the artist Millet as possessing "the old American versatility, the abounding energy that can be turned at will to whatever task insistently demands it."[27] Landscape painting was still the strongest and most characteristic branch, with masters like Inness and Martin assimilating French influence on a basis of native training and practice.

Tonalism and "the attempt to infuse personal feeling into the copying of nature" prevails as in "no other country."[28] The impressionists Twachtman, Weir, Hassam, and Metcalf "acclimatized a principle . . . and not a manner"; their individuality and "Americanism count pre-eminently in the establishment of their rank."[29]

Isham felt that portraiture and figure painting lacked this sense of unity; the nude subjects painted by many artists returning from abroad were not in accord with national habits of prudishness. Practical, energetic, sentimental, the Americans lacked religious and mythological traditions, "but something of what goddess, saint, or heroine represented to other races they find in the idealization of their womankind," as in the work of Thayer and Brush.[30] Isham concluded that American painting exhibited sanity, wholesomeness, optimism, joy, and beauty, as well as a preference for aesthetic qualities rather than intellectual content.

J. Walker McSpadden contended that true art is international in his survey of 1907. Nevertheless, he characterized Inness as a master whose "genius grew in native soil," representing "a new American movement . . . which was to shake itself free from foreign tradition and rest upon the bed-rock of nature alone."[31] In 1908 Christian Brinton asserted that every artist is essentially a nationalist who suggests a larger heritage by freely expressing himself. The eclectic, spiritual Whistler's "equipment was typically American and national. The inquisitiveness, the independence, and the seeming irreverence of his nature were his by right of birth."[32] As for Sargent, so "dazzled has the majority been by [his] cosmopolitanism that the real racial basis of his nature has been overlooked," especially his "adaptability and his very lack of marked bias."[33] Similarly in 1909 William Howe Downes attempted to define William Merritt Chase as a "typical American artist" who is "sane, unsentimental, truthful, and unpretentious"—part of a larger phenomenon of American painting as "pervaded by a refined, orderly, intelligent eclecticism, which has . . . more cleverness than inspiration, more skill than passion."[34]

As a member of the younger generation who would challenge the complacency, sentimentality, and effete academicism of much of turn-of-the-century American art, Robert Henri in 1909 broached the subject of nationalism. Embracing Whitman's ideal of self-knowledge as a first step, Henri contrasted the approaches to nature of two native masters whom he revered: Homer and Twachtman. He concluded that, as a result of their own individual attitudes toward the beauty or the power of their environment, these Americans expressed a national point of view. Henri's refusal to provide a "recipe for this making of American artists" was typical of his emphasis upon freedom of thought and expression, as well as his organization of independent exhibitions, which paved the way for the landmark Armory Show of 1913 in New York.[35]

Further Growth of an American Tradition: 1910–1920

Known primarily as the *succès-de-scandale* that introduced European modernism to America on a large scale, the Armory Show was also the occasion for mostly negative inquiries into the notion of a national art. Henri's associate William Glackens, a participant in Paris 1900 and a co-organizer of the Armory Show's American section, decried the lack of honesty, vigor, and innovation in native art, observing that even "Homer so much lauded as a purely native product, was . . . never the power that he became, until he got under the influence of France."[36] Nevertheless, this reversal of attitudes toward the Paris 1900 generation was only a temporary setback. Many among their ranks were featured and critically acclaimed in San Francisco's Panama-Pacific Exposition in 1915, which celebrated the opening of the Panama Canal. Separate galleries or walls were devoted to the work of deceased artists, including Whistler, Abbey, Homer, La Farge, Robinson, and Twachtman. Prominent among the living artists allotted this honor were Chase, Sargent, Weir, Tarbell, Hassam, and Redfield.

In his extensive analysis of the show, J. Nilson Laurvik repeatedly referred to the native aspects of such masters

as Sargent, praised as the consummate interpreter of "the volatile and highly assimilative genius of America."[37] Whistler's attentive restlessness, rare powers of assimilation, and cosmopolitanism made him "the representative American"—a Yankee who is at home everywhere.[38] Therefore, Whistler's "modern mysticism," which retained strong suggestions of his Puritan origin, and Sargent's "modern realism" suggested the scope and diverse character of American portrait and figure painting.[39] Laurvik also reiterated the common belief that landscape painting was the one domain of American art in which painters had most quickly emancipated themselves from foreign traditions and achieved a truly national expression. Indeed Laurvik contended that "the dominant traits of American character: its delicate, high-strung, nervous energy and alert restlessness—are directly traceable to the intense, penetrating brilliancy of the light here which has a greater actinic quality than that of any other country."[40] For Laurvik, this "vibrant violet" was "the color of America, which is gradually being revealed to us by our present-day progressive landscape painters [such as the impressionists Hassam, Weir, Redfield, and Metcalf], who are interpreting the color and character of our country with increasing truthfulness."[41]

Turning to realism in recent landscape painting, Laurvik praised the independent, virtually self-taught Homer as the most "forceful and thoroughly American personality" whose work had "a racy, colloquial accent that smacks of the soil from which he came and to which he held fast."[42] He made similar remarks concerning the very different work of Weir, as poet of the intangible whose art possessed a racy, vernacular accent that partook of the New England hills. Comparing Weir's work to that of Twachtman, Laurvik concluded that one would look in vain "for anything approaching this clear, vibrant sensitiveness and simplicity of statement in the work of foreign artists."[43] This quality, still defined in terms of turn-of-the-century theory, was regarded as essentially American; the product of assimilated influences that were both refined and revitalized.

The modernist struggles of American painters were virtually uncharted by this exhibition. Reviewing the American display, Christian Brinton noted a quotidian familiarity as well as a lack of individuality, fervor, and creative productivity in comparison with foreign colleagues. He observed that the "Fontainebleau-Barbizon tradition which so long darkened and sentimentalized native landscape, and the aesthetic anaemia that emanated from the delicate organism of Whistler, have been succeeded by fresher, more invigorating tendencies" in the work of such younger painters as Frederic C. Frieseke, George Bellows, and Arthur B. Carles.[44]

Although Brinton detected a pervasive familiarity in the American display, others such as Michael Williams found a manifestation "of what Bergson calls the 'vital urge' the powerful impression of Americanism [that is] a happy mingling of ideas taken from other civilizations and adapted to our own use."[45] Among the landscape painters, selective realism was the keynote of some of the varied work, whereas with others there was an animated, spiritual presence of poetry. Furthermore, the "poetics of Twachtman should not make one dim-eyed to the realities of Redfield, nor the physiological-psychology of Sargent stun us to the psychic enchantments of Whistler."[46] Dominated by portrait and landscape painting, this synthetic, virile, and lyrical Americanism was rooted in a common soil of commingled cultures that nourished eclecticism and spelled the end of America's dependence upon the Old World.

The aesthetic standards of the Paris 1900 generation thus continued to exert a strong impact upon American art, as articulated in 1912 by one of the participants, Robert Vonnoh: "Added to a high moral tone and a fine sense of reserve, born of Puritan ancestry, together with a modern catholicity, they have steadily advanced from the already high standard attained at the International Exhibition at Paris in 1900, until today, the American artist's work is as good an investment artistically and financially as his fellow artist's abroad."[47]

Entering the annals of history, several key members of the Paris 1900 generation were honored by memorial exhibitions that provided opportunities to assess their contributions to American art. In 1917 Chase and Eakins were the subjects of retrospectives at The Metropolitan Museum of Art. Eakins's show set the stage for his posthumous emergence as America's great "old

master" painter. He was praised as "the most consistent of American realists" whose "manly and thoughtful art" attained technical competence through study abroad and "still kept something of the quality of the rugged and homely America of [his] prime."[48] He had become the hero of a younger generation of artists; John Sloan regarded him as the only great American painter who had yet occurred.[49] For Henri, Eakins was a man of iron will, independence, and integrity who was the greatest portrait painter America had produced.[50] By 1914 Eakins (despite his training abroad) publicly espoused ideas somewhat akin to those of his supporters as he exhorted artists to stay home "to study their own country and portray its life and types free from any foreign superficialities" in order to create "a distinctly American art."[51]

More available to the younger generation as a nationalistic model of artistic integrity was Winslow Homer, whose work was often exhibited and reproduced. In 1914 he was the subject of a monograph by his Paris 1900 academic colleague Kenyon Cox who contrasted him to Whistler, "the brilliant cosmopolitan . . . whose art is American only because it is not quite English and not quite French."[52] Descending from "pure New England stock," Homer was "the sturdy realist who attacks his subject with forthright simplicity and sincerity [and] has given us the most purely native work, as it is perhaps the most powerful yet produced in America."[53] Writing in 1919 of Homer's independence and pervasive influence, John Van Dyke applauded "the Americanism" of Homer's art:

> For nothing more virile, more positive, more whole-
> some has ever been turned out in American art
> The very rudeness of it proclaims its place of origin.
> Reflecting a civilization as yet new to art, a people
> as yet very close to the soil, what truer tale has been
> told! The fortitude of the pioneer, with the tang of
> the unbroken forest and the unbeaten sea are in it.[54]

Furthermore, Van Dyke asked whether the foreign-based art of the generation active from 1878 to 1915 proclaimed American ideals and reflected American life.[55]

His questioning of cosmopolitan trends in American art would characterize a widespread search for national identity during the 1920s and 1930s.

The 1920s: Quest for National Identity

During the 1920s American artists and writers grew increasingly aware of their heritage and wanted to manifest in their work an American spirit or presence. This pervasive search for national identity culminated in the foundation of such institutions as the Whitney Museum of American Art in 1931. Gertrude Vanderbilt Whitney, future founder of this most comprehensive museum of American modern art, declared the "end of America's apprenticeship in art" in 1920.[56] Declaring a reawakened patriotism in the wake of World War I, she reviewed the history of art in America, finding Inness, Wyant, Martin, and La Farge to be among those who used the language of Europe as a point of departure for an individual and national art. Discarding French influences, Eakins "embodied America's Puritanism and its intolerance towards evil, whereas the "rugged strength" characterizing the work of Homer "is an entirely native product."[57] She concluded that, above all, American artists express a Puritan point of view, characterized by austerity, strictness, rigidity, and power, as well as a severe simplicity that lacked subtlety, imagination, and passion.

Another key participant in this search for national identity was the critic-collector Duncan Phillips, founder of the first museum of European and American modern art in this country, the Phillips Memorial Art Gallery, which opened in 1920 in Washington D.C. The members of the Paris 1900 generation were well represented with works by Whistler, La Farge, Inness, Chase, Twachtman, Weir, Melchers, Hassam, and Homer, "an independent American . . . untouched by foreign influence and delighting in the character of his native land and of his countrymen."[58] Phillips believed that America, although a cosmopolitan amalgam of alien races, had developed a national way of seeing gained from our own

observations and experiences, with merely technical aspects learned from abroad.[59] He identified the following native qualities which Homer and Inness inherited and transmitted to present-day American painters: "Buoyancy of normal healthful spirit, free from too much constraint of tradition . . . combined with a natural frankness . . . an eloquent enthusiasm, and an ardent love of life."[60] Believing that American taste was chiefly characterized by its moderation, modification, and refinements upon European techniques, Phillips referred to the "spiritualized impressionism" of Weir and Twachtman as superior to that of the French masters.[61]

In his monograph on Weir, Phillips in 1921 stressed the artist's Anglo-Saxon Americanism as an aristocratic "subtlety of observation . . . delicacy of feeling reticent idealism" in contrast to the typically American qualities associated with Walt Whitman and Mark Twain: plain-spoken, democratic, sensational, and vulgar.[62] For Phillips, "this chivalry of thought and this idealizing love of familiar things are traits of the fundamental, the original American."[63] Believing in "the coming of an American Renaissance," Phillips concluded that a "truly national art" must "grow up out of the soil and retain something of its savour."[64] Similarly critic Royal Cortissoz in 1925 praised The Metropolitan Museum of Art for opening its new American wing the previous year, asserting that "Americans need to know the soil in which the evolution of their art is rooted."[65]

This nationalistic concept of the American soil was also employed by Henri and the modernist painter-critic Marsden Hartley in a 1921 book of essays. In "American Values in Painting," Hartley characterized Martin, Ryder, Fuller, and Homer as "typical of our soil and temper," declaring that these men "and not the Barbizonian echoes as represented by Inness, Wyant & Co.," would "represent for us the really great beginnings of art in America."[66] Conscious of "nothing really outside of native associations," these "imaginative artists" seldom "ventured beyond more than a home-spun richness of color," having "worked out their artistic destinies on home soil with all the virility of creators."[67] He dedicated chapters to Martin, Ryder, and Fuller as "Our Imaginatives" and the only "consistently convincing American Impressionists" Twachtman and Robinson who "never slipped into the banalities of reiteration and marketable self-copy."[68] Another essay is dedicated to "the unflinching realist" Homer, whose "pictures are yankee in their indications . . . flinty and unyielding, resolute as is the yankee nature itself one of New England's strongest spokesmen."[69] Hartley found a "virility of technique" to be a typical native characteristic of Homer, Whistler, Sargent, and their successors whose work constituted "a localized tradition."[70]

Hartley's book was introduced by Waldo Frank, who, along with Van Wyck Brooks, Randolph Bourne, Paul Rosenfeld, Lewis Mumford, William Carlos Williams, and others, were devoted to America's growing self-consciousness and maturity in the arts, as reflected in a significant body of literature. Frank Jewett Mather authored *The American Spirit in Art* (1927). The painter-critic Nathaniel Pousette-Dart compiled the Distinguished American Artists books on Hassam, Sargent, Thayer, Whistler, and others. The keynote of this series was national integrity.[71] Hassam's Puritan "birthright" was reflected in the masculine "vigorous quality . . . New England thoroughness" that was "bred into his art."[72] Sargent "is the most characteristically American" of all painters, whether or not "he owes to his Yankee forebears his keen objective vision, the variety and elasticity of his invention, and the expertness of his hand."[73]

The nationalism fostered by these cosmopolitan critics and artists was inclusive and rooted in the diversity of this country's "usable past." America, Rosenfeld claimed in 1924, is "the native soil of anyone who *feels* it to be his."[74] These shifting, expansive formulations of national identity were, however, already challenged by the conservative Cortissoz. He identified the honest, straightforward, clean-cut force of Eakins's work and almost blunt naturalism and truthful directness of Homer's work which was permeated with the spirit of place.[75] Cortissoz also, however, demonstrated a bias against foreigners participating in the formation of an American art that was shared by the young critic Thomas Craven who would epitomize the chauvinistic American Scene movement of the 1930s. In

1925, Craven questioned the patrimony of Oscar Bluemner, Andrew Dasburg, Abraham Walkowitz and others lacking "good American names," asserting that Ryder, "our greatest painter, was . . . independent of all Europeans, dead or alive."[76] Believing that "American soil cannot at present nourish a metaphysical imported culture," Craven equated foreignness with effeminacy and called for the restoration of "masculine virtues [for] all great painters have been coarse, earthy, and intolerable."[77] Among the latter he would later identify Homer and Eakins as "true reflections of the American spirit homegrown stuff [that] stands out vigorous and healthy, crude perhaps, and a little naive but real."[78]

In her important history of American art in 1929, Suzanne LaFollette noted there was a strong tendency in the United States to condemn foreign influence and to contend that if American art is to be truly American it must develop on American soil.[79] Regarding this prescription as somewhat drastic, for art should develop from the richest available sources, LaFollette nevertheless criticized the two most cosmopolitan artists of the Paris 1900 generation, Whistler and Sargent, for their superficial virtuosity, their lack of force and carrying power.[80] Her criticism coincided with the decline of these masters' reputations (especially that of Sargent) and a concomitant rejection of their genteel cosmopolitanism.[81] On the other hand, Eakins's ardor for objectivity and independent-minded neglect of the beauties and graces of painting typified the essential spirit of late nineteenth-century America. Homer's powerful and strongly individual appeal secured his rank among the foremost American artists.[82] Rising to the foreground as part of this nativist, isolationist search for a "usable" past were three great homegrown masters Homer, Ryder, and Eakins who were, as Barbara Weinberg has observed, extracted "from the cosmopolitan matrix of their time."[83]

Definitions of a National School: The 1930s

The key event that thrust this triumvirate to the fore was the new Museum of Modern Art's exhibition of their work in 1930, accompanied by an important catalogue. For Director Alfred H. Barr, Jr., Homer, Eakins, and Ryder seemed considerably more important than they did in 1920 when most progressive painters were still concerned primarily with the problem of form.[84] The generation of the Great Depression years possessed "a new regard for the values of objective observation."[85] Therefore, "Eakins's passion for truth as he saw it in the awkward American man and woman of forty years age, Homer's naive enthusiasm for American scenery may have far more meaning for the immediate future, especially for us, than have the recent, more sophisticated experiments in . . . formal distortion of the great Parisians."[86] Mather asserted that the "realistic endeavor which is the most constant strain in our American painting finds its fullest and finest expression" in Eakins and Homer.[87] For Lloyd Goodrich, Eakins's entirely personal realism "shows no trace of the attempt to capture superficial appearances that preoccupied most of his generation [such as] Sargent, Chase, and Duveneck, masters of surface naturalism."[88] He concluded "now that the tide of impressionism has ebbed and its frothy waves subsided now that we demand clarity and precision, and mistrust the vague and sentimental; now that we aspire towards a more masculine and architetonic art" rooted in "the expression of life and experience," we have "rediscovered Eakins."[89]

The press affirmed these masters' status as "recognizably American in their fidelity to the native scene."[90] In his own musings on the show, Marsden Hartley questioned "the prevailing prejudice" that requires the American artist to "exploit his national characteristic" in "the strictly American atmosphere," as typified by "the unalloyed realism of Eakins" and "the romantic realism of Homer."[91] Defining Eakins's art as "reportorial and not interpretative," Hartley felt that "this Modern

Museum exhibition . . . would have proven more thrilling if Fuller . . . Martin, Blakelock . . . and perhaps Inness" had been included as "a possible and plausible basis for a genuine American art."[92]

In 1932 the Museum of Modern Art presented the first comprehensive survey of American art since 1862 to the present. In his catalogue essay Holger Cahill credited Whistler, Inness, Martin, Eakins, Homer, and Ryder with lifting American art "out of the provincial stage" after the Civil War, establishing "a national and cosmopolitan phase" with European "ancestors but no analogues."[93] Asserting that Whistler's "cosmopolitanism makes his connection with American art rather tenuous," Cahill noted that the artist had "suffered a temporary eclipse because art today is not much concerned with the problems which interested him."[94] Eakins, Homer, and Ryder "run the gamut of the American spirit in art, its dramatic realism, its sober sense of the actual, and its romantic idealism which ranges to mysticism and vision."[95] He contrasted the "rugged honesty of Homer" and "sober objectivity of Eakins" to the work of the "technicians" Duveneck, Chase, and the "surface brilliance" of Sargent.[96]

The show garnered considerable criticism. One reviewer commented that "the high point in American painting was reached some years ago" and observed that the "poetry that Twachtman found in nature is . . . seldom met with in the art of today."[97] Another noted that American art of the past was recognized more and more as distinctly American in terms of a pervasive sense of honesty, dignity, straightforwardness, a lack of charm, and "a new tight approach without the fancy parlor tricks of the English portrait painters."[98] For eminent critic Margaret Breuning, "the actual expatriates, Sargent, Whistler, and . . . Cassatt . . . are good gems to adorn our diadem of chauvinism with, but they are hardly American, if again, they are hardly English or French."[99] However, Inness, Weir, Robinson, Twachtman, Chase, and others were examples of the benefit of foreign study "when there was native . . . talent to assimilate, not imitate."[100] Eakins and Homer induce "belief in the existence of a real American art of essential integrity of character, however protean its guises."[101]

Commenting on the growing tendency among critics of American culture to discover a "usable past," renowned journalist critic Helen Appleton Read concluded that Inness, Homer, and Eakins are among "the men in whom the race speaks the most audibly."[102] She observed that the historical group shared certain qualities: "refinement, austerity, craftsmanship, and an emotional response to nature" influenced by Puritanism.[103]

The highlight of the show was Whistler's "Mother" (*Arrangement in Grey and Black: Portrait of the Painter's Mother*, 1871, Musée d'Orsay) which was exhibited in America for the first time since 1882 and hailed as the first painting by an American to have been placed in the Louvre. The widely read, highly influential critic Edward Alden Jewell saw this momentous loan as an opportunity "to revive interest in a chapter in the history of American art that had grown a little dim with the dust of passing time" for "Whistler 'belongs,' despite all that may be said about his expatriation. Cosmopolitanism is decidedly an American trait."[104] Read, of the generation "who commenced dispelling the inflated Whistler legend," observed that America's best-loved picture needed an American environment in conjunction with compatriots who share the same refinement and concluded that "we may be in for a Whistler revival."[105]

Whistler's "Mother" was also featured in the landmark Century of Progress exhibition at the Art Institute of Chicago in 1933, organized in conjunction with the World's Fair. This large survey of one hundred years of international art provided ample opportunities for critics to reappraise the Paris 1900 generation. Sargent, for example, "was much more than the facile, swift manipulator of oil paint . . . [for] he could achieve incisive, restrained characterization."[106] Also featured were works by the "sober realist" Eakins, Homer, Cassatt, Beaux, Duveneck, Blakelock ("romantic American painting at its best"), Inness, Robinson, Weir, and Twachtman, the latter adding "a decorative note to the sobriety of American realism and tonal painting."[107] Applauded for its simple dignity, Whistler's "Mother" could seem to provide an American pedigree for Grant Wood's "American Gothic," also on view.[108]

Native art was emphasized to an even greater extent

in the 1934 Century of Progress exhibition, with a stronger showing of Eakins's work (including *Salutat*), as well as rooms dedicated to Whistler and to Homer, "perhaps the first to paint the truly American scene from the purely American viewpoint."[109] Nevertheless, Weir and Twachtman "combined the delicate and elusive color harmonies of the French masters with something distinctly native."[110]

The Century of Progress exhibition coincided with a critically acclaimed renewal of interest in American painting of the last century. Scholarship on the history of American art developed significantly with the contributions of Lloyd Goodrich, John Baur, Eugen Neuhaus, and others. In 1931 the Whitney Museum of American Art opened and future Director Goodrich joined its staff as researcher and writer, contributing the first major monograph on Eakins in 1933. Goodrich then surveyed the American genre paintings of Johnson, Eakins, Homer, and others in an exhibition of 1935, and organized the Homer centenary show in 1936, which affirmed the artist's apotheosis as a great American master of "honesty, freshness, and masculine vigor."[111]

Goodrich's 1938 survey of a century of American landscape painting from 1800 to 1900 revisited Inness as the greatest, most multifaceted, and widely influential pioneer whose "change to a more intimate viewpoint" was his special contribution."[112] Concluding with impressionism as "the dominant spirit of an entire generation," Goodrich credited Hassam with creating a New England version of this style.[113] His colleague John Baur had in 1937 included Hassam in a survey of American impressionism at The Brooklyn Museum, along with Cassatt, Weir, and Twachtman as "the dominant figures . . . as far as our still short perspective can judge."[114] In 1940 Baur organized the first comprehensive presentation of Eastman Johnson's "strong, clean painting in a peculiarly native American idiom" as "a necessary part of that larger re-examination of American art in the second half of the nineteenth century . . . aimed to discover whether in fact Eakins, Homer, and Ryder were the only real painters of a much maligned era, or whether a few others do not deserve at least their smaller niches next to the Triumvirate."[115]

In 1938 The Museum of Modern Art organized *Three Centuries of Art from the United States* for the French Government. The Paris 1900 generation was represented with works by Inness, Blakelock, Whistler, Sargent, La Farge, Chase, Duveneck, Homer, Eakins, Twachtman, Hassam, and others. Held at the Jeu de Paume in Paris, this most comprehensive display provoked many discussions on the nature of American art. The most extensive criticism came from Edward Alden Jewell whose compilation *Have We an American Art?* (1939) summarized the European critics' reception. Eclectic, cosmopolitan American art was derived entirely from European sources. Culturally young, it was deemed "a transplanted art, not an art born of the soil," with "little to show in the way of a distinctive national expression," despite "a certain local color."[116] Only Homer and Eakins "appear to have remained wholly independent" in relation to "a peculiarly American way of looking at things: letting facts speak for themselves, but with an awareness of their novelty in painting" in unpretentious commentaries on American life.[117] Despite this prognosis, Jewell concluded that an American art would emerge as the expression of destinies caught up in America's geographical and spiritual environment. Warning against the American Scene "jingoistic parade of surface traits" and subjects that are deemed 'native,' Jewell affirmed the identity of American art as part of the Western European tradition.[118] He also advocated Henri's definition of national art as that which emerges from vital individual expression.

Conclusion

The Paris 1900 generation provided the basis for an ongoing debate in the new century as to the character and qualities of American art. Amidst the cataclysmic socioeconomic changes of the period, the usable past was evoked as a means to validate the present. America's Anglo-Saxon, Yankee-Puritan heritage was invoked in relation to an eclectic array of work from the domesticated impressionist landscapes of Hassam to the rugged realist seascapes of Homer and the wholesome, idealized neo-Renaissance mother-and-child paintings of Brush. The subject most commonly linked to a national

form of expression was the American landscape, which was associated with local color, regional authenticity, and the reintegration of man with his native soil.

The masters of this generation were credited with employing their native powers of assimilation to absorb the best of European art without sacrificing their own unique American identities. Struggling to define the characteristics of the "American School," critics wielded a wide range of epithets in opposition to European art which they defined as formulaic, genteel, effeminate, over-refined, and based on a superficial, academic dexterity. Homer's seascapes in particular epitomized the nationalist agenda of critics who described them as big, virile, and real in their possession of manly vigor, strength, austerity, sobriety, rawness, and an uncompromising integrity. The direct, frank, unsentimental truthfulness and emotional restraint of American art were seen as aspects of a pragmatic, middle-class, materialistic culture tied to fact and unpretentious description. Nevertheless, the poetic, spiritual values and subtlety of the work of Inness, Whistler, and others were also recognized as peculiarly American, as were the psychic attributes of alert restlessness and nervous energy. Versatility, independence, freshness, straightforwardness, irreverence, naturalness, simplicity, sincerity, sanity, moderation, and individuality were among the other terms frequently employed as elements of the national school.[119]

This quest for national identity was an open, flexible process of personal self-discovery and self-expression rooted in a complex appreciation of the American environment and its commingled cultures. By the 1930s, however, some chauvinist critics associated with the American Scene movement narrowed the terms of the debate. Erroneously isolated from their cosmopolitan roots, Homer, Eakins, and Ryder were promoted as the archetypal American artists, least susceptible to the taint of European influence. Nevertheless, others continued to advocate the legacy of the Paris 1900 generation which had effectively established the eclectic identity of the "American School" within the international arena. Although a largely overlooked relic of the past by 1940, the cosmopolitan anti-academicism of this post–Civil War generation would serve as a strong foundation for the international triumph of American art after World War II.

APPENDIX A

SELECTED PARTICIPANTS, U.S. COMMISSION TO THE PARIS EXPOSITION OF 1900

U.S. Commissioner-General: Ferdinand W. Peck
Assistant Commissioner-General: Benjamin D. Woodward

DEPARTMENT OF FINE ARTS

Director: John B. Cauldwell
Assistant Director: Charles Kurtz (resigned); Henry B. Snell
Assistants to the Director: Charles C. Curran (painting), John Flanagan (sculpture), H. Hobart Nichols (editor of catalogue)
National Advisory Board: Thomas Allen, John W. Beatty, Daniel H. Burnham, Howard Russell Butler, Thomas B. Clarke, Walter Cook, J. Templeman Coolidge, Joseph H. Gest, Charles L. Hutchinson, Halsey C. Ives, Samuel H. Kauffmann, Harrison S. Morris, and James W. Ellsworth

SELECTION JURIES

Director, Ex-Officio, Member for all Juries and Committees: John B. Cauldwell
Preliminary Jury, Convened in Chicago, for Western Artists: J. G. Brown, Ralph Clarkson, Frank Duveneck, Henry B. Snell (substitute for William M. Chase), Theodore Steele, Edmund Wuerpel, Robert Vonnoh
Juries Convened in New York:
 Paintings: Cecilia Beaux, Edwin H. Blashfield, John G. Brown, William M. Chase, Ralph Clarkson, Frederick Dielman, Frank Duveneck, Francis C. Jones, H. Bolton Jones, John La Farge, George W. Maynard, H. Siddons Mowbray, Edward Simmons, Theodore C. Steele, Edmund C. Tarbell, Dwight W. Tryon, Frederick Porter Vinton, Robert W. Vonnoh, J. Alden Weir, Charles H. Woodbury, and Edmund H. Wuerpel
 Illustrations and Drawings: Otto H. Bacher, B. West Clinedist, Arthur B. Frost, Howard Pyle, William A. Rodgers, William T. Smedley
 Miniatures: William J. Baer, Laura C. Hills, Isaac A. Josephi, Emily Drayton Taylor
 Etchings and Engravings: A. W. Drake, Frank French, Henry Wolf
 Sculpture: John Quincy Adams Ward, Herbert C. Adams, Charles Grafly, Bela R. Pratt, Lorado Taft, Daniel Chester French

 Architecture: John M. Carrère, Frank Miles Day, Robert Swain Peabody, Cass Gilbert, William R. Mead, Charles I. Berg
Juries Convened in Paris:
 Paintings, Drawings, and Engravings: Edwin A. Abbey, John W. Alexander, William T. Dannat, Alexander Harrison, Gari Melchers, Francis Davis Millet, John Singer Sargent, Julius Stewart
 Sculpture: Paul W. Bartlett, Frederick MacMonnies, A. Phimister Proctor, Augustus Saint-Gaudens
 Painting Installation Committee: Charles C. Curran, Walter Gay, Francis David Millet, Walter MacEwen, Charles Sprague Pearce, Henry B. Snell, Francis C. Jones (resigned)
 Sculpture Installation Committee: Frederick MacMonnies, Augustus Saint-Gaudens
International Awards Jurors, Fine Arts, Group II
 Paintings and Drawings: Francis Davis Millet, Alexander Harrison
 Etchings and Engravings: John White Alexander
 Sculpture: Paul W. Bartlett
 Architecture: Thomas Hastings

DELEGATES TO THE FINE ARTS CONGRESS

William A. Coffin, Augustus Saint-Gaudens

U.S. NATIONAL PAVILION

American Architect: Charles A. Coolidge
Consulting Architect: George B. Post
Associate French Architect: Georges Morin-Goustiaux
Director of Fine Arts: John B. Cauldwell
Exterior Sculptural Decorations: Daniel Chester French, Clara Hill, A. Phimister Proctor, John Flanagan, Hermon MacNeil
Committee for Decorating and Furnishing: George B. Post (President), Howard Russell Butler (Secretary), Charles L. Hutchinson (Treasurer), Daniel Chester French, Halsey C. Ives, John La Farge, Charles F. McKim, Robert Swain Peabody, Henry Van Brunt, Henry Walters
Supervisor of Decorations: Francis Davis Millet
Mural Decorations: Elmer E. Garnsey, Robert Reid
Mural Decorations, U.S. Section, Palace of Diversified Industries: Albert Herter, Augustus Koopman

THE ANNOTATED CATALOGUE OF AMERICAN PAINTINGS, PARIS EXPOSITION OF 1900

Note: This catalogue contains selected data from the original *Official Illustrated Catalogue,* including the artists' places of birth, education, and address. Information not directly connected with the exposition, such as previous awards and professional affiliations, has been omitted. Unlike the original catalogue, in which paintings were generally numbered according to their placement in the galleries, artists are listed here alphabetically. Titles of works precede the catalogue number listed in the *Official Illustrated Catalogue;* the catalogue number to the French *Catalogue général officiel* follows in parentheses. Occasionally a work was featured in the American catalogue only, and in those instances, the text will read "no French number." If the name of a work has changed, its current name is in brackets next to the original title. All works are oil on canvas unless otherwise indicated; lenders to the 1900 exposition are listed next to a work when that information from the original catalogue was supplied.

All excerpts from the original catalogue appear in regular typeface, while annotations, such as the death dates of the artists, medals awarded for the exposition, dates of the paintings, and the current or last known owner of the paintings are italicized. The last names of the artists are in capital letters and the titles of paintings are indented to aid with location.

Catalogue

ABBEY, Edwin A*ustin 1852–1911*
Born in Philadelphia. Pupil of Pennsylvania Academy of Fine Arts. Address, Fairford, Gloucestershire, England. *Gold Medal.*
Hamlet [*The Play Scene in "Hamlet"*], *1897.* 131 *(Fr.1); Yale University Art Gallery, New Haven, Connecticut. Fig. 38*

ABBOT, Katherine G. *1867–1929*
Born in Zanesville, Ohio. Pupil of H. Siddons Mowbray, William M. Chase, of New York, Léon Merson, Jean Geffroy, and Delance, of Paris. Address, Paris. *Bronze Medal.*
Anxiety, *ca. 1895.* 135 *(Fr.5); unlocated.*

ALEXANDER, John W*hite 1856–1915*
Born in Pittsburgh, Pennsylvania. Pupil of the Royal Academy, Munich, and of Frank Duveneck. Address, Paris. *Gold Medal.*
The Mother. 9 *(Fr. 6); unlocated.*

Portrait of Rodin, *1899.* 17 *(Fr. 7); First National Bank of Chicago. Fig. 69*
Autumn. 13 *(Fr. 8); unlocated.*

ALLEN, Thomas 1849*–1924*
Born in St. Louis, Missouri. Pupil of the Royal Academy, Düsseldorf, Germany; studied three years in France. Address, Boston.
On Grasmere Meadows. 122 *(Fr. 9); lent by* Boston Art Club; *unlocated.*

ANDERSON, A*braham Archibald 1847–1940*
Born in New York City. Pupil of Bonnat, Cormon, and Collin, Paris. Address, New York City.
[*The*] Hon[*orable*] Elihu Root, *ca. 1890.* 205 *(Fr. 10); lent by* Hon. Elihu Root; *Association of the Bar of New York City, New York.*

BARLOW, T. [*sic. John*] Noble 1861*–1917*
Born in Manchester, England. Became an American citizen 1887. Pupil of Constant, Lefebvre, and Delance, Paris. Address, St. Ives, Cornwall, England. *Silver Medal.*
One Summer Night. 83 *(Fr. 19); unlocated.*

BEAUX, Cecilia *1855–1942*
Born in Philadelphia. Pupil of William Sartain, the Julian School, and the Lazar School, Paris. Address, Philadelphia. *Gold Medal.*
Mother and Daughter, *1898.* 35 *(Fr. 21); lent by* Clement A. Griscom, Esq.; *Pennsylvania Academy of the Fine Arts, Philadelphia. Fig. 54*
Mother and Son [*Mrs. Beauveau Borie and Son Adolph*], *1896.* 117 *(Fr. 22); lent by* Beauveau Borie, Esq.; *Amon Carter Museum, Fort Worth, Texas.*
Portrait of Miss [*Anna*] Fisher, *1898.* 204 *(Fr. 23); lent by* George H. Fisher, Esq.; *unlocated.*

BECKWITH, J*ames Carroll 1852–1917*
Born in Hannibal, Missouri. Pupil of the Ecole des Beaux-Arts and of Carolus-Duran, Paris. Address, New York City. *Bronze Medal.*
Portrait of Mrs. Beckwith [*Portrait of the Artist's Wife*], *1897.* 141 *(Fr. 26); Arnot Art Museum, Elmira, New York.*

BENSON, Frank Weston 1862–1951
Born in Salem, Massachusettus. Pupil of Museum of Fine Arts,
Boston, and Académie Julian, Paris, under Boulanger and Lefebvre.
Address, Salem, Massachusetts. *Silver Medal.*

 Children in the Woods, *1898.* 49 *(Fr. 28); private collection.*
 The Sisters, *1899.* 201 *(Fr. 29); Daniel J. Terra Collection. Fig. 64*

BISBING, Henry Singlewood 1854–1919
Born in Philadelphia. Pupil of J.H.L. de Hass, New York, and F.
de Vuillefroy, Paris. Address, Paris. *Silver Medal.*

 The Meadow. 199 *(Fr. 31); unlocated.*
 Cattle. 156 *(Fr. 32); unlocated.*

BLAKELOCK, Ralph Albert 1847–1919
Born in New York City. Self-taught. *Honorable Mention.*

 Landscape. 97 *(Fr. 33); lent by* George A. Hearn, Esq.; *unlocated.*

BLUM, Robert 1857–1903
Born in Cincinnati, Ohio. Studied at the McMicken School of
Design, Cincinnati, Academy of Fine Arts, Philadelphia, and in
Paris. Address, New York. *Bronze Medal.*

 The Ameya, *1890–1892.* 161 *(Fr. 34); lent by* Mrs. A. C. Clark;
 The Metropolitan Museum of Art, New York.. Fig. 41
 A Flower Market in Tokio, *ca. 1892.* 174 *(Fr. 35); lent by* Mrs. A. C.
 Clark; *Manoogian Collection. Fig. 40*

BOGERT, George H. 1864–1944
Born in New York City. First studied art under Thomas Eakins. Went
to France in 1884, and studied under Raphael Collin, Aimé Morot,
and Puvis de Chavannes. Address, New York. *Bronze Medal.*

 Sea and Rain, *1893.* 96 *(Fr. 36); lent by* William Clausen, Esq.;
 formerly the National Museum of American Art, Washington,
 D.C., 1909–1985; unlocated.

BOHM, Max 1868–1923
Born in Cincinnati, Ohio. Pupil of Jean-Paul Laurens and Ben-
jamin Constant, Paris. Address, Etaples, Pas-de-Calais, France.
Silver Medal.

 On the Sea. 206 *(Fr. 37); Alfred J. Walker Fine Art, Boston.*

BRECKENRIDGE, Hugh Henry 1870–1937
Born in Leesburg, Virginia. Pupil of the Pennsylvania Academy
of Fine Arts and of Bouguereau, Ferrier, and Doucet, of Paris.
Address, Philadelphia. *Honorable Mention.*

 Lantern Glow. *pastel.* 207 *(Fr. 39); lent by* H. J. Breckenridge,
 Esq.; *unlocated.*

BRIDGMAN, Frederick Arthur 1847–1928
Born in Tuskegee, Alabama. Pupil of J. L. Gérôme, Paris. Address,
Paris. *Silver Medal.*

 Pharaoh [*Pharaoh and His Army Engulfed by the Red Sea*], *1900.*
 24 *(Fr. 40); collection of Dr. and Mrs. Peter L. Perry. Fig. 32*
 The Arab and his Horses. 120 *(Fr. 41); unlocated.*

BROWN, John George 1831–1913
Born in Durham, England. Pupil of Robert Scott, Lander, and
William B. Scott, England, and of Thomas Cummings, of New
York. Address, New York City.

 Heels Over Head, *ca. 1894.* 155 *(Fr. 42); private collection. Fig. 66*

BROWNE, Charles Francis 1859–1920
Born in Massachusetts. Studied at the Art Museum, Boston;
Academy of Fine Arts, Philadelphia; Ecole des Beaux-Arts,
Paris, under Gérôme. Address, Chicago, IL.

 Reflections. 16 *(Fr.43); unlocated.*

BRUSH, George de Forest 1855–1945
Born in Tennessee. Pupil of the Ecole des Beaux-Arts and
Gérôme, Paris. Address, New York City. *Gold Medal.*

 Mother and Child, *1895.* 39 *(Fr. 44); lent by* J. M. Sears, Esq.;
 Addison Gallery of American Art, Phillips Academy, Andover,
 Massachusetts.
 Mother and Child, *ca.1897.* 183 *(Fr. 45); lent by* Pennsylvania
 Academy of the Fine Arts; *Pennsylvania Academy of the*
 Fine Arts, Philadelphia. Fig. 59
 The Artist [*The Portrait*], *1892.* 7 *(Fr.46); lent by* Potter Palmer,
 Esq.; *collection of Mr. and Mrs. Willard G. Clark.*

BUNCE, William Gedney 1840–1916
Born in Hartford, Connecticut. Address, New York. *Bronze Medal.*
 Venice. 100 *(Fr. 47); lent by* E. F. Milliken, Esq.; *unlocated.*

BURBANK, Elbridge Ayer 1858–1949
Born in Harvard, Illinois. Studied at the National Academy, New
York, 1874; under Emil Carlsen, Felix Regimes, and J. F. Good-
kins, of Chicago; later under Paul Navin and Frederick Fehr at
Munich. Address, Chicago.

 Thi-ich-no-pa (Navajo). 208 *(Fr. 48); unlocated.*

BUTLER, Howard Russell 1856–1934
Born in New York. Address, New York City.
 Clearing [*Clearing, Marine*]. 123 *(Fr. 49); unlocated.*

CARL, Kate [*Katherine Augusta*] 1862–1938
Born in Louisiana. Pupil of Gustave Courtois. Address, Paris.
Honorable Mention.

 The Mirror, *ca. 1896.* 194 *(Fr. 51); unlocated.*

CHAPMAN, Carlton Theodore 1860–1925
Born in New London, Connecticut. Studied at Art Students'
League and National Academy, New York, and Académie Julian,
Paris. Address, New York City.

 Constitution and Guerrière [*Engagement Between the U.S.*
 Frigate Constitution and H.M.S. Guerrière], *1895.* 209 *(Fr.*
 56); New-York Historical Society, New York.
 Oregon in Action. 210 *(Fr. 57); unlocated.*

CHASE, William Merritt 1859 [sic./1849]–1916
Born in Franklin, Indiana. Pupil of Wagner and Piloty in Munich.
Address, New York City. *Gold Medal.*

 Woman with a White Shawl [*Portrait of Mrs. C. (Lady with a White Shawl)*], 1893. 121 *(Fr. 58)*; *lent by* the Pennsylvania Academy of the Fine Arts, *Pennsylvania Academy of the Fine Arts, Philadelphia. Fig. 53*

 First Touch of Autumn. 149 *(Fr. 59)*; *unlocated.*

 The Big Brass Bowl [*Big Brass Bowl*], ca.1899. 41 *(Fr. 60)*; *lent by* H. K. Porter, Esq.; *Indianapolis Museum of Art, Indiana. Fig. 95*

CHURCH, Frederic Stuart 1842–1924
Born in Grand Rapids, Michigan. Studied at the National Academy of Design and with Walter Shirlaw. Address, New York City. *Honorable Mention.*

 The Sorceress. 124 *(Fr. 62)*; *lent by* Mrs. Potter Palmer; *unlocated.*

CLARK, Walter 1848–1917
Born in Brooklyn, New York. Pupil of the National Academy of Design and Professor Wilmarth and of the Art Students' League, New York. Address, New York City.

 A New England Village. 38 *(Fr. 67)*; *unlocated.*

COFFIN, William Anderson 1855–1925
Born in Allegheny, Pennsylvania. First studied at the Yale Art School; pupil of Léon Bonnat, Paris. Address, New York City.

 Sunrise. 200 *(Fr. 69)*; *unlocated.*

COMAN, Charlotte Buell 1833–1924
Born in Waterville, New Hampshire. Pupil of James R. Prevoost, Harry Thompson, and Emile Vernier, Paris. Address, New York City.

 A Winter Morning; *watercolor.* 211 *(Fr. 70)*; *unlocated.*

 A Hill of Hazel Bushes; *watercolor.* 212 *(Fr. 71)*; *unlocated.*

COOPER, Emma Lampert 1860–1920
Born in Nunda, New York. Pupil of Harry Thompson, Paris, J. Kever, Holland, and William M. Chase, New York. Address, Paris.

 The Bread Winners; *watercolor.* 213 *(Fr. 72)*; *Memorial Art Gallery, University of Rochester, Rochester, New York.*

COUSE, Eanger Irving 1866–1936
Born in Saginaw, Michigan. Pupil of the National Academy of Design, New York, under L. E. Wilmarth and Edgar Ward; 1886, Académie Julian, Paris, under Bouguereau and T. Rober-Fleury, and the Ecole des Beaux-Arts. Address, New York City. *Honorable Mention.*

 Along the Quai. 118 *(Fr. 73)*; *lent by* W.H. Burger, Esq.; *unlocated.*

COX, Kenyon 1856–1919
Born in Warren, Ohio. Pupil of Gérôme and Carolus-Duran. Address, New York City.

 Pursuit of the Ideal, 1893. 140 *(Fr. 75)*; *destroyed, as per records National Museum of American Art, Washington, D.C..*

COX, Louise Howland King 1865–1945
Born in San Francisco. Pupil of the National Academy of Design and the Art Students' League of New York. Address, New York City. *Bronze Medal.*

 Leonard, 1896. 70 *(Fr. 76)*; *unlocated.*

CRANE, Bruce 1857–1937
Born in New York City. Pupil of A. H. Wyant. Address, New York. *Bronze Medal.*

 Signs of Spring, 1897. 147 *(Fr. 77)*; *lent by* L. G. Bloomingdale; *unlocated.*

CURRAN, Charles Courtney 1861–1942
Born in Hartford, Kentucky. Pupil of the Art Students' League of New York, Benjamin Constant and L. Doucet, of Paris. Address, New York City. *Honorable Mention.*

 The Dew. 214 *(Fr. 78)*; *unlocated.*

 The Peris, 1898. 139 *(Fr. 79)*; *lent by* C. C. Glover, Esq.; *collection of Dr. Ronald Berg. Fig. 36*

CURTIS, Constance Birth and death dates unknown
Born in Washington, D. C. Studied at the Art Students' League of New York [*1888–1898, and possibly again in 1921*]; pupil of William M. Chase and Robert Reid. Address, New York City.

 Joan. *watercolor.* 215 *(Fr. 80)*; *unlocated.*

DANNAT, William Turner 1853–1929
Born in New York. Pupil of the Munich Academy and Munkácsy; also studied in Paris and Italy. Address, Paris.

 Portrait of the Duchess of Mecklenburg. 31 *(Fr. 82)*; *unlocated.*

 Portrait of Miss C. 68 *(Fr. 83)*; *unlocated.*

DARLING, Wilder M. 1856–1933
Born in Sandusky, Ohio. Pupil of the Académie Julian, Jean-Paul Laurens, and Benjamin Constant, Paris. Address, Laren, North Holland. *Bronze Medal.*

 Helping Mother, 1900. 8 *(Fr. 84)*; *Toledo Museum of Art, Ohio.*

DAVIS, Charles Harold 1856–1933
Born in Amesbury, Massachusetts. Pupil of Otto Grundman and Museum of Art, Boston, and of Boulanger and Jules Lefebvre, Paris. Address, Boston. *Bronze Medal.*

 Summer Evening. 176 *(Fr. 85)*; *lent by* Oliver G. Ricketson, Esq.; *unlocated.*

 Clouds over Water. 146 (Fr. 86); unlocated.

DEARTH, Henry *Golden 1863 [sic.1864]–1918*
Born in Bristol, Rhode Island. *Bronze Medal.*
 Autumn. 15 *(Fr. 87)*; *unlocated.*

DECAMP, Joseph *Rodefer 1858–1923*
Born in Cincinnati, Ohio. Studied at the Cincinnati School of
Design under Frank Duveneck, and at the Royal Academy, Mun-
ich. Address, Boston. *Honorable Mention.*
 Woman Drying Her Hair, ca. 1899. 179 *(Fr. 50)*; *lent by*
 Cincinnati Museum; *Cincinnati Art Museum, Ohio. Fig. 50*

DESSAR, Louis Paul *1867–1952*
Born in Indianapolis, Indiana. Pupil of the National Academy of
Design, New York, W.A. Bouguereau and Fleury, the Ecole des
Beaux-Arts, Paris. Address, New York City. *Bronze Medal.*
 Evening in Picardy. 59 *(Fr. 89)*; *lent by* C. W. Kraushaar, Esq.
 unlocated.
 Sheep in the Dunes. 43 *(Fr. 88)*; *unlocated.*

DICKSON, *Mary Estelle Birth and death dates unknown*
Born in the United States [*St. Louis, Missouri*]. Pupil of Tony
Robert-Fleury and Jules Lefebvre. Address, Paris. *Bronze Medal.*
 Fancy Head. 153 *(Fr. 90)*; *unlocated.*

DONOHO, *Gaines Ruger 1857–1916*
Born in Church Hill, Mississippi. Pupil of Boulanger, Lefebvre,
Bouguereau, and Fleury. Address, East Hampton, Long Island,
New York.
 Moonlight in Egypt Lane. 216 *(Fr. 91)*; *unlocated.*

EAKINS, Thomas *1844–1916*
Born in Covington, Kentucky. Pupil of Gérôme, Bonnat, and
Dumont, Paris. Address, Philadelphia. *Honorable Mention.*
 The Cello Player, *1896.* 114 *(Fr. 93)*; *lent by* Pennsylvania Acad-
 emy of the Fine Arts; *Pennsylvania Academy of the Fine
 Arts, Philadelphia. Fig. 70*
 Salutat, *1898.* Am. 143 (Fr. 94); *Addison Gallery of American Art,
 Phillips Academy, Andover, Massachusetts. Fig. 72*

EATON, Charles Warren *1857–1954*
Born in Albany, New York. Pupil of National Academy of Design
and Art Students' League of New York. Address, New York City.
Honorable Mention.
 The Marsh in Winter; *pastel.* 67 *(Fr. 96)*; *unlocated.*
 Spirit of the Twilight; *watercolor.* 109 *(Fr. 97)*; *unlocated.*
 River at Evening. 93 *(Fr. 98)*; *unlocated.*

EICHELBURGER, *Robert H. ? –ca.1900*
No information given.
 The Wave. 22 *(Fr. 99)*; *lent by* Brayton Ives, Esq.; *unlocated.*

ELLIS, Harvey *1852–1904*
Born in Rochester, New York. Pupil of Edwin White, N.A.
Address. Rochester.
 Silhouettes; *watercolor, 1899.* 217 *(Fr. 100)*; *The Strong Museum,
 Rochester, New York.*

EMMET, Lydia Field *1866–1952*
Address, New Rochelle, *New York.*
 Garden Days. 218 *(Fr. 101)*; *unlocated.*

ENNECKING, John Joseph *1841–1916*
Born in Minster, Ohio. Pupil of Bonnat and Daubigny, Paris, and
of Lear, Munich. Address, Boston. *Honorable Mention.*
 Twilight. 48 *(Fr. 102)*; *unlocated.*

FISHER, *William Mark 1841–1923*
Born in Boston. Studied in Boston and Paris. Address, Newport,
Essex, England.
 The Swineherd. 219 *(Fr. 103)*; *unlocated.*

FOSS, Harriet *Campbell ca.1860–1957*
Born in Middletown, Connecticut., U.S.A. Pupil of J. Alden
Weir, Alfred Stephens, and Gustave Courtois, Paris. Address,
Paris.
 Pink Phlox; *pastel.* 220 *(Fr. 104)*; *unlocated.*

FOSTER, Ben *1852–1926*
Born in North Anson, Maine. Pupil of Abbott Thayer, New York,
and Luc Olivier Merson and Aimé Morot, Paris. Address, New
York City. *Bronze Medal.*
 Lulled by the Murmuring Stream [*Bercé par le murmure d'un
 ruisseau*], *1899.* 101 *(Fr. 105)*; *Musée d'Orsay, Paris. Fig 147*

FRANZEN, August *1863–1938*
Born in Norrköping, Sweden. Pupil of Dagnan-Bouvert, Paris.
Address, New York City. *Bronze Medal.*
 Charity. 221 *(Fr. 106)*; *lent by* Samuel MacMillian, Esq.; *unlo-
 cated.*
 The House Builders, *ca. 1894.* 77 *(Fr. 107)*; *unlocated.*

FROMUTH, Charles H. *1863 [sic. 1861]–1937*
Born in Philadelphia. Pupil of Thomas Eakins. Address, Concar-
neau, France. *Silver Medal.*
 Fishing Boats (A dock harmony). Am. 82 (Fr. 108); *unlocated.*
 Dismantled Boats [*Un décor de neige, bateaux désarmés*], *1897.*
 80 (Fr. 109); *Musée des beaux-arts de Quimper, France.*

GALLAGHER, Sears *1869–1910*
Born in Boston. Pupil of Tommaso Juglaris, Boston, of Jean-Paul
Laurens and Benjamin Constant, Paris. Address, Boston.
 Foggy Weather; *watercolor.* 222 *(Fr. 115)*; *unlocated.*

GALLISON, Henry H. 1850–*1910*
Born in Boston. Pupil of Bonnefoy, Paris. Address, Boston. *Honorable Mention.*

Grey Day, *ca. 1898.* 2 *(Fr. 116); private collection. Fig 88*

GAULEY, Robert David 1875–*1943*
Born in Ballylag, Ireland. Pupil of Denman Ross of Cambridge, the Art Museum of Boston, and the Julian Academy, Paris. Address, New York City. *Bronze Medal.*

Polly. 128 *(Fr. 118); unlocated.*

GAY, Walter 1856–*1937*
Born in Hingham, Massachusetts. Pupil of Léon Bonnat. Address, Paris. *Silver Medal.*

Maternity. 18 *(Fr. 119); unlocated.*

The Weavers. 185 *(Fr. 120); unlocated.*

GIFFORD, R*obert* Swain *1840–1905*
Born on the island of Naushon, Massachusetts. Pupil of Albert Van Beest, Holland. Address, New York City.

Headwaters of the Westport River. 10 *(Fr. 123); unlocated.*

GIHON, Albert D*ankin* 1866 [*sic. 1876*]– ?
Born at Portsmouth, New Hampshire. Pupil of Thomas Eakins, Philadelphia; Benjamin Constant, Jean-Paul Laurens, Gérôme, A. T. A. Motley, and the Ecole des Arts Décoratifs. Address, Paris.

Old Mill, Picardy. 6 *(Fr. 124); unlocated.*

GROTHJEAN, Fanny 1871– ?
Born near Hamburg, Germany. Pupil of Courtois, Girard, Paul J. Blanc, Pierre Fritel, and A.G. Delécluze. Address, New York City.

The August Moon. 224 *(Fr. 127); unlocated.*

The New Moon. 223 *(Fr. 128); lent by* Mrs. Britton Busch; *unlocated.*

GUY, Seymour J*oseph* 1824–*1910*
Born in Greenwich, England. Pupil of Ambrose, Gérôme, Paris, and Buttersworth, of London. Came to the United States in 1854. Address, New York City. *Bronze Medal.*

Rest. 127 *(Fr. 130); unlocated.*

Preparing for To-morrow. 115 *(Fr. 131); unlocated.*

HARRISON, *Thomas* Alexander 1853–*1930*
Born in Philadelphia. Pupil of Gérôme at the Ecole des Beaux-Arts and of Bastien-Lepage. Address, Paris. *Hors Concours.*

Twilight [Le *Crépuscule*], *1899.* 29 *(Fr. 135); Collection of Graham Williford. Fig 90*

Mysteries of the Night, *1895.* 225 *(Fr. 136); unlocated.*

Evening in the Sun [*Feux du soleil*], *1897.* 3 *(Fr. 137); unlocated.*

Landscape. 226 *(no French number); unlocated.*

HARRISON, *Lovell* Birge 1854–*1929*
Born in Philadelphia. Pupil of Carolus-Duran and Cabanel, of Paris. Address, Plymouth, Massachusetts.

Morning off Santa Barbara. 158 *(Fr. 138); unlocated.*

HASSAM, Childe *1859–1953*
Born in Boston. Pupil of Boulanger and Lefebvre, Paris. Address, New York. *Silver Medal.*

Snowy Day on Fifth Avenue [*Fifth Avenue in Winter*], *ca.1892.* 145 *(Fr. 139); lent by* Carnegie Institute; *Carnegie Museum of Art, Pittsburgh. Fig. 96*

HAYDEN, Charles H. 1856–*1901*
Born in Plymouth, Massachusetts. Pupil of Museum of Fine Arts, Boston, Boulanger, Collin, and Lefebvre, Paris. Address, Boston. *Bronze Medal.*

A Connecticut Hillside. 33 *(Fr. 140); deaccessioned by the Cincinnati Art Museum, Ohio, in 1945; unlocated.*

HERTER, Albert *1871–1950*
Born in New York City. Pupil of Art Students' League of New York and of F. Cormon and Jean-Paul Laurens, of Paris. Address, New York. *Bronze Medal.*

Sorrow; *watercolor.* 190 *(Fr. 141); unlocated.*

HITCHCOCK, George *1850–1913*
Born in Providence, Rhode Island. Pupil of Boulanger and Lefebvre, Paris. Address, Egmond Hoef, Holland. *Bronze Medal.*

Magnificat, *1894.* 26 *(Fr. 147); Belmont, The Gari Melchers Estate and Memorial Gallery, Mary Washington Collection, Fredricksburg, Virginia. Fig 60*

Vanquished [*Vaincu*], *n.d.* 148 *(Fr. 148); Musée d'Orsay, Paris. Fig. 45*

HOLMAN, Frank 1865–*1930*
Born in Attleboro, Massachusetts. Pupil of Carolus-Duran and the Ecole des Beaux-Arts. Address, Paris. *Honorable Mention.*

Portrait of my Mother, *1894.* 227 *(Fr. 151); unlocated.*

HOMER, Winslow 1836–*1910*
Born in Boston. Pupil of National Academy School and Frederick Kindel. Address, Scarboro, Maine. *Gold Medal.*

The Fox Hunt [*Fox Hunt*], *1893.* 192 *(Fr. 152); lent by* Pennsylvania Academy of the Fine Arts; *Pennsylvania Academy of the Fine Arts, Philadelphia. Fig. 94*

The Maine Coast [*Maine Coast*], *1895.* 58 *(Fr. 153); lent by* F. A. Bell, Esq.; *The Metropolitan Museum of Art, New York. Fig. 91*

"All's Well" [*The Lookout: "All's Well"*], *1896.* 107 *(Fr. 154); lent by* Boston Museum of Fine Arts; *Museum of Fine Arts, Boston. Fig. 73*

Summer Night [*Nuit d'été*], *n.d.* 61 *(Fr. 155); Musée d'Orsay, Paris. Fig. 92*

HOUSTON, Frances C. 1867–1906
Born in Hudson, Michigan. Studied in Paris under Lefebvre and Boulanger. Address, Boston.

> Portrait. 151 *(Fr. 158)*; *unlocated.*

HYDE, William Henry 1858–1943
Born in New York City. Studied in Paris with Boulanger, Lefebvre, Doucet, and Alexander Harrison. Address, New York. *Honorable Mention.*

> Portrait [*Bishop Henry Codman Potter*]. 177 *(Fr. 162)*; *lent by Bishop Henry C. Potter; formerly in the collection of the City Club of New York; unlocated.*

INNESS, George 1825–1894
Born in Newburgh, New York; died at Bridge of Allan, Scotland. Pupil of Regis Gignoux, New York.

> The Mill Pond, *1889.* 56 *(Fr. 166)*; *lent by* Emerson McMillin; *The Art Institute of Chicago. Fig. 82*
>
> The Clouded Sun, *1891.* 66 *(Fr. 164)*; *lent by* Carnegie Institute; *Carnegie Museum of Art, Pittsburgh. Fig. 80*
>
> Sunny Autumn Day, *1892.* 40 *(Fr. 163)*; *lent by* Chauncey J. Blair, Esq.; *The Cleveland Museum of Art, Ohio. Fig. 81*

JOHNSON, Eastman 1825–1906
Born in Lowell, Maine [*sic. Massachusetts*]. Pupil of Professor Lentye in Düsseldorf. Address, New York City.

> Prisoner of State; *oil on academy board, 1874.* 110 *(Fr. 167)*; *lent by* Homer Lee, Esq.; *private collection. Fig. 67*

JOHNSTON, John Humphreys, *1857–1941*
Address, Paris. *Silver Medal.*

> Portrait of the Artist's Mother [*Portrait de la mère de l'artiste*], *1895.* 88 *(Fr. 159)*; *Musée National de la Coopération franco-américaine, Château de Blérancourt, France. Fig. 146*
>
> *Le Mystère de la Nuit.* 195 *(Fr. 160)*; *unlocated.*
>
> *Fortune (Paysanne).* 87 *(Fr. 161)*; *unlocated.*

JONES, Hugh Bolton 1848–1927
Born in Baltimore, Maryland. Address, New York. *Bronze Medal.*

> November, *ca. 1898.* 62 *(Fr.168)*; *lent by* C. C. Glover, Esq.; *unlocated.*

KAELIN, Charles S. 1858–1929
Born in Cincinnati, Ohio. Pupil of the Cincinnati Art School, the Art Students' League of New York, and Cincinnati Museum Association. Address, Cincinnati, Ohio.

> Melting Snows; *pastel.* 228 *(Fr. 172)*; *unlocated.*

KENDALL, Margaret *Stickney* 1871– ?
Born on Staten Island, New York. Pupil of J. Alden Weir, Julius Rolshoven, and Sargent Kendall. Address, New York.

> Pastures and Pudding Stones. 229 *(Fr. 175)*; *unlocated.*

KENDALL, *William* Sergeant *1869–1938*
Born in Spuyden Duyvil, New York. Pupil of the Art Students' League, New York, Thomas Eakins, Philadelphia, Ecole des Beaux-Arts and Olivier Merson, Paris. Address, New York. *Bronze Medal.*

> St. Ives, Pray for Me [*Saint Yves, priez pour nous!*], *1891.* 157 *(Fr. 176)*; *unlocated. Fig. 131*
>
> Cloud's Shadow. 230 *(Fr. 177)*; *unlocated.*

KNIGHT, Louis Aston *1873–1948*
Born in Paris. Pupil of Jules Lefebvre, Tony Robert-Fleury and Ridway Knight, Paris. Address, Poissy, Seine-et-Oise, France. *Bronze Medal.*

> The Riverside Path; *watercolor.* 30 *(Fr. 178)*; *unlocated.*

KNIGHT, *Daniel* Ridgway *1839–1924*
Born in Philadelphia. Pupil of Gleyre and Meissonier. Address, Poissy, Seine-et Oise, France.

> A July Morning, *1895.* 168 *(Fr. 179)*; *Manoogian Collection. Fig. 43*

KOOPMAN, *Augustus* 1869–1914
Born in Charlotte, North Carolina. Studied at Pennsylvania Academy Fine Arts; Bouguereau and Fleury; pupil of Ecole des Beaux-Arts, Paris. Address, Paris. *Bronze Medal.*

> The Two Forces, *1897.* 132 *(Fr. 180)*; *formerly the collection of the Cosmos Club, Washington, D.C.; unlocated.*

KOST, Frederick Weller 1861–1923
Pupil of National Academy Schools. Address, New York. *Honorable Mention.*

> Old Vanderbilt Dock. 90 *(Fr. 181)*; *lent by* George Inness, Jr., Esq.; *unlocated.*

KRONBERG, Louis 1871 [*sic.1872*]–1965
Born in the United States. Pupil of Jean-Paul Laurens, Benjamin Constant, and Raphael Collin, Paris. Address, Boston.

> Study from the Nude; *pastel.* 231 *(Fr. 182)*; *unlocated.*

LA FARGE, John *1835–1910*
Born in New York. Address, New York City.

> Girls Making Kava [*Siva with Siakumu Making Kava in Tofae's House*]; *watercolor on velum, ca. 1893.* 106 *(Fr. 183)*; *lent by* Mrs. Bancel La Farge; *Sterling and Francine Clark Art Institute, Williamstown, Massachusetts. Fig. 42*
>
> Mt. Tohivea, Society Islands [*Mt. Tohivea, from the Edge of Rotui, Island of Moorea, Society Islands, South Pacific, 1891*]; *watercolor and gouache over pencil on white wove paper, 1891.* 164 *(Fr. 184)*; *Harvard University Art Museums, Fogg Art Museum, Cambridge, Massachusetts.*

LATHROP, Francis 1849–1909
Born at sea, near the Hawaiian Islands. Pupil of Ford Madox-Brown and Sir Edward Burne-Jones. Address, New York City.
> Portrait of the Artist. 113 *(Fr. 185)*; *unlocated.*

LATHROP, William Langson 1859–1938
Born in Warren, Illinois.
> Grey Day. 232 *(Fr. 186)*; *lent by* Judge Horace Russell; *unlocated.*

LEE, Homer 1856–1923
Born in Mansfield, Ohio. Studied under his father and Robert Mackintosh, Toronto, Canada; afterward studied abroad. Address, New York. *Honorable Mention.*
> The Building of the Sky-scraper. 112 *(Fr. 188)*; *unlocated.*

LEWIS, Arthur Allen 1873– ?
Born in Mobile, Alabama. Studied with Bridgman and Gérôme. Address, Paris. *Honorable Mention.*
> Portrait of Michael Robinson. 233 *(Fr. 190)*; *unlocated.*

LOCKE, Caroline T. ? – ca. 1909
No information given.
> Purple Rhododendrons. 198 *(Fr. 191)*; *unlocated.*

LOCKWOOD, Wilton Robert 1861–1914
Born in Wilton, Connecticut. Pupil of John La Farge, also studied in Paris. Address, Boston. *Silver Medal.*
> The Violinist, *1897.* 130 *(Fr. 192)*; *lent by* Andrew Carnegie, Esq.; *unlocated.*

LOW, Will Hicok 1853–1932
Born in Albany, New York. Pupil of the Ecole des Beaux-Arts, Gérôme, and Carolus-Duran, Paris. Address, Bronxville, New York.
> At the Spring, *1897.* 175 *(Fr. 193)*; *unlocated.*

MAC CHESNEY, Clara Taggart 1861–1928
Born in San Francisco. Pupil of San Francisco Art School, Gotham Art School, Colarossi School, Paris, and William, Mowbray, Courtois, and Giradot. Address, New York City.
> Pomegranates; *watercolor.* 234 *(Fr. 195)*; *unlocated.*

MAC EWEN, Walter 1860–1943
Born in Chicago. Pupil of Cormon and Tony Robert-Fleury, Paris, France. Address, Paris. *Silver Medal.*
> Portraits. 21 *(Fr. 197)*; *unlocated.*
> Sunday in Holland [*Dimanche en Hollande*], *ca. 1898.* 188 *(Fr. 198)*; *Musée d'Orsay, Paris. Fig. 48*
> Pieter Van Wint. 63 *(Fr. 199)*; *unlocated.*

MAC ILHENNY, Charles Morgan 1858–1904
Born in Philadelphia. Studied in Philadelphia. Honorable Mention.
> November Evening. 20 *(Fr. 200)*; *lent by* Judge Horace Russell; *unlocated.*
> On the Highlands. 150 *(no French number)*; *lent by* Samuel T. Shaw, Esq; *unlocated.*

MAC KUBIN, Florence 1861–1918
Born in Florence, Italy. Pupil of Deschamps, of Paris, and Julius Rolshoven and Professor Herterrich, of Munich. Address, Baltimore, Maryland.
> Portrait of Mrs. Rockwood Hoar; *miniature, 1898.* 202 *(Fr. 201)*; *Maryland Historical Society, Baltimore.*

MAC MONNIES, Mary Fairchild 1858–1946
Born in New Haven, Connecticut. Studied in School of Fine Arts, St. Louis, Académie Julian, Paris, and with Carolus-Duran. Address, Paris. *Bronze Medal.*
> Lilies and Roses [*Roses et Lys*], *1897.* 197 *(Fr. 202)*; *Musée des beaux-arts de Rouen, France. Fig. 63*

MARSH, Fred Dana 1872–1961
Born in Chicago. Entered Art Institute of that city, 1890; remained in Art Institute until 1893. Address, Paris. *Bronze Medal.*
> Portrait [*The Lady in Scarlet*], *ca. 1900.* 235 *(Fr. 203)*; *The Newark Museum, New Jersey. Fig. 52*

MARTIN, Homer Dodge 1836–1897
Born in Albany, New York. Pupil of William Hart, New York.
> Newport Neck, *1893.,* 119 *(Fr. 204)*; *lent by* Lotos Club, New York; *Fine Arts Museums of San Francisco, M.H. de Young Memorial Museum, San Francisco. Fig. 84*
> The Adirondacks. 99 *(Fr. 205)*; *lent by* Samuel Utermyer; *The Berkshire Museum, Pittsfield, Massachusetts.*
> Westchester Hills, *n.d.,* 79 *(Fr. 206)*; *lent by* Edward F. Millikin, Esq.; *collection of Dr. John Larkin, Jr. Fig. 83*

MAURER, Alfred H. 1868–1932
Born in New York. Studied at the National Academy of Design, under Edgar M. Ward. Address, Paris.
> Portrait [*At the Window*], *1899–1900.* 181 *(Fr. 207)*; *Hirshhorn Museum and Sculpture Garden, Smithsonian Institution, Washington, D.C.. Fig. 51*

MAYNARD, George Willoughby 1843–1923
Born in Washington, D.C. Pupil of Academy of Fine Arts, Antwerp, Belgium. Address, New York City.
> In Strange Seas, *1889.* 167 *(Fr. 208)*; *lent by* William T. Havemeyer, Esq.; *The Metropolitan Museum of Art, New York. Fig. 37*

MAYNARD, Guy *Birth and death dates unknown*
Born in Chicago. Studied in Art Institute of Chicago and in Paris.
Address, Paris.

Portrait. 236 *(Fr. 210)*; *unlocated.*

MEAKIN, Lewis Henry *1850–1917*
Born in England. Studied in Munich under Professors Raupp,
Gysis, and Loeffts. Address, Cincinnati, Ohio.

Eden Park Reservoir. 237 *(Fr. 211)*; *unlocated.*

MELCHERS, *Julius* Garibaldi *1860–1932*
Born in Detroit, Michigan. Pupil of Lefebvre and Boulanger.
Address, Paris.

The Fencing Master, *ca. 1900.* 65 *(Fr. 212)*; *The Detroit Institute
of Arts; Michigan. Fig. 68*

Portrait [*Man with a Cloak*], *ca. 1900.* 55 *(Fr. 213)*; *Galleria
Nazionale de L'Arte Moderna, Rome.*

The Sisters, *ca. 1895.* 178 *(Fr. 214)*; *National Gallery of Art,
Washington, D.C.. Fig. 45*

METCALF, Willard L. *1858–1925*
Address, New York City. *Honorable Mention.*

Summer Twilight [*Midsummer Twilight*], *ca.1890.* 193 *(Fr. 215)*;
lent by Mrs. H. K. Pomroy. *National Gallery of Art, Wash-
ington, D.C.. Fig. 76*

MILLET, Francis Davis *1846–1912*
Born in Mattapoisett, Massachusetts. Pupil of Van Lerius, Royal
Academy of Fine Arts, Antwerp. Address, Broadway, Worcester-
shire, England. *Hors Concours.*

The Expansionist. 182 *(Fr. 216)*; *unlocated.*

Unconverted, *ca. 1880.* 152 *(Fr. 217)*; *lent by club "Black and
White"; private collection. Fig. 39*

MINOR, Robert Crannell *1840–1904*
Born in New York. Pupil of Van Luppen, Antwerp, and Diaz and
Boulanger, Paris. Address, New York City. *Honorable Mention.*

Moonlight. 129 *(Fr. 218)*; *unlocated.*

MUHRMAN, Henry H. *1854–1916*
Born in Cincinnati, Ohio. Studied at Munich. Address, London.

Trees and Pond. 91 *(Fr. 220)*; *unlocated.*

Broad Stairs. 71 *(Fr. 221)*; *unlocated.*

MURPHY, *John* Francis *1853–1921*
Born in Oswego, New York. Self-taught. *Honorable Mention.*

Landscape. 34 *(Fr. 222)*; *lent by* W. B. Lockwood, Esq.; *unlo-
cated.*

Under Grey Skies. *watercolor and pastel, 1893.* 75 *(Fr. 223)*; *lent
by* H.H. Harrison, Esq.; *Indianapolis Museum of Art, Indi-
ana. Fig. 87*

NEEDHAM, Charles Austin *1844–1923*
Born in Buffalo, New York. Pupil of August Will and the Art Stu-
dents' League of New York. Address, New York. *Bronze Medal.*

Park Snows, *1898.* 25 *(Fr. 224)*; *unlocated.*

A River Bank; *watercolor.* 238 *(Fr. 225)*; *unlocated.*

NETTLETON, Walter *1861–1936*
Born in New Haven, Connecticut. Graduate of Yale University,
1883. Studied under Lefebvre and Boulanger, and afterward under
Carolus-Duran and Alexander Harrison. Address, Stockbridge,
Massachusetts.

Early Snowfall. 239 *(Fr. 227)*; *unlocated.*

NEWMAN, *Robert* Loftin *1827–1912*
Born in Richmond, Virginia. Went to Europe in 1850 to study art.
Pupil of Thomas Couture. Visited Barbizon several times.
Address, New York City.

Christ Stilling the Tempest, *n.d.* 240 *(Fr. 228)*; *lent by* Edward
D. Page, Esq.; *Virginia Museum of Fine Arts, Richmond.
Fig. 34*

NEWMAN, Mrs. *Willie* Betty *1865–1935*
Born in Tennessee. Studied at Cincinnati Art School, under T. S.
Noble, later studying in Paris with Benjamin Constant, J.P. Lau-
rens, and Bouguereau. Address, Paris.

Reverie. 241 *(Fr. 229)*; *unlocated.*

NICHOLLS, Rhoda Holmes *1854–1930*
Born in Coventry, England. Pupil of the Bloomsbury School of
Art, London, where she won the Queen's Scholarship. Address,
New York City.

Search the Scriptures; *watercolor.* 102 *(Fr. 230)*; *unlocated.*

NORTON, William Edward *1843–1916*
Born in Boston. Pupil of the Lowell Institute of Boston, and of
George Inness, of Jacquesson and Vollon of Paris. Address, London.

Normandy Fish-weir. 242 *(Fr. 231)*; *unlocated.*

NOURSE, Elizabeth *1859–1938*
Born in Cincinnati, Ohio. First studied in Cincinnati, later stud-
ied under Boulanger and Lefebvre at the Julian Academy in
Paris, then became a pupil of Carolus-Duran and Henner, Paris.
Address, Paris. *Silver Medal.*

In the Church at Volendam, Holland, *1892.* 243 *(Fr. 232)*; *pri-
vate collection.*

OCHTMAN, Leonard *1854–1934*
Born in Bonnemaire, Holland. Address, Mianus, Connecticut.

Winter Morning, *1898.* 172 *(Fr. 233)*; *Gallerie 454. Fig. 86*

Autumn Twilight, *1899.* Am. 138 *(Fr. 234)*; *lent by* A. C.
Humphreys, Esq.; *unlocated.*

PALMER, Walter *Launt 1854–1932*
Born in Albany, New York. Pupil of F.S. Church, New York, and Carolus-Duran, Paris. Address, Albany, New York. *Honorable Mention.*

>The Senator's Birthplace, *1899.* 203 *(Fr. 235); unlocated.*
>San Marco, Venice, *1894–1895.* 244 *(Fr. 236); private collection.*

PARRISH, Clara *Weaver 1861–1925*
Born in Selma, Alabama. Pupil of the Art Students' League, New York, H. Siddons Mowbray, J. Alden Weir, and William M. Chase. Address, New York City.

>Portrait; *pastel.* 180 *(Fr. 238); unlocated.*

PARRISH, Maxfield 1870–*1966*
Born in Philadelphia. Pupil of the Pennsylvania Academy of Fine Arts and Howard Pyle. Address, Windsor, Vermont. *Honorable Mention.*

>The Sandman, *1896.* 137 *(Fr. 239); lent by* Mrs. Michael Van Beuren, Esq.; *original presumably destroyed. See later version, Fig. 35*

PEARCE, Charles Sprague *1851–1914*
Born in Boston. Studied under M. Léon Bonnat. Address, Auvers, Seine-et-Oise, France.

>The Shawl, *ca. 1900.* 46 *(Fr. 240); Elvehjem Museum of Art, University of Wisconsin-Madison. Fig. 62*

PERRINE, Van Dearing *1869–1955*
Born in Kansas. Studied in New York at the Cooper Union, National Academy of Design, and with William M. Chase. Address, New York City.

>The Flower Market in Winter. 11 *(Fr. 242); lent by* William M. Chase, Esq.; *unlocated.*

PICKNELL, William *Lamb 1853–1897*
Born in Boston. Pupil of Gérôme, Paris, and George Inness.

>Morning on the Loing [*at Moret*], *ca. 1895.* 245 *(Fr. 243); lent by* Mrs. W. L. Picknell; *Museum of Fine Arts, Boston. Fig. 77*

PLATT, Charles *Adams 1861–1933*
Born in New York. Pupil of National Academy of Design and Art Students' League, New York; Académie Julian, under Boulanger and Lefebvre, Paris. Address, New York. *Bronze Medal.*

>Winter. 19 *(Fr. 244); lent by* Boston Art Club; *unlocated.*
>Clouds [*Landscape near Cornish*], *ca. 1894.* 4 *(Fr. 245); lent by* C. S. Houghton, Esq.; *Museum of Fine Arts, Boston.*

POORE, Henry *Rankin 1859–1940*
Born in Newark, New Jersey. Pupil of Peter Moran, Pennsylvania Academy of Fine Arts, National Academy, New York, and of Luminais and Bouguereau, Paris. Address, Orange, New Jersey.

>The Wounded Hound. 37 *(Fr. 246); unlocated.*

PORTER, Benjamin *Curtis 1843–1908*
Born in Melrose, Massachusetts. Studied in Boston with Dr. Rimmer, in Italy and France, principally self-taught. Address, New York. *Bronze Medal.*

>Portrait of Mrs. P[*orter*]. 196 *(Fr. 247); unlocated.*
>Portrait of Master P. [*Sydney Porter*]. 246 *(Fr.248); unlocated.*

PROCTOR, *Alexander* Phimister *1860–1950*
Pupil of Puech and Injalbert, Paris. Address, Paris.

>A Puma. 105 *(Fr. 249); lent by* James S. Inglis, Esq.; *unlocated.*

PYLE, Howard *1853–1911*
Born in Wilmington, Delaware. Address, Wilmington, Delaware. *Bronze Medal.*

>The Buccaneers; *illustration, ca. 1899.* 160 *(Fr. 250); lent by* Horatio R. Harper, Esq.; *unlocated.*

RANGER, Henry *Ward 1858–1916*
Born in New York State. Travelled extensively, but self-taught. Address, New York City. *Bronze Medal.*

>Becky Coles Hill. 36 *(Fr. 251); lent by* Mrs. A. C. Humphreys; *unlocated.*
>Brooklyn Bridge, *1899.* 165 *(Fr. 252); The Art Institute of Chicago, Chicago. Fig. 97*

REDFIELD, Edward *Willis 1868–1965*
Born in Bridgeville, Delaware. Studied at the Pennsylvania Academy of Fine Arts and under Bouguereau and Fleury. Address, Alfort, Seine, France. *Bronze Medal.*

>The Bridge at Joinville, 1898. 57 *(Fr. 253); unlocated.*
>The Road to Edge Hill. 54 *(Fr. 254); lent by* Chauncey Blair, Esq.; *unlocated.*

REHN, *Frank Knox Morton 1848–1914*
Born in Philadelphia. Pupil of the National Academy, New York. Address, New York City. *Honorable Mention.*

>A Northwester in Gloucester Harbor. 126 *(Fr. 255); unlocated.*

REID, Robert *1862–1929*
Born in Stockbridge, Massachusetts. Pupil of Boulanger and Lefebvre, Paris. New York City. *Silver Medal.*

>Azalea[s], *ca. 1900.* 173 *(Fr. 256); private collection.*

ROBINSON, Theodore *1852–1896*
Born in Irasburg, Vermont. Pupil of Carolus-Duran and M. Gérôme.

>The Canal [*Port Ben, Delaware and Hudson Canal*], *1893.* 27 *(Fr. 264); lent by* Society of American Artists; *Pennsylvania Academy of the Fine Arts, Philadelphia. Fig. 68*
>Woman at the Piano [*Girl at Piano*], *ca. 1887.* 186 *(no French number); lent by* Pennsylvania Academy of the Fine Arts; *Pennsylvania Academy of the Fine Arts, Philadelphia. Fig. 56*

ROBINSON William S. *1861–1945*
Address, New York City. *Honorable Mention.*
 Early Evening. 52 *(Fr. 266)*; *unlocated.*

ROLSHOVEN, Julius C. *1858–1930*
Address, Detroit, Michigan. *Honorable Mention.*
 "My Great-grandmother's Finery," *ca. 1899.* 247 *(Fr. 268)*; *unlocated.*

SARGENT, John Singer *1856–1903*
Born in Florence, Italy. Pupil of Academy of Fine Arts, Florence, and of Carolus-Duran, Paris. Address, London. *Grand Prize.*
 Portraits of Mrs. Meyer and Children [*Mrs. Carl Meyer, later Lady Meyer, and her two Children*], *1896.* 60 *(Fr. 272)*; *private collection. Fig. 30*
 Portrait of Asher B. Wertheimer, *1898.* 5 *(Fr. 271)*; *lent by* Asher B. Wertheimer, Esq.; *Tate Gallery, London.*
 Portrait of Miss Carey M. Thomas [*President of Bryn Mawr College (1894–1922)*], *1899.* 14 *(Fr. 270)*; *lent by* Bryn Mawr College; *Bryn Mawr College, Pennsylvania. Fig. 29*

SAXON, John Gordon *1860– ?*
Born in Troy, New York. Studied in Paris under Lefebvre, Tony Robert-Fleury, and Merson. Address, New York City. *Honorable Mention.*
 Sunset in the Dunes. 64 *(Fr. 273)*; *lent by* A. C. Humphreys, Esq.; *unlocated.*

SCHOFIELD, Walter Elmer *1867–1944*
Born in Philadelphia. Studied in Philadelphia, Academy of Fine Arts, and in Paris under MM. Bouguereau, Doucet, and Ferrier, and Aman Edmond Jean. Address, Ognotz, Pennsylvania. *Honorable Mention.*
 January Evening, *ca. 1898.* 94 *(Fr. 274)*; *unlocated.*

SCHREYVOGEL, Charles *1861–1912*
Born in New York City. Studied in Munich under Frank Kirchbach and Carl Marr. Address, Hoboken, New Jersey. *Bronze Medal.*
 My Bunkie, *1899.* 28 *(Fr. 275)*; *The Metropolitan Museum of Art, New York. Fig. 75*

SCOTT, Mrs. Emily Maria Spaford *1832–1915*
Born in Springwater, New York. Pupil of the National Academy of Design and Art Students' League, New York; studied in Paris. Address, New York City.
 Yellow Roses; *watercolor.* 248 *(Fr. 276)*; *unlocated.*

SEARS, Sarah Choate *1858–1935*
Born in Cambridge, Massachusetts. Pupil of the Cowles Art School and Museum of Fine Arts. Address, Boston. *Honorable Mention.*
 Portrait of a Lady in White; *pastel.* 74 *(Fr. 277)*; *lent by* Mrs. T. C. Fairchild; *unlocated.*

Romola. 104 *(Fr. 278)*; *lent by* C. A. de Gersdorff, Esq.; *unlocated.*

SHARP, Joseph Henry *1859–1953*
Born in Bridgeport, Connecticut. Studied in Antwerp under Charles Verlat, Munich Academy under Carl Marr, with Jean-Paul Laurens and Benjamin Constant, Paris. Address, Cincinnati.
 Head of Cheyenne. 249 *(Fr. 279)*; *unlocated.*

SHERWOOD, Rosina Emmet *1854–1948*
Born in New York City. Pupil of William M. Chase and Julian Academy. New York City.
 Portrait Study [*Head of a Child*]; *watercolor.* 116 *(Fr. 281)*; *collection of Mr. and Mrs. Christopher T. Emmet. Fig. 65*

SNELL, Henry Bayley *1858–1943*
Born in Richmond, England. Address, New York City. *Honorable Mention.*
 Twilight at Sea, *ca. 1899. watercolor.* 73 *(Fr. 287)*; *lent by* A. C. Humphreys, Esq.; *unlocated.*

STEELE, Theodore Clement *1847–1926*
Born in Indiana. From 1880 to 1885 studied in Munich under Professors Bentzer and Loeffts. Address, Indianapolis, Indiana. *Honorable Mention.*
 The Bloom of the Grape, *1893.* 50 *(Fr. 290)*; *lent by* The H. Lieber Company; *Indianapolis Museum of Art, Indiana. Fig. 79*

STERNER, Albert Edward *1863–1946*
Born in London, England. Studied in Birmingham, England, and later at the Julian Academy, Paris, and with Boulanger and Lefebvre, also at the Ecole des Beaux-Arts. Address, Nutley, New Jersey. *Bronze Medal.*
 Portrait of a Lady. *watercolor.* 250 *(Fr. 292)*; *unlocated.*
 Mother and Child. *watercolor.* 111 *(Fr. 293)*; *unlocated.*

STEWART, Jules [*Julius*] *1855–1919*
Born in Philadelphia. Pupil of J. L. Gérôme and R. de Madzo. Address, Paris.
 Nymphs of Nysa [*Nymphes de Nysa*], *n.d.* 84 *(Fr. 296)*; *Musée d'Orsay, Paris. Fig. 49*
 Laughing Woman. 1 *(Fr. 297)*; *unlocated.*

STORY, Julian Russell *1857–1919*
Born in Oxford, England. Pupil of Frank Duveneck, Boulanger, and Lefebvre. Address, Paris. *Silver Medal.*
 Columbine. 251 *(Fr. 298)*; *unlocated.*
 Portrait [*of his wife, Emma Eames*], *ca. 1891.* 86 *(Fr. 299)*; *Museum of Fine Arts, Boston.*

TABER, Edward M. *1863–1898*
Address, New York City.

> Mt. [*Mount*] Mansfield in Winter, *1895.* 252 *(Fr. 301); lent by* Mrs. C. M. F. Taber; *The Metropolitan Museum of Art, New York.*

TANNER, Henry Ossawa *1859–1937*
Born in Pittsburgh, Pennsylvania. Studied at the Pennsylvania Academy of Fine Arts under Thomas Eakins; afterward pupil of Jean-Paul Laurens and Benjamin Constant. Address, Paris. *Silver Medal.*

> Daniel in the Lions' Den, *ca. 1896.* 89 *(Fr. 302); unlocated. Fig. 33*

TARBELL, Edmund C. *1862–1938*
Born in West Groton, Massachusetts. Pupil of Boulanger and Lefebvre. Address, Boston, Massachusetts. *Bronze Medal.*

> The Venetian Blind [*La Jalousie*], *1898.* 125 *(Fr. 303);* Worcester Art Museum, Massachusetts.
> Across the Room, *ca. 1899.* 72 *(Fr. 304); The Metropolitan Museum of Art, New York. Fig. 55*

THAYER, Abbott Handerson *1849–1921*
Born in Boston. Pupil of Professor Wilmarth and Henry D. Morse, and of the Ecole des Beaux-Arts with Lehman and Gérôme. Address, Dublin, New Hampshire. *Gold Medal.*

> Brother and Sister [*Mary and Gerald Thayer*], *1889.* 159 *(Fr. 310); lent by* A. A. Carey, Esq.; *National Museum of American Art, Washington, D. C.*
> Virgin Enthroned, *1891.* 98 *(Fr. 311); lent by* J. M. Sears, Esq.; *National Museum of American Art, Smithsonian Institution, Washington, D.C. Fig 58*
> Young Woman, *ca. 1898.* 92 *(Fr. 312); lent by* George A. Hearn, Esq.; *The Metropolitan Museum of Art, New York. Fig. 57*

THERIAT, Charles James *1860– ?*
Born in New York. Studied with Jules Lefebvre and Boulanger in Paris. Address, Le Mee, par Melun, Seine-et-Marne, *France. Honorable Mention.*

> Portrait. 78 *(Fr. 316); unlocated.*

THOMAS, Stephen Seymour *1868–1956*
Born in San Augustine, Texas. Studied in Paris under Jules Lefebvre and Benjamin Constant and Alexander Harrison. Address, Paris. *Bronze Medal.*

> Lady in Brown. *pastel.* 134 *(Fr. 317); unlocated.*

VAIL, Eugene Laurent *1856–1934*
Born in Dervan, Brittany. Studied under Cabanel at the Ecole des Beaux-Arts, later under Messrs. Dagnan-Bouvet and Raphael Collin. Address, Paris.

> Evening in Brittany, *ca. 1899.* 189 *(Fr. 318); unlocated.*
> Voice of the Sea. 69 *(Fr. 319); unlocated.*
> Morning in October. 42 *(Fr. 320); unlocated.*

VAN BOSKERCK, Robert W. *1855–1932*
Born in New Jersey. Pupil of R. S. Gifford, and of A. H. Wyant, New York. Address, New York City.

> Landscape. 253 *(Fr. 38); unlocated.*

VAN DER WEYDEN, Harry *1868– ?*
Born in Boston. Studied in London, under Mr. Legros, at the Slade School; later with Mr. Fred Brown at his own school of art; studied at M. Jean-Paul Laurens's private academy and at Julian's in Paris. Address, Montreuil-sur-mer, Pas-de-Calais, France. *Bronze Medal.*

> Calm. 255 *(Fr. 337); unlocated.*
> The Hillside. 47 *(Fr. 338); lent by* Dr. Daniel Serrand; *unlocated.*

VEDDER, Simon Harmon *1866–1913*
Born in Montgomery County, New York. Studied at the schools of the Metropolitan Art Museum of New York, afterward at the Académie Julian in Paris, under Bouguereau and T. Robert-Fleury, and at the Ecole des Beaux-Arts with Gérôme; also with Léon Gleyre. Address, London.

> Portrait [*Auguste Suchetet*], *ca. 1894.* 187 *(Fr. 321); unlocated.*

VINTON, Frederick Porter *1846–1911*
Born in Bangor, Maine. Pupil of William M. Hunt and Dr. William Rimmer, Boston, Léon Bonnat and Jean-Paul Laurens, Paris; also studied in Munich. Address, Boston. *Silver Medal.*

> Portrait of A[*lonson*] W. Beard. 144 *(Fr. 322); lent by* U. S. Customs House, Boston; *unlocated.*

VONNOH, Robert W. *1858–1933*
Born in Hartford, Connecticut. Pupil of Boulanger and Lefebvre, Julian Academy. Address, Rockland Lake, New York. *Bronze Medal.*

> Miss Mildred Blair. 163 *(Fr. 323); lent by* Chauncey J. Blair, Esq.; *unlocated.*
> Little Louise [*Elkins*], *1897.* 166 *(Fr. 324); lent by* W. L. Elkins, Esq.; *formerly collection of Mrs. Wharton Sinkler (née Louise Elkins); unlocated.*

WALDEN, Lionel *1862–1933*
Born in Norwich, Connecticut. Studied with Carolus-Duran. Address, Paris. *Silver Medal.*

> Fishing in the Bay, *ca. 1899.* 154 *(Fr. 325); unlocated.*

WALKER, Horatio *1858–1938*
Address, New York City.

> Spring Ploughing. 53 *(Fr. 326); lent by* George A. Hearn, Esq.; *unlocated.*

WALL, A. Bryan *1872–1937*
Born in Allegheny City, Pennsylvania. Pupil of A. Wall. Address, Allegheny City, Pennsylvania.

> Sheep. 45 *(Fr. 327); unlocated.*

WATERS, Sadie *1869–1900*
Address, Paris, France. *Honorable Mention.*
> The Virgin with Lilies; *miniature, ca. 1896.* [Not in American catalogue, but in *Report of the Commissioner General*] *(Fr.328); unlocated.*

WEEKS, Edwin Lord *1849–1903*
Born in Boston. Pupil of the Ecole des Beaux-Arts and Léon Bonnat, Paris. Address, Paris.
> Indian Barbers [*Indian Barbers: Saharanpore*], *ca. 1895.* 191 *(Fr. 329); Joslyn Art Museum, Omaha, Nebraska. Fig. 31*
> The Awakening of Nourredin, *ca. 1899.* 12 *(Fr. 330); unlocated.*
> On the Road to Ispahan, *ca. 1896.* 32 *(no French number); unlocated.*

WEIR, *J*ulian Alden *1852–1919*
Born in West Point, New York. Pupil of Robert W. Weir and of J. L. Gérôme. Address, New York. *Bronze Medal.*
> The Ice Cutters, *ca. 1898.* 81 *(Fr. 333); lent by* C. E. Ladd, Esq.; *Portland Art Museum, Oregon.*
> Portrait of Young Girl in Grey. 169 *(Fr. 334); unlocated.*
> Noonday Rest [*Midday Rest in New England*], *1897.* 51 *(Fr. 335); lent by* Pennsylvania Academy of the Fine Arts; *Pennsylvania Academy of the Fine Arts, Philadelphia. Fig. 74*

WEIR, John F*erguson 1841–1926*
Born in West Point, New York. Studied under his father, Robert W. Weir; also studied in Holland, France, and Italy. Address, New Haven, Connecticut.
> Roses. 23 *(Fr. 336); lent by* Miss Hegeman; *unlocated.*

WENTWORTH, Cecilia *Smith* de *1853?–1933*
Born in New York City. Pupil of Sacred Heart Convent and Cabanel at Paris. Address, Paris.
> Cardinal Ferrata, *ca. 1894.* 254 *(Fr. 53); unlocated.*

WHISTLER, J*ames A*bbott *McNeill 1834–1903*
Born in the United States. Pupil of Gleyre, Paris. Address, Paris. *Grand Prize.*
> Brown and Gold, *ca. 1895–1900.* 108 *(Fr. 339); Hunterian Museum and Art Gallery, University of Glasgow, Scotland. Fig. 26*
> [*Mother of Pearl and Silver: The Andalusian*], *ca. 1894.* 103 *(Fr. 340); National Gallery of Art, Washington, D. C. Fig. 27*

> Symphony in White [*The Little White Girl: Symphony in White No. II*], *1864.* 76 *(no French number); Tate Gallery, London. Fig 28*

WILES, Irving R*amsay* 1862 [*sic. 1861*]*–1948*
Born in Utica, New York. Pupil of his father, Art Students' League, New York, and of Lefebvre and Carolus-Duran of Paris. Address, New York City. *Bronze Medal.*
> Portraits [*The Artist's Mother and Father*], *1889.* 162 *(Fr. 342); The Corcoran Gallery of Art, Washington, D.C. Fig. 61*

WOODBURY, Charles H*erbert 1864–1940*
Born in Lynn, Massachusetts. Pupil of Boulanger and Lefebvre. Address, Boston. *Bronze Medal.*
> The Green Mill, *1896.* 170 *(Fr. 343); MIT Museum, Cambridge, Massachusetts. Fig. 44*
> A Rock in the Sea. 171 *(Fr. 344); destroyed, as per records in Woodbury scrapbook, MIT Museum, Cambridge, Massachusetts.*

WOODBURY, Marcia O*akes 1864–1913*
Born in Lynn, Massachusetts. Studied at the Julian Academy, Paris. Address, Boston.
> *Mother and Daughter* [The Whole of Life], *triptych, watercolor. 1894.* 184 *(Fr. 345); Museum of Fine Arts, Boston. Fig. 47*
> The Smoker; *watercolor.* Am. 136 (Fr. 346); *unlocated.*

WUERPEL, Edmund H. *1866–1958*
Born in St. Louis, Missouri. Pupil of the St. Louis School of Fine Arts, W.A. Bouguereau, Gabriel Ferrier, and Edmund Aman-Jean, Paris. Address, St. Louis, Missouri.
> Dreaming Waters. 85 *(Fr. 347); unlocated.*

WYANT, Alexander Helwig *1836–1892*
Born in Ohio. Pupil of Hans Gude, Düsseldorf.
> Sunlit Vale, *ca. 1886.* 44 *(Fr. 348); lent by* H. H. Benedict, Esq.; *unlocated.*
> Moonlight and Frost, *ca. 1891.* 133 *(no French number); lent by* Mrs. Geo. A. Hearn; *The Brooklyn Museum of Art, New York.*
> In the Adirondacks, *ca.1881.* 142 *(Fr. 349); lent by* Miss Mary Hearn; *collection of Anthony E. Battelle. Fig. 85*

Notes to Fischer

1. John B. Cauldwell, "Report of the Department of Fine Arts," *Report of the Commissioner-General for the United States to the International Universal Exposition, Paris, 1900,* vol. II (Washington, D.C.: Government Printing Office, 1901), 513–514.

2. Picard's pivotal remark was quoted in translation in the *Official Illustrated Catalogue, Fine Arts Exhibit. United States of America, Paris Exposition of 1900* (Boston: Noyes, Platt & Co.), xv, but it originally appeared in Ministère du commerce, de l'industrie et des colonies, *Rapport général administratif et technique,* vol. 4 (Paris: Imprimerie nationale, 1891–1892), iii.

3. See Annette Blaugrund et al., *Paris 1889: American Artists at the Universal Exposition* (New York: Harry N. Abrams, 1989).

4. On the rich topic of French training, see H. Barbara Weinberg, *The Lure of Paris: Nineteenth-Century American Painters and their French Teachers* (New York: Abbeville Press, 1991).

5. Lois Marie Fink, *American Art at the Nineteenth-Century Paris Salons* (Washington, D.C.: Smithsonian Institution Press, 1990).

6. For example, Jules Adeline, *The Adeline Art Dictionary* (New York: Frederick Ungar Publishing Co., 1966), which is based on Adeline's *Lexique des terms d'art* (Paris: Quantin, 1854, English edition 1891), lists only four contemporary "schools"— the French, English, Spanish and German. Sixteen prior schools, including the Italian and the Dutch, were eliminated, indicating that "schools of art" were both elitist and evolutionary.

7. *Revisiting the White City: American Art at the 1893 World's Fair* (Washington, D.C.: National Museum of Art and National Portrait Gallery, Smithsonian Institution, 1993). On nationalism after the fair, see Linda Docherty's essay in this volume.

8. Such positivistic thinking was "less a systematic philosophy than a cultural tendency," according to T. J. Jackson Lears in *No Place of Grace: Antimodernism and the Transformation of American Culture, 1880–1920* (New York: Pantheon Books, 1983), 20. See also, Walter La Feber, *The New Empire: An Interpretation of American Expansion, 1860–1898* (Ithaca, N.Y.: Cornell University Press, 1963); and Kathleen Pyne, *Art and the Higher Life: Painting and Evolutionary Thought in Late Nineteenth-Century America* (Austin, Tex.: University of Texas Press, 1996).

9. John C. Van Dyke, "Painting at the Fair," *Century* 48 (July 1894): 439–447.

10. "American Studio Talk," *The International Studio* 7 (June 1899): supp. xiii–xiv.

11. "Art at the Exposition of 1900," *New York Times,* 22 May 1897, 2; Special Commissioner Moses P. Handy also urged emphasizing the arts in "Paris Exposition of 1900," 26 September 1897, 1. After the exposition closed, art was singled out for its contributions in *Report of the Commissioner-General,* I, 69. On expositions as political agents, see Robert W. Rydell, *All the World's a Fair: Visions of Empire at America's International Expositions, 1876–1916* (Chicago: University of Chicago Press, 1984).

12. Harry W. Watrous, Carleton T. Chapman, Edward Simmons, R.W. Van Boskerck, J. Carroll Beckwith, and William A. Coffin to the Council of the National Academy of Design, 22 November 1897, National Academy of Design Archives. I am grateful to David Dearinger for bringing this material to my attention.

13. "For Art Commissioner to Paris," *New-York Tribune,* 27 February 1898, 6. Through the Fine Arts Federation, other New York societies later endorsed the decision. On this appointment see also "J. B. Cauldwell Recommended," *New-York Tribune,* 7 August 1898, 6; "Art Topics of the Week," Saturday Review of Books and Art, *New York Times,* 13 August 1898, 535; and "Gallery and Studio," *Brooklyn Daily Eagle,* 9 October 1898: 17.

14. "The American Survey," ed. Charles H. Caffin, *The Artist* 25 (August 1899): supp. xxv.

15. *Memoir of W. A. Cauldwell (1827–1893),* n.d., n.p., 5–15. Unfortunately, little is known about Cauldwell, a bachelor, whose personal papers are presumed to have been destroyed. Cauldwell's will, however, reveals that he possessed a collection of antique and modern arms as well as paintings.

16. For Kurtz's correspondence relating to the exposition, see the Papers of Charles Kurtz, c. 1881–1980s, Archives of American Art reels 4804, 4826 and 4912. I am indebted to Arleen Pancza-Graham, who is preparing a dissertation on Kurtz, for her assistance.

17. "Pictures for Paris," *New York Times,* 4 March 1900, 22.

18. The exception to this was Winslow Homer, who exhibited four paintings. (Alexander Harrison is listed in the U.S. Catalogue in Appendix B as exhibiting four paintings, but only three appear in the final report to Congress.) Ultimately, while most artists were limited to one to two paintings, nine stateside and eight expatriate painters exhibited three paintings each.

19. For the general itinerary, see "Art at the Paris Exposition," *New-York Tribune,* II, 5 March 1899, 3. This tour is described in the Papers of Charles Kurtz.

20. For Kurtz's travel plans, see "Abroad on an Art Mission," *New-York Tribune,* III, 7 May 1899, 2. See also the Papers of Charles Kurtz.

21. A preliminary screening of work by Western artists was made at the Art Institute of Chicago, before being shipped to New York for final approval. See Appendix A.

22. "The American Survey," ed. Charles H. Caffin, *The Artist* 26 (October 1899): supp. lxii.

23. "American Art at Paris: Director Cauldwell Names the Exposition Committee," *New York Times,* 13 January 1900, 7.

24. Cauldwell, *Report* II, 518; Harrison Morris, "Growth and Needs of American Art," *The Independent* (6 May 1901): 1118–1119.

25. For an account of the New York jury meeting, see "Art Works for the Paris Fair," *New York Tribune,* 11 November 1899: 10. A list of the 168 oils, watercolors, and pastels selected in New York appears in "Our Art at Paris" *The Mail and Express,* 27 February 1900: 7. See also "American Art at Paris," *Brush and Pencil* 6 (June 1900): 127–133.

26. Regarding Dewing on this matter, see Sarah Burns, *Inventing the Modern Artist: Art and Culture in Gilded Age America* (New Haven, Conn.: Yale University Press, 1996), 74.

27. Cauldwell, *Report,* II: 515; "Our Exhibit at the Paris Exposition," ed. Charles H. Caffin, *Artist* 28 (July 1900): supp. ix. See note 41 for final space allocations.

28. R[oger] R[iordan], "The Paris Exposition," *Art Amateur* 42 (April 1900): 102.

29. "The Week in Art," Saturday supplement, *New York Times,* 22 July 1899, 494.

30. Paul Greenhalgh, *Ephemeral Vistas: The Expositions Universelles, Great Expositions, and World's Fairs, 1851–1939* (Manchester, N.Y.: Manchester University Press, 1988), 191–193. Greenhalgh notes that American women represented a quarter of the national contingent in art. However, most of the work exhibited by women consisted of space-saving miniature paintings and small works on paper. Only Cecilia Beaux, Elizabeth Nourse, Mary Fairchild MacMonnies, the eccentric Marquessa Cecilia Smith de Wentworth, and a few others displayed oil paintings.

31. See Robert Rydell's essay in this volume.

32. J. B. Cauldwell to B[enjamin] D. Woodward, Assistant Commissioner General, 21 February 1900, "Records of the Commission Representing the United States at the Paris Universal Exposition," Record Group 43, United States National Archives, Washington D.C. (hereafter abbreviated as NARA, RG 43), Box 8, Entry 1263, "Records of the Assistant Commissioner General," folder 140, claiming that Sargent, Fisher, Abbey, and Millet have all signed papers "which indicates their desire to exhibit with us."

33. Woodward to Cauldwell, 4 May 1899, NARA, RG 43, Box 8, E1265, f. 140.

34. [Charles Francis Browne], "The Editor," *Brush and Pencil* 6 (May 1900): 96.

35. Cauldwell to Kurtz, 22 May 1899, Kurtz Papers.

36. "American Artists' Exhibits," *New York Herald,* 8 April 1900, 1.

37. "American Art at the Exposition," *New York Herald,* 1 April 1900, 1.

38. John W. Beatty, letter, "American Artists," *New York Herald,* 6 April 1900: 3.

39. B. Guinaudeau, "La Décennale," *L'Aurore,* 19 May 1900: 1. As translated in *The Chefs d'Oeuvre: Art and Architecture,* 10 vols., with essays by William Walton (art and architecture), V[ictor] Champier (applied arts), and A[ndré] Saglio (centennial and retrospective), (Philadelphia: George Barrie and Son, 1900–1901), I: 30-1.

40. John Singer Sargent et al. to Woodward, 14 February 1900, NARA, RG 43, Box 8, E 1265, f. 140; a translation of this letter is on file in the Archives Nationales, Paris, F21/4066.

41. Fifty-eight additional feet of line space were added. The final allotment gave the United States 13,500 square feet of wall space for art (as opposed to 20,900.3 sq. ft. in 1889, which had been more than any other visiting nation). In 1900, however, Russia, Germany, and Italy received more space than the U.S. See Alfred Picard, *Rapport général administratif et technique,* vol.4 (Paris: Imprimerie nationale, 1902), 125.

42. In total, there were 342 works in all of Class 7, which also included two murals in the U.S. Pavilion (by Robert Reid and Elmer Garnsey). However, the 256 oils, watercolors, and pastels by 174 artists were the focus of the exhibit. Refer to the annotated catalogue of these in Appendix B.

43. John La Farge to Ferdinand Peck, 2 September 1898, NARA, RG 43, Box 8, E 1265, f. 140. For more on where Americans displayed fine and decorative art at the exposition, see Diane Pietrucha Fischer, "The 'American School' in Paris: The Repatriation of American Art at the Universal Exposition of 1900," Ph.D. diss., City University of New York, 1993.

44. Much to Stieglitz's dismay, photography was not part of the fine arts, but the liberal arts group. See Alfred Stieglitz, letter, "Why American Pictorial Work Is Absent from the Paris Exhibition," *The Amateur Photographer* 35 (5 July 1900): 44.

45. R[iordan], *Art Amateur,* 100.

46. Fischer, 138–147; 157–162.

47. For more on sculpture, see Fischer, 149–152.

48. Cauldwell, *Report,* II: 520.

49. See William H. Gerdts, *American Impressionism* (New York: Abbeville Press, 1984): 175; and Dianne H. Pilgrim, "Decora-

tive Art: The Domestic Environment," *The American Renaissance, 1876–1917* (Brooklyn, N.Y.: The Brooklyn Museum, 1979): 117. In 1905, Alfred Stieglitz's Little Galleries of the Photo-Secession were likewise decorated in olive and salmon. See Robert Doty, *Photo-Secession: Stieglitz and the Fine-Art Movement in Photography* (1960; repr. New York: Dover Publications, 1978), 38.

50. See Diane Pietrucha Fischer, "The Spirit of Inness: Creating an 'American School' at the Paris Exposition of 1900," in *George Inness: Presence of the Unseen* (Montclair, N.J.: The Montclair Art Museum, 1994).

51. R[oyal] C[ortissoz], "American Art in Paris," *New-York Tribune,* 22 July 1900, II: 1.

52. See, for example, Camille Mauclair, "La Décennale étrangère," *La Grande Revue de l'Exposition,* 10 July 1900, 178; and Royal Cortissoz, "Egotism in Contemporary Art," *Atlantic Monthly* 73 (May 1894): 648, as cited in Sarah Burns, "Old Maverick to Old Master: Whistler in the Public Eye in Turn-of-the-Century America," *American Art Journal* 22, no.1 (1990): 28–49.

53. N. N. [Elizabeth Robins Pennell], "The Paris Exposition–V, The American Section," *Nation* 71 (2 August 1900): 89.

54. N. N., *Nation,* 89.

55. See Pyne's discussion of this painting, in *Art and the Higher Life* pp. 94–95.

56. "Painting in Paris: Brilliant Portraiture," *Boston Evening Transcript,* (8 September 1900) in Cecilia Beaux Papers Archives, Pennsylvania Academy of the Fine Arts, Philadelphia. I am grateful to Tara Tappert for bringing this article to my attention.

57. For the ramifications of this scandal on the exposition, see Richard D. Mandell, *Paris 1900: The Great World's Fair* (Toronto, Canada: University of Toronto Press, 1967).

58. The claim that Sargent "admired, and thoroughly enjoyed painting, the energetic features of the men and exotic beauty of the women of the Semitic race," was made by the painter William Rothenstein. See Rothenstein, *Men and Memories,* vol. 1 (London: Faber and Faber, 1931), 195, as quoted in Carter Ratcliff, *John Singer Sargent* (New York: Abbeville Press, 1982), 231.

59. Albert Boime, "Sargent in Paris and London: A Portrait of the Artist as Dorian Gray," in Patricia Hills et al., *John Singer Sargent* (New York: Whitney Museum of American Art, 1986), 91. Boime interprets *Madame X* as "a testament to a compact between two cocky Americans to thumb their noses at envious foreign hosts."

60. C[ortissoz], "American Art in Paris," 1.

61. Samuel Isham, *The History of American Painting* (New York: The Macmillan Company, 1905), 468.

62. See D. Dodge Thompson, "'Loitering Through the Paris Exposition': Highlights of the American Paintings at the Universal Exposition of 1889," in Blaugrund et al.

63. Concerning Gérôme's influence on his American students,

see H. Barbara Weinberg, *The American Pupils of Jean-Léon Gérôme* (Fort Worth, Tex.: Amon Carter Museum, 1984), and *The Lure of Paris.*

64. C[ortissoz]. "American Art in Paris," 1.

65. Ilene Susan Fort, "Frederick Arthur Bridgman and the American Fascination with the Exotic Near East," Ph.D. diss. (City University of New York, 1990): 400–404.

66. According to Richard D. Mandell, "the world seemed eager to punish France" after Dreyfus was pardoned. This "denunciation of France" was "most violent in the Anglo-Saxon countries." For example, in the United States, newspaper accounts and protests condemning France were rampant, as were motions to boycott the exposition. See Mandell, "The Affair and the Fair: Some Observations on the Closing Stages of the Dreyfus Case," *Journal of Modern History* 39 (September 1967): 257-258.

67. Dewey F. Mosby, et al., *Henry Ossawa Tanner* (New York: Rizzoli, 1991), 93, 258–259. I would like to thank Ilene Susan Fort for supplying information prior to publication in Fort and Michael Quick, *American Art: A Catalogue of the Los Angeles County Museum of Art Collection* (Los Angeles: Los Angeles County Museum of Art, 1990), 225–227.

68. Ellis T. Clarke, "Alien Element in American Art," *Brush and Pencil* 7 (October 1900): 39.

69. See Charles C. Eldredge, *American Imagination and Symbolist Painting* (New York: Grey Art Gallery and Study Center, New York University, 1979).

70. Natalie Spassky, *American Painting in the Metropolitan Museum of Art Volume II* (New York: The Metropolitan Museum of Art, 1985), 580.

71. Eldredge, 62–64.

72. Walton, in *The Chefs d'Oeuvre,* III: 26.

73. On Millet, see H. Barbara Weinberg, "The Career of Davis Millet," *Archives of American Art Journal* 17, no. 1 (1977): 12–13.

74. Charles A. Coolidge, "Report of the Architect," *Report,* II: 203–205.

75. Clarke, *Brush and Pencil,* 39.

76. C[ortissoz], "American Art in Paris," 1.

77. For an examination of La Farge's excursion, see James L. Yarnall, *Recreation and Idleness: The Pacific Travels of John La Farge* (New York: Vance Jordan Fine Art Inc, 1900.). I am grateful to Yarnall, who is preparing a catalogue raisonné on La Farge, for sharing his research.

78. See Gabriel P. Weisberg, *The Realist Tradition: French Painting and Drawing, 1830–1900* (Cleveland, Ohio: Cleveland Museum of Art, 1980), 8–10.

79. Concerning American art colonies abroad, see Peter Bermingham, *American Art in the Barbizon Mood* (Washington, D.C.: National Collection of the Fine Arts, 1975); David Sellin, *Americans in Brittany and Normandy, 1860–1910* (Phoenix, Ariz.: Phoenix Art Museum, 1982); and Michael Jacobs, *The Good and Simple Life: Artist Colonies in Europe and America* (Oxford, U.K.: Phaidon Press, 1985).

80. Annette Stott, "American Painters Who Worked in the Netherlands, 1880–1914," Ph.D. diss., Boston University, 1986, 338–339.

81. Clarke, *Brush and Pencil*, 38.

82. C[ortissoz], "American Art in Paris," 1.

83. Isham, 464.

84. Henry Adams, "The Dynamo and the Virgin," *The Education of Henry Adams* (1918; repr. Boston: Houghton Mifflin, 1961): 384–385.

85. Leila Bailey Van Hook, "The Ideal Woman in American Art, 1875–1910," Ph.D. diss. City University of New York, 1988, 7.

86. As quoted in Ronald G. Pisano, *A Leading Spirit in American Art: William Merritt Chase 1849–1916* (Seattle, Wash.: Henry Art Gallery, 1983), 175.

87. Martha Banta, *Imaging American Women: Idea and Ideals in Cultural History* (New York: Columbia University Press, 1987), 104. On women as subjects at this time, see Bailey Van Hook, *Angels of Art: Women and Art in American Society* (University Park: Pennsylvania State University Press, 1996).

88. Banta, 109. See also Tara Tappert, "Choices—The Life and Career of Cecilia Beaux: A Professional Biography," Ph.D. diss. George Washington University, 1990.

89. C[ortissoz], "American Art in Paris," 1.

90. N. N., *Nation*, 90.

91. C[ortissoz], "American Art in Paris," 1.

92. Adams, *The Education of Henry Adams*, 383.

93. See Lears, 183ff.

94. Alan Trachtenberg, *America and Lewis Hine, Photographs 1904–1940* (Millerton, N.Y.: Aperture, 1977), 123.

95. Banta, *Imaging American Women: Idea and Ideals in Cultural History*, 109.

96. William H. Gerdts, "Frank Benson—His Own Man: A Study of the Artist's Development and Its Critical Reception," *Frank W. Benson: The Impressionist Years* (New York: Spanierman Gallery, 1988): 41.

97. Ellis Clarke, *Brush and Pencil*, 38.

98. C[ortissoz], "American Art in Paris," 1.

99. Alexander functioned as an unofficial ambassador for Cauldwell, charged with greeting Commissioner Peck upon his arrival in Paris. Cauldwell to Peck, 22 April 1899, NARA, RG 43 Box 8, Entry 1265, f. 140.

100. For a recent examination of Eakins's reputation, particularly his scandal-ridden resignation from the Pennsylvania Academy of the Fine Arts, see Kathleen A. Foster and Cheryl Leibold, *Writing about Eakins: The Manuscripts in Charles Bregler's Thomas Eakins Collection* (Philadelphia: University of Pennsylvania Press). See also William Innes Homer, *Thomas Eakins: His Life and Art* (New York: Abbeville Press, 1992), 194.

101. N. N., *Nation*, 89.

102. N. N., *Nation*, 89.

103. Weinberg, *The American Pupils of Jean-Léon Gérôme*.

104. Sadakichi Hartmann, *A History of American Art*, vol. 1 (Boston: L.C. Page, 1902), 203, as quoted in Lloyd Goodrich, Thomas Eakins, II: 203.

105. Doreen Bolger Burke, *American Paintings in the Metropolitan Museum of Art. Volume III* (New York: The Metropolitan Museum of Art), 401–404.

106. See Robert W. Rydell's essay in this volume.

107. Cauldwell, *Report*, II: 556.

108. "Painting in Paris. Brilliant Portraiture."

109. Clarke, *Brush and Pencil*, 45.

110. H. Barbara Weinberg, Rubin lecture, Metropolitan Museum of Art, 14 May 1991. Regarding artists (re)adjusting to the American countryside, see, in particular, H. Barbara Weinberg, Doreen Bolger, and David Park Curry, *American Impressionism and Realism: The Painting of Modern Life, 1885–1915* (New York: Metropolitan Museum of Art, 1994); and Lisa N. Peters, *Visions of Home: American Impressionist Images of Suburban Leisure and Country Comfort* (Carlisle, Penn.: Trout Gallery, Dickinson College, 1997).

111. Martin F. Krause, *The Passage: Return of Indiana Painters from Germany, 1880–1905* (Indianapolis, Ind.: Indianapolis Museum of Art, 1991), 130.

112. William H. Gerdts, *American Impressionism.*

113. William H. Gerdts, "American Tonalism: An Artistic Overview," in Gerdts et al., *Tonalism: An American Experience,* (New York: Grand Central Art Galleries, 1982): 21–22. For a recent examination of tonalism, see *American Tonalism: Paintings, Drawings, Prints and Photographs from The Metropolitan Museum of Art and The Montclair Art Museum* (Montclair, N.J.: The Montclair Art Museum, 1999).

114. This is discussed in Fischer, "The Spirit of Inness," Blaugrund in Blaugrund et al., and Nicholai Cikovsky, Jr., *The Life and Work of George Inness* (New York: Garland, 1977).

115. "An American Triumph: Our Painters at the Paris Exposition," *Boston Transcript,* 29 August 1900.

116. Cauldwell, *Report*, II: 552. A fourth painting by Inness, *Valley on a Gloomy Day* (1892; Colby College Museum of Art) was accepted by the jury but probably not installed due to space restrictions. I appreciate the generosity of Michael Quick, who is preparing a catalogue raisonné on Inness.

117. N. N., *Nation*, 90.

118. Inness had used the phrase "civilized landscape," in "A Painter on Painting," *Harper's New Monthly Magazine* 56 (February 1878): 461. For a recent interpretation, see Diane Pietrucha Fischer, "The 'Inness' Colony of Montclair," *The Montclair Art Colony: Past and Present* (Montclair, N.J.: The Montclair Art Museum, 1997). See also Nicholai Cikovsky, Jr. and Michael Quick, *George Inness* (Los Angeles: Los Angeles County Museum of Art, 1985).

119. Discussions of Inness's spirituality appear in Cikovsky and Michael Quick, *George Inness* (Los Angeles: Los Angeles County Museum of Art, 1985); Michael Quick, "George Inness: The Spiritual Dimension," *George Inness, Presence and the Unseen*; Sally Promey, "The Riband of Faith: George

Inness, Color Theory, and the Swedenborgian Church," *American Art Journal* 26 (numbers 1 and 2, 1994): 44–65; and Eugene Taylor, "The Interior Landscape: George Inness and William James on Art from a Swedenborgian Point of View," *Archives of American Art Journal* vol. 37, numbers 1 & 2, 1997, 2–10.

120. Albert Boime, *The Magisterial Gaze: Manifest Destiny and American Landscape Painting, c. 1830–1865* (Washington, D.C.: Smithsonian Institution Press, 1991). Also on nationalism in Jacksonian landscape painting, see Angela Miller, *The Empire of the Eye: Landscape Representation and American Cultural Politics, 1825–1875* (Ithaca, N.Y.: Cornell University Press, 1993).

121. Gerdts, *Tonalism*, 27. Of the twelve members of the landscape society, only Carleton Wiggins failed to exhibit at the 1900 exposition. Bronze medals were awarded to George Bogert, Bruce Crane, and Charles Harold Davis; and Frederick Kost, John Francis Murphy, Robert Minor, and Walter Palmer received Honorable Mentions, leaving only Walter Clark, William Coffin, Robert Swain Gifford, and Leonard Ochtman empty-handed.

122. Abraham A. Davidson, *Ralph Albert Blakelock* (University Park: Pennsylvania State University Press, 1996). I would like to thank Davidson, who is preparing a catalogue raisonné on Blakelock, for his assistance.

123. The literature on regional American art is extensive. For an encyclopedic overview, see William H. Gerdts, *Art Across America: Two Centuries of Regional Painting, 1710–1920*, 3 vols. (New York: Abbeville Press, 1990).

124. Cortissoz, "American Art in Paris," 1.

125. "An American Triumph," *Boston Evening Transcript*, 29 August 1900.

126. Walton, in *Chefs d'Oeuvre*, III: 42. On Homer's seascapes see David Latham, "Winslow Homer and the Sea," in Philip C. Beam, et al., *Winslow Homer in the 1890s: Prout's Neck Observed* (New York: Hudson Hills Press, 1990); and Bruce Robertson, *Reckoning with Winslow Homer: His Late Paintings and Their Influence* (Cleveland, Ohio: The Cleveland Art Museum, 1990).

127. F. Hopkinson Smith, "The Pictorial Side of the Exposition of 1900," *Outlook* 67 (January 1901): 41.

128. Robert Rosenblum has identified Anders Zorn's *Midsummer Dance* (1897) in the Swedish decennial as part of this trend, in Rosenblum and H. W. Janson, *Nineteenth-Century Art* (New York: Harry N. Abrams, 1984), 461.

129. N. N., *Nation*, 90.

130. Merrill Schleier, *The Skyscraper in American Art, 1890–1931* (Ann Arbor, Mich.: UMI Research Press, 1986).

131. Joseph Stella, "The Brooklyn Bridge (A page of my life)," *Transition* 16 (June 1929): 87, as quoted in Lewis Kachur, "The Bridge as Icon," *The Great East River Bridge* (New York: The Brooklyn Museum, 1983), 154.

132. Sadakichi Hartmann, "A Plea for the Picturesqueness of New York," *Camera Notes* 4 (October 1990): 91–97.

133. Within Class 7, the 174 American painters, exhibiting oils, watercolors, and pastels, received 96 medals. The United States total of 114 includes two Cuban artists, Armando Menocal and Leopoldo Romanach. For the 1889 statistics, see Blaugrund, in Blaugrund et al., 27.

134. Weinberg, *The Lure of Paris*, 224.

135. Alexander Harrison was the other U.S. juror for Class 7. Again, Cauldwell was insulted that the allotment was not in proportion to the importance of the American exhibition, was not in conformity with what the French led him to expect, and was less than it had been in 1889. Cauldwell, *Report*, II, 522–523.

136. N. N.[Elizabeth Robins Pennell], "The Paris Exposition–III. The French Fine-Arts Section–II," *Nation* 71 (12 July 1900): 31.

137. Walton, in *Chefs d'Oeuvre*, I: v.

138. Roger Riordan, "The Paris Exposition," *Art Amateur* 43 (August 1900): 62. Riordan erroneously refers to this painting as *Les Bouches Quatiles*.

139. Walton, in *Chefs d'Oeuvre*, III: 15.

140. Cauldwell, *Report*, II: 514.

141. C[harles] H. C[affin], "American Art in Paris," *Evening Post*, 11 August 1900, 5.

142. After the war, a new generation of expatriates was recognized at both the Ecole des Beaux-Arts and the Salons as comprising an "Ecole américaine." Elizabeth Hutton Turner, *American Artists in Paris, 1919–1929* (Ann Arbor, Mich.: UMI Research Press, 1988).

143. C[affin], "American Art in Paris," 5.

144. C[ortissoz], "American Art in Paris," 1.

145. Georges Lafenestre, "La Peinture. Les Ecoles étrangères," *Revue de l'art ancien et moderne* 8 (October 1900): 218. Translation of "le caractère commun . . . est l'énergie, saine et intense, de l'impression, par les moyens d'expression très simples et très nets Le dilettantisme du vieux monde, mythologie, religion, fantaisie, ne tiennent pas grande place dans l'art du nouveau."

146. N. N., "The Paris Exposition V–The American Section," *Nation* 89.

147. C[affin], "American Art in Paris," 5.

148. Cauldwell, *Report*, II: 553.

149. See Robert R. Preato, "Collectors of American Tonal Painters: Charles Land Freer, Thomas B. Clarke, William T. Evans, and George A. Hearn," in Gerdts et al, *Tonalism*.

150. "The Society of Landscape Painters," *Brush and Pencil* 4 (May 1899): 114.

151. N. N., "The Paris Exposition–V. The American Section," *Nation*, 90.

152. Refer to Gail Stavitsky's essay on the legacy of the American School in this book.

Notes to Docherty

1. For an overview of international expositions, see John E. Findling, ed., *Historical Dictionary of World's Fairs and Expositions, 1851–1988* (New York: Greenwood Press, 1990); and Paul Greenhalgh, *Ephemeral Vistas: "The Expositions Universelles," Great Exhibitions and World's Fairs, 1851–1939* (Manchester, N.Y.: Manchester University Press, 1988).

2. On the American art exhibit at the World's Columbian Exposition, see *Revisiting the White City: American Arts at the 1893 World's Fair*, exh. cat. (Washington, D.C.: National Museum of American Art and National Portrait Gallery, Smithsonian Institution, 1993). On the Centennial display, see Susan Hobbs, *1876: American Art of the Centennial*, exh. cat. (Washington, D.C.: National Collection of Fine Arts, Smithsonian Institution, 1976).

3. John C. Van Dyke, "Painting at the Fair," *Century* 48/3, n.s., 26/3 (July 1894): 446.

4. John Higham, "The Reorientation of American Culture in the 1890s," in *Writing American History: Essays on Modern Scholarship* (Bloomington: Indiana University Press, 1970), 73–102.

5. For a discussion of this culture, see Alan Trachtenberg, *The Incorporation of America: Culture and Society in the Gilded Age* (New York: Hill and Wang, 1982).

6. Higham, "The Reorientation of American Culture in the 1890s," 79–80.

7. Theodore Roosevelt, *The Strenuous Life: Essays and Addresses* (New York: The Century Company, 1900), 21.

8. Theodore Roosevelt, "What 'Americanism' Means," *Forum* 17 (April 1894): 205.

9. Ibid., 200–201.

10. Sadakichi Hartmann, "How an American Art Could Be Developed," *The Art Critic* 1/1 (November 1893), 3–4; reprinted in Jane Calhoun Weaver, ed., *Sadakichi Hartmann: Critical Modernist, Collected Art Writings* (Berkeley: University of California Press, 1991), 58–62. *The Art Critic* was designed to bring advanced ideas on art to American readers. The journal terminated after three issues when Hartmann went bankrupt. See Weaver, 2–3.

11. Quoted in Weaver, 14.

12. From Sadakichi Hartmann, "A National American Art," *The Art Critic* 1/3 (March 1894), 45–49; reprinted in Weaver, 74.

13. On these two definitions of nationalism, see David M. Potter, "The Historian's Use of Nationalism and Vice Versa," in *History and Society: Essays of David M. Potter*, ed. Don E. Fehrenbacher (New York: Oxford University Press, 1973), 61–108.

14. Wilbur Zelinsky, *Nation into State: The Shifting Symbolic Foundation of American Nationalism* (Chapel Hill: University of North Carolina Press, 1988).

15. On the Nashville fair, see Marks White Handly, "Tennessee and Its Centennial," *Century* 54/1, n.s., 32/1 (May 1897), 92–97; F. Hopkinson Smith, "Some Notes on Tennessee's Centennial," *Scribner's Magazine* 22/3 (September 1897): 333–344; and Findling, 146–149.

16. Smith, 849.

17. Ibid., 341.

18. On the Omaha fair, see Charles Howard Walker, "The Great Exposition at Omaha," *Century* 55/4, n.s., 33/4 (February 1898): 518–521; Albert Shaw, "The Trans-Mississippians and Their Fair at Omaha," *Century* 56/6, n.s., 34/6 (October 1898): 836–852; and Findling, 152–154.

19. Shaw, 849.

20. A. H. Griffith, "American Pictures at the Trans-Mississippi and International Exposition at Omaha, Nebraska," *Brush and Pencil* 3/1 (1898): 35–46.

21. Ibid., 37. On Howe's salon career, see Lois Marie Fink, *American Art at the Nineteenth-Century Paris Salons* (Washington, D.C.: Smithsonian Institution Press; Cambridge, U.K.: Cambridge University Press, 1990), 227.

22. In addition to the livestock exhibit at the fair, visitors to Omaha could see stockyards and packing houses.

23. Total attendance at Nashville was 1,167,000 and at Omaha, 2,614,000, compared to 27,529,000 at Chicago. See Findling, 377–378.

24. On this point, see Robert W. Rydell, *All the World's a Fair: Visions of Empire at American International Expositions, 1876–1916* (Chicago: University of Chicago Press, 1984), 72–125.

25. A. R. Spofford, "The Nation's Library," *Century* 53/5, n.s., 31/5 (March 1897): 682–694.

26. See *The American Renaissance, 1876–1917*, exh. cat. (New York: The Brooklyn Museum, 1979).

27. Montgomery Schuyler, "The New Library of Congress," *Scribner's Magazine* 21/6 (June 1897): 721.

28. See William A. Coffin, "The Decorations in the New Congressional Library," *Century* 53/5, n.s., 31/5 (March 1897): 694–711; and Pauline King, *American Mural Painting* (Boston: Noyes, Platt & Company, 1902), 169–218.

29. Royal Cortissoz, "A National Monument to Art: The Congressional Library at Washington," *Harper's Weekly* 39/2036 (28 December 1895): 1241; quoted in Sarah J. Moore, "In Search of an American Iconography: Critical Reaction to the Murals at the Library of Congress," *Winterthur Portfolio* 25/4 (winter 1990), 235.

30. "The Decorations for the Library of Congress," *Scribner's Magazine* 20/2 (August 1896): 258.

31. The major mural cycle for the Boston Public Library was painted by the French artist Pierre Puvis de Chavannes, who never saw the building. American expatriates Edwin Austin Abbey and John Singer Sargent also contributed decorations; a mural by James Abbott McNeill Whistler was planned for the main reading room.

32. "Decorative Art in America," *Scribner's Magazine* 20/2 (August 1896): 260.

33. Will H. Low, "National Expression in American Art," *International Monthly* 3 (1901): 241.

34. Ibid., 248.

35. R[ussell] S[turgis], "The Sculptures of the Dewey Reception in New York," *Scribner's Magazine* 26/6 (December 1899): 765–768.

36. On the proliferation of art organizations in the 1890s, see "Social Art Gatherings in New York," *Scribner's Magazine* 20/6 (December 1896): 784. On the Mural Society specifically, see King, 145–153.

37. On the sculptural program and the artists who executed it, see Ernest Knaufft, "Dewey Day Decorations in New York," *Review of Reviews* 20/4 (October 1899): 458–462; and *American Renaissance*, 87.

38. For a brief history of this debate, see Barbara Tuchman, *The Proud Tower: A Portrait of the World Before the War, 1890–1914* (New York: Macmillan Company, Bantam Books, 1966), 134–194. See also E. Berkeley Tompkins, *Anti-Imperialism in the United States: The Great Debate, 1890–1920* (Philadelphia: University of Pennsylvania Press, 1970).

39. Van Dyke, 446.

40. For a synopsis of the conditions blamed for America's failure to develop a distinctive art, see Henry B. Fuller, "Art in America," *Bookman* 10 (November 1899): 218–224.

41. See Albert Boime, "The Chocolate Venus, 'Tainted' Pork, the Wine Blight, and the Tariff: Franco-American Stew at the Fair," in Annette Blaugrund et al, *Paris 1889: American Artists at the Universal Exposition*, exh. cat. (Philadelphia: Pennsylvania Academy of the Fine Arts; New York: Harry N. Abrams, 1989), 67–91; and Diane Pietrucha Fischer, "The 'American School' in Paris: The Repatriation of American Art at the Universal Exposition of 1900," Ph.D. diss., City University of New York, 1993, 57–59.

42. See H. Barbara Weinberg, *The Lure of Paris: American Painters and Their French Teachers* (New York: Abbeville Press, 1991).

43. "A National American Art," reprinted in Weaver, 68.

44. "Artistic Atmosphere," *Scribner's Magazine* 19/6 (June 1896): 786.

45. "The Art World," *The Art Collector* 9/8 (15 February 1899): 115.

46. "A National American Art," reprinted in Weaver, 71.

47. [Sadakichi Hartmann], "Boston Art Gossip," *Art News* 1/4 (June 1897): 6–7; reprinted in Weaver, 79.

48. Hamlin Garland, *Crumbling Idols* (Chicago: Stone and Kimball, 1894), 131–132.

49. Ibid., 63–64.

50. Ibid., 57.

51. Winslow Homer and Abbott Thayer were invited to join the original group, but declined. When Twachtman died in 1902, he was replaced by William Merritt Chase. On The Ten, see Patricia Jobe Pierce, *The Ten* (Concord, N.H.: Rumford Press, 1976); William H. Gerdts, *American Impressionism* (New York: Abbeville Press, 1984), 171–185;

52. On *The Factory Village*, see H. Barbara Weinberg, Doreen Bolger, and David Park Curry, *American Impressionism and Realism: The Painting of Modern Life, 1885–1915*, exh. cat. (New York: The Metropolitan Museum of Art, 1994), 25–27 and 83–85.

53. "American Studio Talk," *International Studio* 4/15, supplement (May 1898): xiv.

54. "The Fine Arts: Ten American Painters," *The Critic* 32/842 (9 April 1898): 255.

55. See Linda J. Docherty, "A Search for Identity: American Art Criticism and the Concept of the Native School" (Ph.D. diss., University of North Carolina at Chapel Hill, 1985).

56. See "Art Prizes and Awards," *Scribner's Magazine* 22/5 (November 1897): 655–658.

57. John Lavery of Glasgow received the gold for *A Lady in Brown*; Jean François Raffaëlli of Paris, the silver for *Notre Dame*; and Cecilia Beaux of Philadelphia, the bronze for *Ernesta*.

58. The value and terms of the awards changed slightly in 1897.

59. "American Studio Talk," *International Studio* 5/9, supplement (September 1898): xxx.

60. See William H. Truettner, "William T. Evans, Collector of American Paintings," *American Art Journal* 3/2 (fall 1971): 52.

61. See Linda Henefield Skalet, "The Market for American Painting in New York: 1870–1915," Ph.D. diss., Johns Hopkins University, 1980.

62. On Macbeth, see Skalet, 201–211; Victor G. Wexler, "Creating a Market in American Art: the Contribution of the Macbeth Gallery," *Journal of American Studies* 25 (1991): 245–255; and Malcolm Goldstein, "William Macbeth: Art Dealer," *Drawing* 15/3 (September-October 1993): 53–58.

63. In his early years of operation, Macbeth mounted six shows of foreign painting, presumably for economic reasons.

64. On Clarke, see Skalet, 131–145; and H. Barbara Weinberg, "Thomas B. Clarke: Foremost Patron of American Art from 1872 to 1899," *American Art Journal* 8/1 (spring 1976): 52–83.

65. The Thomas B. Clarke Prize was awarded for the best figure painting of an American subject exhibited by a nonacademician at the Academy's spring exhibition.

66. Quoted in Weinberg, "Thomas B. Clarke," 64–65.

67. Van Dyke, 446.

68. William Howe Downes, *The Life and Work of Winslow Homer* (Boston: Houghton Mifflin Company, 1911; reprint, New York: Dover Publications, 1989), 205.

69. "American Art," *Century* 57/6, n.s., 35/6 (April 1899): 955.

70. On Evans, see Skalet, 146–155; and Truettner. On other collectors of American painting in this period, see Skalet, 156–177.

71. Evans also gave paintings to The Metropolitan Museum of Art, The Newark Museum, The Brooklyn Museum of Art, and the Detroit Institute of Art.

72. On these alternative definitions of culture, see George Cotkin, *Reluctant Modernism: American Thought and Culture, 1880–1900* (New York: Twayne Publishers, 1992), 101–103.

Notes to Rydell

1. Henry Adams, *The Education of Henry Adams* (1918; Boston: Houghton Mifflin Company, 1961), 79.

2. Ibid., 381–382, 388.

3. The best short introduction to the Paris 1900 fair is Robert W. Brown, "Paris 1900," in *Historical Dictionary of World's Fairs and Expositions, 1851–1988*, ed. John E. Findling and Kimberly D. Pelle (New York: Greenwood Press, 1990), pp. 155–164. Lengthier treatments include Richard D. Mandell, *Paris 1900: The Great World's Fair* (Toronto: University of Toronto Press, 1967); Debora L. Silverman, *Art Nouveau in Fin-de-Siècle France: Politics, Psychology, and Style* (Berkeley: University of California Press, 1989); and Diane Pietrucha Fischer, "The 'American School' in Paris: The Repatriation of American Art at the Universal Exposition of 1900," Ph.D. diss., City University of New York, 1993. See also Michael Wilson, "Consuming History, the Nation, the Past, and the Commodity at L'Exposition Universelle de 1900," *American Journal of Semiotics* 8, no. 4 (1991): 131–154.

4. Adams, 380.

5. A good starting point for understanding these issues is Eric Foner, *Reconstruction, 1863–1877* (New York: Harper & Row, 1988).

6. Aram A. Yengoyan, "Culture, Ideology and World's Fairs: Colonizer and Colonized in Comparative Perspective," in *Fair Representations: World's Fairs and the Modern World*, eds. Robert W. Rydell and Nancy E. Gwinn (Amsterdam, The Netherlands: VU University Press, 1994), pp. 62–83; Penelope Harvey, *Hybrids of Modernity: Anthropology, the Nation State, and the Universal Exhibition* (New York: Routledge, 1996). For a good discussion of the relationship between the 1900 fair and the Dreyfus Affair, see Mandell, 89–103.

7. See Robert W. Rydell, *All the World's a Fair: Visions of Empire at America's International Expositions, 1876–1916* (Chicago: University of Chicago Press, 1984).

8. Ibid., ch. 2; "National School Celebration of Columbus Day: The Official Program," *The Youth Companion* 65 (8 September 1892): 446–447.

9. Andrew Carnegie, "Value of the World's Fair to the American People," *The Engineering Magazine* 6, 4 (January 1894): 421–422.

10. Tony Bennett, *The Birth of the Museum* (New York: Routledge, 1995), p. 62.

11. Carnegie, 422.

12. Rydell, *All the World's a Fair*, passim.

13. Emily S. Rosenberg, *Spreading the American Dream: American Economic and Cultural Expansion, 1890–1945* (New York: Hill and Wang, 1982); Amy Kaplan and Donald E. Pease, eds., *Cultures of United States Imperialism* (Durham, N.C.: Duke University Press, 1993).

14. W. T. Stead, *The Americanisation of the World* (London: Review of Reviews, 1902).

15. "The United States and the Paris Exposition of 1900," *Nineteen Hundred*, 3, 2 (August 1897): 1.

16. W. I. Buchanan to Moses Handy, 6 September 1897, University of Michigan, William L. Clements Library, Moses Handy Papers, Box 27, f. 15.

17. *Report of the Commissioner-General for the United States to the International Universal Exposition, Paris, 1900*, vol. 1 (Washington, D.C.: Government Printing Office, 1901), 16–18 (cited hereafter as *Report of the Commissioner-General*).

18. Helen Lefkowitz Horowitz, *Culture and the City: Cultural Philanthropy in Chicago from the 1880s to 1917* (Lexington: University of Kentucky Press, 1976), 40.

19. Thomas W. Palmer to William McKinley, 29 August 1987, U.S. National Archives, U.S. Department of State Application and Recommendation Files, Record Group 59, Box 82, f. Peck, Ferdinand; "The United States at the Paris Fair," *New York Times*, 17 June 1900, 10.

20. "United States at the Paris Fair," *New York Times*, 17 June 1900, 10.

21. Peck, "Response," *The United States and the Paris Exposition. Speeches of Representative Americans at [a] Banquet Given to Commissioner-General Ferdinand W. Peck, in Chicago, on the Eighth Day of December, 1898*. no imprint, 8, in U.S. National Archives, Records of the Commission Representing the United States at the Paris Universal Exposition, 1900, Record Group 43 (cited hereafter as NA, RG 43), Box 12, entry 1279, f. 155–158.

22. Gurton W. Allen, "The East and the Paris Exposition," Ibid., 11; E. O. Stanard, "The Southwest and the Paris Exposition," Ibid., 17; Thomas C. Search, "Manufacturers and the Paris Exposition," Ibid., 30.

23. Charles A. Collier, "The South and the Paris Exposition," Ibid., 13.

24. Alexander H. Revell, "The Lafayette Monument," Ibid., 44.

25. Elbridge G. Keith, "Growth of Our Foreign Trade," Ibid., 35.

26. *Report of the Commissioner-General*, vol. 1, 53.

27. Frederick Jackson Turner, *The Significance of the Frontier in American Life*, ed. Harold P. Simonson (1893; New York: Frederick Ungar Publishing Co., 1966), 57.

28. B. D. Woodward, "The Exposition of 1900," *North American Review* 170 (April 1900): 473.

29. "Reply of Mr. A. Picard to Commissioner-General Ferdinand W. Peck . . . October 15, 1898," NA, RG 43, Box 1, entry 1279, f. affairs.

30. "United States at the Fair," *New York Times*, 17 June 1900, 19; Woodward, 476.

31. "Cuban Exhibit in Paris," *New York Times*, 16 March 1900, 7. See also *Exposition Universelle Internationale de 1900 à Paris. Catalogue Spécial Officiel de Cuba* (Paris: Prieur et DuBois, 1900).

32. Ferdinand Peck to John Hay, 7 July 1899, U.S. National Archives, Records of the Bureau of Insular Affairs, Record Group 350, Entry 5, f. 906-1 and 906-2. These issues cropped up again at the 1901 Buffalo fair. See "Flag for Cuban

Exhibits," *Buffalo Enquirer*, 28 June 1900, clipping. Buffalo and Erie County Historical Society, Pan-American Scrapbooks.

33. Richard Nelson Current and Marcia Ewing Current, *Loïe Fuller: Goddess of Light* (Boston: Northeastern University Press, 1997).

34. Woodward, 475.

35. "Correspondent Challenged," *New York Times*, 9 June 1900, 6; "Nationality in Art," *New York Times*, 17 June 1900, 20.

36. Fischer, 177.

37. Walter Benjamin, "The Work of Art in the Age of Mechanical Reproduction," in *Illuminations*, ed. Hannah Arendt (New York: Schocken, 1969).

38. "Three Annexes of the United State," *The Nineteen Hundred* 10, 6 (June 1900): 17–18; Eugène-Melchior de Vögué, "The Exposition of 1900," *The Living Age* 10 (January 26, 1901): 208.

39. "Three Annexes," 17–18; *Report of the Commissioner-General*, vol.1, 69.

40. A good overview of women's world's fair exhibits is Mary F. Cordato's "Representing the Expansion of Women's Sphere: Women's Work and Culture at the World's Fairs of 1876, 1893, and 1904," Ph.D. diss., New York University, 1990.

41. Lester G. Moses, *Wild West Shows and the Images of American Indians, 1883–1933* (Albuquerque: University of New Mexico Press, 1996).

42. Rydell, *All the World's a Fair*, 72–104.

43. Bok's argument was reported in "American Women at Paris in 1900," *The Nineteen Hundred* 7, 1 (July 1898): 3–4. See also Bertha Honoré Palmer to Peck, n.d.; "The Paris Exposition," *New York Times*, 9 June 1899, clipping; Peck to Lyman Gage, 25 July 1899; Delaunay-Belleville to Peck, 24 October 1898; [?] to Woodward, 8 June 1899; all in NARG 43, Box 6, entry 1279, f. 85-1. For an account of women's representations at the fair that agreed with Bok, see Th. Bentzon, "Women at the Paris Exposition," *Outlook* 66 (29 September 1900): 259–265.

44. Bertha Honoré Palmer to Peck, n.d.; "The Paris Exposition," *New York Times*, 9 June 1899, clipping; Peck to Lyman Gage, 25 July 1899; Delaunay-Belleville to Peck, 24 October 1898; [?] to Woodward, 8 June 1899; all in NA RG 43, Box 6, entry 1279, f. 85-1. See also Silverman, 63–74.

45. Woodward to Peck, 29 June 1899; Skiff to Peck, 7 July 1899; both in NA, RG 43, Box 6, entry 1279, f. 85-1. French women were bitterly divided about women's representations at the fair. Their disagreements led to the organization of two separate international congresses, one devoted to Works and Institutions of Women, the other to Women's Condition and Rights. Only a handful of American women chose to attend. Among them were Jane Addams and May Wright Sewall. See *Report of the Commissioner-General*, vol. 6, 306–319.

46. *Annual Report of the Commissioner, Bureau of Indian Affairs to the Secretary of the Interior* (Washington, D.C.: General Printing Office, 1899/1900), 47–51.

47. Ibid., 46.

48. "Colonial Exhibitions," *The Nineteen Hundred* 6, 5 (May 1898): 2.

49. Thomas J. Calloway, "Booker Washington and the Tuskegee Institute," *The New England Magazine*, n.s., vol. 17, no. 2 (October 1897): 136–137, 146; "Negro Exhibit at Paris," circular, reprinted from the *New York Age*, 9 November 1899, Library Company of Philadelphia. For information on Calloway's life, consult *Who's Who of the Colored Race*, ed. Frank Lincoln Mather (Chicago: [Half-Century Anniversary of Negro Freedom in U.S.], 1915), 58.

50. The two best descriptions of the exhibit are in Calloway's report in *Report of the Commissioner-General*, vol. 2, 463–467; and W. E. Burghardt Du Bois, "The American Negro at Paris," *American Monthly Review of Reviews* 22 (November 1900): 575–577.

51. Du Bois, 575–577.

52. Ibid.

53. Ibid., 577; Burton Benedict, "Rituals of Representation: Ethnic Stereotypes and Colonized People at World's Fairs," *Fair Representations*, 55.

54. Stead, op. cit.; "Great Triumph for America," *New York Times*, 2 September 1900, 21.

Notes to Weisberg

1. See *Ministère des Affaires Etrangères, Correspondance Commerciale*, New York, July 1899–June 1900, tome 48, 51–52, under "Arrangement Franco-Américan." The tariff wars between France and the United States had been extreme since the Paris Exposition Universelle of 1889. They had begun to improve when the French were well represented at the World's Columbian Exposition, held in Chicago in 1893. For further reference see Lois Marie Fink, *American Art at the Nineteenth-Century Paris Salons* (New York: Cambridge University Press, 1990).

2. Edmond Bruwaert, Consulat Général de France à New York, 19 August 1899, in *Ministère des Affaires Etrangères, Correspondance Commerciale*, tome 48, 51–52.

3. For further reference see *New York Herald*, 22 January 1900.

4. "To the Exhibitors at the Paris Exposition in 1900," Document, *Ministère des Affaires Etrangères, Correspondance Commerciale*, dated 1 March 1900, 225 ff.

5. "Argument Presented by the Manufacturers Committee to the U.S. Senate Committee on Foreign Relations," Washington, D.C., 19 February 1900, Document, *Ministère des Affaires Etrangères, Correspondance Commerciale*, tome 48, 226–230 ff.

6. On Bing's role in promoting awareness of the United States see Gabriel P. Weisberg, *Art Nouveau Bing: Paris Style 1900* (Washington, D.C.: Smithsonian Institution, and New York: Harry N. Abrams, 1986). Champier's numerous articles stressed the eventual improvement in French applied

arts. An article in the November 1893 issue of *Figaro* was mentioned in a "consular dispatch" sent back to the United States by Samuel E. Morse, General Consul in Paris.

7. See *Archives Nationales, Bourses*, F17/4600 1894–95; F17/4598 *Bourse de Voyage 1900*. George Leygues initiated much of this, since he was particularly interested in bettering student ties between the countries.

8. Roujon's personal papers have eluded location. Logically, his descendants might still own documentation which would permit further insight into the artistic policies of the Third Republic.

9. See Henry Roujon, *Artistes et Amis des Arts* (Paris: Librarie Hachette, 1912). Roujon also published insightful articles in *Revue Bleue*, using the "nom de plume" Ursus.

10. Georges Dagrav, "Figures du jour, Henry-François-Joseph Roujon," *Le Voltaire* (29 September 1900): 1.

11. G. D., "Les Obsèques de M. Henry Roujon," *Le Gaulois* (5 June 1914): 2; "Mort de Henry Roujon," *La Liberté* (2 June 1914): 1.

12. "M. Leygues et l'enseignement moderne," *Le Voltaire* (27 April 1900): 1.

13. Georges Saint-Agnan, "Figures du jour, Georges-Jean-Claude Leygues, Député et ministre," *Le Voltaire* (29 June 1900): 1.

14. See Georges Leygues, *L'Ecole et la vie* (Paris: Calmann-Lévy, 1903).

15. Discussions with descendants of Leygues have been inconclusive in determining whether American paintings were in his possession. American newspapers citing his interest in American art are *New York Daily Tribune*, 9 December 1900, 2, and *New York Times*, 9 December 1900.

16. On Leygues's death and his larger-than-life role in society see "Mort de M. Georges Leygues, ministre de la marine, ancien président du conseil," *Le Temps* (3 September 1933): 6.

17. See Léonce Bénédite, "Note sur le programme de la reconstruction du Musée du Luxembourg," Archives du Louvre (25 October 1899). The author is indebted to Françoise Aujogue, chief archivist at the *Archives du Louvre*, for her expert help during his search in the archives.

18. For reference to this see *Archives Nationales* F21/2194, "M. Tiffany, Achat de M. Bing," 1894, with letters of support from Bénédite.

19. See Léonce Bénédite, "Introduction générale. Deuxième Partie—Beaux-Arts, Etats Unis d'Amérique," *Rapports du Jury International, Exposition Universelle Internationale de 1900 à Paris* (Paris: Imprimerie nationale, 1902–1905), 508–514.

20. Commissariat des Etats-Unis, Exposition Universelle de 1900, Paris, Séction des Beaux-Arts, *Catalogue officiel illustré. Exposition des Beaux-Arts, Etats-Unis d'Amérique, Exposition Universelle de Paris, 1900* (Boston: Noyes, Platt & Co., 1900), 52. This catalogue notes: "En outre des décorations et des sculptures du Pavillon National, de nombreuses peintures, etc. ont été placées au dernier moment trop tard pour être cataloguées

séparément ici. Cependant, celles qui portent le numéro d'ordre spécial seront facilement reconnues si on se reporte au numéro indiqué au catalogue dans les pages suivantes."

21. See Diane Pietrucha Fischer, "The 'American School' in Paris: The Repatriation of American Art at the Universal Exposition of 1900," Ph.D. diss., City University of New York, 1993, 267 ff.

22. "France et Etats Unis," *Le Rapide* (27–28 March 1900): 2.

23. Stanislas Rzewuski, "L'Ame américaine," *L'Evénement* (3 May 1900): 2.

24. Georges Denoinville, "L'Art à l'Exposition Universelle de 1900, Les Palais des Beaux-Arts," *Le Voltaire* (4 May 1900): 1.

25. "L'Exposition, Le Pavillon des Etats-Unis," *La Liberté* (13 May 1900): 2. Also see "A L'Exposition, Les inaugurations d'hier," Le Journal (13 May 1900): 3. Some writers saw the American exhibit as an area for "ultra-modernisme." See "L'Exposition Universelle, au pavillon américain," *Le XIXè Siècle* (14 May 1900): 1.

26. See Gustave Geffroy, "Les Beaux-Arts à l'Exposition, Les Ecoles étrangères de peinture," *Le Journal* (16 July 1900): 3.

27. "L'Art étranger au Grand-Palais," *Le National* (11 July 1900): 2. Also see "L'Art étranger au Grand-Palais," *Le Voltaire* (11 July 1900): 1–2.

28. "L'école américaine est définitivement consacrée. Les peintres de talent qu'elle compte forment une majorité très appréciable. Malgré tous ses emprunts, elle reste originale, et il transpire, de l'ensemble de la production artistique, un parfum de liberté et d'indépendance, bien spécial." "L'Art étranger au Grand-Palais II Etats-Unis," *Le Voltaire* (18 July 1900): 1–2.

29. "vrais peintres," "harmonies colorées." Ibid.

30. "L'Art étranger au Grand-Palais, Etats-Unis," *Le Rapide* (20 July 1900): 1.

31. Léon Plée, "L'Art à l'exposition, La peinture américaine," *La Liberté* (20 July 1900): 2.

32. "un tableau vraiment religieux de sentiment et d'expression." E. Grosjean-Maupin, "Le Grand-Palais, La peinture étrangère," *Le Matin* (16 August 1900): 2.

33. B. Guinaudeau, "La Décennale américaine," *L'Aurore* (31 August 1900): 1.

34. Ibid.

35. Ibid.

36. See Louis de Fourcaud, "Les Peintres américains à l'Exposition," *Le Gaulois du Dimanche* (15–16 September 1900): 1–2.

37. "école profondément unifiée," "école déjà franchement constituée et qui prend conscience d'elle-même." Ibid., p. 1.

38. "un robuste exécutant, de personnalité très accentuée, insuffisament connu en Europe," "fermement naturellement américain." Ibid., p. 2.

39. See *Exposition Universelle Internationale de 1900, Catalogue spécial-Etats Unis* (Paris: Lemercier; Lille: L. Danel, 1900), Groupe XII, p. 475 ff. Also see *Catalogue of Exhibitors in the United States, Section of the International Universal Exposition*

Paris, 1900 (Paris: Société Anonyme des Imprimeries Lemercier, 1900), 395–412. The latter catalogue lists the exhibitors but does not refer specifically to the range of examples, as is documented in the *Archives Nationales*.

40. Ibid., 156–59, 483–94, 542–43, and 544–46.

41. Some of these pieces, which were noted for their references to Japanese models, were given to the Cincinnati Museum of Art in 1903. Only now are they receiving the attention and research they deserve. The author is indebted to Jennifer Howe, assistant curator at the Cincinnati Art Museum, for bringing this material to his attention.

42. See "Les Récompenses de l'Exposition, Classe LXXI— Céramique," *L'Evénement* (4 October 1900): 3.

43. Ibid., p. 3.

44. "Les Récompenses de l'Exposition, Classe LXXI— Céramique," *L'Evénement* (5 October 1900): 3.

45. See *Archives Nationales*, F12/4235, card no. 37900 under Groupe 12, Classe 72.

46. See *Archives Nationales*, F12/4235, card no. 37894 for A. R. Valentien, card no. 37904 for Geneva Reed, and card no. 87923 for H. Grueby.

47. "premier élève direct de M. Whistler." Camille Mauclair, "La Décennale étrangère," *La Grand Revue de l'Exposition* (10 July 1900): 178.

48. Auguste Marguiller, "L'Art étranger," *Revue Encyclopédique*, no. 368 (22 September 1900).

49. "coeur humain," "les humbles," A. Quantin, *L'Exposition du siècle, Paris: Le monde moderne, 1900* (Paris, 1900): 37–48.

50. Ibid., "L'Art décoratif étranger," 116–18.

51. *Le Livre d'or de l'exposition de 1900*, vol. 1 (Paris: Edouard Cornéley, Editeur, 1900), 181–183. In general this book glosses over the exposition.

52. *Report of the Commissioner General for the United States to the International Exposition, Paris, 1900*, 6 vols. (Washington, D.C.: Government Printing Office, 1901).

53. Ibid., vol. 2, 513.

54. Ibid., vol 2, 514.

55. Léon Greder, *Loisirs d'art, Mélanges-La Peinture étrangère à l'exposition de 1900* (Paris: Imprimerie de Daupeley-Gouverneur, 1901).

56. "une saveur de terroir," "rivaliser avec leur confrères européens." Ibid., 113–114.

57. Ministère du Commerce, de l'Industrie des Postes et des Télégraphes, "Etats-Unis," *Exposition Universelle Internationale de 1900 à Paris, Rapports du Jury international, Groupe XV, Industries diverses* (Paris: Imprimerie Nationale, 1902), 309–315.

58. Ibid. This report is invaluable in discussing the role and importance of Moore.

59. "de tonalités étranges," Ibid., 506. The author acknowledges Jennifer Howe of the Cincinnati Art Museum for bringing the Storer pieces to his attention.

60. *Exposition Universelle Internationale de 1900 à Paris, Rapports du Jury International, Deuxième Partie—Beaux-Arts, par Léonce Bénédite* (Paris: Imprimerie Nationale, 1904), 508–514. Note: Bénédite also reviewed American art in "L'Exposition décennale," in "Les Beaux-Arts et les arts décoratifs à l'Exposition Universelle de 1900," *Paris Gazette des Beaux-Arts*.

61. "tempérament original," Exposition Universelle Internationale de 1900 à Paris, *Le Bilan d'un siècle (1801–1900)* (Paris: Librarie H. le Soudier, 1906), par Alfred Picard.

62. "Les peintres des Etas-Unis, sans qu'on s'en étonne, montrent déjà, dans leurs bons ouvrages, plusieurs des grandes qualités. . . . La franchise complète de l'observation, la simplicité vigoureuse de l'impression, la subordination du procédé à l'expression. . . . C'est une des sections étrangères, où, depuis vingt ans, les progrès ont été les plus rapides et décisifs. . . ." Georges Lafenestre, "Les Ecoles étrangères," in *L'Art à L'Exposition Universelle de 1900* (Paris: Librarie de l'Art Ancien et Moderne, 1907), 195.

63. *Archives du Louvre*, "Réclassification du Luxembourg, 1898–1912," 2HH4.

64. *Archives du Louvre*, "Note sur le Programme de la Reconstruction du Musée du Luxembourg," 25 October 1899, signed by Léonce Bénédite.

65. See *Archives du Louvre, Fonds Bénédite*, 375.5.1, for letters from Harrison, MacEwen, Sargent, and others that were written from 1905 to the 1920s.

66. *Archives Nationales*, "M. L. Walden, les Docks de Cardiff" for the Musée du Luxembourg, 27 July 1896.

67. *Archives Nationales*, F21/2136, Alexander Harrison, "Achat En Arcadie," 6 July 1900, for 1,000 francs. Bénédite, in his letter to Roujon supporting En Arcadie (dated 2 May 1900) wrote it was "comme son meilleur ouvrage."

68. *Archives Nationales*, F21/2136, "G. Johnston Humphreys [sic], Portrait de Femme," 14 December 1900, for 1,000 francs.

69. *Archives Nationales*, F21/2132, "Sunday in Holland, Walter MacEwen." Also see "Dossier RF 1189, Orsay Documentation."

70. Also see Susan Grant, *Le Commerce de l'Art*, essay on "Les achats de tableaux américains pour les collections publiques françaises, 1879–1900," 250 ff.

71. *Archives Nationales*, F21/4209, although the dossier is now empty.

72. *Archives Nationales*, F21/4221, "Winslow Homer, Achat d'un tableau, Nuit d'Eté," 21 January 1901.

73. *Archives Nationales*, F21/4221, letter from John Cauldwell to Henry Roujon, dated 12 February 1901.

74. Also see dossier RF 1977-427, Orsay Documentation, "Nuit d'Eté."

75. Archives du Louvre, 030-275, 1907, "Epreuve du discours de Léonce Bénédite, représentant le Musée du Luxembourg pour l'inauguration du Musée Carnegie," fol. 110–15.

76. Archives du Louvre, 030-275, 1907, "Mission aux Etats-Unis," fol. 104, 105. The invitation to Bénédite apparently came directly from Andrew Carnegie.

77. For further reference see *Les Etats-Unis et la France, leurs rapports historiques, artistiques et sociaux par E. Boutoux . . . P. W. Bartlett, J. M. Baldwin . . . Léonce Bénédite, W. V. R. Berry etc. . . .* (Paris: F. Alcan, 1914).

78. See *Exposition d'artistes de l'école américaine organisée avec le concours d'un comité américain et français et sous le haut patronage de MM. Woodrow Wilson Président des Etats Unis d'Amérique . . . Octobre–Novembre, 1919* (Paris: Musée Nationale du Luxembourg, 1919), text by Léonce Bénédite.

79. For reference see "Mr. Cauldwell Returns," *New York Tribune* (9 December 1900), and *New York Times* (10 December 1900). These references are contained within Diane P. Fischer's doctoral dissertation. Cauldwell's quote that Leygues purchased "works for his private collection" is significant.

80. Pierre Rosenberg, in discussion with the author in January 1998, reiterated his belief that Leygues was an important art collector whose works mirrored the interests of his friend Georges Clemenceau.

81. Telephone interview held with Mrs. V. Jordan Brown, Leygues's granddaughter, on 26 October 1997. In documents later sent to the author, she asserted that Leygues had no collection. She also wrote that he "worked hand in glove with Bénédite and Roujon. I dare say the paintings he is supposed to have bought were for the French Museums?" Letter to the author, dated 5 November 1997.

82. "Les Millions de M. Chauchard, M. Georges Leygues et sa famille héritent de quinze millions," *Le Journal* (7 June 1909), pp. 1–2.

83. The author has been in continuous contact with Leygues's descendants who are still searching their private holdings and archives for works collected by Leygues. Since numerous documents relating to him are now being deposited and classified in the archives established in his name at Villeneuve-sur-Lot, his place of birth, more discoveries on Leygues as a collector are expected.

84. Commissariat des Etats-Unis, Exposition Universelle de 1900, *Official Illustrated Catalogue. Fine Arts Exhibit. United States of America at the Paris Exhibition of 1900.* (Boston, 1900).

85. The author has examined all state records on official purchases and records of provincial museums for this period and has found no evidence that Leygues acquired works for the museum, meaning that if these works were purchased at all, it was for Leygues's private collection.

86. According to a member of the Leygues family, a lawyer, in examining part of a family inheritance and in checking material from 1900, located a letter from Homer Lee to Leygues.

87. Letter from Léonce Bénédite to Georges Leygues, dated 1 March 1901, in *Archives de la Marine, Papiers Georges Leygues.*

88. *League of American Artists* (Paris: Clarke and Bishop, 1905). Also see John Joseph Conway, "An American Salon in Paris," *Paris American* (10 September 1905). The concept of an American Salon was quite controversial at the time.

89. See *Paris American* (10 September 1905) for the list of patrons that includes Stanford White, L. L. Lorillard, and Louis C. Tiffany.

Notes to Stavitsky

1. Charles Caffin, *American Masters of Painting* (Garden City, N.Y.: Doubleday, Page & Company, 1913), 72–73.

2. See Diane Pietrucha Fischer, "The 'American School' in Paris: The Repatriation of American Art at the Universal Exposition of 1900," Ph.D. diss., City University of New York, 1993, 306.

3. "Art in America," *Evening Telegraph*, February 9, 1901, The Pennsylvania Academy of the Fine Arts Papers, Archives of American Art, Smithsonian Institution, Reel P53, #421.

4. "The Academy's Annual Exhibition," *Philadelphia Inquirer*, January 13, 1901, P53, #436 and unidentified clipping, February 10, 1901, #419.

5. Harrison Morris, "Growth and Needs of American Art," *The Independent*, May 16, 1901, P53, #455.

6. *Catalogue of The Exhibition of Fine Arts* (Buffalo, N.Y.: David Gray, 1901), XII. See also Joann Marie Thompson, "The Art and Architecture of the Pan-American Exposition, Buffalo, New York, 1901," Ph.D. diss. Rutgers The State University, 164–227.

7. Charles Caffin, "The Pan-American Exposition as a Work of Art," *World's Work*, II (August 1901): 1051. On Caffin, see Sandra Lee Underwood, *Charles H. Caffin: A Voice for Modernism 1897–1918* (Ann Arbor, Mich.: UMI Research Press, 1983), 72–81.

8. Ibid.

9. Royal Cortissoz, "Art at Buffalo," *New York Tribune Illustrated Supplement*, (July 7, 1901): 8.

10. Ibid.

11. Cortissoz, op. cit. (July 14, 1901): 2.

12. Cortissoz, op. cit. (July 7, 1901): 8.

13. John Rummell and E. M. Berlin, *Aims and Ideals of Representative American Painters* (Buffalo, N.Y.: Pan American Exposition, 1901): 106–107. See also 11, 40, 43.

14. Ibid., 73.

15. "Foreword," *Official Catalogue of Exhibitors, Universal Exposition* (St. Louis, Missouri, 1904), 17.

16. J. W. Buel, ed., *Louisiana and The Fair* (St. Louis, Missouri: World's Progress Publishing Co., 1904), 2502. See also 2435–2437, 2457.

17. Charles Caffin, "The Exhibit of Paintings and Sculpture," *The World's Work* (August 1904): 5179–80.

18. Charles Caffin, *American Masters . . .* , op. cit., 6. See also 33, 74, 79–80, 117, 156.

19. Ibid., 167.

20. Charles Caffin, *The Story of American Painting* (New York: Frederick A. Stokes Company, 1907): 168, 186–189.

21. Ibid., 344.

22. Ibid., 382.

23. Ibid., 339. See also 78, 198, 233, 332, 335.

24. Sadakichi Hartmann, *A History of American Art*, 1902; rev. ed. (New York: Tudor Publishing Company, 1934), 190. See also Jane Calhoun Weaver, *Sadakichi Harmann: Critical Modernist* (Berkeley: University of California Press, 1991), 22–32.

25. Ibid., 189, 349.

26. Ibid., See also 96, 157,161, 191, 225, 280–281.

27. Samuel Isham, *The History of American Painting*, 1905; rev. ed. (New York: The Macmillan Company, 1927), 419.

28. Ibid., 449.

29. Ibid., 587.

30. Ibid., 471. See also 419, 439, 440, 449, 464, 561, 587.

31. J. Walker McSpadden, *Famous Painters of America* (New York: Thomas Y. Cromwell & Co., 1907), viii, 115, 118.

32. Christian Brinton, *Modern Artists* (New York: The Baker and Taylor Co., 1908), 100.

33. Ibid., 157.

34. William Howe Downes, "William Merritt Chase, A Typical American Artist," *The International Studio* XXXIX (December 1909): XXIX.

35. Robert Henri, "Progress in Our National Art Must Spring from the Development of Individuality of Ideas and Freedom of Expression," *The Craftsman* XV (January 1909): 390.

36. William Glackens, "The American Section. The National Art," *Arts and Decoration* 3 (March 1913): 159–160. The show included Whistler, Charles Harold Davis, Gaines Ruger Donoho, Maurer, and the "strong men," Hassam, Weir, Robinson, and Twachtman, who introduced "the light of life into our art."

37. John E. D. Trask and J. Nilsen Laurvik, ed., *Catalogue De Luxe of The Department of Fine Arts Panama-Pacific International Exposition* I (San Francisco, CA: Paul Elder and Company, 1915), 9.

38. Ibid., 47.

39. Ibid., 11, 47.

40. Ibid., 12.

41. Ibid. On Inness's "distinctively American . . . simplicity of statement," see p. 16. On Metcalf's landscapes as the best "illustration of the hyper-sensitive, super-refined Americanized product of Impressionism," see p. 21.

42. Ibid., 22.

43. Ibid., 24.

44. Christian Brinton, *Impressions of the Art and the Panama-Pacific Exposition* (New York: John Lane Company, 1916), 97, 98 ("Cubism . . . and the like were excluded from the native section.")

45. Michael Williams, "A Pageant of American Art," *Art and Progress* VI (August 1915): 337, 340.

46. Ibid., 351.

47. Robert Vonnoh, "Increasing Values in American Paintings," *Arts and Decoration* (May 1912): 254.

48. Bryson Burroughs, "Introduction," *Loan Exhibition of the Works of Thomas Eakins* (New York: The Metropolitan Museum of Art, 1917), vi. See also Jennifer Hardin, "The Critical Reception of Thomas Eakins' Work, II. Posthumous," *Thomas Eakins* (Washington, D.C.: Smithsonian Institution Press, 1993), 195–198.

49. See Van Wyck Brooks, *John Sloan: A Painter's Life* (New York: E. P. Dutton & Co., Inc., 1955), 11.

50. Robert Henri, *The Art Spirit* (Philadelphia and London: J.B. Lippincott Company, 1923), 86.

51. Jennifer Hardin, op. cit., 195.

52. Kenyon Cox, *Winslow Homer* (New York, priv. print, 1914), 12–13. On Homer's Americanism, criticism, and influence, see Bruce Robertson, *Reckoning with Winslow Homer* (Cleveland, Ohio: The Cleveland Museum of Art, 1990).

53. Ibid., 13, 29.

54. John C. Van Dyke, *American Painting and Its Tradition* (New York: Charles Scribner's Sons, 1919), 111–113.

55. Ibid., 10.

56. Gertrude Vanderbilt Whitney, "The End of America's Apprenticeship in Art," *Arts & Decoration* (September 1920): 230.

57. Ibid., 231.

58. Duncan Phillips, *A Collection in the Making* (New York and Washington, D.C.: E. Weyne Phillips Publication, 1926), 31.

59. Duncan Phillips, "Nationality in Pictures," *The Enchantment of Art as Part of the Enchantment of Experience: Fifteen Years Later* (Washington, D.C.: Phillips Publication, 1927), 66.

60. Ibid., 68.

61. Ibid., 69.

62. Duncan Phillips, *Julian Alden Weir* (New York: The Century Club, 1921), 8, 10.

63. Ibid., 12.

64. "Nationality in Pictures," 53.

65. Royal Cortissoz, *Personalities in Art* (New York: Charles Scribner's Sons, 1925), 349. See also his essays on Inness and Weir, 385–406.

66. Robert Henri, "Progress in Our National Art . . . ," 388 and Marsden Hartley, *Adventures in the Arts* (New York: Boni and Liveright, Inc., 1921), 50, 52–53.

67. Ibid., 55, 57.

68. Ibid., 65, 74, 79.

69. Ibid., 43, 48.

70. Ibid., 97, 101.

71. See Ernest Haskell, intro., *Childe Hassam* (New York: Frederick A. Stokes Company, 1922), vii.

72. Ibid.

73. Lee Woodward Zeigler, "Introduction," *John Singer Sargent* (New York: Frederick A. Stokes Company, 1924), vii. For Whistler's exemption from nationalism as the greatest artist of his day whose greatness cannot be accounted for by environment or inheritance, see Joseph and Elizabeth Robbins Pennell, intro., *James McNeill Whistler* (New York: Frederick A. Stokes Company, 1924), v.

74. Paul Rosenfeld, *Port of New York* (Urbana: University of Illi-

nois Press, 1961), xlvi. See also Matthew Baigell, "American Art and National Identity: The 1920s," *Critical Issues in American Art*, (Boulder, Col.: Westview Press, 1998), 269–284 and H. Barbara Weinberg, "Late-Nineteenth-Century American Painting: Cosmopolitan Concerns and Critical Controversies," *Archives of American Art Journal* 23 (1983): 19–26.

75. Royal Cortissoz, *American Artists* (New York: Charles Scribner's Sons, 1923), 77, 125.

76. Thomas Craven, "Men of Art: American Style," *The American Mercury* 6 (December 1925): 426, 428.

77. Ibid., 432.

78. Thomas Craven, *Modern Art* (New York: Simon and Schuster, 1934), 260–261.

79. Suzanne LaFollette, *Art in America* (New York and London: Harper & Brothers Publishers, 1929), 170.

80. Ibid., 170, 177.

81. See Lewis Mumford, *The Brown Decades A Study of the Arts in America 1865–1895* (New York: Harcourt, Brace and Company, 1931), 189–190 and H. Barbara Weinberg, "John Singer Sargent: Reputation Redivivus," *Arts* 54 (March 1980): 104–109.

82. LaFollette, 180.

83. H. Barbara Weinberg, "Renaissance and Renascences in American Art," *Arts* 54 (November 1979): 175.

84. Alfred H. Barr, Jr., intro., *Winslow Homer Albert P. Ryder Thomas Eakins* (New York: The Museum of Modern Art, 1930), 6.

85. Ibid.

86. Ibid.

87. Ibid., 8.

88. Ibid., 18–19.

89. Ibid., 20.

90. Lillian Semons, "Three 19th Century Artists in Modern Museum Show," *Brooklyn N.Y. Times*, 11 May 1930. Public Information (PI) Scrapbooks, The Museum of Modern Art Library.

91. Gail R. Scott, ed., *On Art by Marsden Hartley* (New York: Horizon Press, 1982), 168.

92. Ibid., 171–172.

93. Holger Cahill, intro., *American Painting & Sculpture 1862–1932* (New York: The Museum of Modern Art, 1932), 9, 13.

94. Ibid., 13.

95. Ibid., 14.

96. Ibid., 15.

97. "American Art in Retrospect," *Philadelphia Public Ledger*, 11 December 1932, P.I. Scrapbooks.

98. "Around the Galleries," *Creative Art* (October 1932), PI Scrapbooks.

99. Margaret Breuning, "Last Seventy Years of American Art," *New York Evening Post*, 5 November 1932, 8S.

100. Ibid.

101. Ibid.

102. Helen Appleton Read, "A Usable Past," *Brooklyn Eagle*, 30 October 1932, PI Scrapbooks.

103. Ibid.

104. Edward Alden Jewell, "In the Realm of Art," *New York Times*, 6 November 1932, PI Scrapbooks.

105. Helen Appleton Read, "American Tradition Revealed," *Brooklyn Eagle*, 6 November 1932, p. E10.

106. "America's Valuation of Its Own Masters Revealed at World's Fair," *The Art Digest* 7 (15 May 1933): 28.

107. "American Art Featured in Great Century of Progress Show . . . ," *The Art News* (May 27, 1933): 1, 8.

108. For C. J. Bulliet's comments on these works as the most popular American works in the fair, see *Art Masterpieces* (Chicago: The North Mariano Press, 1933), 1, 31.

109. "The Art of America Is Feature of Chicago's Great 1934 Exhibition," *The Art Digest* VIII (June 1934): 6.

110. Ibid. See also Fiske Kimball, "The Arts," *A Century of Progress* (New York and London: Harper & Brothers, 1932), 381–398.

111. Lloyd Goodrich, *Winslow Homer Centenary Exhibition* (New York: Whitney Museum of American Art, 1936), 7. See also Eugen Neuhaus, *The History and Ideals of American Art* (Stanford, Calif.: Stanford University Press, 1931), 296–300, passim.

112. Lloyd Goodrich, *A Century of American Landscape Painting 1800 to 1900* (New York: The Whitney Museum of American Art, 1938), 15.

113. Ibid., 20–21.

114. John Baur, *Leaders of American Impressionism* (New York: The Brooklyn Museum, 1937), 14.

115. John Baur, *An American Genre Painter Eastman Johnson 1824–1906* (New York: The Brooklyn Museum, 1940), 3, 28.

116. Edward Alden Jewell, *Have We an American Art?* (New York: Longmans, Green & Company, 1939), 19, 20, 36–38, 199.

117. Ibid., 39, 62 (the comment about "the peculiarly American way of looking at things" referred specifically to a Hopper landscape.)

118. Ibid., 175–176.

119. On the subject of defining a national school, see also H. Barbara Weinberg, Doreen Bolger, and David Park Curry, *American Impressionism and Realism: The Painting of Modern Life, 1885–1915* (New York: The Metropolitan Museum of Art, 1994), 2–33.

Archival Sources

New York. Archives of American Art, Smithsonian Institution. Paul Wayland Bartlett Papers. Reels 4899–4902.

———. Thomas Benedict Clarke Scrapbooks. Reels 597, 598, 1358.

———. Papers of Charles Kurtz, c. 1881–1980s. Reels 4804, 4826, 4912.

———. Pennsylvania Academy of the Fine Arts Records. Scrapbooks. Reel P 53.

———. Pennsylvania Academy of the Fine Arts Records. Minutes. Executive Committee, Reel 4337.

Paris. Bibliothèque Nationale. Cabinet des estampes. Exposition Universelle, 1900.

Paris. Musée d'Orsay. Documentation. Exposition Universelle, 1900.

Paris. Archives Nationales. Commerce et l'industrie. L'Exposition 1900: sections étrangères; correspondence Etats-Unis, F12 4229–4237.

———. Paris. Beaux-Arts. Exposition Universelle, Groupe II, Beaux-Arts, F21 4061–4066.

———. Beaux-Arts. Ben Foster, F21 4209.

———. Beaux-Arts. Winslow Homer, F21 4221.

Washington, D.C. U.S. National Archives. Records of the Commission Representing the United States at the Paris Universal Exposition, 1900. Record Group 43. Entries 1265–1298.

Books

Blaugrund, Annette et al. *Paris 1889: American Artists at the Universal Exposition.* Philadelphia: Pennsylvania Academy of the Fine Arts; New York: Harry N. Abrams, 1989.

Borsi, Franco. *Paris 1900.* New York: Rizzoli, 1977.

Boyd, James Penny. *The Paris Exposition of 1900: A Vivid Descriptive View and Elaborate Scenic Presentation of the Site, Plan and Exhibits.* Philadelphia: P. W. Ziegler, 1900.

Campbell, James B. *Illustrated History of the Paris Exposition Universelle of 1900.* Chicago: Chicago and Omaha Publishing Company, 1900.

Catalogue général officiel. Group II. Oeuvres d'art classes 7 à 10. Exposition Internationale Universelle de 1900. Paris: Lemercier, 1900; reprint, New York: Garland Press, 1981.

Catalogue illustré officiel de l'Exposition décennale des Beaux-Arts, 1889 à 1900. Paris: Lemercier, 1900; reprint, New York: Garland Press, 1981.

Catalogue officiel illustré. Exposition des beaux-arts, Etats-Unis d'Amérique, Exposition universelle de Paris, 1900. Boston: Noyes, Platt and Co., 1900.

The Chefs d'Oeuvre: Art and Architecture. 10 vols. With essays by William Walton, V[ictor] Champier, and A[ndré] Saglio. Philedphia: George Barrie and Son, 1900–1902.

Comte, Jules, ed. *L'Art à l'Exposition Universelle de 1900.* Paris: Librarie de l'art ancien et moderne, 1900.

Findling, John E. and Kimberly D. Pelle, eds. *Historical Dictionary of World's Fairs and Expositions, 1851–1988.* New York: Greenwood Press, 1990.

Fink, Lois Marie. *American Art at the Nineteenth-Century Paris Salons.* Washington, D.C.: National Museum of American Art, Smithsonian Institution, 1990.

Gerdts, William H. *American Impressionism.* New York: Abbeville Press, 1984.

———. *Lasting Impressions: American Painters in France, 1865–1915.* Evanston, Ill.: Terra Foundation for the Arts, 1992.

Grant, Susan. *Paris: A Guide to Archival Sources for American Art History.* Washington, D.C.: Archives of American Art, Smithsonian Institution, 1997.

Greder, Léon. *Loisirs d'art. Mélanges. La Peinture Etrangère à l'Exposition de 1900.* Paris: n.p., 1901.

Greenhalgh, Paul. *Ephemeral Vistas: The Expositions Universelles, Great Exhibitions and World's Fairs, 1851–1939.* Manchester, U.K.: Manchester University Press, 1988.

Holt, Elizabeth Gilmore, ed., *The Expanding World of Art 1874–1902, vol. 1: Universal Expositions and State-Sponsored Fine Arts Exhibitions.* New Haven, Conn.: Yale University Press, 1988.

Jullian, Philippe. *The Triumph of Art Nouveau: Paris Exhibition of 1900.* New York: Larousse, 1974.

Le Livre des expositions universelles, 1851–1989. Paris: Union Centrale des Arts Décoratifs, 1983.

L'Exposition Universelle 1900. Preface by Jacques Duquesne. Paris: Les Editions 1900, 1992.

Mandell, Richard D. *Paris 1900: The Great World's Fair.* Toronto, Canada: University of Toronto Press, 1967.

Official Illustrated Catalogue. Fine Arts Exhibit. United States of

America at the Paris Exposition of 1900. Boston: Noyes, Platt & Co., 1900.

Ory, Pascal. *Les expositions universelles de Paris.* Paris: Editions Ramsay, 1982.

Paris Exposition Reproduced from the Official Photographs Taken Under the Supervision of the French Government. New York: R. S. Peale, 1900.

Picard, Alfred. *Le bilan d'un siècle.* 6 vols. Paris: Imprimerie nationale, 1906.

———. *Exposition Universelle Internationale de 1900 à Paris. Rapport général administratif et téchnique.* 9 vols. Paris: Imprimerie nationale, 1902.

Quick, Michael. *American Expatriate Painters of the Late Nineteenth Century.* Dayton, Ohio: Dayton Art Institute, 1976.

Rapports du jury internationale. 46 vols. Paris: Imprimerie nationale, 1902–1905.

Report of the Commissioner-General for the International Universal Exposition, Paris, 1900. 6 vols. Washington, D.C.: Government Printing Office, 1901.

Revisiting the White City: American Art at the 1893 World's Fair. Washington, D.C.: National Museum of American Art and National Portrait Gallery, Smithsonian Institution, 1993.

Schroeder-Gudehus, Brigitte, and Anne Rasmussen. *Les fastes du progrès. Le guide des expositions universelles, 1851–1992.* Paris: Flammarion, 1992.

Silverman, Deborah Leah. *Art Nouveau in Fin-de-Siècle France.* Berkeley: University of California Press, 1989.

Smithsonian Institution Libraries. *The Books of the Fairs: Materials About World's Fairs, 1834–1916, in the Smithsonian Institution Libraries.* With an Introduction by Robert W. Rydell. Chicago: American Library Association, 1992.

Weinberg, H. Barbara. *The Lure of Paris: Nineteenth-Century American Artists and their French Teachers.* New York: Abbeville Press, 1991.

Weinberg, H. Barbara; Doreen Bolger and David Park Curry. *American Impressionism and Realism: The Painting of Modern Life, 1885–1915.* New York: Metropolitan Museum of Art, 1994.

Weisberg, Gabriel P. *Art Nouveau Bing: Paris Style 1900.* New York: Harry N. Abrams, 1986.

Articles

[Caffin, Charles H., ed.] "Our Exhibit at the Paris Exposition," *The Artist* 28 [supplement] (July 1900): vi-ix.

Caffin, Charles H. "American Art in Paris: The Exhibit and Its Significance." *Evening Post,* 11 August 1900, 5.

———. "The Paris Exposition." *Evening Post,* 15 June 1900, 7.

Clarke, Ellis. T., "Alien Element in American Art." *Brush and Pencil* 7 (October 1900): 35-47.

C[ortissoz], R[oyal]. "American Art in Paris." *New-York Tribune,* 22 July 1900, II: 1.

Davis, Julia Finette, comp. "International Expositions 1851-1900," in *The American Association of Architectural Bibliographers Papers,* William B. O'Neal, ed., vol. 4. Charlottesville: University of Virginia Press, 1967.

Gerdts, William H. "American Tonalism: An Artistic Overview," in Gerdts, et. al., *Tonalism: An American Experience,* (New York: Grand Central Art Galleries, 1982).

N. N. [Elizabeth Robins Pennell]. "The Paris Exposition—V. The American Section." *Nation* 71 (2 August 1900): 88–90.

R[iordan], R[oger], "The Paris Exposition, I—Some American Exhibits." *The Art Amateur* 42 (April 1900): 100–102.

PHOTOGRAPH CREDITS

Photos 1 and 8: © Photothèque des Musées de la Ville de Paris. Cliché-Habouzit.

Photos 2, 58, 101: Smithsonian Institution, Photographic Services.

Photo 3: Photograph taken from *Paris 1889 American Artists at the Universal Exposition*, Pennsylvania Academy of Fine Arts, Philadelphia in association with Harry N. Abrams, Inc. Publishers, New York. Copyright © 1989 Joseph E. Garland, photographer.

Photo 4: AG Ville de Nantes, Musée des Beaux-Arts.

Photo 5: Courtesy of The Century Association.

Photos 6, 14, 65, 89, 137: Peter Jacobs, photographer.

Photo 9: © RMN, Lagiewski, photographer.

Photos 11 and 122: William H. Rau, photographer.

Photo 16: Wayne Geist, photographer.

Photos 25, 61, 148: The Corcoran Gallery of Art, Washington, D.C.

Photo 26: © Hunterian Art Gallery, University of Glasgow.

Photos 27, 46, 76: ©1998 Board of Trustees, National Gallery of Art, Washington, D.C.

Photo 28: © Tate Gallery, London. John Webb, photographer.

Photo 29: Joseph Painter, photographer.

Photo 30: The Bridgeman Art Library International.

Photo 31: © Joslyn Art Museum, Omaha, Nebraska.

Photos 34 and 143: © Virginia Museum of Fine Arts, Katherine Wetzel, photographer.

Photo 35: Jordan-Volpe Gallery, Inc., New York.

Photo 37, 41, 55, 75, 91, 108: The Metropolitan Museum of Art, New York. All Rights Reserved.

Photo 38: Joseph Szaszlai, photographer.

Photo 39: Hollis Taggart Galleries, New York.

Photos 45, 48, 130, 145, 146, 147: © Agence photographique de la réunion des musées nationaux (RMN).

Photo 47 and 73: Museum of Fine Arts, Boston.

Photo 49: © RMN, Hervé Lewandowski, photographer.

Photos 50, 132, 133, 136: © Cincinnati Art Museum.

Photo 51: Lee Stalsworth, photographer.

Photo 52: © Newark Museum. Armen Photographers.

Photos 53, 54, 56, 59, 70, 74, 78, 94: Courtesy of Pennsylvania Academy of the Fine Arts.

Photo 57: © 1983 The Metropolitan Museum of Art.

Photo 60: Gari Melchers Estate.

Photo 62: © The Elvehjem Museum of Art, University of Wisconsin-Madison.

Photo 63: Didier Tragin and Catherine Lancien, photographers.

Photos 64 and 107: Courtesy Terra Museum of American Art, Chicago.

Photo 66: © 1998 Sotheby's, Inc.

Photo 67: Courtesy of Frank Martucci.

Photo 68: © 1997 The Detroit Institute of Arts.

Photo 69: Courtesy of First Chicago.

Photo 71: © Addison Gallery of American Art, Phillips Academy, Andover, Massachusetts. All Rights Reserved.

Photo 72: Courtesy Philadelphia Museum of Art.

Photo 79: © 1987 Indianapolis Museum of Art.

Photos 80, 96, 109: Courtesy Carnegie Museum of Art, Pittsburgh.

Photo 81: © 1998 The Cleveland Museum of Art.

Photos 82 and 97: © 1998 The Art Institute of Chicago. All Rights Reserved.

Photo 83: Gary Mortensen, photographer.

Photo 84: Photo Services, Fine Arts Museum of M. H. de Young Memorial Museum, San Francisco.

Photo 85: Clive Russ, photographer.

Photos 87 and 95: © 1990 Indianapolis Museum of Art.

Photo 89: The Montclair Art Museum.

Photo 90: Courtesy Federal Reserve Board, Fine Arts Program.

Photo 92: © RMN, Jean Schormans, photographer.

Photos 99 and 100: Photographic Reproduction Services, Chicago Public Library.

Photo 102: National Museum of American Art.

Photos 103 and 104: Library of Congress, LC-US262–104459, 104460, 104461, 104462.

Photo 105: Library of Congress, LC-US262–083851.

Photo 106: Scribner's Magazine.

Photo 110: © Davis Museum and Cultural Center, Wellesley, College. David Stansbury, photographer.

Photo 112 and 121: © Photothèque des Musées de la Ville de Paris. Cliché-I. Andreani.

Photo 129: © Musée Rodin. Adam Rzepka, photographer.

Photos 130, 145, 147: Musée d'Orsay.

Photo 138, 139, 140: © Dallas Museum of Art. All Rights Reserved.

Photo 141: © 1998 Tiffany & Co. Archives.

Photo 142: Graydon Wood, photographer, 1993.

Abbey, Edwin Austin, 6, 29, 34, 91, 106n. 31, 185, 194

Abbot, Katherine G., 194

academicism, 2, 26, 42, 81, 91

Adams, Brooks, 2

Adams, Henry, 39, 119

Adeline, Jules, 2n. 6

African Americans, representations at world's fairs, 6, 21, 26, 28, 138, 141–144, 141n. 50

Alexander III Bridge, Paris, 136, 137

Alexander, John White, 7, 61, 61n. 99, 62, 91, 154, 156, 164, 165, 183, 194

Allen, Gorton W., 126

Allen, Thomas, 194

"America" as subject, 88

American art, 1, 183; in collections, 113–114, 117; in France, 145–180; history, 187, 189, 191; native characteristics, 153, 157, 165, 191–192; regional, 8n. 123; world stature, 124, 136

American Art Association, 176

American Art Galleries, New York, 114

"American character" in art, 153, 156, 187, 188, 190–192

American frontier, 65, 67, 128

American history as subject, 68

American Indian exhibit, Paris, 139

American painting, analysis, 183–184

American Renaissance, 2, 50, 103, 188

American Salon, 176, 179nn. 88, 89

American Scene movement, 188, 191, 192

"American school," 92–93, 92n. 142, 94, 172, 181–182, 191–192, 192n. 119; definition, 68; at Paris 1900, 1–2, 21–88

American themes, 70, 109

American Virgins, 50, 53–56

"Americanism," for Roosevelt, 96

Anderson, Abraham A., 194

animals as subject, 87

anti-academicism, 33, 91

anti-imperialism, 126

applied arts, 146, 148–149, 157–163; at Paris 1900, 153; museums, 163

architecture, 124, 179; at world's fairs, 100, 103

Archives du Louvre, 173

Archives Nationales, France, 163

Armory Show, New York 1913, 185, 185n. 36

The Art Collector, 109

art collectors, 6, 113, 163, 173, 175–176, 173nn. 79, 80, 81, 175nn. 83, 85, 86, 179

The Art Critic, 96n. 10

art dealers, 113–114, 117, 163

Art Institute of Chicago, 190

Art Notes, 113–114

art organizations, 106n. 36

art teachers, 148

artists' colonies, 35n. 79, 81

Ashcan School, 74, 88

Atlanta Cotton States and International Exposition, 1895, 99, 142; Negro Building, 138

Atwood, Charles B., 96

L'Aurore (newspaper), 8, 154

awards, 81, 91, 91n. 133, 113, 113nn. 57, 58, 144, 153, 157, 163

Baigell, Matthew, 188n. 74

Bailey Van Hook, Leila, 47nn. 85, 87

Banta, Martha, 47

Barbizon School, 33, 73, 81, 182, 184

Barlow, John Noble, 194

Barr, Alfred H., Jr., 189

Bartlett, Paul W., 126, 175, 178, 179

Baur, John, 191

Beam, Philip C., 84n. 126

Beatty, John, 8

Beaux, Cecilia, 47, 91, 113n. 57, 154, 165, 190, 194

beaux-arts school, 92n. 142, 124

Beckwith, James Carroll, 56, 194

Bellows, George, 186

Benedict, Burton, 142, 142n. 53

Bénédite, Léonce, 148, 151–152, 151nn. 17, 18, 19, 164, 165, 165n. 60, 170–171, 170nn. 64, 65, 173, 176

Benjamin, Walter, 137

Benjamin-Constant, Jean-Joseph, 11

Benson, Frank W., 56, 59, 110, 154, 195

Bentzon, Th., 138n. 43

Berlin, E. M., 183

Bermingham, Peter, 35n. 79

Besnard, Albert, 164

Besnard, Paul, 11

Bigot, Alexandre, 170

Bing, Siegfried, 146, 146n. 6, 163

Bisbing, Henry, 154, 195

Blackmar, Paul, 124

Blakelock, Ralph, 81, 81n. 122, 82, 190, 191, 195

Blashfield, Edwin, 6, 100, 103, 104

Blaugrund, Annette, 1n. 3, 74n. 114

Blum, Robert, 33, 36, 37, 154, 195

Bogert, George H., 8n. 121, 195

Bohm, Max, 195

Boime, Albert, 25n. 59, 74n. 120, 109n. 41

Bok, Edward, 138, 138n. 43

Bolger, Doreen, 70n. 110, 110n. 52, 192n. 119. *See* Burke

Bonnat, Léon-Joseph-Florentin, 61

Boston painters, 109

Boston Public Library, 106n.31

Boston Transcript [newspaper], 68

Bouguereau, William, 10, 11, 53

Bouilhet, Henri, 165

Bourne, Randolph, 188

Breckenridge, Hugh H., 195

Breuning, Margaret, 190

Bridgman, Frederick Arthur, 26, 28, 195

Brinton, Christian, 185, 186

bronzes, 156, 157, 157n. 41, 165

Brooklyn Museum, 191

Brooks, Van Wyck, 187n. 49, 188

Brown, John George, 60, 61, 183, 195

Brown, Robert W., 120n. 3

Brown, Mrs. V. Jordan, 175n. 81

Browne, Charles Francis, 195

Brush, George de Forest, 21, 26, 50, 53, 54, 91, 185, 195

Bruwaert, Edmond, 145n. 2

Buchanan, William I., 123

Buel, J. W., 183

Bulliet, C. J., 191n. 108

Bunce, William Gedney, 195

Burbank, Elbridge Ayer, 195

Burke, Doreen Bolger, 67n. 105

Burns, Sarah, 6n. 26, 22n. 52

Burroughs, Bryson, 187n. 48

business, support for arts, 106

Butler, Howard Russell, 195

Caffin, Charles H., 5, 91, 92, 181, 182, 182n. 7, 183–184

Cahill, Holger, 190

Calloway, Thomas J., 141, 141nn. 49, 50, 142

Capehart, Alexander, 124, 125

Carl, Kate, 195

Carles, Arthur B., 186

Carnegie, Andrew, 114, 122, 172n. 76

Carnegie Institute, Department of Fine Arts (Pittsburgh), 6, 113, 173

Carrière, Eugène, 164

Casey, Edward Pearce, 103

Cassatt, Mary, 6, 190

catalogue (Paris 1900), 194–205

Catholic tradition, 53, 56

Cauldwell, John Britton, 5–7, 11, 16, 68, 74, 91, 91n. 135, 92, 94, 124, 164, 173, 175, 175n. 79

Centennial Exhibition, Louisville 1883–1887, 122

Centennial Exhibition, New Orleans 1884–1885, 122

Centennial Exhibition, Philadelphia 1876, 96n. 2, 120

Century, 100

Century Club, 5

Century of Progress exhibition, Chicago 1933–1934, 190–191, 191n. 108

ceramics, 153, 157–163

Champier, Victor, 8n. 39, 146, 146n. 6

Chapman, Carlton, 68, 195

Chase, William Merritt, 47, 48, 87, 88, 91, 110n. 51, 154, 183, 185, 186, 187, 196

Chauchard, Alfred, 173

children as subject, 56, 59, 60

Church, Frederic S., 196

Cikovsky, Nicholai, Jr., 74nn. 114, 118, 119

Cincinnati Art Museum, 6

cityscapes, 88

"civilization," triumph of, 128, 133, 136

"civilized landscape" (Inness), 74, 74n. 118

Clark, Walter, 8n. 121, 196

Clarke, Ellis T., 28, 33, 37, 61, 70

Clarke, Thomas B., 114, 114n. 64

Clemenceau, Georges, 173, 173n. 80

Codman, William C., 166

Coffin, William A., 8on. 121, 103n. 28, 196

Cole, Thomas, 2

collectors, 6, 113, 163, 175–176, 175nn. 79, 80, 81, 176nn. 83, 85, 86, 179

Collier, Charles A., 126

colonialism, American, 34–35

colonies, U.S., 128; see also artists' colonies

Coman, Charlotte B., 196

Conway, John Joseph, 179n. 88

Coolidge, Charles A., 11, 29n. 74, 124

Cooper, Emma Lampert, 35, 196

Cordato, Mary F., 138n. 40

corporations, 128

Cortissoz, Royal, 22n. 52, 25, 26, 34, 39, 49, 53, 61, 83, 92, 103, 182–183, 188

cosmopolitanism, 184, 188–189, 190

Cotkin, George, 117n. 72

Couse, E. Irving, 196

Couture, Thomas, 61

cowboy as subject, 65

Cox, Kenyon, 187, 196

Cox, Louise, 196

Crane, Bruce, 8on. 121, 196

Craven, Thomas, 188–189

The Critic, 110

critics, 2, 61–62, 91, 92, 103, 106, 109, 153–154, 156–157, 163, 164–165, 172, 176, 182–191; see also individual names

Crystal Palace Exhibition, London 1851, 120

cultural development, American, 103

cultural exchange, 148

cultural nationalism, 117

"cultural reorientation" (Higham), 96

culture, American, 137–138; definitions of, 117, 117n. 72

Curran, Charles C., 32, 175, 196

Current, Marcia Ewing, 135n. 33

Current, Richard Nelson, 135n. 33

Curry, David Park, 73n. 110, 110n. 52, 192n. 119

Curtis, Constance, 196

Dagrav, Georges, 149n. 10

daily life as subject, 164

daily press, in France, 153–154, 156–157, 163

Dallin, Cyrus, 13

Dalpayrat, Adrien, 170

Dannat, William Turner, 196

Darling, Wilder M., 196

Davidson, Abraham A., 8on. 122

Davies, Arthur B., 114

Davis, Charles Harold, 8on. 121, 185n. 36, 196

Dearth, Henry Golden, 197

DeCamp, Joseph, 42, 45, 110, 197

decorative arts, 11, 11n. 43, 124, 151–152, 171

decorative painting, 95–106

Delaunay-Belleville, Louis-Marie-Gabriel, 11, 138nn. 43–44

Denoinville, Georges, 153n. 24

Dessar, Louis Paul, 197

de Vogüé, Eugène-Melchior, 137n. 38

Dewey Arch, 106–109, 106n. 37

Dewing, Thomas W., 6, 6n. 26, 110

Dickson, Mary Estelle, 197

Diers, Edward George, 160

diversity in American art, 186

Docherty, Linda J., 113n. 55, 224

Dodge, Charles, 124

Donoho, Gaines Ruger, 185n. 36, 197

Doty, Robert, 19n. 49

Downes, William Howe, 114n. 68, 185

Dreyfus Affair, 23, 23n. 57, 26, 26n. 66, 59, 120n. 6

Du Bois, W.E.B., 141–142, 141n. 50, 143–144

Duveneck, Frank, 6, 189, 190, 191

Eakins, Thomas, 26, 62–65, 94, 182, 184, 186–187, 188–190, 191, 197

Eaton, Charles Warren, 81, 175, 175n. 86, 197

eclecticism, 182, 183, 186

Ecole des Beaux-Arts, Paris, 91, 92n. 142, 124

education (French), under the Third Republic, 149–150, 172

Eichelburger, Robert H., 197

Eiffel Tower, 128

The Eight, 114

Eldredge, Charles C., 28n. 69

Ellis, Harvey, 197

Emmet, Lydia Field, 197

Ennecking, John Joseph, 197

European culture, 91–92

Evans, William T., 80, 114, 114n. 70, 117, 117n. 71
evolutionary theories, 2, 67, 91
exhibit managers, Paris 1900, 124
exhibitions, in France, 2, 149
exoticism, 26
expatriates, 2, 6–8, 26, 59, 92n. 142
Exposition, Paris 1878, 74
Exposition, Paris 1889, 1, 128, 139
Exposition Universelle et Internationale de Paris, 1900, 1, 94, 119–121, 120n. 3, 128–144, 184; American Indian exhibit, 139; annexes, 128; awards, 157, 163; catalogues, 21, 153, 153n. 20, 157n. 39, 183, 194; Champ de Mars, 128, 132; Château d'Eau, 130; classification scheme, 128; colonial exhibits, 133; Cuban Exposition, 126, 127, 128, 133; French installation, 91, 153; exhibit managers, 124; exhibition avenues, 128, 129–131; exhibition space, 8–9, 11, 12, 12n. 41, 16–19, 21, 123, 124, 133; Grand Palais des Beaux-Arts, 8–9, 11, 12, 14–19, 136, 153, 154, 154n. 27, 156; guidebook poster, xiv; impact on American art, xvii; international sculpture decennial, 13; juries, 5–6, 6n. 25, 19, 91; Machinery Hall, 138; medals, 81, 91, 91n. 133; moving sidewalk, 131; Negro exhibit, 141–144, 141n. 50; Palace of Diverse Industries, 11, 12, 147, 157; Palace of Mines, 133; Palace of Social Economy, 141; Petit Palais, 9, Pont Alexandre III, 136, 137; Porte Binet, 129; textile building, 133; Trocadéro, 6, 127, 128, 133; U.S. Commission, 138, 139, 193; U.S. decennial, 21–88; U.S. Department of Fine Arts, 6, 21, 74; U.S. National Pavilion, 11, 12, 13, 123, 124, 135, 136, 152–153, 153n. 25; U.S. Publisher's Building, 137; U.S. representation, 122, 123; Vincennes Annex, 138; Women's Pavilion, 139

"family pictures," 56, 57, 58, 174
Farnham, Paulding, 167
figure paintings, 26, 39–58, 184, 185; see also portraits
Findling, John E., 96n. 1, 100n. 18, 101n. 23
fine arts, defined, 11, 13
Fine Arts Federation, 5n. 13

Fink, Lois Marie, 2n. 5, 100n. 21, 145n. 1
Fischer, Diane Pietrucha, 11n. 43, 19n. 50, 74nn. 114, 118, 109n. 41, 120n. 3, 136, 153n. 21, 175n. 79, 182n. 2, 224
Fisher, Mark, 7, 197
Foner, Eric, 120n. 5
foreign influence on American art, 28, 84, 154, 184, 189
foreign subjects, 26–46, 68–70
Fort, Ilene Susan, 26n. 65, 28n. 67
Foss, Harriet C., 197
Foster, Ben, 81, 165, 171, 173, 177, 197
Fourcaud, Louis de, 156–157
France, art in, 180; government, 148–152; political ideologies, 164; relations with U.S., 8, 11, 91, 145–146, 145n. 1, 148–152, 153, 172; Third Republic, 148–152, 179–180
Frank, Waldo, 188
Franzen, August, 197
French, Daniel Chester, 97, 106, 163
Frieseke, Frederic C., 186
Fromuth, Charles H., 197
frontier, 65, 67, 128
Fuller, George, 114, 188
Fuller, Henry B., 109n. 40
Fuller, Loïe, 133–135

Gallagher, Sears, 197
galleries, 113–114, 117
gallery design, 16–19
Gallison, Henry, 81, 198
Gandara, Antonio de la, 164
Garland, Hamlin, 110
Garnsey, Elmer, 11n. 42
Gauley, Robert David, 198
Le Gaulois du Dimanche [newspaper], 156
Gay, Walter, 35, 198
Geffroy, Gustave, 153–154
genre painting, 29, 34, 39, 87–88, 172, 191
Gerdts, William H., 19n. 49, 56n. 96, 74n. 113, 80n. 121, 83n. 123, 94n. 149
Gérôme, Jean-Léon, 1, 3, 26, 26n. 62, 61, 91
Getz, John, 124
Gifford, Robert Swain, 80n. 121, 198
Gihon, Albert D., 198
Glackens, William, 6, 183, 185
glasswork, 151, 157
Goldstein, Malcolm, 113n. 62
Goodrich, Lloyd, 189, 191
Gorham Manufacturing, New York, 153, 157, 165, 166

Goss Press, 137
Grant, Susan, 172n. 70
Greder, Léon, 165
Greenhalgh, Paul, 6n. 30, 96n. 1
Griffith, A. H., 100
Grosjean-Maupin, E., 154
Grothjean, Fanny, 198
group shows, 110
Grueby, William H., 157
Grueby Faïence Company, Boston, 153, 157, 161
Guy, Seymour Joseph, 198

Handly, Marks White, 99n. 15
Handy, Moses P., 2n. 11, 123
Hardin, Jennifer, 187n. 48
Harrison, (Thomas) Alexander, 5n. 18, 83, 91n. 135, 164, 165, 171, 172, 183, 198
Harrison, (Lowell) Birge, 81, 198
Hartley, Marsden, 188, 189–190
Hartmann, Sadakichi, 62, 88, 96, 96n. 10, 99, 109–110, 184
Harvey, Penelope, 120n. 6
Haskell, Ernest, 188n. 71
Hassam, Childe, 88, 89, 110, 185, 185n. 36, 187, 188, 191, 198
Hay, John (secretary of state), 133
Hayden, Charles H., 198
Henri, Robert, 183, 185, 187, 188
Herter, Albert, 198
Higham, John, 96
Hitchcock, George, 40, 54, 55, 154, 198
Hobbs, Susan, 96n. 2
Holman, Frank, 198
Holmes, Burton, 127
Homer, Winslow, 5n. 18, 65, 84–87, 83n. 126, 91, 92, 94, 110n. 51, 113–115, 157, 171, 181, 183–188, 187n. 52, 189–190, 191, 198
Hoosier School, 73
Horowitz, Helen Lefkowitz, 124n. 18
Houston, Frances C., 199
Howe, William Henry, 100, 100n. 21, 102
Hudson River School, 74
Hunt, William Morris, 114
Hyde, William H., 199

imperialism, 11, 122–123, 123n. 13, 124, 126, 128
impressionism, 88, 92, 191; American, 73, 81, 110, 185, 188
individualism, 110
industrial arts, 12, 148, 157, 165, 179

Inness, George, 6, 19, 73–76, 74n. 114, 113, 114, 116, 118, 119, 186n. 41, 187, 188, 190, 191, 199
international congresses, Paris, 139n. 45
international expositions, 96n. 1
The International Studio, 110, 113
Isham, Samuel, 26, 39, 184–185

Jacobs, Michael, 35n. 79
Jewell, Edward Alden, 190, 191
Johnson, Eastman, 61, 184, 191, 199
Johnston, John Humphreys, 56, 154, 164, 171, 174, 199
Jones, Hugh Bolton, 199
juries, class, 92n. 144, 193, 210n. 135; selection, 5–5, 193

Kachur, Lewis, 88n. 131
Kaelin, Charles S., 199
Kaiser Wilhelm Museum, Krefeld, Germany, 163
Keith, Elbridge G., 126
Kendall, Margaret Stickney, 199
Kendall, William Sergeant, 154, 155, 165, 175, 199
Kendrick, George Prentiss, 161
Kimball, Fiske, 19n. 110
King, Pauline, 103n. 28, 106n. 36
Knaufft, Ernest, 106n. 37
Knight, Louis Aston, 199
Knight, Daniel Ridgway, 199
Koopman, Augustus, 12, 199
Kost, Frederick W., 80n. 121, 199
Krause, Martin F., 70n. 111
Kronberg, Louis, 199
Kurtz, Charles M., 5, 5n. 16

Ladies' Home Journal, 138
La Farge, John, 11, 33–34, 34n. 77, 38, 183–184, 185, 187, 191, 199
La Feber, Walter, 2n. 8
La Liberté (newspaper), 154
Lafenestre, Georges, 92, 165
LaFollette, Suzanne, 189
Lamb, Charles R., 106
landscape painting, American, 68–83, 172, 182, 184, 186, 186n. 41, 191
Latham, David, 84n. 126
Lathrop, Francis, 200
Lathrop, William L., 200
Laurvik, J. Nilson, 185–186
Lavery, John, 113n. 57
League of American Artists, 176

Lears, Jackson, 2n. 8
Lee, Homer, 154, 157, 175, 200
Legion of Honor (French), 11
Lewis, Arthur, 200
Leygues, Georges, 148, 148n. 7, 149–151, 151n. 16, 173, 175–176, 173nn. 79, 80, 81, 175nn. 83, 85, 86, 179
Library of Congress, 103–106, 103n. 28
light, American, 186
literature, American, 188
Le Livre d'or de l'exposition de 1900, 164
"local color" (Garland), 110
Locke, Caroline T., 200
Lockwood, Wilton, 200
Lorillard, L. L., 179n. 89
Lotos Club, 80
Low, Will H., 106, 200
Luxembourg Museum. *See* Musée National de Luxembourg.

MacChesney, Clara, 200
McCormick Company exhibition, 138
MacEwen, Walter, 37, 43, 171, 200
MacIlhenny, C. Morgan, 200
McKinley administration, 2, 94, 139
MacKubin, Florence, 200
MacMonnies, Frederick, 13
MacMonnies, Mary Fairchild, 7, 56, 58, 200
MacNeil, Hermon Atkins, 13
McSpadden, J. Walker, 185
Macbeth, William, 113–114, 113n. 62, 114n. 63
Madonna. *See* Virgin paintings
Mandell, Richard D., 23n. 57, 26n. 66, 120n. 3, 120n. 6
Manufacturers Committee, 146
Marguiller, Auguste, 164
marine paintings, 182, 184; *see also* seascapes
Marsh, Fred Dana, 47, 200
Martin, Henri, 10, 11
Martin, Homer Dodge, 6, 74, 77, 78, 113, 114, 182, 183, 184, 187, 188, 200
mass culture, American, 137–138
Mather, Frank Jewett, 188, 189
Mather, Frank Lincoln, 14n. 49
Le Matin [newspaper], 154
Mauclair, Camille, 22n. 52, 164
Maurer, Alfred, 6, 46, 47, 184n. 36, 200
Maynard, George Willoughby, 29, 33, 200
Maynard, Guy, 201

Meakin, Lewis H., 201
medals, 81, 91, 91n. 133
Melchers, Gari, 7, 41, 61, 113, 183, 187, 201
memorial exhibitions, 186–187
men as subjects, 61
Metcalf, Willard, 68, 69, 110, 185, 186n. 41, 201
Metropolitan Museum of Art, New York, 187, 188
Miller, Angela, 74n. 120
Millet, Francis Davis, 6, 7, 29, 91, 183, 184, 201
Millet, Jean-François, 35
Minor, Robert, 80n. 121, 201
modern art museums, 187
modernism, 26, 146, 185
Monet, Claude, 73
Montclair (New Jersey) Art Museum, 117
morality, in figure painting, 56
Morris, Harrison, 182n. 5
Morse, Samuel E., 146n. 6
Mosby, Dewey F., 28n. 67
Moses, Lester G., 138n. 41
"moving stairway," 133
Muhrman, Henry H., 201
Mumford, Lewis, 188
Munch, Edvard, 87
Mural Society, 106n. 36
murals, 11–13, 103–106
Murphy, John Francis, 81, 81n. 121, 201
Murray, Daniel P., 141, 142
Musée National du Luxembourg, 148, 151, 165, 170, 173, 175, 176
Museum für Angewandte Kunst, Vienna, 163
Museum für Kunst und Gewerbe, Hamburg, 163
Museum of Modern Art, New York, 189–190, 191
museums, 6, 113–114, 117, 163, 176n. 85, 187; *see also individual names*
mythological themes, 28, 29

National Academy of Design, 5
national art, American, 74, 109, 185, 188, 191; definition of, 117
National Association of Manufacturers, 126
national identity, in art and literature, 110, 187–189, 192
national school, 183, 191–192, 192n. 119; *see also* American school
National Sculpture Society, 106

National Society of Mural Painters, 106
nationalism, 70–83, 88, 96, 99, 99n. 13,
 109, 110, 122, 124, 185, 188
Native Americans, 67, 138, 139, 140
nativism, 68, 70, 188
naturalism, 33, 189
nature as subject, 185
Needham, Charles Austin, 88, 201
Nettleton, Walter, 201
Neuhaus, Eugen, 191, 191n. 111
New York Age, 141n. 49
New York Daily Tribune [newspaper], 182
New York Herald [newspaper], 7
New York Post [newspaper], 182
New York Times, 2, 37
New York World, 135
Newman, Robert Loftin, 30, 201
Newman, Mrs. Willie (Betty), 201
newspaper articles, French, 153–154,
 156–157, 163
newspapers, 182; *see also titles*
Nicholls, Rhoda Holmes, 201
Niehaus, Charles B., 106
The Nineteen Hundred, 137n. 38
Norton, William E., 201
Nourse, Elizabeth, 201
nudes, 39

Ochtman, Leonard, 80, 80n. 121, 201
Omaha fair 1898, 139
oriental art, influence of, 33
oriental themes, 33, 183
originality in American art, 154, 180, 183

paintings at Paris exposition 1900, 5, 11,
 16–19, 21–90
Palmer, Bertha Honoré, 138, 138nn. 43, 44,
 139
Palmer, Thomas W., 124n. 19
Palmer, Walter Launt, 202
Pan-American Exposition, Buffalo 1901,
 182–183
Panama-Pacific International Exposition,
 San Francisco 1915, 185
Panic of 1873, 120
Paris, Americans in, 91
Parrish, Clara W., 202
Parrish, Maxfield, 6, 31, 202
paternalism, American, 34
patriotism in American art, 74, 84, 187
Pearce, Charles Sprague, 56, 57, 202
peasant themes, 34–39, 41, 42
Pease, Donald E., 123n. 13

Peck, Ferdinand W., 124–126, 133, 138,
 138nn. 43, 44, 139, 141
Pennell, Elizabeth, 22, 49–50, 62, 74, 88,
 91, 92, 94, 188n. 73
Pennsylvania Academy of the Fine Arts,
 6, 114, 182
Perrine, Van Dearing, 202
Philippines, 126–127
Phillips, Duncan, 187–188
Phillips Memorial Art Gallery, Washing-
 ton, D.C., 187
photography, 11n. 44, 19n. 49, 88
Picard, Alfred, 1, 11, 11n. 41, 165
Picknell, William Lamb, 68, 70, 81, 154,
 202
Pierce, Patricia Jobe, 110n. 51
Pilgrim, Dianne H., 19n. 49
Pisano, Ronald G., 47n. 86
Platt, Charles Adams, 81, 202
Plée, Léon, 154
poetry in American painting, 186
Poore, Henry Rankin, 202
Porter, Benjamin C., 202
portraits, 22, 23–25, 46–68, 47n. 87
Post, George B., 124
Potter, David M., 99n. 13
pottery, 163
Pousette-Dart, Nathaniel, 188
Preato, Robert R., 94n. 149
press, French, 150; *see also* critics
private art collections, 176; *see also* collec-
 tors
Proctor, Alexander Phimister, 11, 13, 21,
 202
Promey, Sally, 74n. 119
public art, 103, 148
public education, 149–150
Puritanism, 187, 190
Pyle, Howard, 202
Pyne, Kathleen, 2n. 8, 22n. 55

Quantin, A., 164n. 49
Quesada, Gonzalo, 133
Quick, Michael, 28n. 67, 74nn. 118, 119

"racial adjustment," in U.S., 141
racial hierarchy, 128
Raffaëlli, Jean François, 113n. 57
Ranger, Henry Ward, 88, 90, 202
Le Rapide (newspaper), 154
Read, Helen Appleton, 190
realism, 34, 34n. 78, 81, 88, 92, 94, 184, 186,
 191

Reconstruction (U. S. history), 120, 120n.
 5, 122
Redfield, Edward W., 185, 202
regional expositions, U.S., 99–103
Rehn, Frank Knox Morton, 202
Reid, Robert, 11, 11n. 42, 12, 110, 202
reliefs, 13–15
religious themes, 28, 74
Renaissance
 American 2, 50, 103, 109
 Italian, 39, 50
republic of the arts, 148
Revell, Alexander H., 126
reviews. *See* critics
Revue Encyclopédique, 164
Riordan, Roger, 6, 11, 91
Robertson, Bruce, 84n. 126, 187n. 52
Robinson, Theodore, 49, 51, 70, 71, 185,
 185n. 36, 190, 202
Robinson, William S., 203
Rodin, Auguste, 150–151
Rogers, Howard T., 124
Rolshoven, Julius, 203
Rookwood Pottery, Cincinnati, 146, 153,
 157–160, 162, 163
Roosevelt, Theodore, 67, 96
Rosenberg, Emily S., 123n. 13
Rosenberg, Pierre, 175n. 80
Rosenblum, Robert, 87n. 128
Rosenfeld, Paul, 188
Rothenstein, William, 23n. 58
Roujon, Henry, 146, 148–149, 149nn. 8, 9,
 10, 11, 170
Rummell, John, 183
Rydell, Robert W., 2n. 11, 122n. 7, 224
Ryder, Albert Pinkham, 114, 188, 189–190
Rzewuski, Stanislas, 153n. 23

Saglio, André, 8n. 39, 11
Saint-Agnan, Georges, 150n. 13
Saint-Gaudens, Augustus, 13, 14–15, 163,
 173
St. Louis fair 1904, 183
salons, 2, 5, 26, 92n. 142, 171, 183
Sargent, John Singer, 6, 7, 21, 23, 23n. 58,
 25, 91, 96, 106n. 31, 156, 165, 182,
 184–186, 188–191, 203
Saxon, John, 203
scenery, American and foreign, 68
Schleier, Merrill, 88n. 130
Schofield, Walter Elmer, 203
"schools of art," 2, 2n. 6; *see also* national
 school

Schreyvogel, Charles, 65, 68, 203
Schuyler, Montgomery, 103
Scott, Mrs. Emily Maria, 203
Scribner's Magazine, 103, 106, 109
sculpture, 13–15, 16, 20, 21, 163, 172
Sears, Sarah Choate, 203
seascapes, 83–85, 83n. 126, 87
Semons, Lillian, 189n. 90
Sèvres, 151–152
Sharp, Joseph Henry, 203
Shaw, Albert, 100n. 18
Shaw, Robert Gould, 14
Sherwood, Rosina Emmet, 56, 59, 203
Shirayamadani, Kataro, 162, 163
Silverman, Debora L., 120n. 3, 138n. 44
simplicity in American art, 187
Simmons, Edward, 110
Skalet, Linda Henefield, 113nn. 61, 62,
 114nn. 64, 70
Skiff, Frederick J. V. 124, 139
Sloan, John, 187
Smith, Francis Hopkinson, 84, 99n. 15, 100
Smithsonian Institution, 117
Snell, Henry B., 5, 203
Society of American Artists, 110
Society of American Landscape Painters,
 81
Society of American Painters, Paris, 7
Sousa, John Philip, 137, 138
Spanish-American War, xvii, 2, 67, 94,
 122–124, 126
Spassky, Natalie, 29n. 70
Spofford, A. R., 103n. 25
Stanard, E. O., 126
Stavitsky, Gail, 224
Stead, W. T., 123n. 14, 144
Steele, Theodore, 72, 73, 203
Stella, Joseph, 88
Sterner, Albert, 203
Stewart, (Julius) Jules, 39, 44, 203
Stieglitz, Alfred, 11n. 44, 19n. 49, 88
still life, 87
Storer, Maria Longworth Nichols, 156,
 157, 157n. 41, 165
Story, Julian, 56, 203
Stott, Annette, 37n. 80
Sturgis, Russell, 106n. 35
subject matter, American, 26, 92, 183
Swedenborgianism, 74, 74n. 119
symbolism, 11, 29, 56, 73, 114, 154, 171

Taber, Edward M., 204
Tanner, Henry Ossawa, 6, 26, 28, 29, 204

Tappert, Tara, 49n. 88
Tarbell, Edmund C., 49, 50, 96, 109–110,
 111, 185, 204
tariffs, 109, 145n. 1, 146
Tattegrain, Francis, 91, 93
Taylor, Eugene, 74n. 119
Taylor, William Watts, 160
technique, American, 92
The Ten, 110, 110n. 51, 113
Tennessee Centennial and International
 Exposition, Nashville 1897, 99–101,
 99n. 15, 101n. 23
Thayer, Abbott H., 49, 52, 53, 91, 96, 110n.
 51, 184, 185, 188, 204
Theriat, Charles J., 204
Third Republic (French), 148–152, 176,
 179
Thomas, S. Seymour, 204
Thompson, D. Dodge, 26n. 62
Thompson, Joann Marie, 182n. 6
Tiffany, Louis Comfort, 151, 169, 179n. 89
Tiffany and Company, New York, 146,
 147, 153, 157, 164, 165, 167–168, 171
Tiffany Glass and Decorating Company,
 165, 169, 170
tokenism, 139
Tompkins, E. Berkeley, 109n. 38
tonalism, 74, 74n. 113, 81, 88, 94, 175, 184,
 185
Trachtenberg, Alan, 56n. 94, 96n. 5
Trans-Mississippi Exposition, Omaha
 1898, 100, 100nn. 18, 22, 101n. 23, 102
Truettner, William H., 113n. 60, 114n. 70
Tryon, Dwight, 6, 184
Tuchman, Barbara, 109n. 38
Turner, Charles Yardley, 4
Turner, Elizabeth Hutton, 92n. 142
Turner, Frederick Jackson, 68, 128
Twachtman, John, 6, 110, 110n. 51, 184, 185,
 185n. 36, 187, 188, 190–191

Underwood, Sandra Lee, 182n. 7
United States, economy, 120, 126; as
 "empire," 2; image abroad, 179; rela-
 tions with France, 145–146, 154n. 1,
 148–152, 153, 172; War for Indepen-
 dence, 126
United States Department of State, xvii,
 2, 213n. 19
United States government, 120, 122;
 Bureau of Indian Affairs, 139; report
 on Paris Exposition, 164; Senate
 Committee on Foreign Relations,

146; tariff policy, 109; War Depart-
 ment, 133
United States National Commission, 139
"usable past," 92, 188, 189, 190

Vail, Eugene, 204
Valentin, Albert R., 157
Van Boskerck, Robert W., 204
Van Briggle, Artus, 158–159
Van der Weyden, Harry, 204
Van Dyke, John C., 2, 96, 109, 114, 187
Vedder, Simon Harmon, 204
versatility, American, 184, 185
Vinton, Frederick Porter, 204
Virgin paintings, 50, 53–56
"virility" of American art, 183, 188
visual arts, place of, 148, 150
Le Voltaire (newspaper), 154
Vonnoh, Bessie O. Potter, 20
Vonnoh, Robert W., 186, 204

Walden, Lionel, 170, 204
Walton, William, 8n. 39, 29, 84n. 126, 91
Walker, Charles Howard, 100n. 18
Walker, Horatio, 204
Wall, A. Bryan, 204
Washington, Booker T., 138, 141, 142
Waters, Sadie, 205
Weeks, Edwin Lord, xxiv, 1, 26, 27, 183,
 205
Weinberg, H. Barbara, xviii, 1n. 4, 26n.
 63, 29n. 73, 73n. 110, 109n. 42, 110n.
 52, 114n. 64, 188n. 74, 189, 192n. 119
Weir, John F., 205
Weir, Julian Alden, 65, 66, 110, 185,
 185n.36, 186, 187, 188, 190, 191, 205
Weisberg, Gabriel P., 34n. 78, 146n. 6, 224
Wentworth, Cecilia de, 205
Wexler, Victor G., 113n. 62
Whistler, James Abbott McNeill, 19,
 21–23, 24, 88, 91, 106n. 31, 154, 164, 165,
 171, 183–191, 185n. 36, 188n. 73, 205
White, Stanford, 179n. 89
Whitman, Walt, 184, 185, 188
Whitney, Gertrude Vanderbilt, 187
Whitney Museum of American Art,
 New York, 187, 191
Wiles, Irving, 56, 205
Williams, Michael, 186
Williams, William Carlos, 188
Wilson, Michael, 120n. 3
women, as artists, 6, 6n. 30, 138–139, 138n.
 43; as subject, 43–68, 47n. 87

women's organizations, 138
Wood, Grant, 190
Woodbury, Charles, H., 40, 205
Woodbury, Marcia Oakes, 35, 42, 205
Woodward, Benjamin D., 11, 124, 125, 128, 135, 138, 139n. 45
World's Columbian Exposition, Chicago 1893, 2, 2n. 7, 68, 73, 95–96, 96n. 2, 97, 98, 114, 122, 123, 128; architecture, 124; Court of Honor, 95; Woman's Building, 138
world's fair movement, 120, 122
world's fairs, 142; U.S. regional, 99–103; women's exhibits, 138n. 40, 43
World's Industrial and Cotton Centennial Exposition. *See* Centennial Exhibition, New Orleans, 1884–1885.
Wuerpel, Edmund H., 205

Wyant, Alexander Helwig, 6, 74, 79, 113, 114, 182, 183, 187, 188, 205

Yarnall, James L., 34n. 77
Yengoyan, Aram A., 120n. 6

Zeigler, Lee Woodward, 188n. 73
Zelinsky, Wilbur, 99
Zorn, Anders, 87n. 128

ABOUT THE AUTHORS

DIANE P. FISCHER
Ph.D., Program in Art History, The Graduate School and University Center of the City University of New York; master's program, Art History, The University of New Mexico; B.F.A., Cornell University. Dr. Fischer is the curator of the exhibition *Paris 1900: The "American School" at the Universal Exposition,* originating at The Montclair Art Museum, Montclair, New Jersey, where she is associate curator. *Paris 1900* is based upon her doctoral dissertation, "The 'American School' in Paris: The Repatriation of American Art at the Universal Exposition of 1900." For The Montclair Art Museum, she contributed essays to *George Inness: Presence of the Unseen* and *The Montclair Art Colony: Past and Present,* which she co-curated. She teaches at Montclair State University and has taught at Seton Hall University and Pratt Institute.

LINDA J. DOCHERTY
Ph.D., Art History, University of North Carolina at Chapel Hill; M.A., Art History, University of Chicago; B.A., Economics, Cornell University. Dr. Docherty is associate professor of art history and chair of the art department at Bowdoin College. She has published articles on Winslow Homer, Isabella Stewart Gardner, colonial and federal portraiture, and images of women as readers. She has also curated numerous exhibitions for the Bowdoin College Museum of Art, including *Context Considered: Perspectives on American Art* and *Face It! A New Approach to Portraiture.* Dr. Docherty is currently completing a book on American art criticism and American identity, 1876 to 1893.

ROBERT W. RYDELL
Ph.D., M.A., History, University of California at Los Angeles; B.A., History and Political Science, University of California at Berkeley. Dr. Rydell is professor of history at Montana State University. He has published numerous books, chapters, and articles on fairs and expositions. His works include *World of Fairs: The Century of Progress Expositions, 1926–1958* and *All the World's a Fair: Visions of Empire at American International Expositions, 1876–1916.*

GAIL STAVITSKY
Ph.D., M.A. Institute of Fine Arts, New York University; B.A., Art History, University of Michigan, Ann Arbor. Dr. Stavitsky is chief curator of The Montclair Art Museum and project director for the exhibition *Paris 1900: The "American School" at the Universal Exposition.* She has curated *Precisionism in America 1915–1944: Reordering Reality* and wrote the primary essay for the accompanying book. Dr. Stavitsky also organized *George Inness: Presence of the Unseen,* and contributed an essay to the catalogue. She has also curated exhibitions for the Carnegie Museum of Art, The New York Public Library, The Metropolitan Museum of Art and the Grey Art Gallery. She has written extensively and is a frequent lecturer.

GABRIEL P. WEISBERG
Ph.D., M.A., Art History, The Johns Hopkins University; B.A., Art History, New York University. Dr. Weisberg is professor of art history at the University of Minnesota. Among his many publications are *The Realist Tradition: French Painting and Drawing, 1830–1900; Art Nouveau Bing: Paris Style 1900; Beyond Impressionism: The Naturalist Impulse.* Other publications include *Collecting in the Gilded Age: Art Patronage in Pittsburgh, 1890–1910* (Pittsburgh: Frick Art and Historical Center, 1997), and *The Popularization of Images; Visual Culture under the July Monarch* (ed. with Petra T. D. Chu). He served as the assistant director, Humanities Projects in Museum and Historical Organizations Program, National Endowment for the Humanities from 1983–1985.